ANNIE LEIBOVITZ

PHOTOGRAPHS
ANNIE LEIBOVITZ
1970-1990

HarperPerennial

A Division of HarperCollins*Publishers*

Photographs Annie Leibovitz 1970–1990

Copyright © 1991 by Annie Leibovitz.
All rights reserved. Printed by Amilcare
Pizzi, Milan, Italy.

A hardcover edition of this book was
published in 1991 by HarperCollins
Publishers.

First HarperPerennial edition published
1992.

Designed by Jeff Streeper

Library of Congress Catalog Card
Number 90-56384

ISBN 0-06-092346-6 (pbk.)

95 96 Pizzi 5 4 3

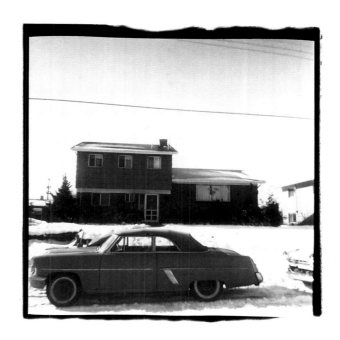

For my brothers and sisters,

Susan, Howard, Paula, Philip, and Barbara

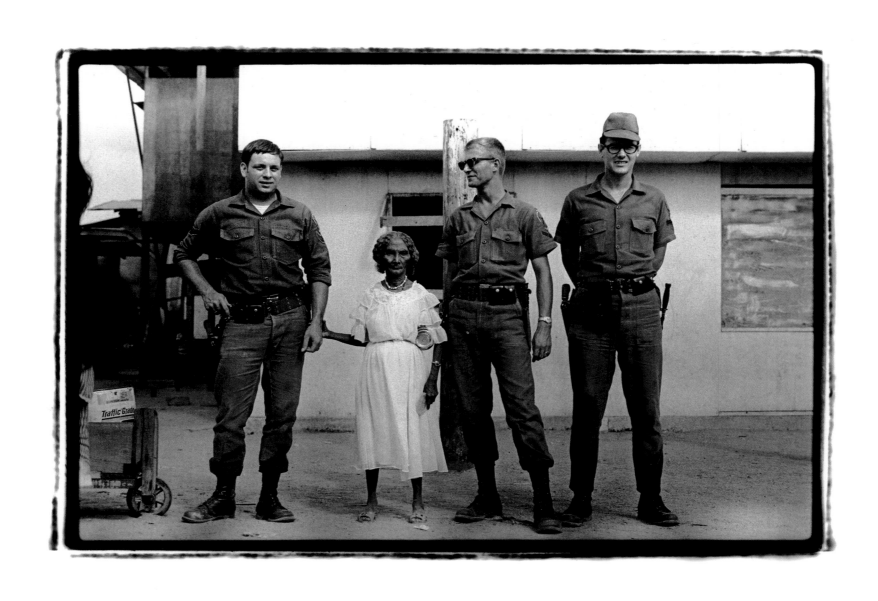

American soldiers and the Queen of the Negritos, *Clark Air Force Base, The Philippines, 1968*

A CONVERSATION WITH INGRID SISCHY

If you shut your eyes in Annie Leibovitz's office, and it's a windy day, you could think that the sound you hear is the sea crashing. Actually, it's the window panes jiggling. There are a lot of them—this is one of those hard-to-come-by places in New York that is flooded with natural light and graced with an unobstructed view of the Hudson River and beyond. But if it weren't for the sight of the Statue of Liberty, you wouldn't necessarily know you were in New York. You could be in a building in any industrial section in any city in America. You see water towers, and cranes, and buildings that are dirty and nondescript. The parking lot and the streets down below have the anonymous, lonely look of an Edward Hopper painting. If you're expecting fancy, it's not here. Leibovitz's office is unpretentious. Among the clutter on one shelf are some antique toy cars, award trophies, and souvenirs of the Eiffel Tower, the Statue of Liberty, and the Leaning Tower of Pisa. Outside her office, in the big white studio where Leibovitz often shoots, and where assistants bustle around, you get a sense of action and purpose, but in here things have been left alone. It's got character, and is in keeping with the personality of the photographer who works here, overtime.

Almost all of the books on Leibovitz's shelves are photog-raphy-related, and photographs spot the room, propped against the shelves, taped to walls, and lurking among the papers on her desk. Family pictures and casual shots of friends are mixed in with photographs of well-known people. The most obvious clue to Leibovitz's reputation is something that's written on a framed cover of *Vanity Fair*, one that features Michael Jackson. He's autographed it in black ink with "Love to Annie. You're really magical. Love, Michael." And in a corner, there's another sign of her working life—various pieces of luggage that never get completely unpacked and put away.

Leibovitz has been following the call of her pictures for over twenty years now, and her work has been published for just as long. Her story is not about a struggle to be recognized, nor does it reflect alienation from commerce. She's been after strong, true-to-herself photographs within the confinements of commissions and assignments that were due yesterday, the results of which would be seen by editors, art directors, and then the general public almost instantly, while they were still wet, as it were. And in the way that these images are particularly American, so is she. Her pictures seem somehow to be in league with both her audience and her subjects. The grasp on popular culture that spikes so much

of her work is a natural result of who Leibovitz is. She's the right medium for her medium.

I can't remember when I first realized I was looking at a photograph by Annie Leibovitz. It was years before I put her name to a picture that had made an impression on me. But thinking back on the images that have represented popular culture for the past twenty years, it's remarkable how many pictures that seemed to hit the nail on the head and capture the times turn out to have come from her cameras. How much Leibovitz herself has changed over the years, I don't know from first-hand experience. I suspect the answer is plenty, and not at all. That's true of her photographs, too.

Ingrid Sischy: This first one, with the soldiers, and the woman who looks so tiny next to them. What is it?

Annie Leibovitz: It's from one of the first rolls of film that I shot. I was studying painting at the San Francisco Art Institute, and I'd just bought my first camera. The woman in the photograph is the Queen of the Negritos, people who lived on the edge of Clark Air Force Base in the Philippines and scavenged the garbage. My father was stationed there in the late sixties, and I'd gone to spend summer vacation with him and the rest of the family. I shot other photographs of the Negritos going through the garbage, but they aren't as strong as this one.

The way the Queen is holding onto the American soldier could break your heart. It looks like she's using him to steady herself, but there's also a feeling that she's calming him down. It's a kind of family picture—a "family" of circumstances.

Some of the photographs that had the biggest influence on me were family pictures. There's a photograph of my mother's family that's very similar to this one of the Queen of the Negritos. In that photograph my grandmother and grandfather flank my mother and her seven brothers and sisters on the Atlantic City boardwalk. And there are formal photographs of my own family—which was big, six children—that show us growing up. You see us happy, or in thin times, whatever, for better or worse. The history of the family is there in those photographs.

How did you become the one with the camera? How did the Rolling Stone *relationship start?*

My boyfriend, Christopher Springmann, had given me a subscription to *Rolling Stone* while I was living on a kibbutz

in Israel for a semester on a work-study program. And when I went back to San Francisco, I showed some of my photographs to the magazine's art director, Robert Kingsbury. I had gotten into the habit of going out and taking photographs every day and developing them at night. He liked the fact that some of the photographs I shot the day before at an antiwar rally were already printed. And a photograph of ladders I'd taken at the kibbutz ended up running in the little photo gallery they had on page three above the letters section. A few months later they used the antiwar pictures for a special issue.

Rolling Stone started giving me assignments right away, which made me worry about having crossed over to the other side. I was selling pictures. The photographers I admired were not photographers who worked for magazines on assignment, but people who chose what they did from the inside—or so it seemed at the time. And I wondered if I was betraying something. And then I found out about what it meant to be published, especially what it was to have a photograph on the cover of a magazine, which is what happened a couple of months later. I can never forget the sensation of being at a newsstand and seeing for the first time my photograph transformed into the *Rolling Stone* cover. It was a lot different from having a photograph floating around in the wash, or pinned on a bulletin board at school.

Who was your first assignment?

Grace Slick. In those days we'd usually do local stories, or wait for people to come through San Francisco. And the subjects were for the most part musicians. Remember this was 1970. In a sense it was the end of the big music revolution. Janis Joplin died that year. Hendrix died. But even though *Rolling Stone* was considered a music magazine, it was about politics, too, and basically I threw myself into whatever was going on there.

The first time I went on an out-of-town assignment was when I flew to New York with Jann Wenner to photograph John Lennon. One of the things I've always liked about Jann is that he is a great fan. He would get excited, and show it, and not be embarrassed. But the biggest lesson for me about photographing stars came from John himself. Here was someone whose music had affected us for years, someone who loomed very large in my imagination—and he acted

completely normal with me. He hung around, asking me what I wanted him to do. And I just got on with what I was there for—the work. John's way of relating set the precedent for how I wanted to work with famous people, successful people, celebrities, or whatever.

But this session did more for me than that. When I started to be published I thought about Margaret Bourke-White and that whole journalistic approach to things. I believed I was supposed to catch life going by me—that I wasn't to alter it or tamper with it—that I was just to watch what was going on and report it as best I could. This shoot with John was different. I got involved, and I realized that you can't help but be touched by what goes on in front of you. I no longer believe that there is such a thing as objectivity. Everyone has a point of view. Some people call it style, but what we're really talking about is the guts of a photograph. When you trust your point of view, that's when you start taking pictures.

On the evidence of the number of your photographs that have been published, and all the files of thousands and thousands of pictures in your studio, you don't appear to be the lazy type. Sometimes—as with photographs of the Allman Brothers asleep in the back of a car—you seem to be the only one who stayed awake. Your shots of the Rolling Stones tours in the mid-seventies are a night-and-day narrative, which means you didn't stop. Ever?

I think the first time I had a break was after the Rolling Stones tour in '75. On that tour I had said to myself that I was never going to put my camera down. No matter what was going on I wasn't going to let go. And, believe me, I went to hell and back. The camera helped me survive.

But we were having a great time, too. I admired so many of the people I photographed and worked with. I was in love with them, I had crushes on them, I thought they knew everything about everything you needed to know. I wanted to be Hunter Thompson, I wanted to drive at night with no lights on, by the light of the moon. When you are a journalist you can pretend that you're trying these things because you have to participate in order to understand them. You have a set of credentials to enter into any world. It took me a while to let go of those old romances. But the work saved me. It was the most important thing.

Does the close-up of Mick Jagger's hand and wrist—the one with the stitches—have anything to do with the intensity of life then?

Yes and no. The Jagger hand was taken just before the tour, when they were all in Montauk staying at Andy Warhol's house, rehearsing. Jagger told me he had put his hand through a plate-glass window, thinking it was the door to a restaurant out there. He's very superstitious—you know that song of his called "Hand of Fate"? When this happened he went out and asked for every book that had the word "hand" in its title. Anyway, I knew he was going to the doctor to have the wound redressed and I asked if I could go along and take pictures. He was reluctant, but he said the decision was up to the doctor, who said "sure." Then when I started shooting, Mick asked, "Are you shooting this in color?" I said, "No! It's too gross. I'm doing it in black-and-white." And he insisted that I go get a roll of color.

Jagger seems almost transparent in some of the photographs you took back then, such as the one in which his torso looks like a carcass in a Francis Bacon painting. It's ugly-beautiful.

He would lose about ten pounds whenever he went on stage. I wanted the photographs to show the amount of energy that's involved in a performance, and how he put out everything that was left in his skinny body, using everything he had.

Many of your photographs use the body as well as the face as a means of expression, which is unusual for a portraitist. There's a mini-history of body fashions buried in your work. The picture of Arnold Schwarzenegger taken in 1976, for instance, is a harbinger of the all-out obsession with self-maintenance and gym mania that took hold in the eighties. In contrast to the body armor that individuals seem to need today, it's nice to see your pictures of people relating to each other in a nondefensive way. I remember seeing your Soledad Prison photograph when I was in college, but I hadn't seen the one of the two women curled up together. Its structure is similar to your most famous photograph, that last portrait of Lennon and Ono.

I realized when I was going through all the work to make up this book that I had been trying to take that picture many times before. I had been putting people in the fetal position, curling them up. And I finally did it successfully with John and Yoko. It was an important photograph for me graphically because it did everything I wanted it to do. Emotionally it was

a strong image by itself, and then circumstances gave it all sorts of other meanings, because John was killed a few hours after I left them. I had wanted to photograph them holding each other, and I imagined him curled up. At the last moment Yoko decided she would take her shirt off but not her pants. I was disappointed—you know, they were always being photographed in bed together. So I said, "Just leave your shirt on, it's OK." I didn't know what the impact would be. I mean, he loved her so much.

It's interesting to think about how Lennon's death affects the way we see that photograph now, and how a photograph's meaning changes so much with time. But magazine photographers can't wait for a picture's power to come out later. The impact has to be instant. Clearly, your work is deeply attuned to the physical reality of a magazine. You seem to think in terms of covers and spreads and bleeds, and the way pages need to breathe. It doesn't seem that this was always the case, however. In your earlier work it's your timing, and your instinct for what makes a photograph, that comes through—and, of course, the intimacy that's become a signature of your work. Toward the end of your time at Rolling Stone *and then with your assignments for* Vanity Fair, *and the campaigns you have done for* American Express *and* The Gap, *one can see something else happening. The photographs get more ambitious and everything's much more sophisticated. There is more of a conceptual approach, and perhaps most noticeable of all, your photographs seem much more produced.*

You're right. I could always rely on my sense of composition and form. And in the beginning it was just me and my subject. Now a whole lot of people are involved. I use assistants both in the studio and on the road, and there are agents, publicists, stylists, etc. Until I got to *Vanity Fair,* my experience with hair and makeup professionals was almost nil. Most of the time you wouldn't even dare ask someone to change their clothes. There was this feeling of "take a picture of me as I am." That's why photographing Tammy Wynette in 1972 was such a big shock. There was no publicist or anything. I just showed up at her house. She kept me waiting for about twenty minutes, and finally she came down the stairs completely dressed up. She had on a long dress, her hair was teased, curled, and sprayed, there was a lot of makeup. I felt like I was going on a date with Tammy

Wynette. That was the first time I experienced someone getting dressed up for a photography session. You'll notice in the other picture from that shoot that George Jones, her husband, wasn't dressed up at all. He was a much bigger deal than she was in those days, and he kept saying, "This is Tammy's shoot."

I still prefer to go to the subject's house before a session, if that is possible. That's one of the ways I get my information, and sometimes I end up taking photographs there. But for several years now the situations have more often than not been set up. There are a variety of reasons for this, primarily that neither the subjects nor I have much time. Actually, I enjoy set-up situations as much as I do informal reportage. It feels more like what photography really is. A lot of manipulation often goes into photographs that people are trying to make look "real."

In order to do this more conceptual kind of photography, I knew I needed to work on technique. Photography's like this baby that needs to be fed all the time. It's always hungry. It needs to be read to, taken care of. I had to nourish my work with different approaches. One of the reasons that I went to *Vanity Fair* was that I knew I would have a broader range of subjects—writers, dancers, artists, and musicians of all kinds. And I wanted to learn about glamour. I admired the work of photographers like Beaton, Penn, and Avedon, as much as I respected grittier photographers such as Robert Frank. But in the same way that I'd had to find my own way of reportage, I had to find my own form of glamour.

Obviously it's different working with a team than working by yourself. For instance, you end up dealing with other people's sense of glamour as well as your own or your subject's.

I've worked with stylists who take over completely and run the shoot. And then there are those who help you develop an idea or push you to play. Sometimes the subjects do a lot of the work. Joan Collins is like that. She's such a professional. She asked for gaffer's tape for her breasts, to enhance the cleavage. I must say, though, that in general I still like the clothes that people usually wear more than anything special that's brought to a shooting. We didn't tell Sammy Davis Jr., what to wear. But there are occasions when different clothes help. For instance, with David Byrne's picture, that fake leaf jacket by Adelle Lutz was an integral part

of the surreal mood we were creating.

Do you think your subjects relax more because you're a woman?

I just always think of myself as a photographer. I never separated those things. I never thought, well, I'm a woman and that's why I'm getting these images as opposed to other images, if that's what you're asking. Are you saying that there's a woman's point of view in my pictures?

Well, yes, I am suggesting that about your point of view. But I'm also thinking about what happens to an individual psychologically when he or she is in front of the camera. One of the most obvious things to grab onto in that complex experience is the person who is taking your picture.

I think that in the beginning, particularly, when I was younger, I didn't seem threatening, and that was useful. I like to think that I let the subject be whoever they want to be, and maybe the fact that I'm a woman makes that process easier. I don't know. Perhaps I empathize with the subjects more than a male photographer might, and so when I direct a sitting ideas may come more often from the people I'm photographing. For example, with the Sting picture, people ask, "How did you get Sting to undress?" Well, I didn't. We were in the desert, out in the middle of nowhere; it was very hot and stark. And he said he wanted to take his clothes off. It felt very natural to him.

Your nudes are different from most photographers'. In a way, they're dressed. You've done some that are nude nudes, but you've taken enough pictures of people who are painted to make this a mini-theme of your work. For example, there's that picture of Sting, there's "Blue Boy"—the primary-colored surfer—there's the artist Jeff Koons, all gilded up, and there are the images of Keith Haring decorated as if he were a warrior. Your photographs of Haring resound with his energy and his graphic talent. Was the session as much fun as it appears?

He was great. We had set up a living room filled with Salvation Army furniture and painted it all white. When he arrived he repainted the room in less than 45 minutes. And then he painted himself. I loved the way he painted his penis. It was so witty, with this elongated line. After we finished he said he felt completely dressed, and didn't want to stop. He wanted to go out. I was exhausted, but I said sure. The problem was, where in that outfit? We went to Times Square. There were a couple of policemen across the street, and I remember waiting to be arrested.

In most of your photographs of public figures, your subjects seem to accept the camera as a collaborator in their high-profile lives. Some of them love the camera, many of them play to it. But what about those people who agree to pose because they feel they have to put their image out there, but who really squirm at the idea? Diane Keaton, for instance, is famous for being camera shy. Your photographs of her are a kind of narrative about running away.

Keaton's a challenge. She's meticulous and she works hard at communicating that she can't communicate. She likes mystery. The first time we worked together, in 1984, she told me she disliked having her picture taken. I'd gone to her apartment. It was all white, with white furniture, and a white cat. I asked her to put on everything white that she owned and took her picture in all that white, with a white turtleneck pulled up over her face. Even her cat's looking away. The next time *Vanity Fair* asked me to take her picture, two years later, we met before the shoot and went through a lot of photography books together. Since Keaton is a photographer and director herself, this part of the process felt even more like a collaboration than usual. We were both on the other side, as it were, looking at her together. She wanted natural light for the photograph, and we had a tough time finding a rental studio in Los Angeles that had the right conditions. I was using Polapan film, which produces a very delicate negative that you can look at right away. And we studied the pictures as they were being done. There was a wonderful moment in which she started to do a little jig that seemed to me to catch her quirkiness. The second she began to do it, I started shooting. The dance didn't go on for very long, but it was riveting. It was an experiment for her, and that's also what was so fascinating about it. I can think of only two other times that people sort of lost it with their bodies when I was photographing them. One time was with Keith Richards because he was on something, and again with Ray Charles, because he is blind. The pictures show how the body would react if it weren't always trying to correct itself.

Clearly, dance is a subject that matters to you. The dance photographs that you end your book with are your most aes-

thetic, classical work. How long have you been interested in photographing dancers?

Dance is a deep-down love, probably because of my mother. She was a modern dancer. It's what she had always wanted to do. If she hadn't gotten married and had six children, who knows what she could have been? And I always took classes. If there wasn't a teacher where we were living, she'd teach the class. The picture of her dancing in the early seventies was taken on one of my trips back home. She had her leotard on, and I photographed her dancing in front of an old wall in the country. It was a wonderful shooting for me, because it was the first time my mother was the dancer and I was her photographer.

Photographing dancers for *Vanity Fair* was very much something I wanted to do. The magazine gave me the chance to take portraits of Baryshnikov, Mark Morris, Suzanne Farrell, Darci Kistler, and Paul Taylor. Because of that work, I was asked to do the photographs for American Ballet Theatre's 50th Anniversary souvenir book. And I worked with Baryshnikov and Morris again recently when they collaborated on the White Oak Dance Project tour, which was put together at a private wildlife reserve in Florida. It was a historic grouping of dancers. I spent several weeks down there working with them, which was a great luxury, but there was still that feeling of not having enough time to do what one hopes for. And I couldn't rush things. I had to be sensitive about when to shoot, how to shoot, etc.

I took a lot of books on dance with me to the plantation at White Oak. I studied the work of other photographers who had done things with dancers—Arnold Genthe, who collaborated with Isadora Duncan, Edward Steichen, George Platt Lynes, Lois Greenfield, Barbara Morgan, whose photographs of Martha Graham were a model of how I wanted to work with a dancer. The White Oak dancers looked at the books as well.

Dancers are a photographer's dream. They communicate with their bodies, and they are trained to be completely responsive to a collaborative situation. At White Oak, I set up a portable studio outside in the woods, near the studio where they were rehearsing. You didn't hear anything except the trees and the birds. The dancers told me that they liked working out there because what they were learning stayed with them longer. It sort of soaked into them as they walked back home from the studio through the woods, uninterrupted by the usual noise. And I wanted to be in the same place. I shot the formal portraits in the morning and at the end of the day, in natural light. When I took on the project I knew I was going to do pages of blur like the one of the naked dancers among the trees. The idea came from looking at Alexey Brodovitch's ballet photographs.

Mark Morris is an especially important dancer for me. By the time I had begun to go to the ballet, there was only Balanchine's shadow. People were always telling me how great Balanchine had been, but he seemed distant to me. And then I began seeing Mark's work, and he was so much a contemporary, but with very solid links to the past. There was also something timeless about his dances. He seemed to be able to draw from anything. The way the men partner the men, and the women carry the women, the way they all carry each other is just one example of his freedom. He's not a beautiful-looking man, and yet he's beautiful to watch. He's mesmerizing. One afternoon at White Oak I walked in and saw him on a couch. He was lying there so elegantly that I realized I didn't have to photograph him dancing. Later we went to an island and did that "Rousseau" portrait.

Do you ever think about doing a self-portrait?

In my early work there are pictures of me reflected in mirrors, and last year *Vanity Fair* asked me to do myself. I didn't actually shoot myself, my assistant did, but I set up the picture. I had just finished photographing Robert Redford, and I was standing in the middle of the dry lake beds outside Salt Lake City with all my equipment. But I was too nervous to get it right.

So how would you do it right?

I think self-portraits are very difficult. I've always seen mine as straightforward, very stripped down, hair pulled back. No shirt. Whatever light happened to be available. I'd want it to be very graphic—about darkness and light. No one else should be there, but I'm scared to do it by myself. I've been thinking about it for a long time. The whole idea of a self-portrait is strange. I'm so strongly linked to how I see through the camera that to get to the other side of it would be difficult. It would be as if I were taking a photograph in the dark.

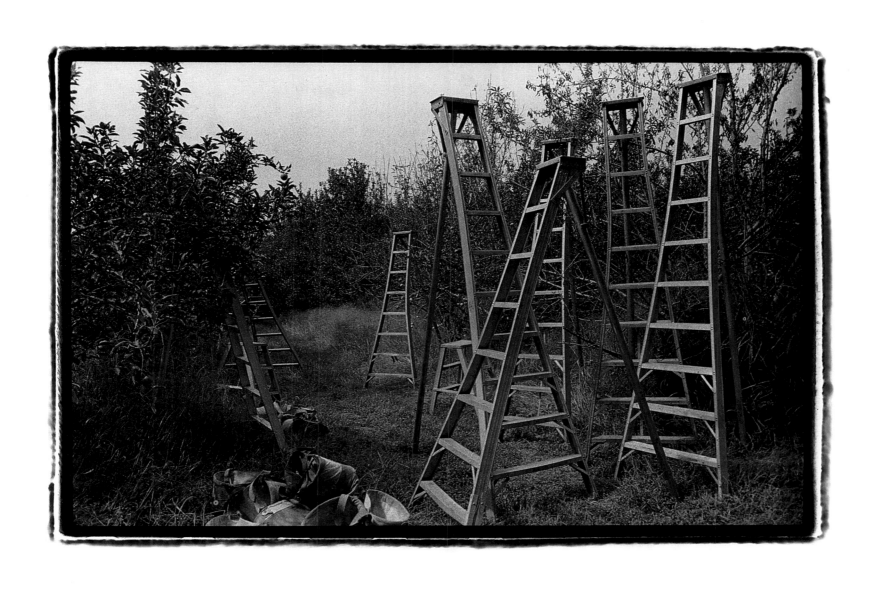

Kibbutz Amir, *Israel, 1969*

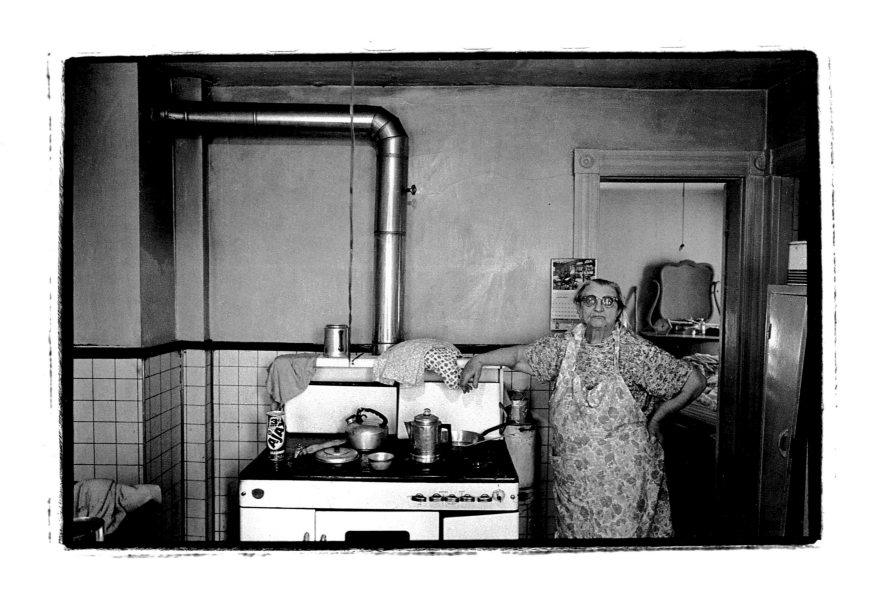

Rachel Leibovitz, *Waterbury, Connecticut, 1974*

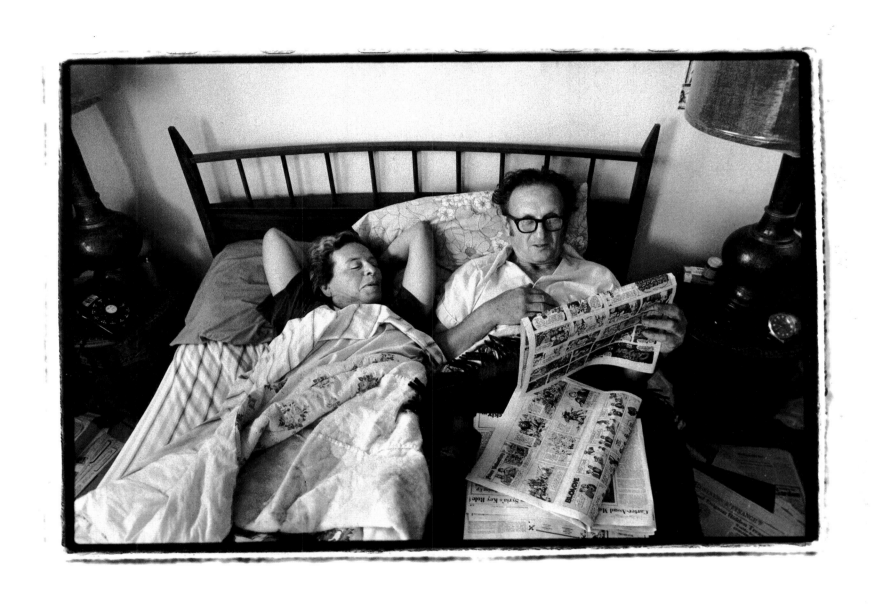

Marilyn and Samuel Leibovitz, *Silver Spring, Maryland, 1975*

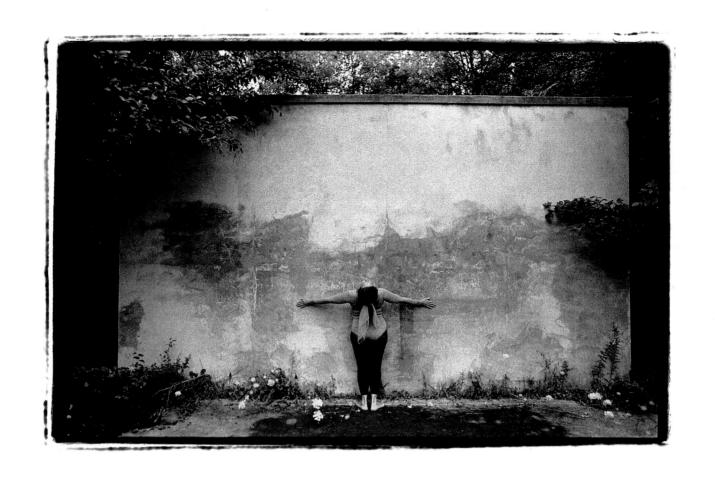

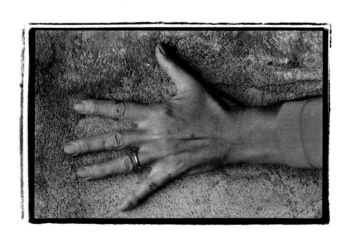

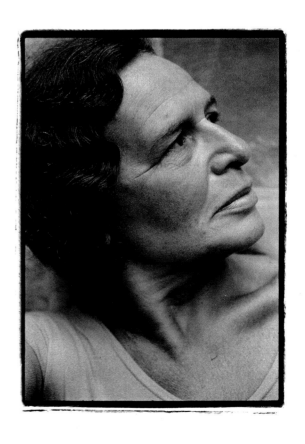

Marilyn Leibovitz, *Ellenville, New York, 1974*

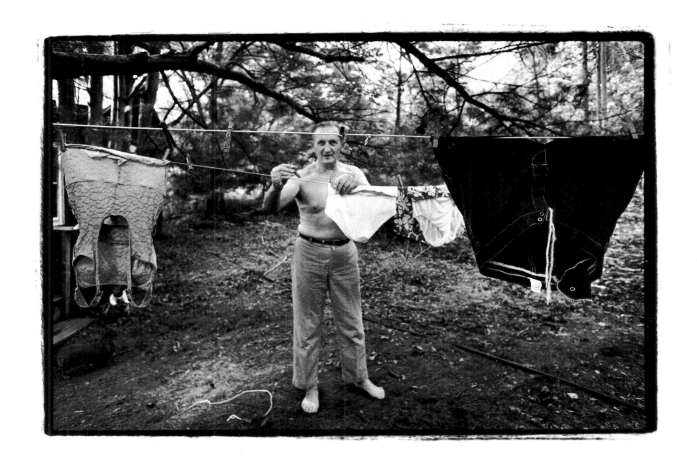

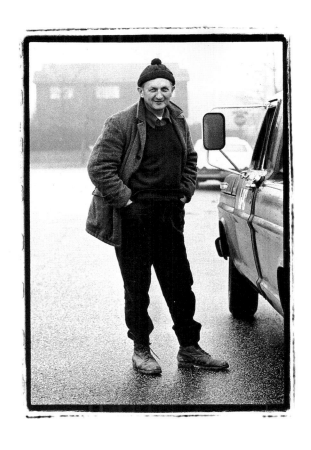

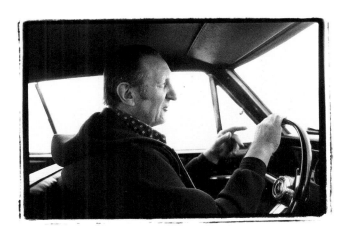

Samuel Leibovitz, *Ellenville, New York, 1974, and Silver Spring, Maryland, 1972*

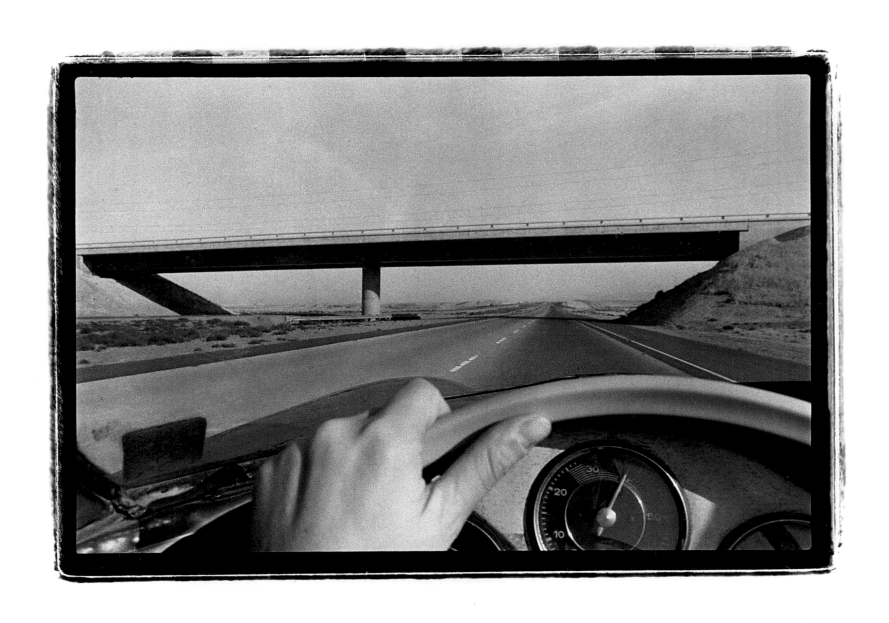

Highway 101, California, 1973

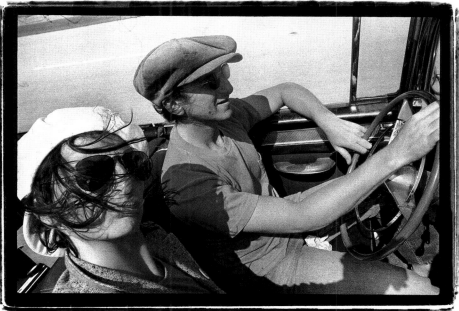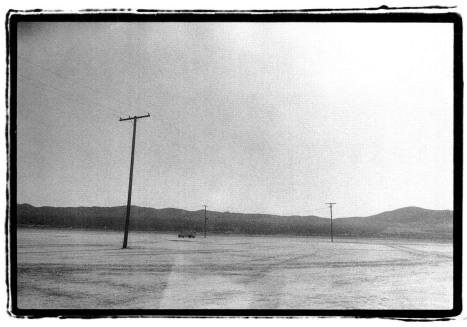

Annie Leibovitz and Bobby Steinbrecher, *Highway 101, California, 1974*

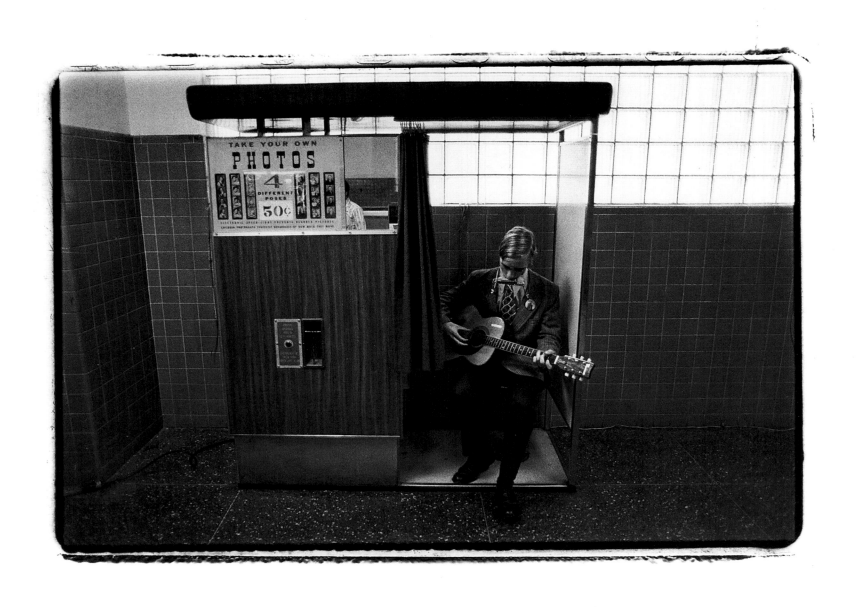

Houston, Texas, 1973

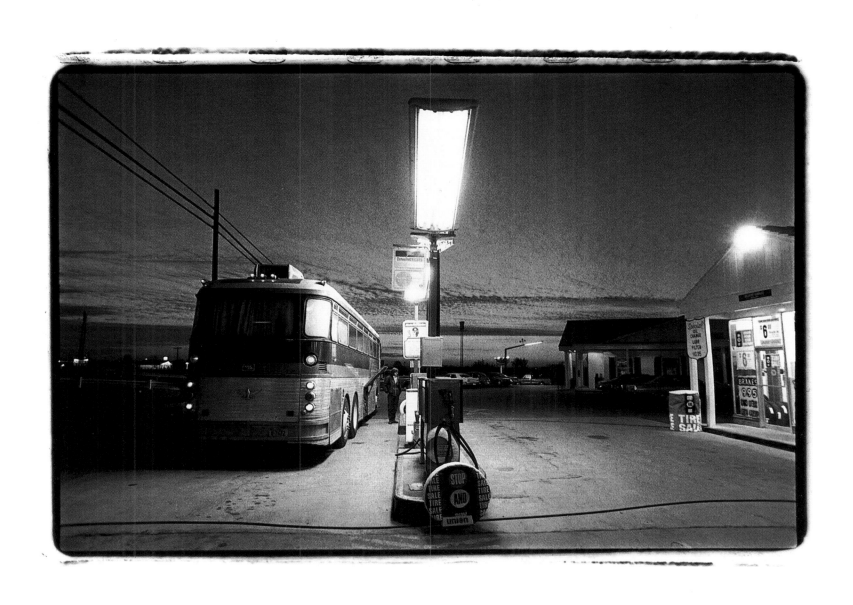

On the road with Jackson Browne, *Iowa, 1976*

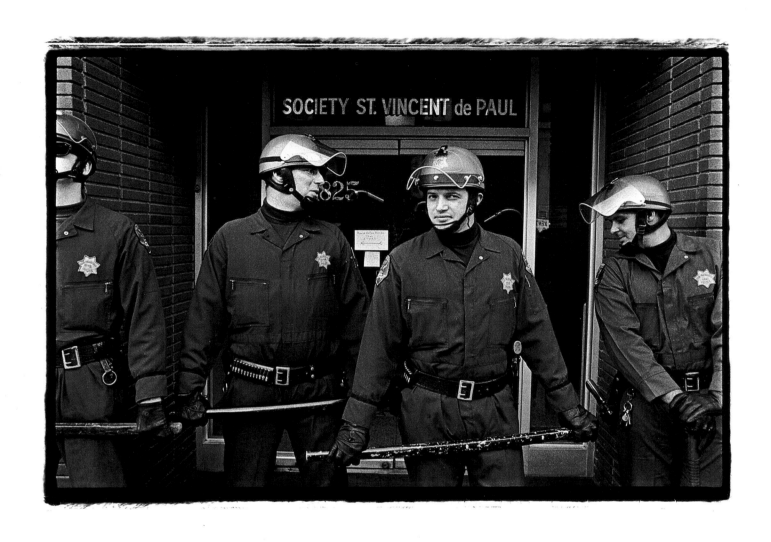

Antiwar demonstration, *San Francisco, 1970*

John Lennon, *New York City, 1970*

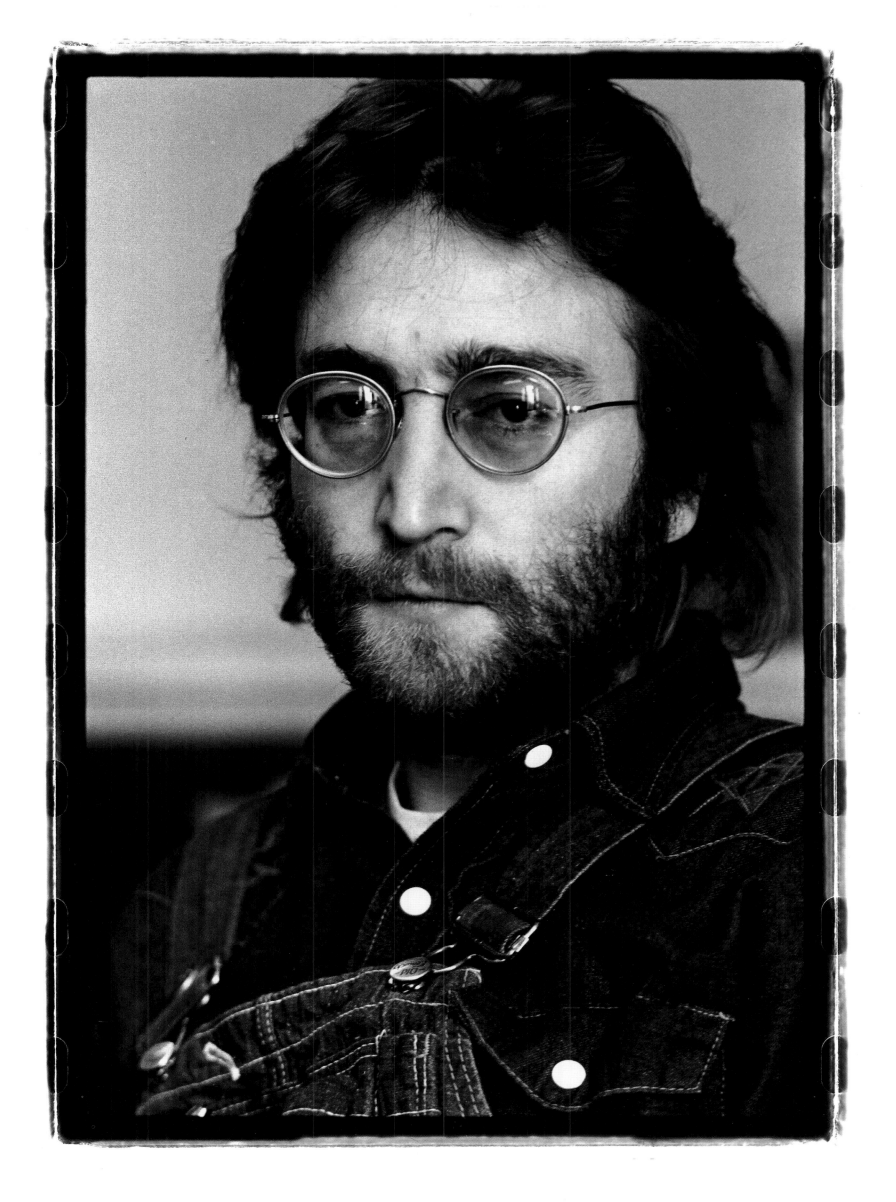

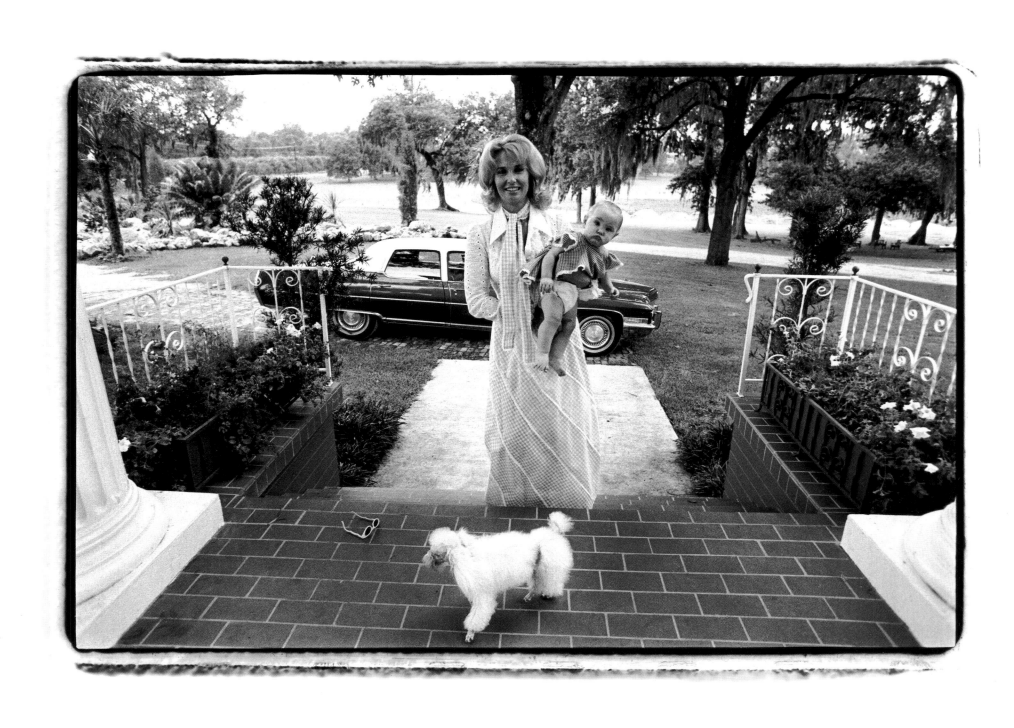

Tammy Wynette, *Lakeland, Florida, 1971*

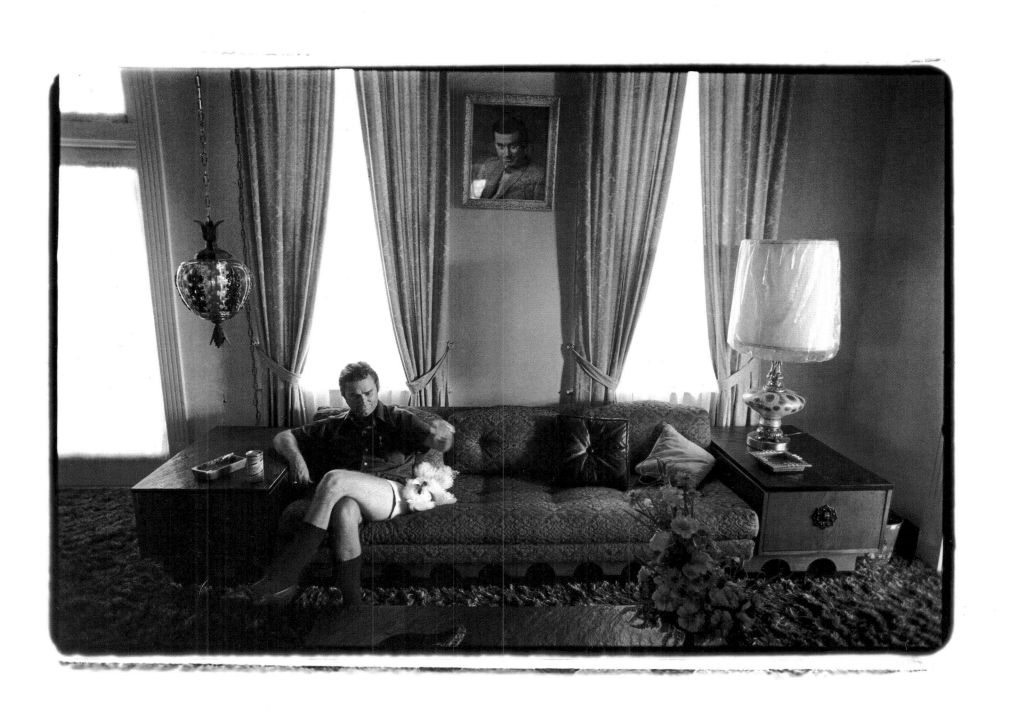

George Jones, *Lakeland, Florida, 1971*

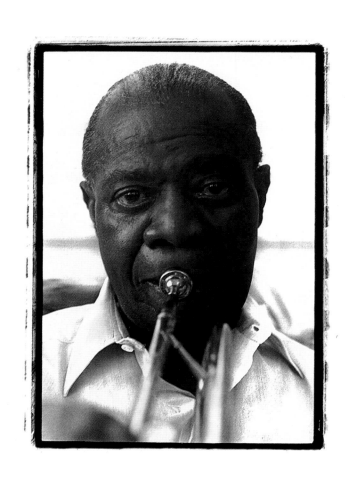

Louis Armstrong, *Queens, New York, 1971*

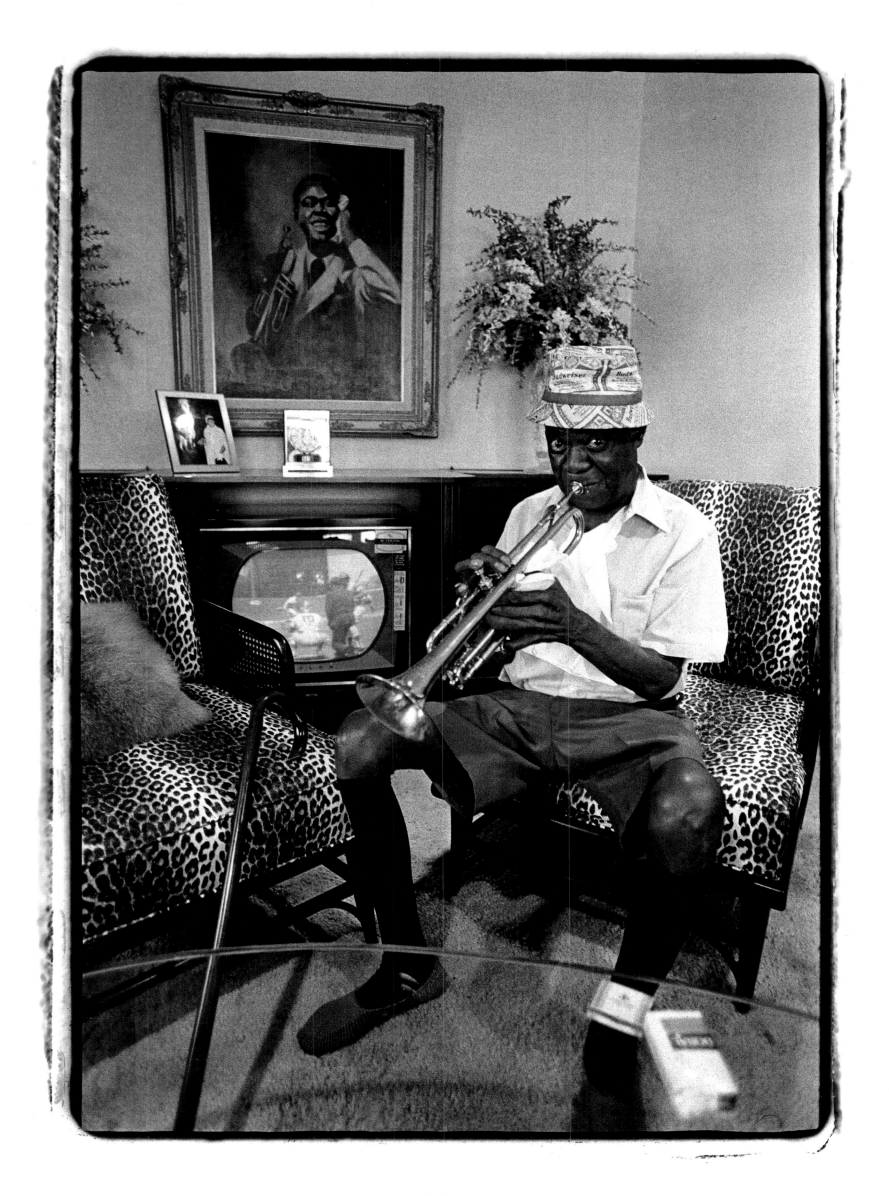

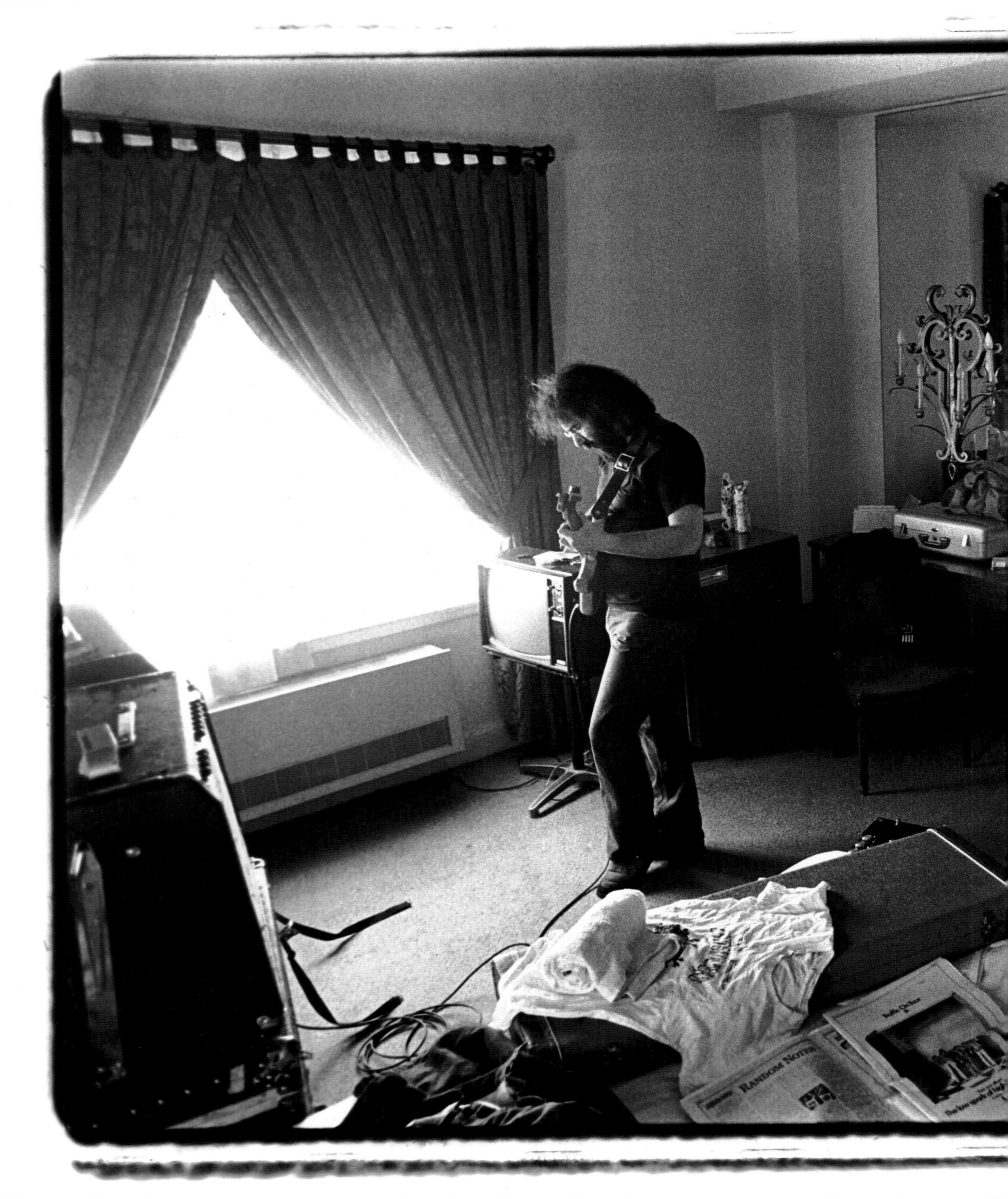

Jerry Garcia, *New York City, 1973*

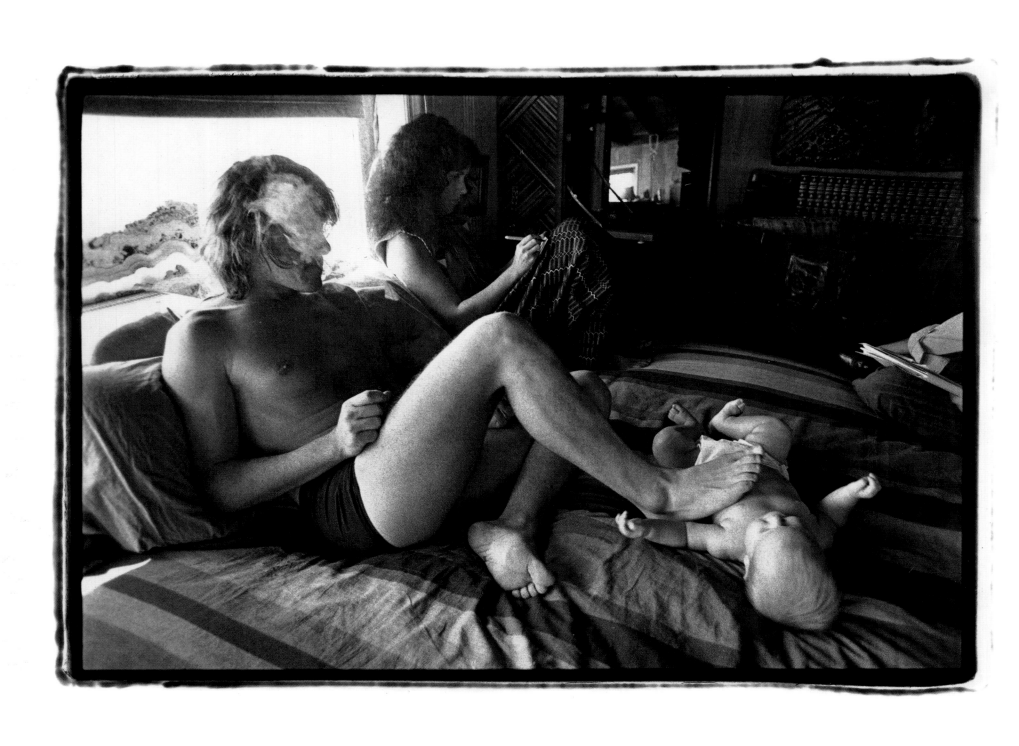

Paul Kantner, Grace Slick, and China, *Bolinas, California, 1971*

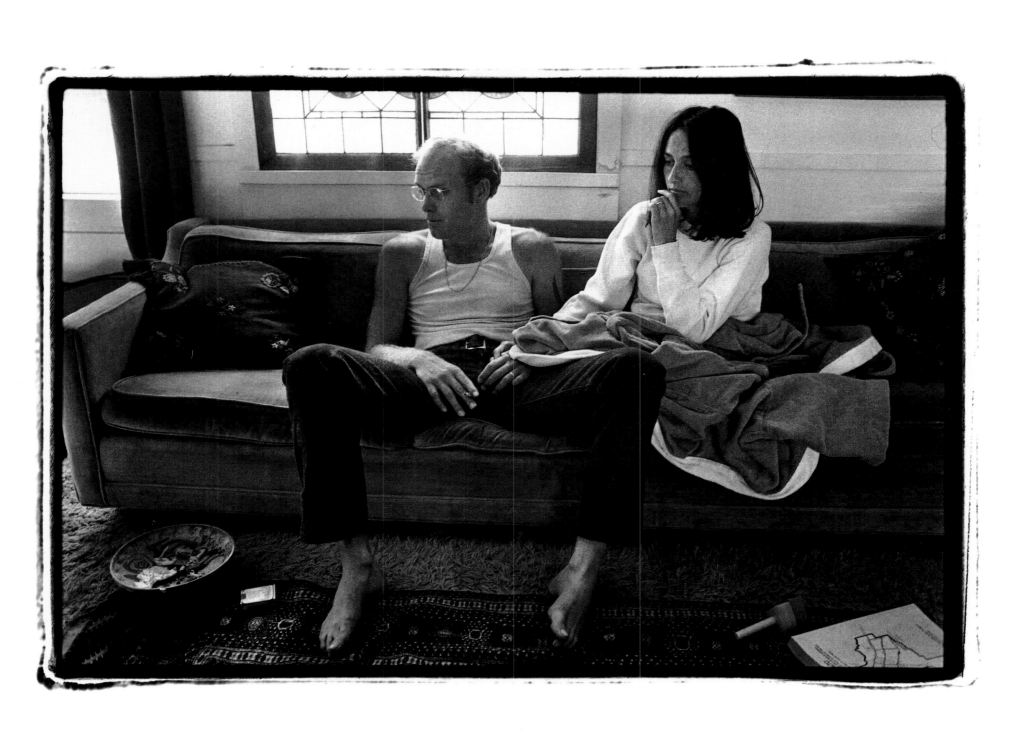

David Harris and Joan Baez, *Los Altos, California, 1971*

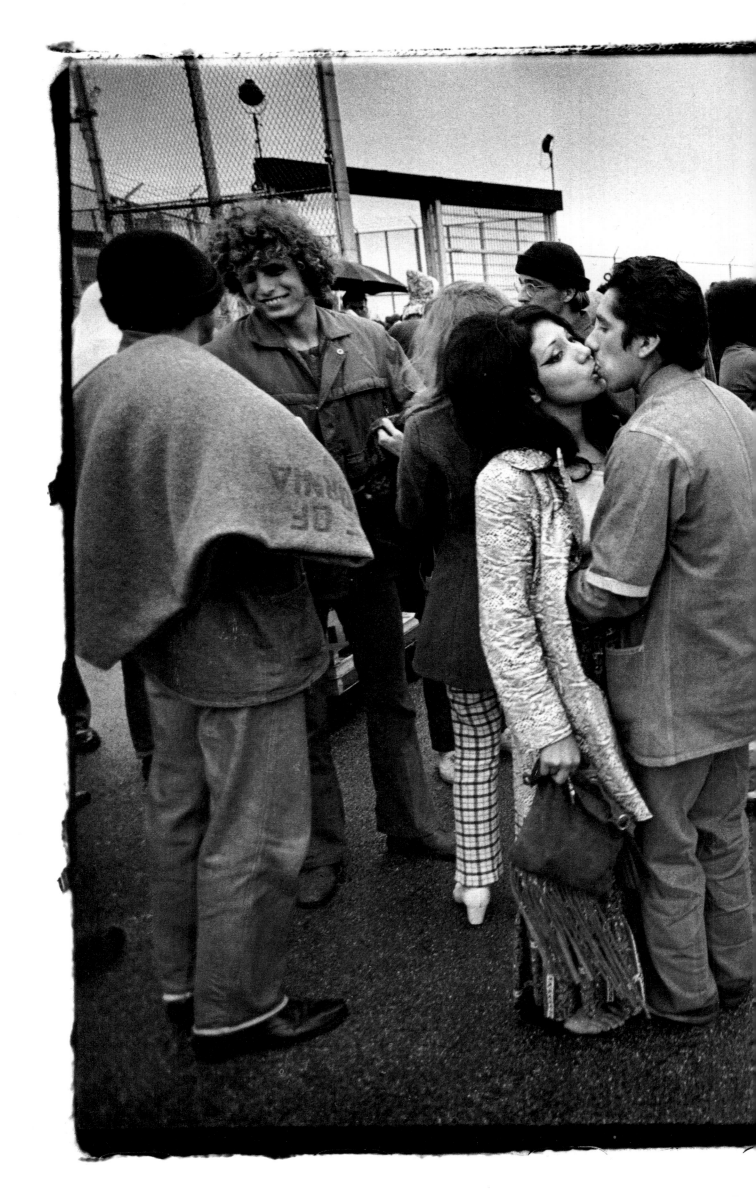

Christmas, 1971,
Soledad Prison, California

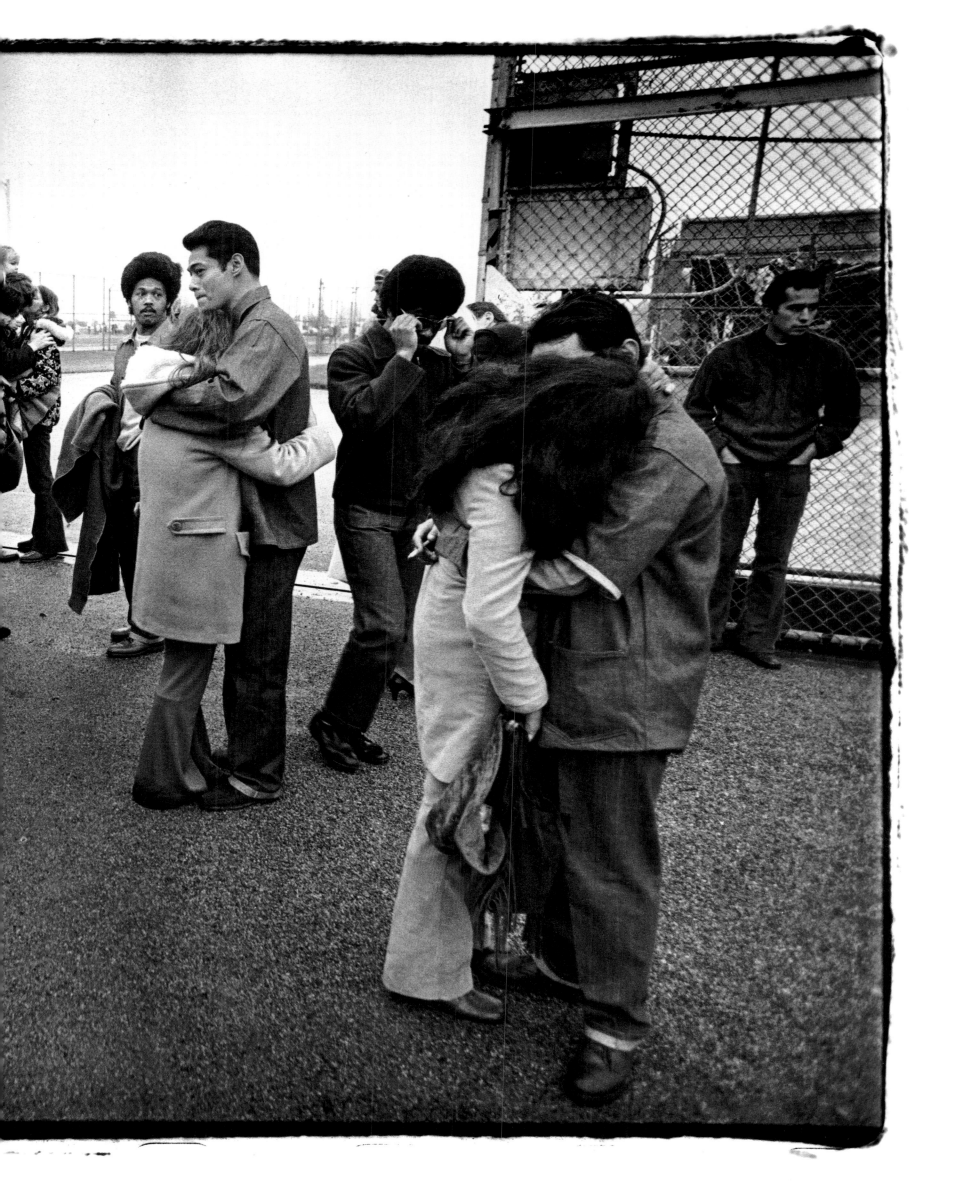

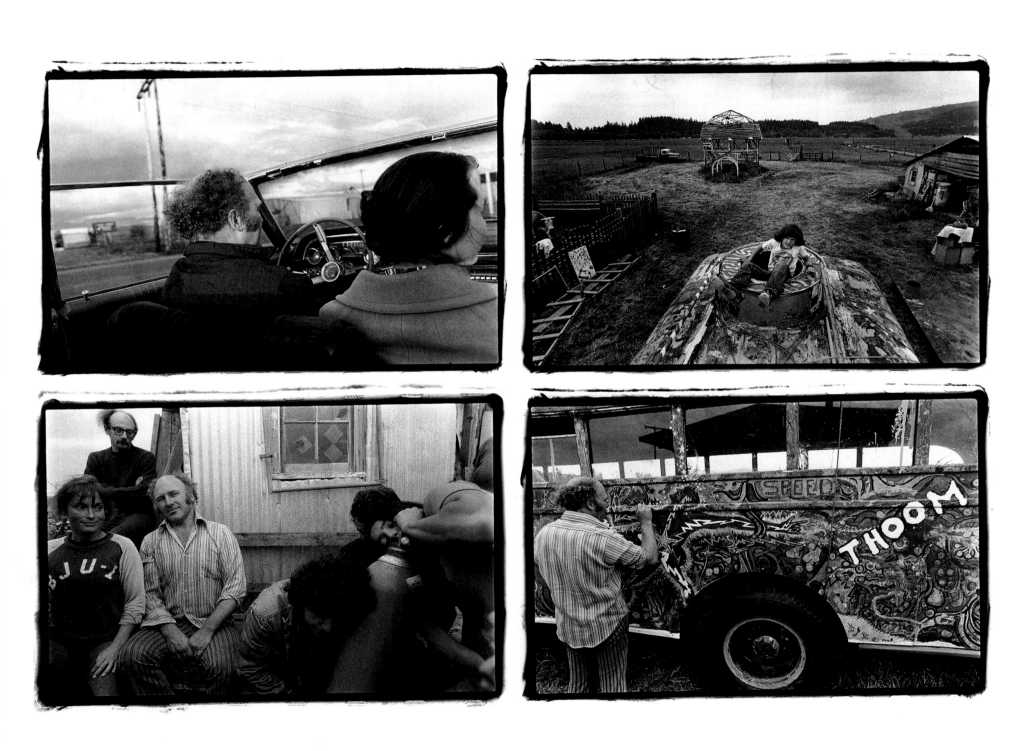

Ken Kesey's farm, *Eugene, Oregon, 1974*

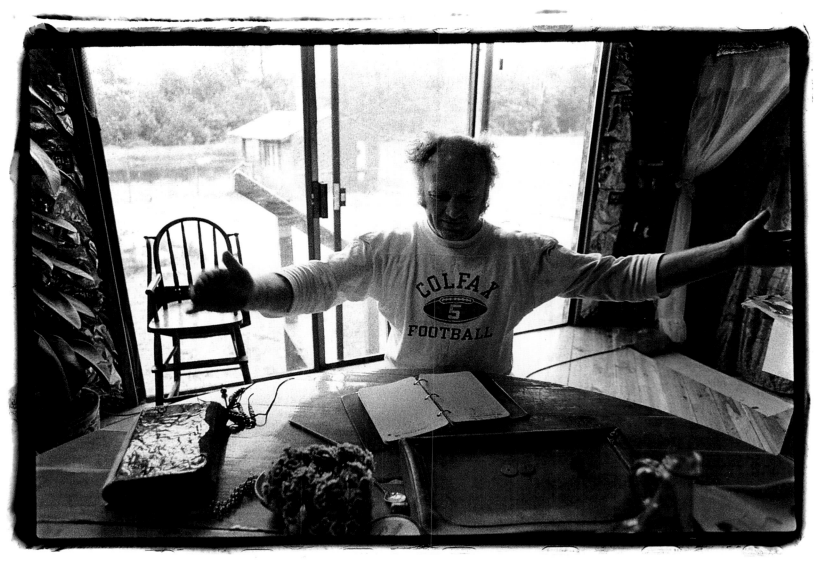

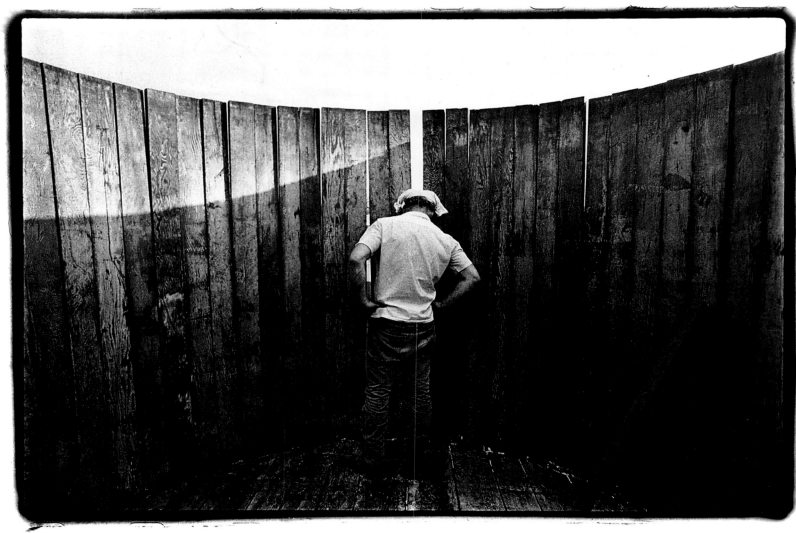

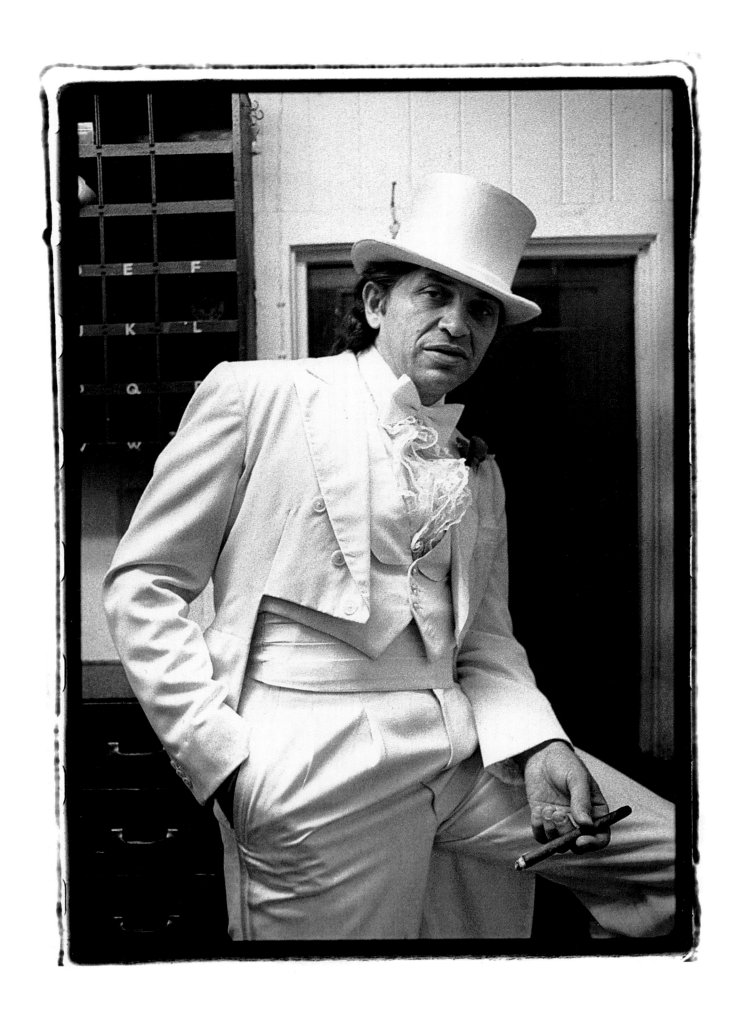

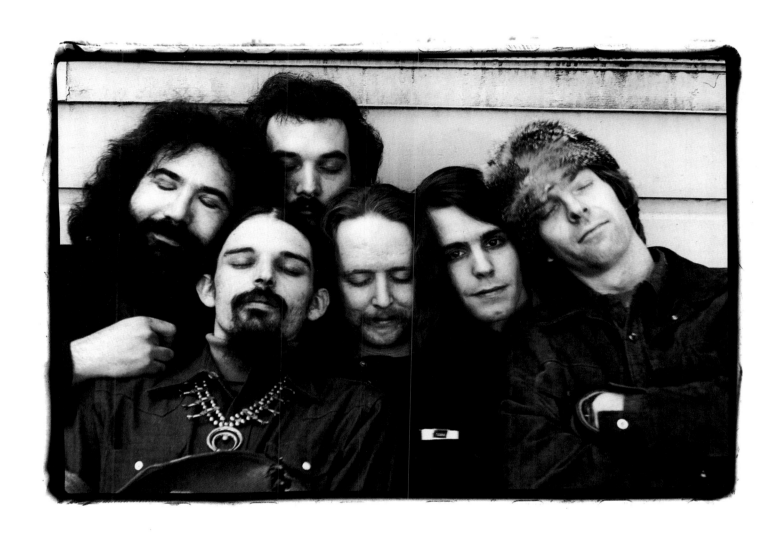

Bill Graham, *San Francisco, 1974*

The Grateful Dead, *San Rafael, California, 1972*

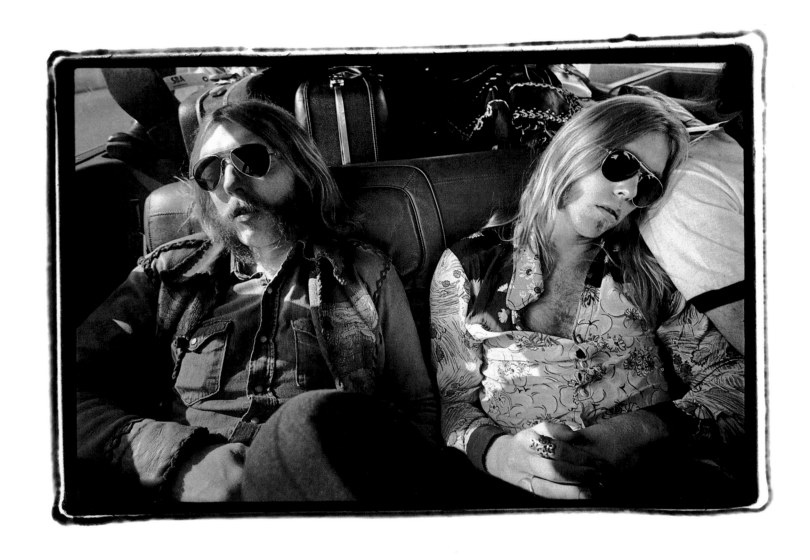

Duane and Gregg Allman, *Ventura, California, 1971*

On the road with Alice Cooper, *Roanoke, Virginia, 1972*

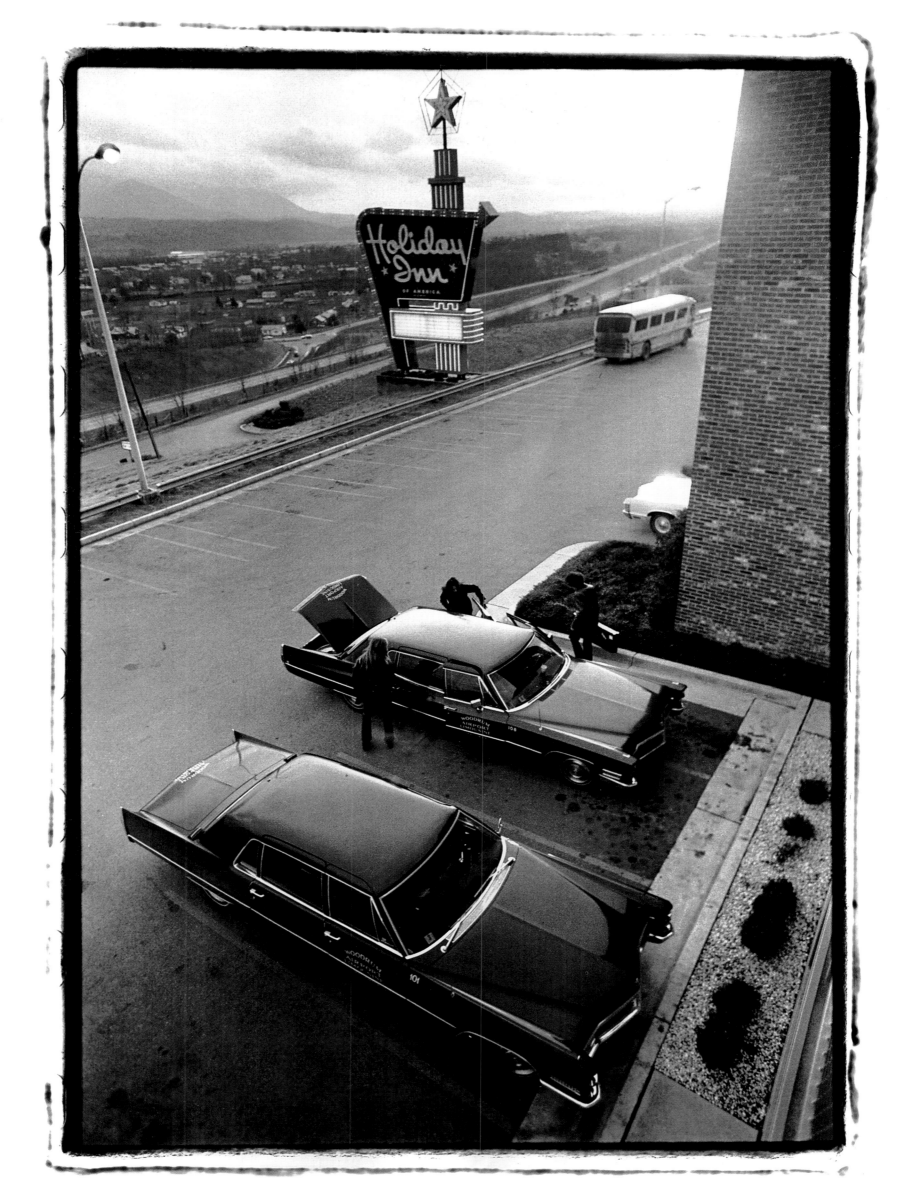

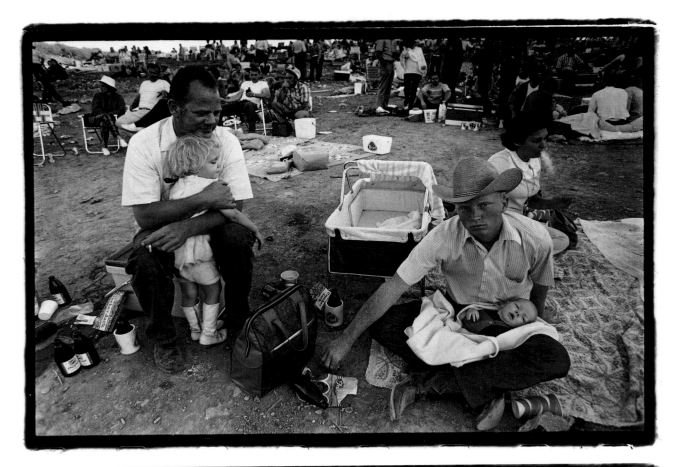

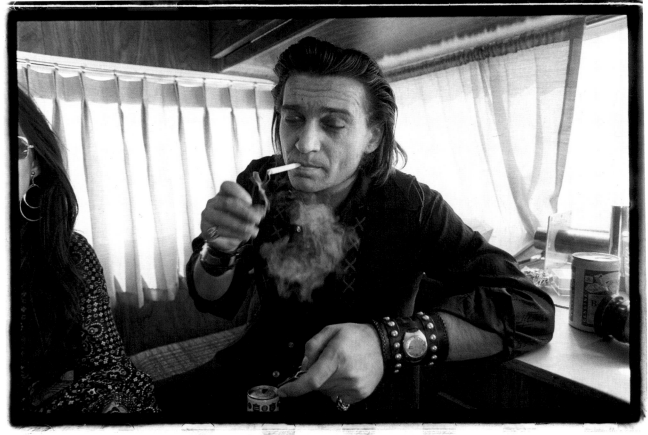

Dripping Springs Reunion, *Texas*, 1972. Waylon Jennings (bottom left) and Hank Snow (bottom right)

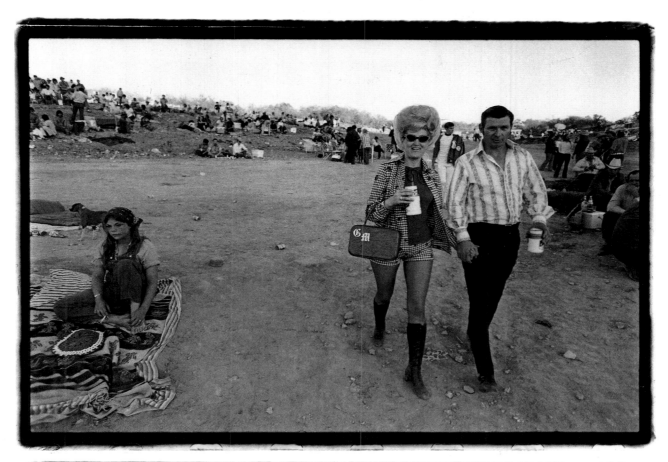

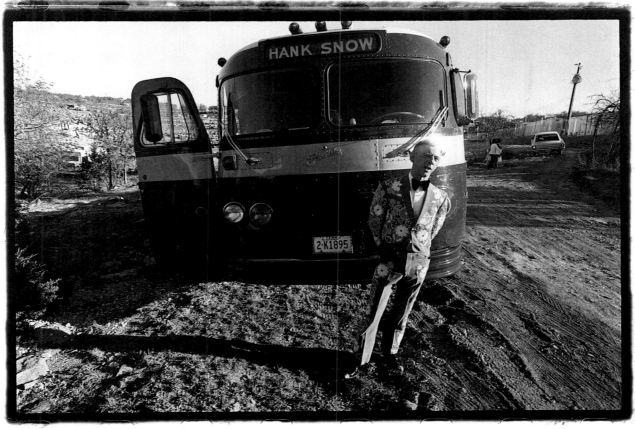

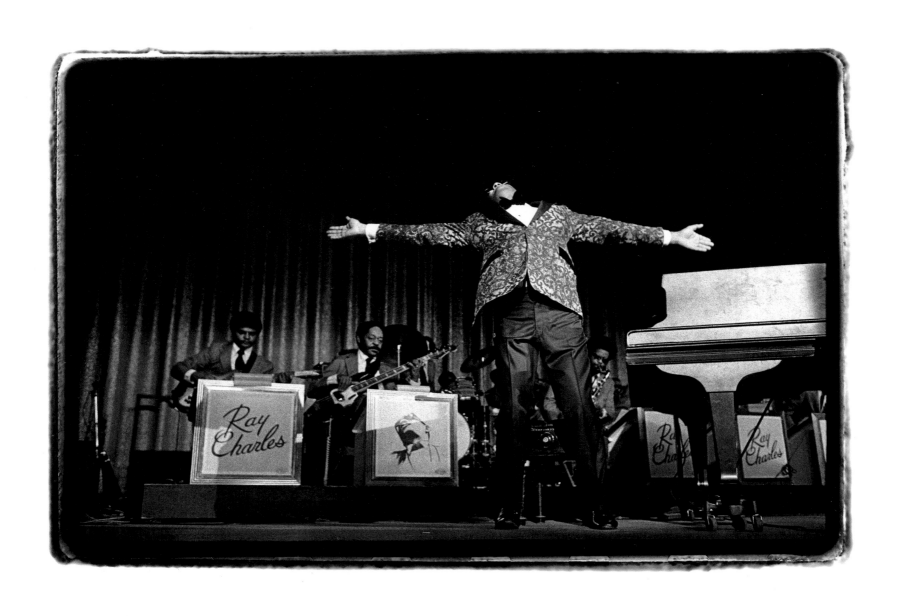

Ray Charles, *Baltimore and San Francisco, 1972*

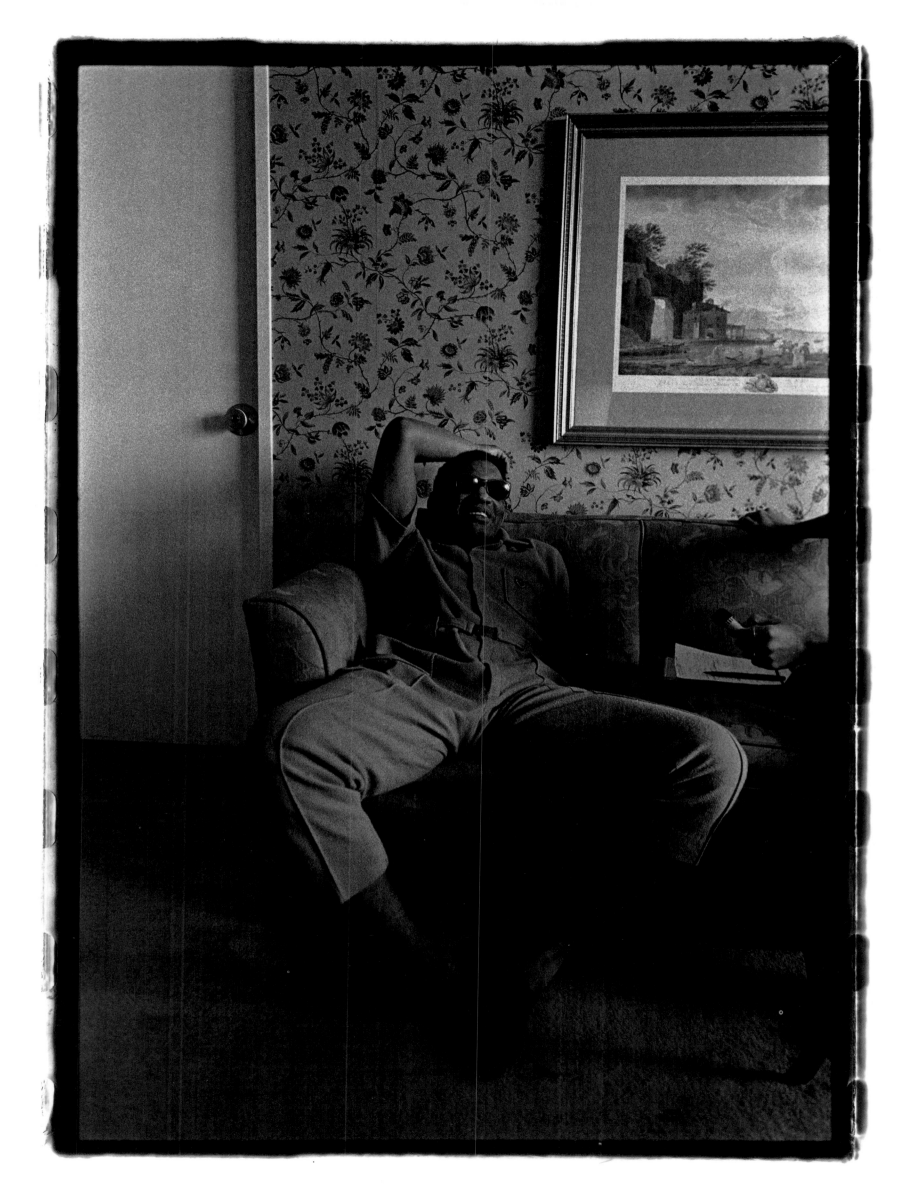

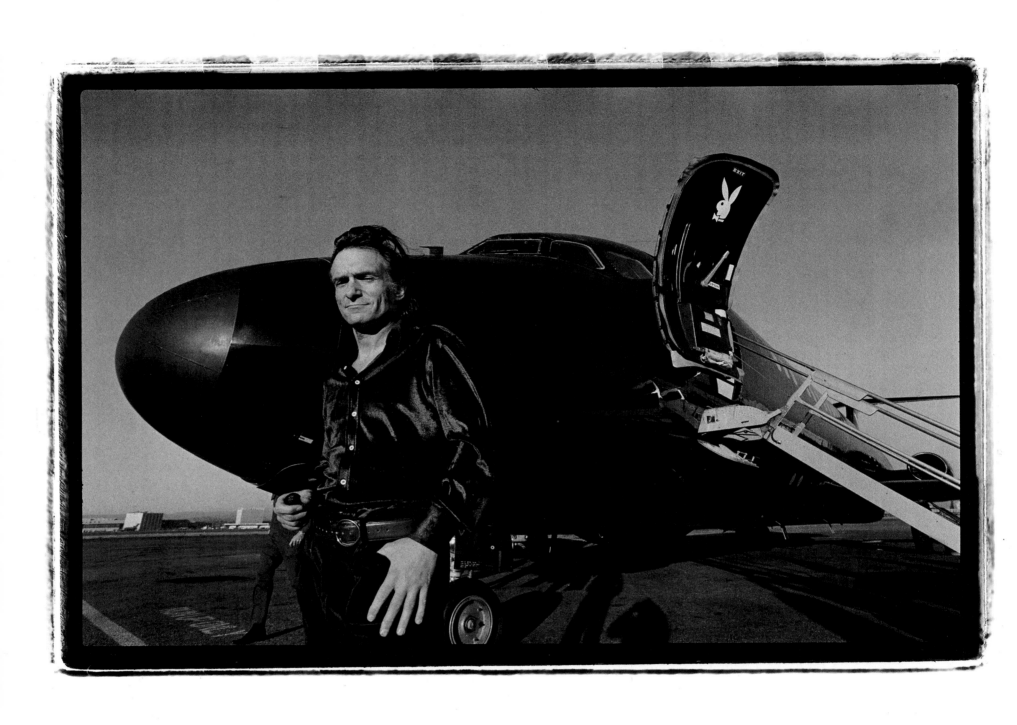

Hugh Hefner, *Los Angeles, 1973*

Lily Tomlin, *Los Angeles, 1973*

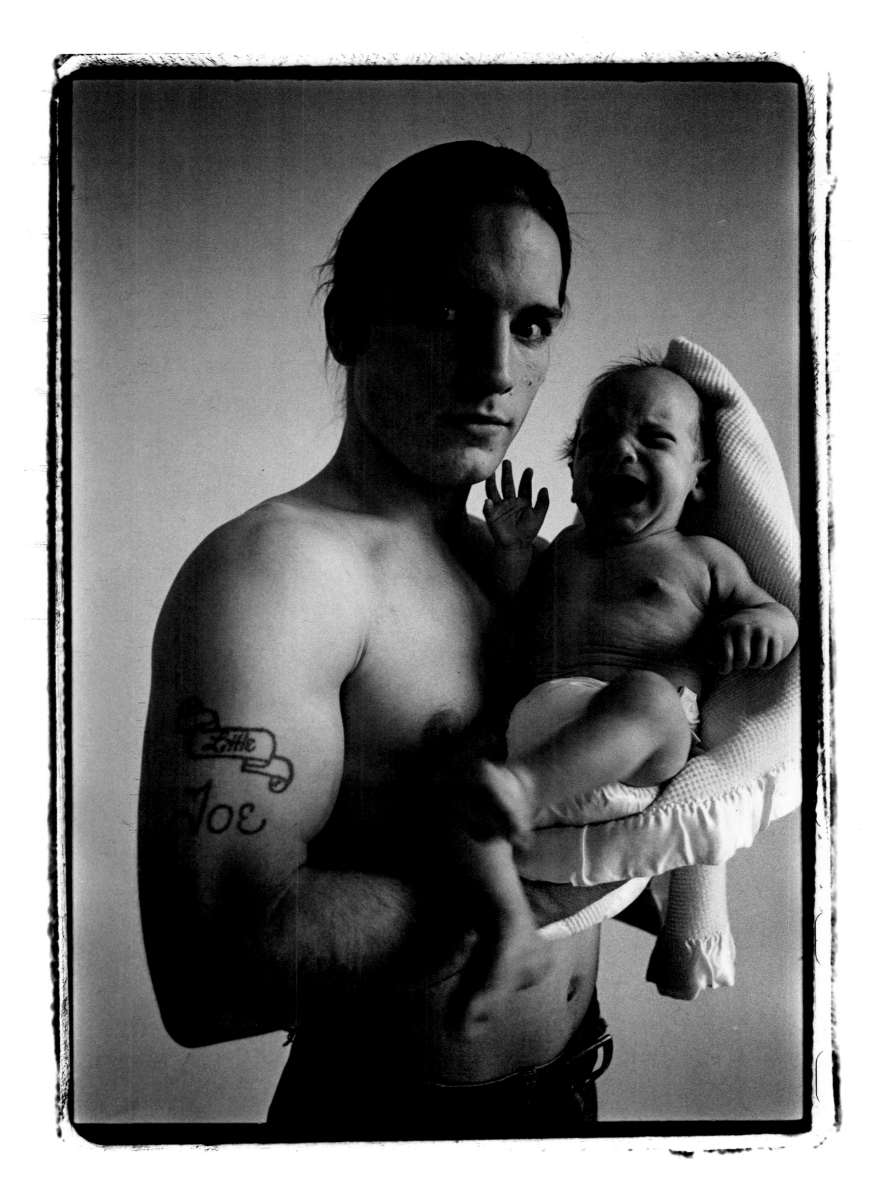

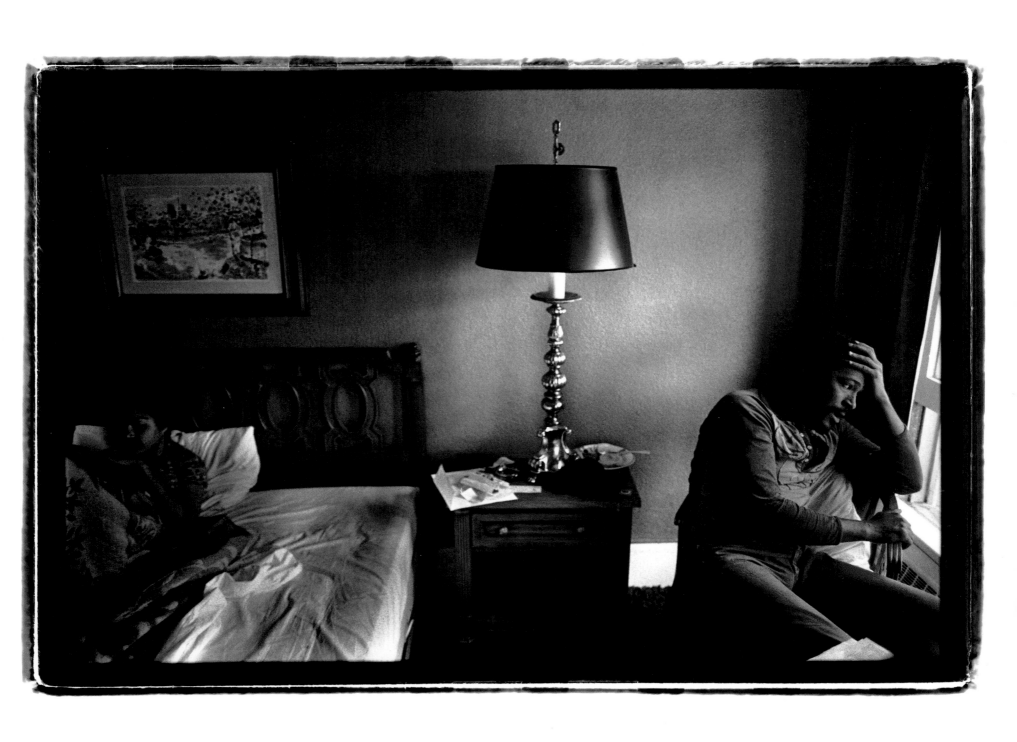

Richard Pryor, *Los Angeles, 1974*

Marvin Gaye and Jan Hunter, *San Diego, California, 1974*

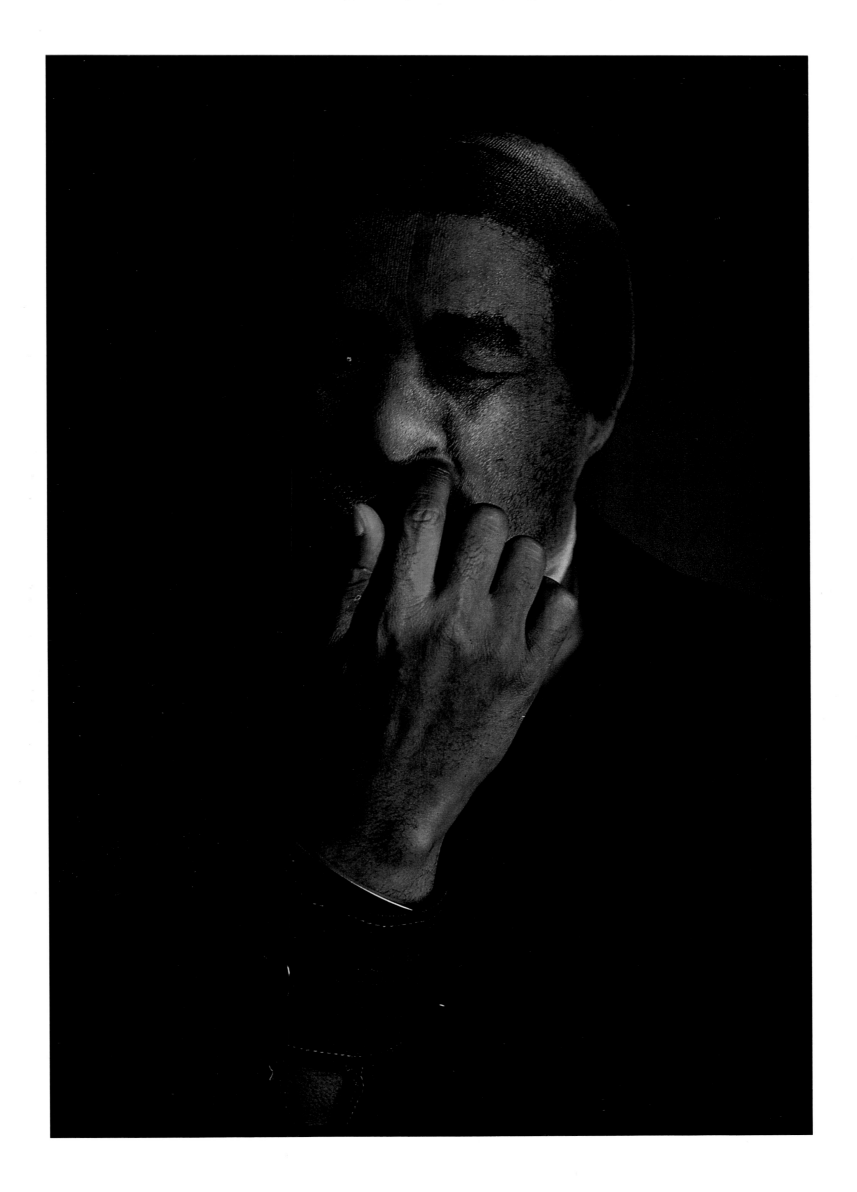

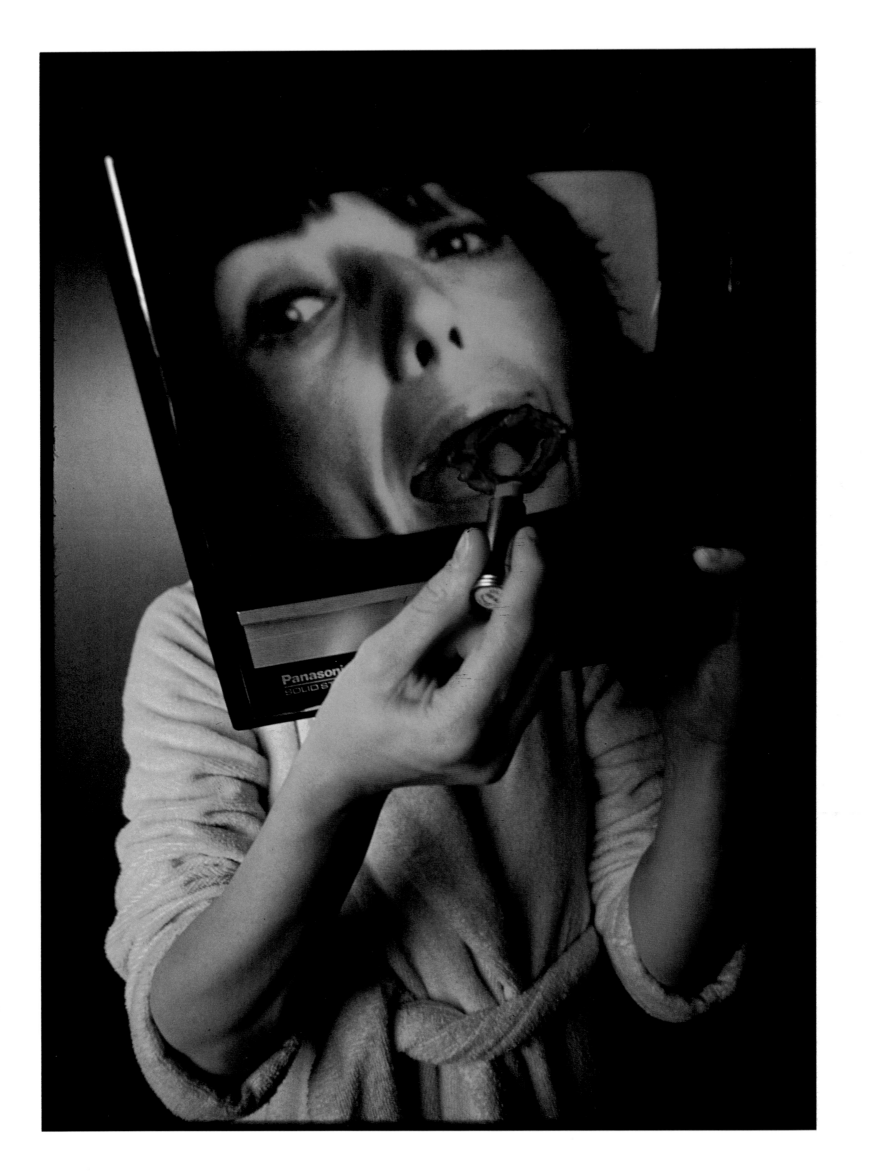

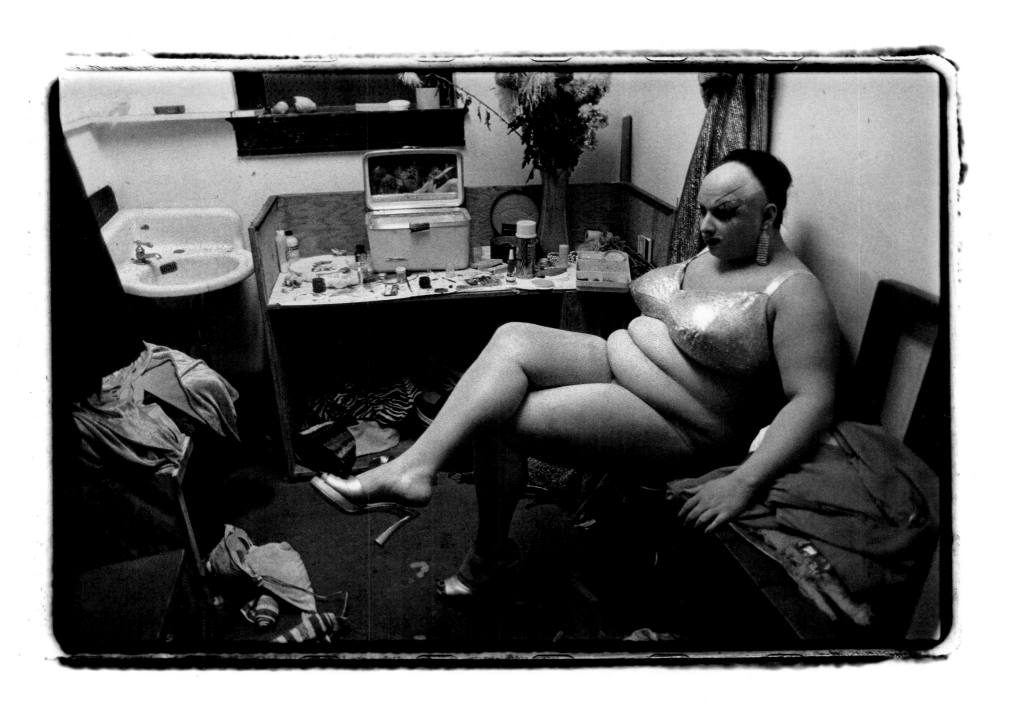

Joe Dallesandro and Joe, Jr., *New York City, 1971*

Divine, *San Francisco, 1972*

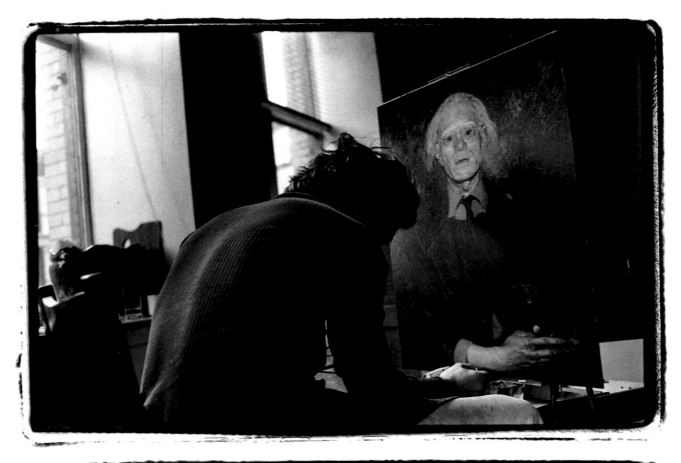

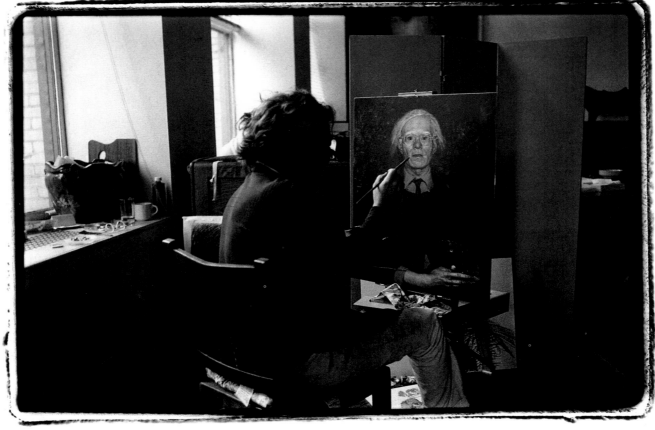

Jamie Wyeth, *New York City, 1975*

Andy Warhol, *New York City, 1976*

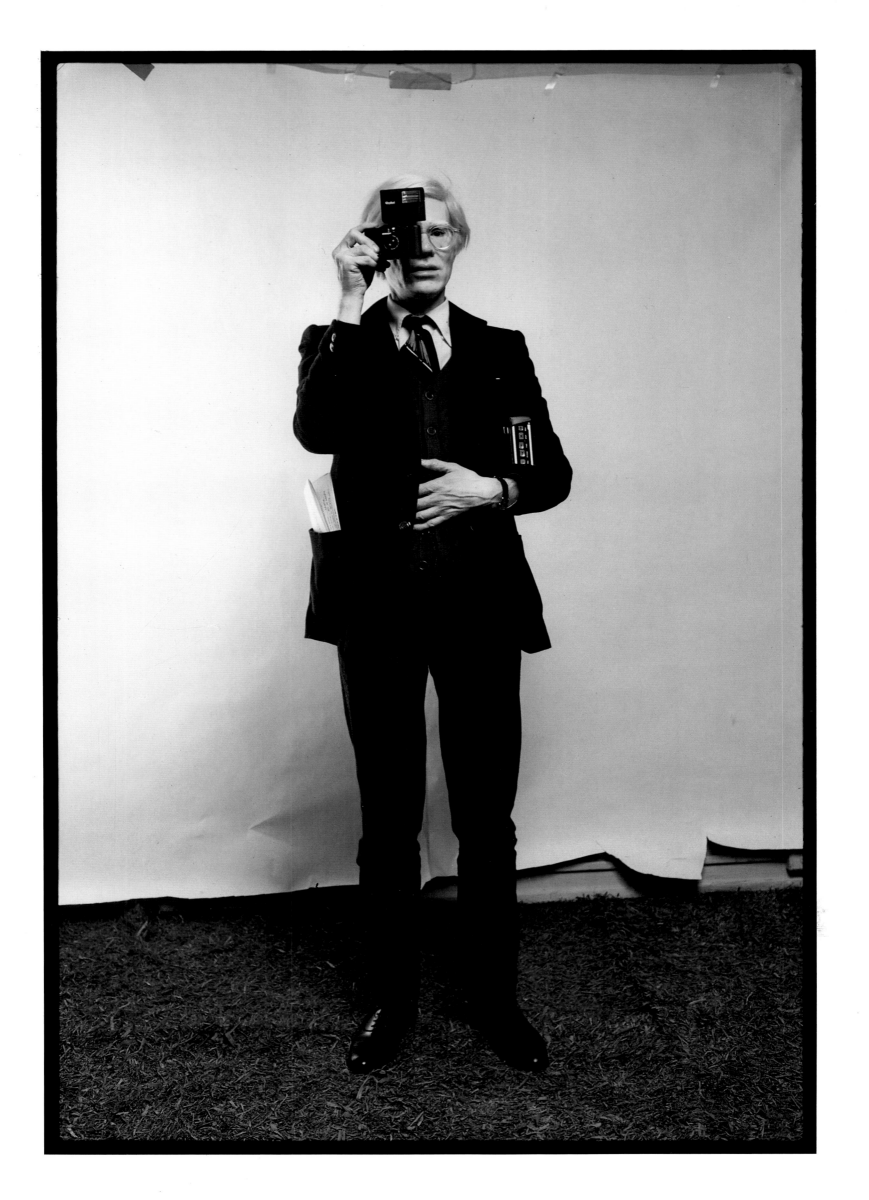

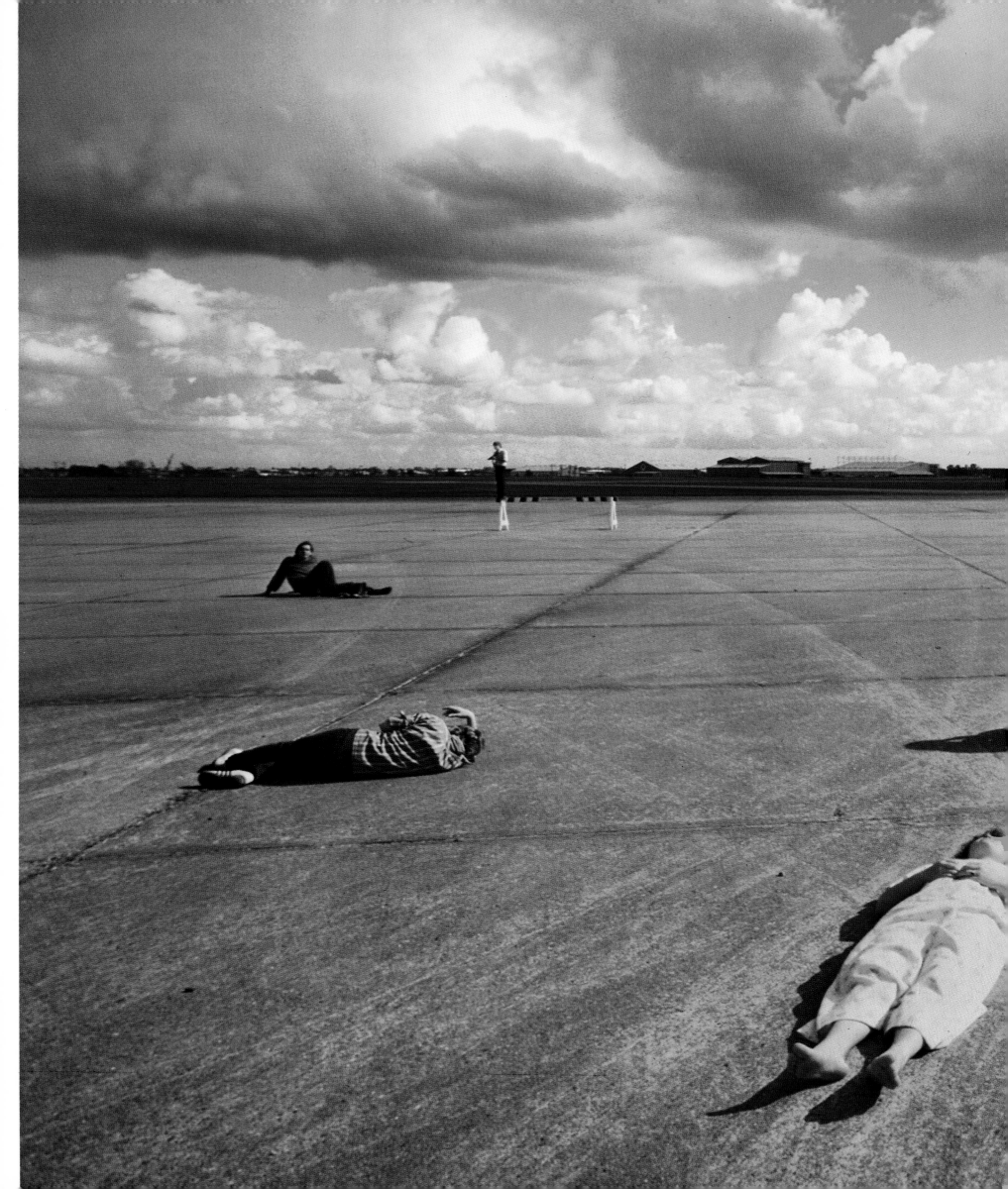

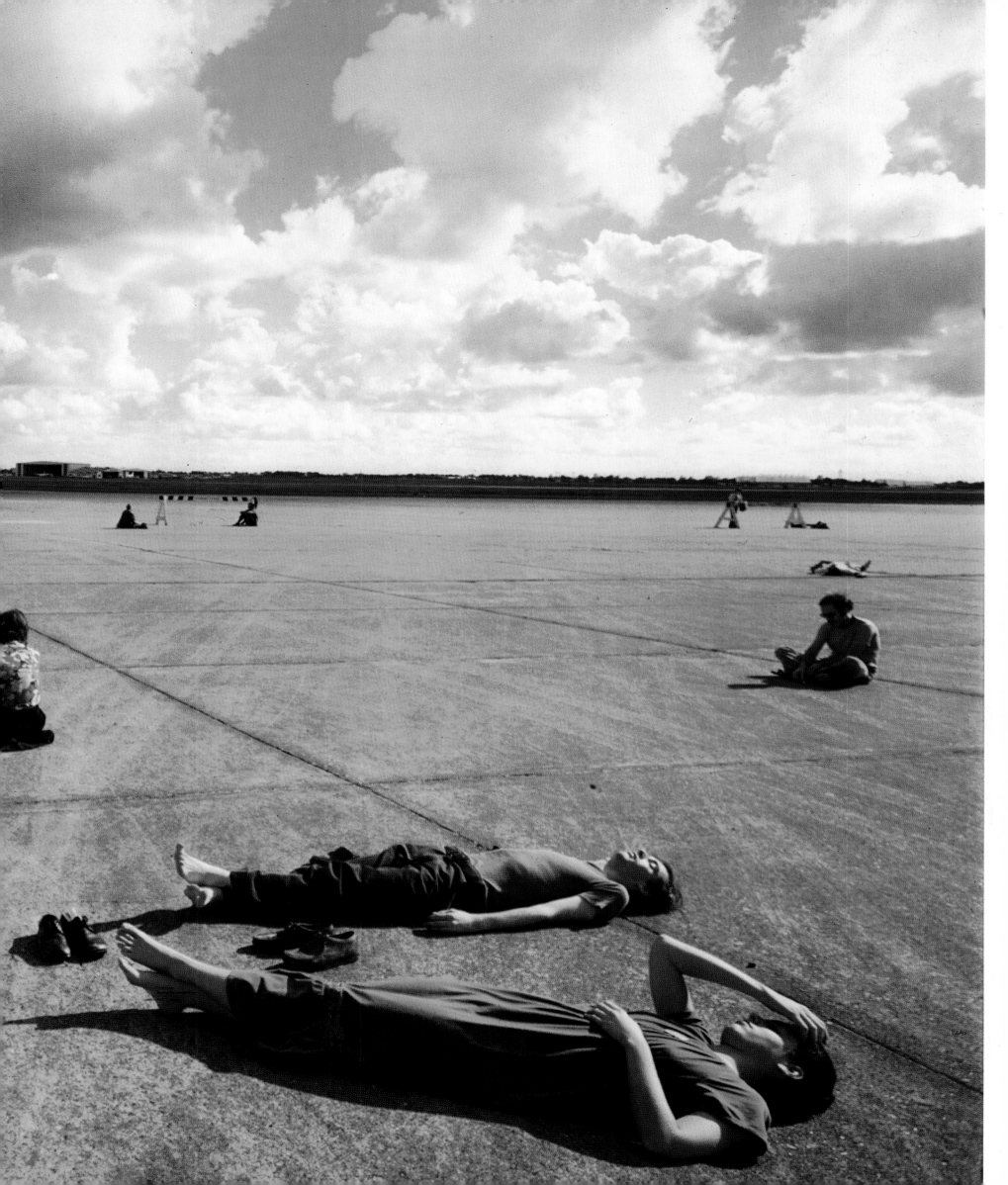

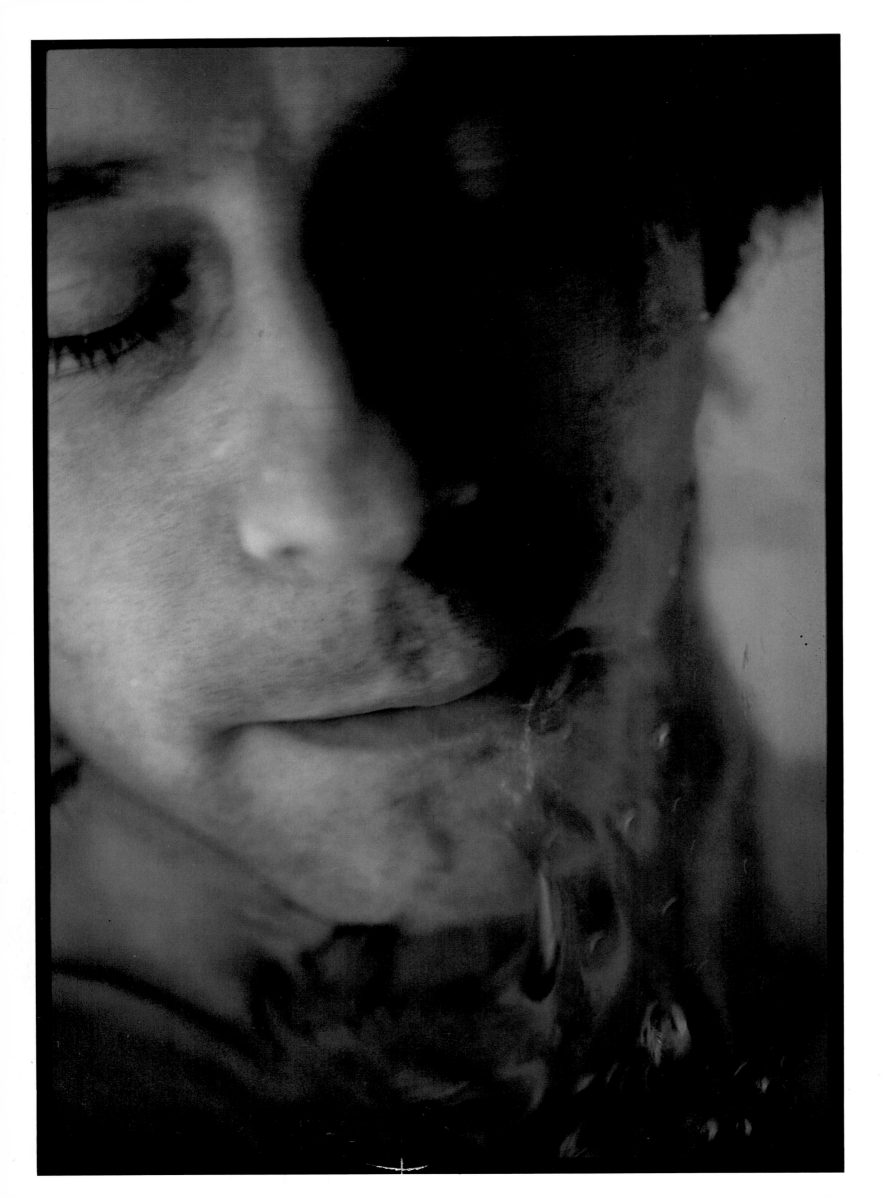

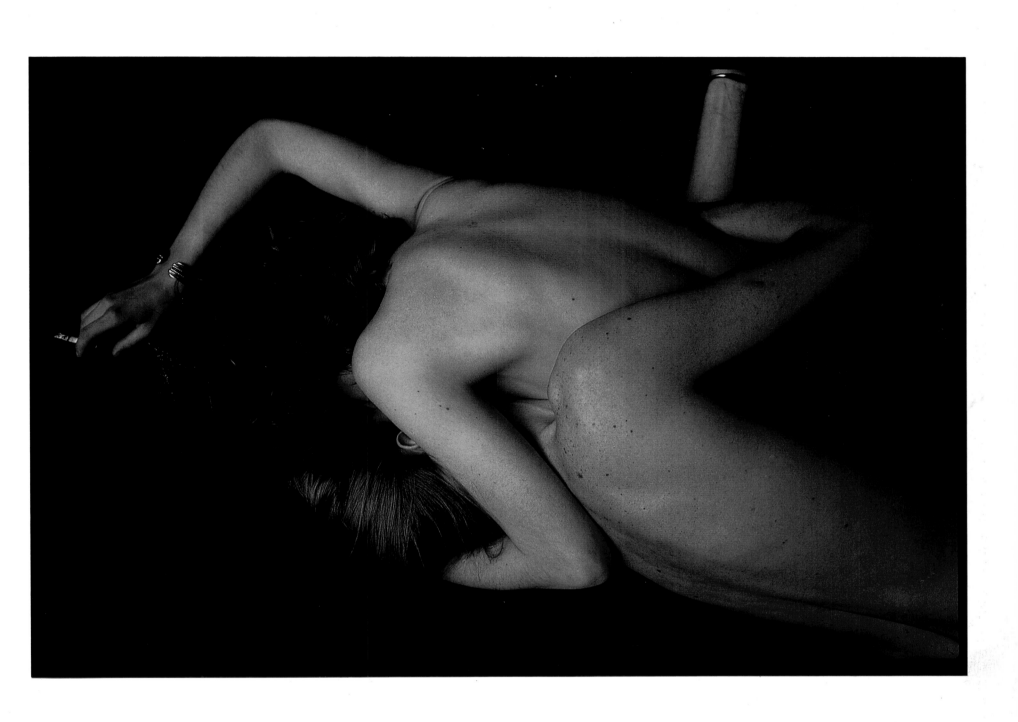

Roman Polanski, *Los Angeles, 1974*

Maria Schneider and friend, *San Francisco, 1973*

Preceding page:

Waiting for Guru Maharaj Ji, William Hobby Airport, *Houston, Texas, 1974*

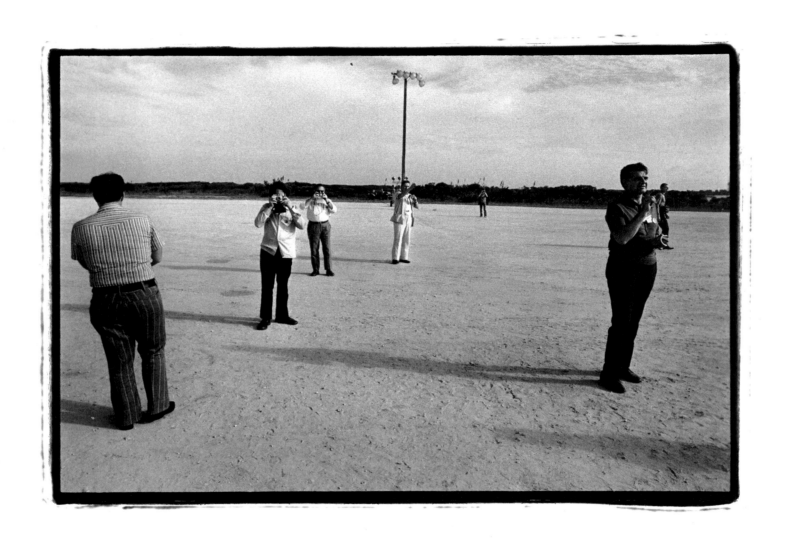

Apollo 17, the last moon shot, *Cape Kennedy, Florida, 1972*

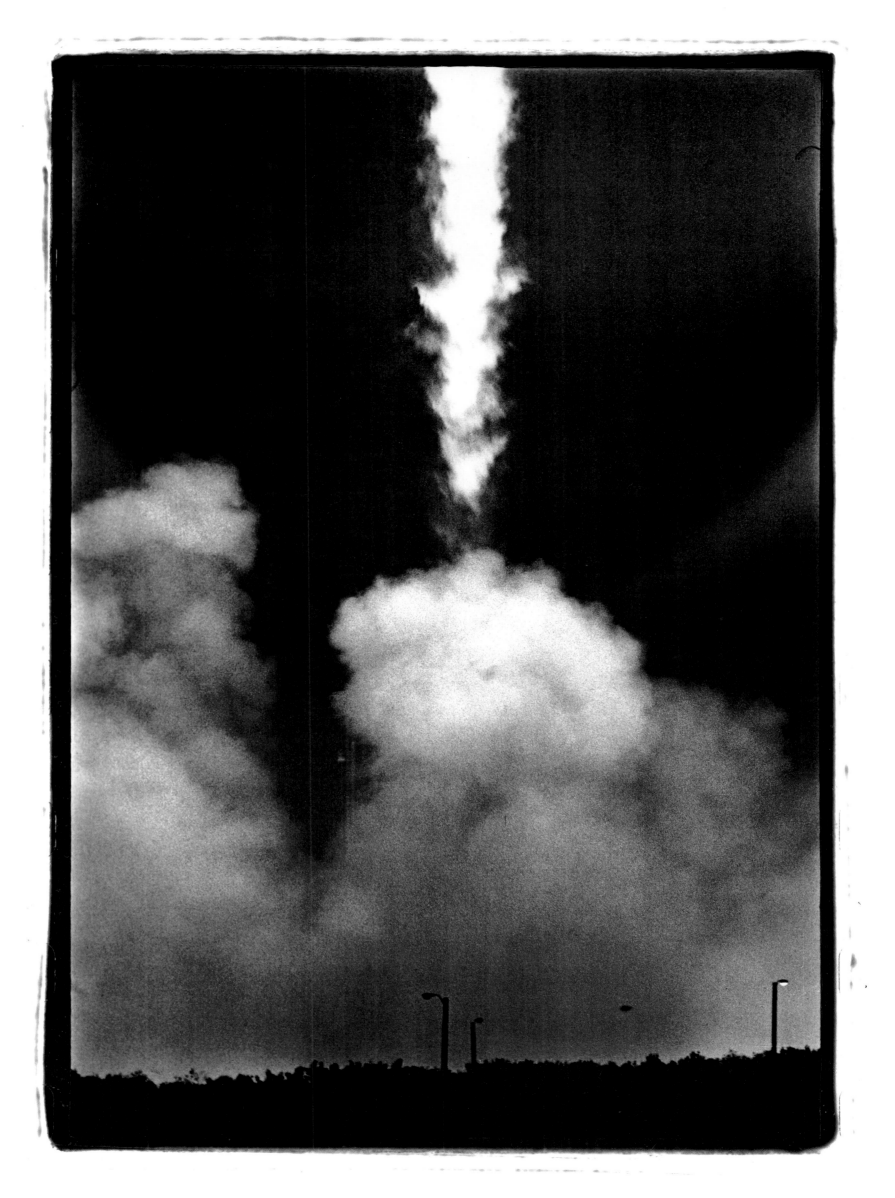

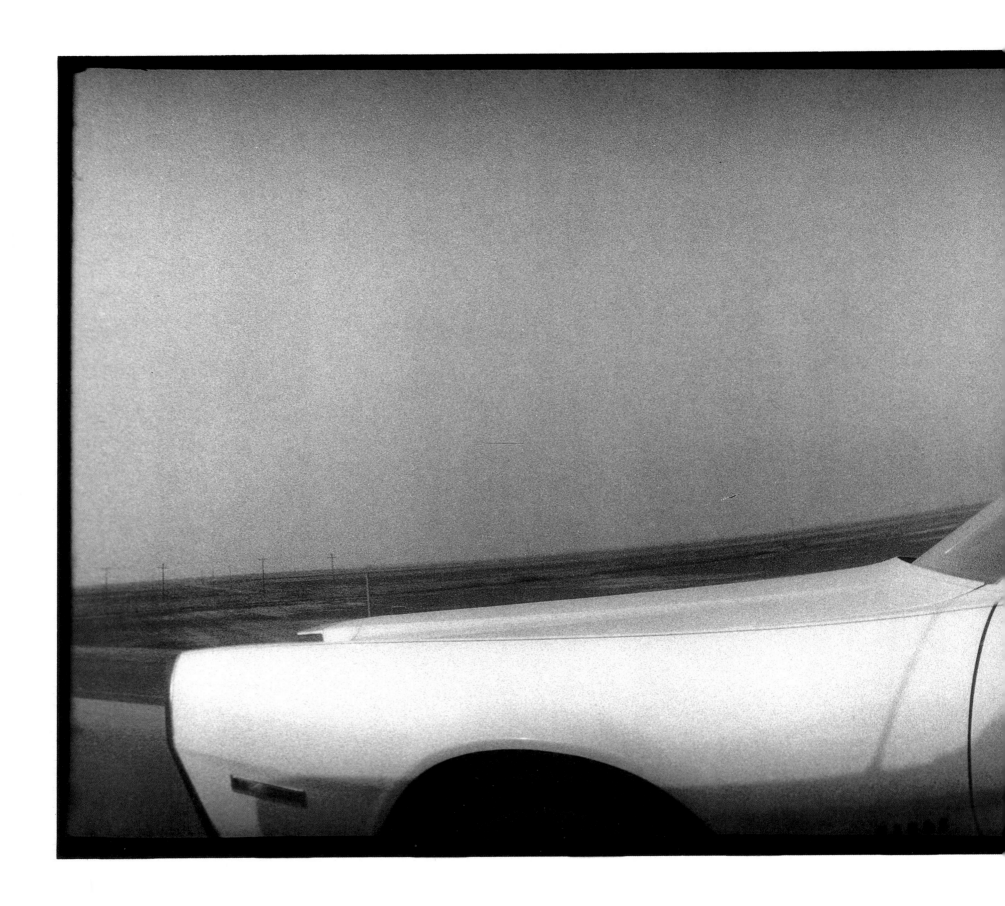

Sly Stone, *Highway 5, California, 1973*

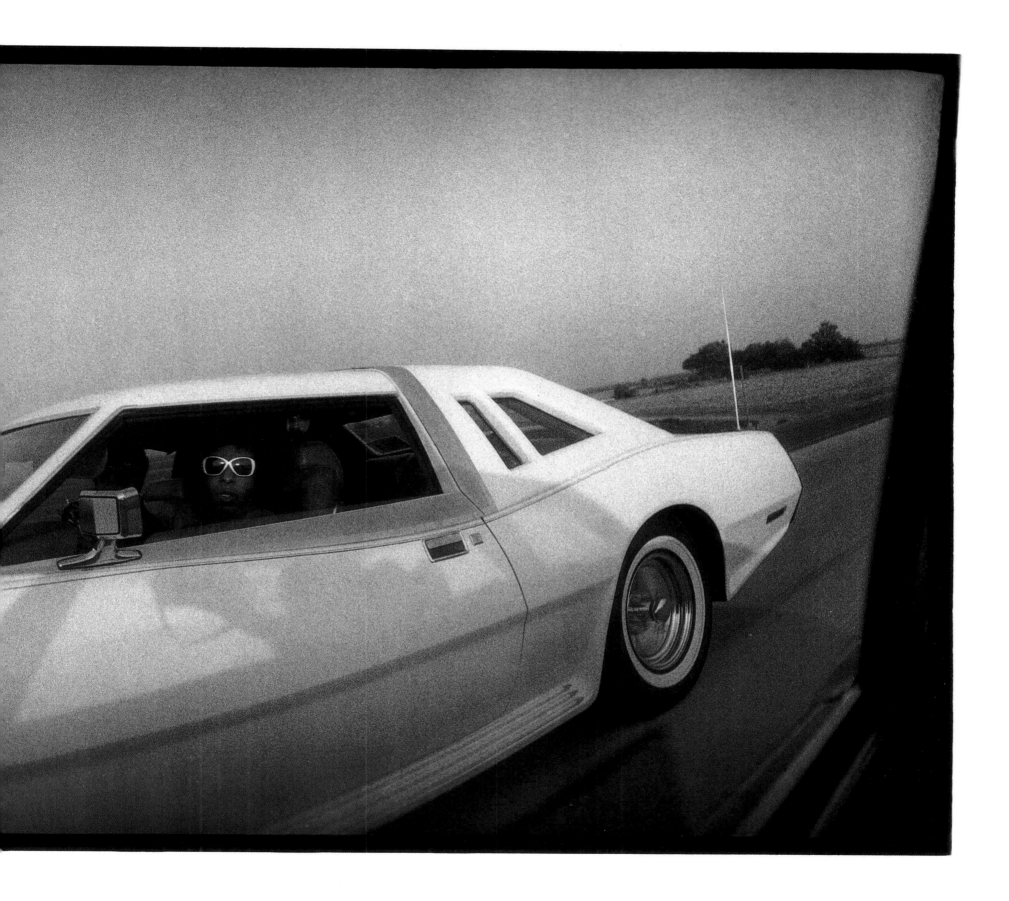

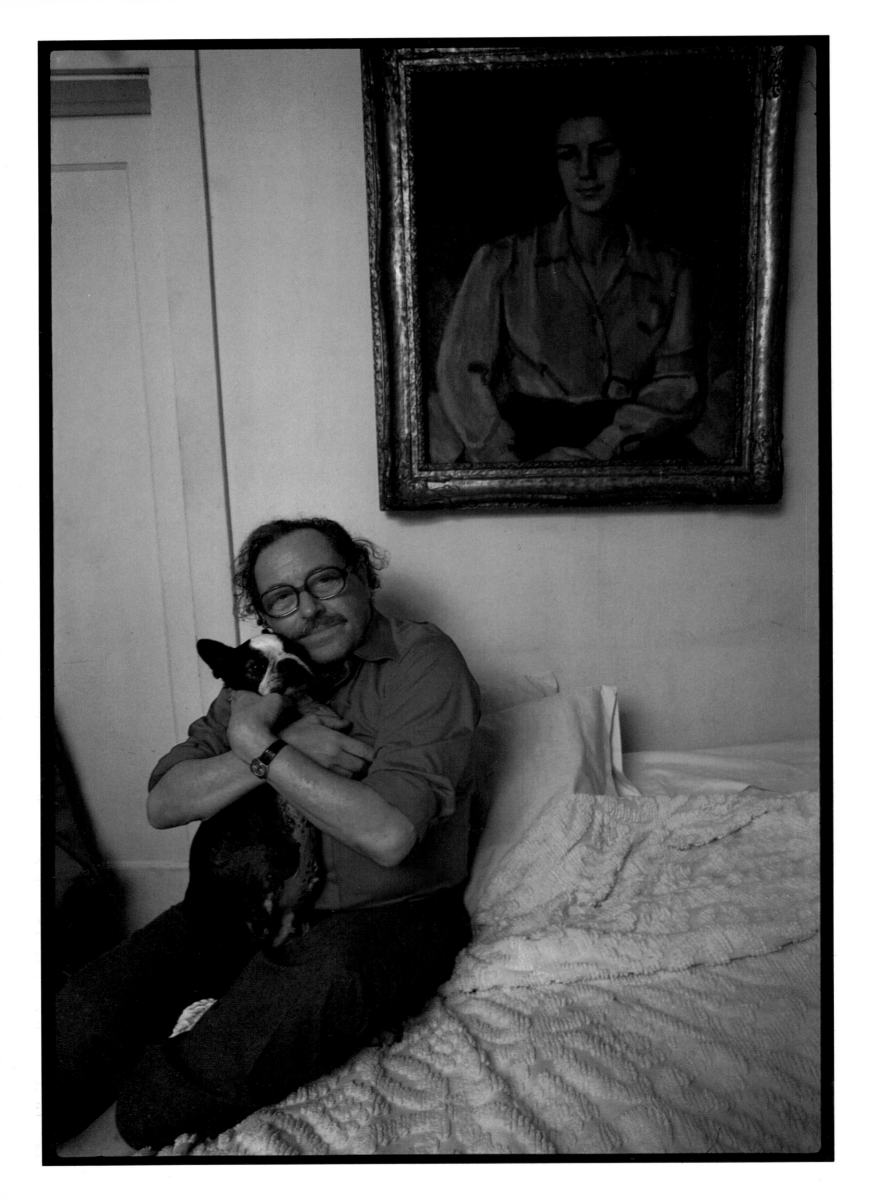

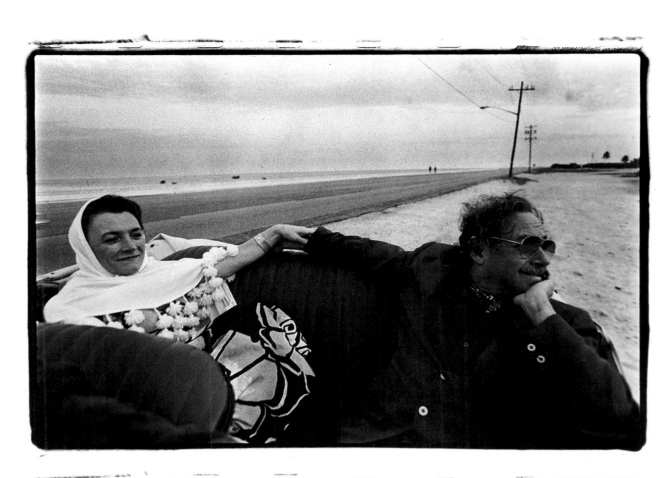

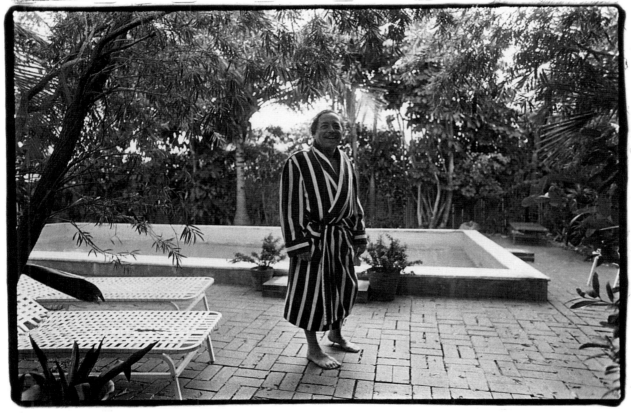

Tennessee Williams and Maria St. Just, *Key West, Florida, 1974*

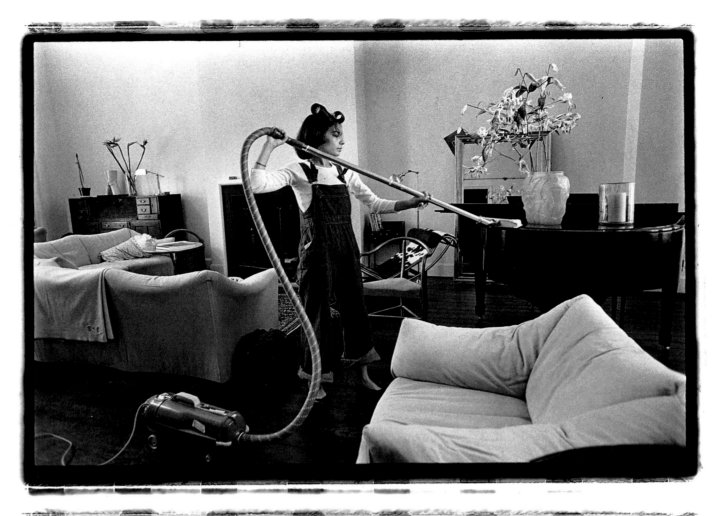

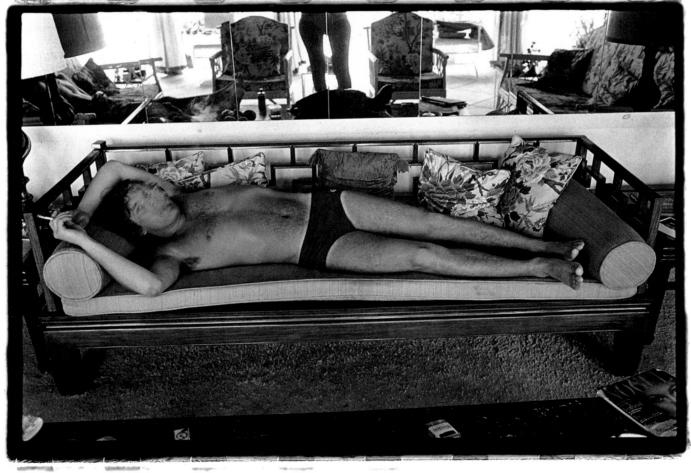

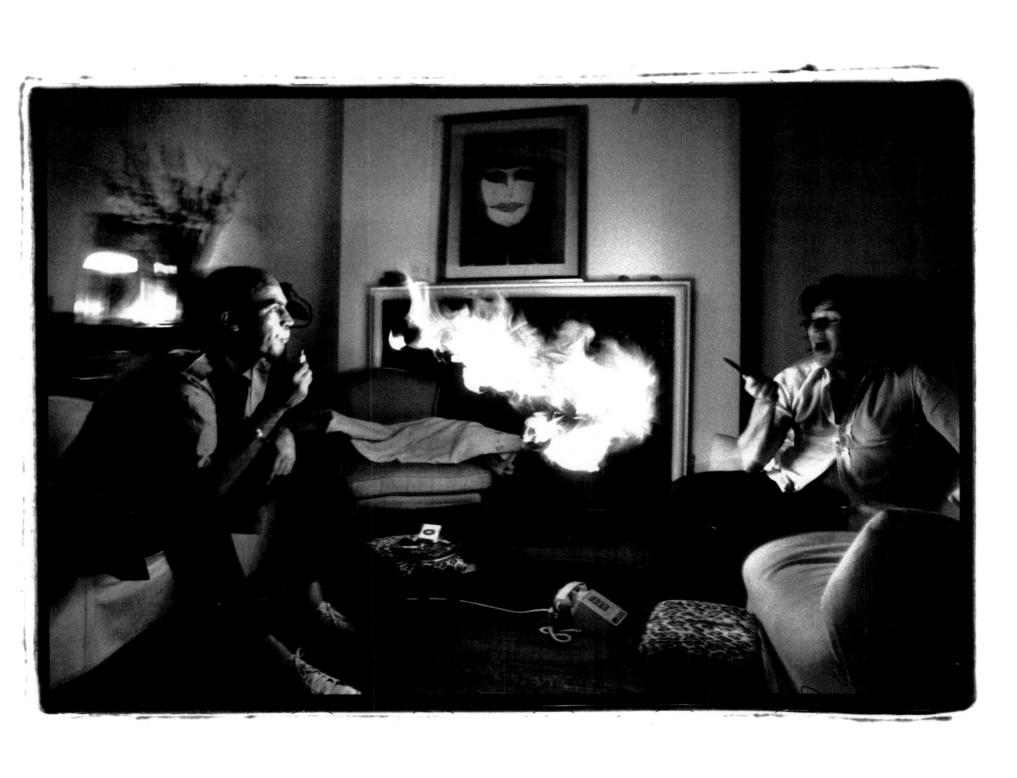

Jane Wenner, *New York City, 1976*

Jann Wenner, *Barbados, 1975*

Hunter S. Thompson and Jann Wenner, *New York City, 1976*

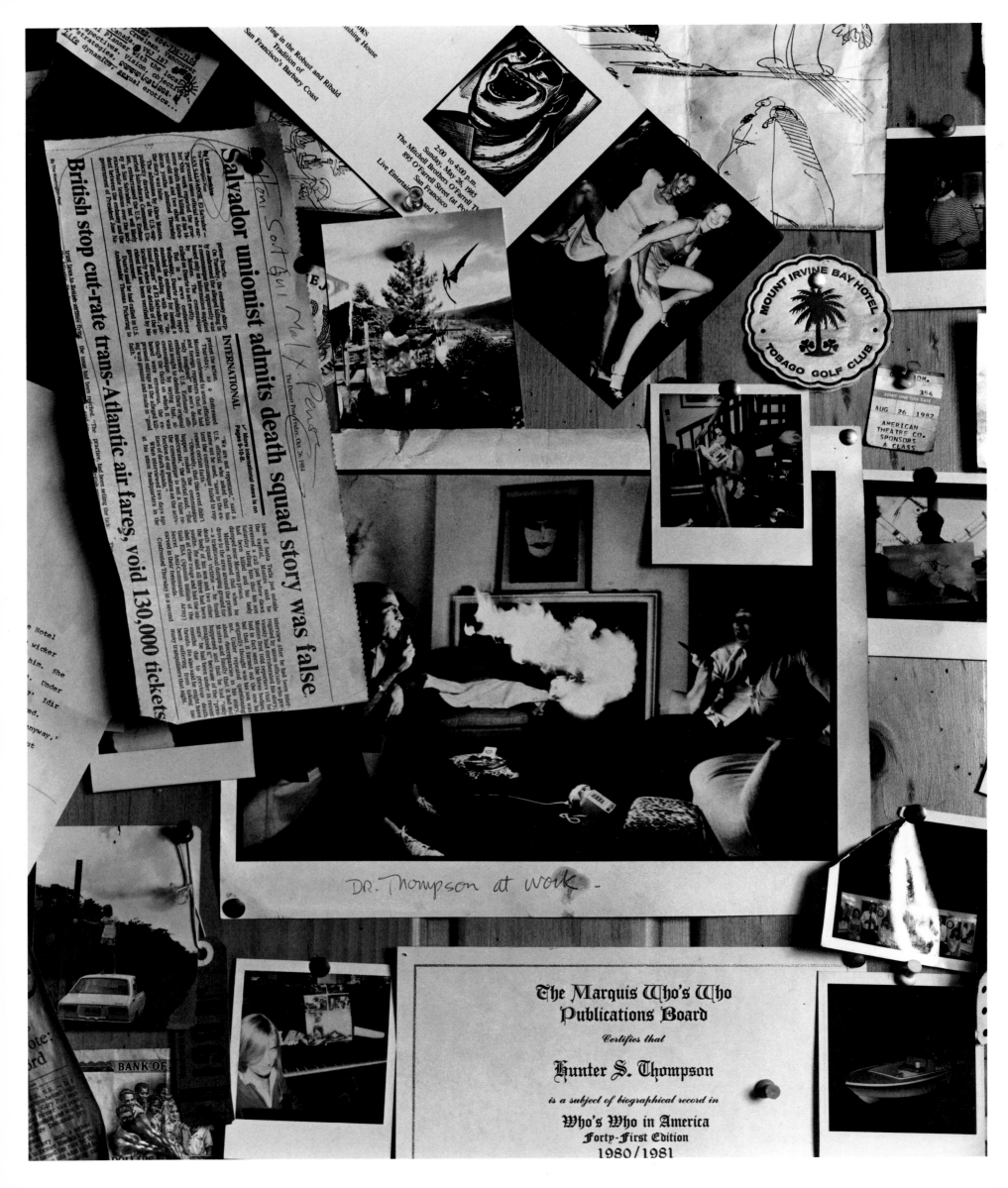

DR. Thompson at work

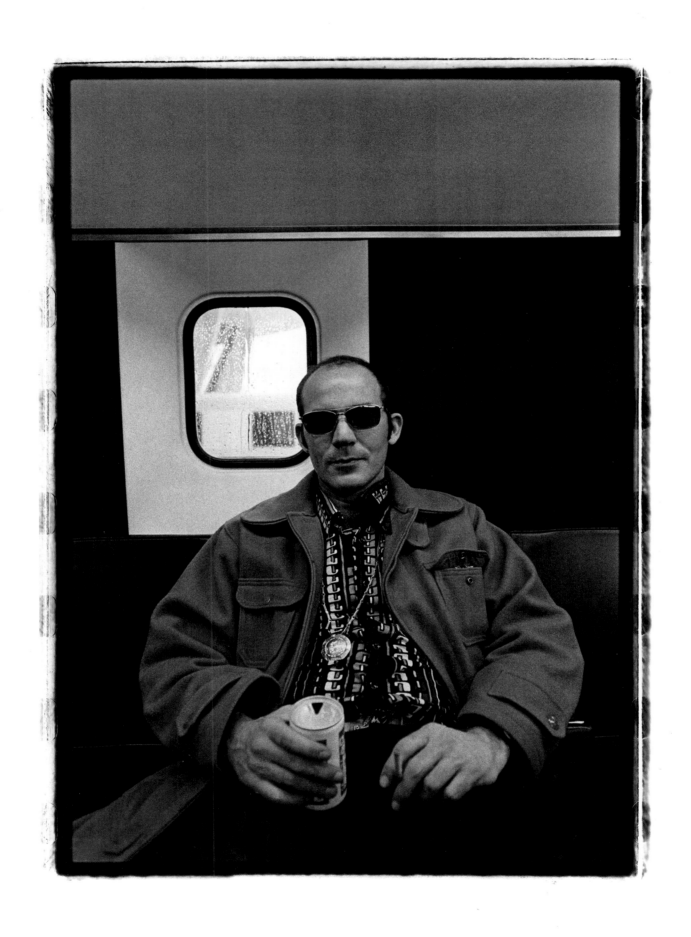

Hunter S. Thompson's kitchen, *Aspen, Colorado, 1987*

Hunter S. Thompson, *Dulles Airport, Washington, D.C., 1972*

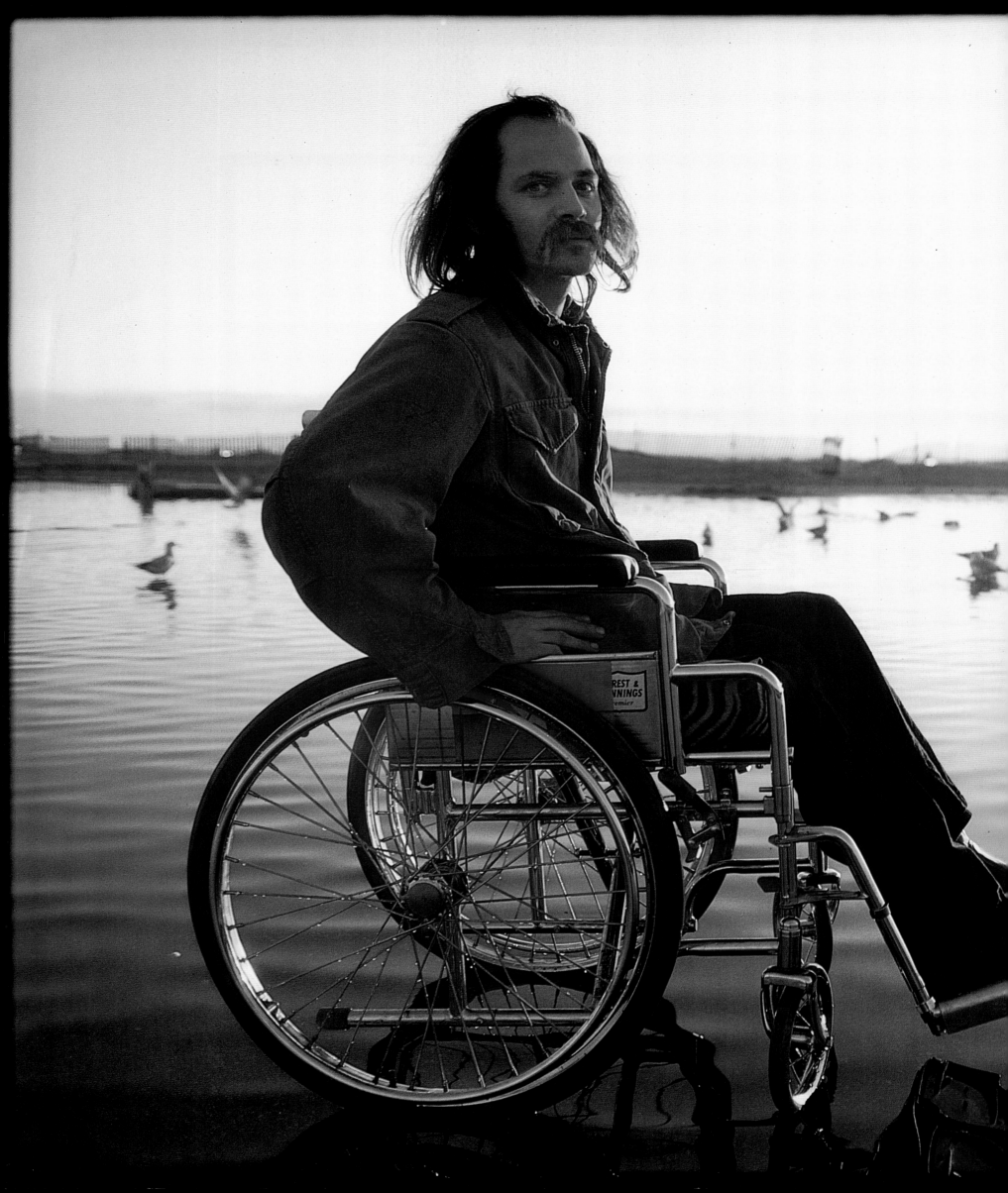

Ron Kovic,
Santa Monica, California, 1973

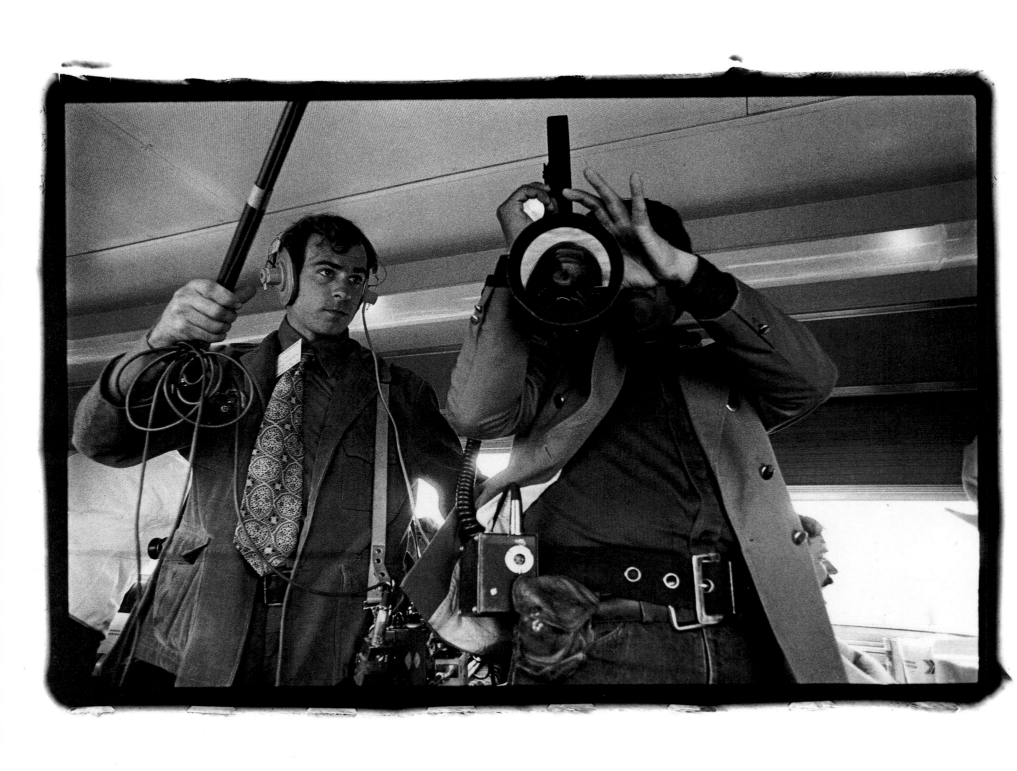

George McGovern's campaign train, *Sacramento, California, 1972*

Blair Clark, Walter Cronkite, and Theodore H. White, *New Hampshire, 1972*

Senator Edmund Muskie, *New Hampshire, 1972*

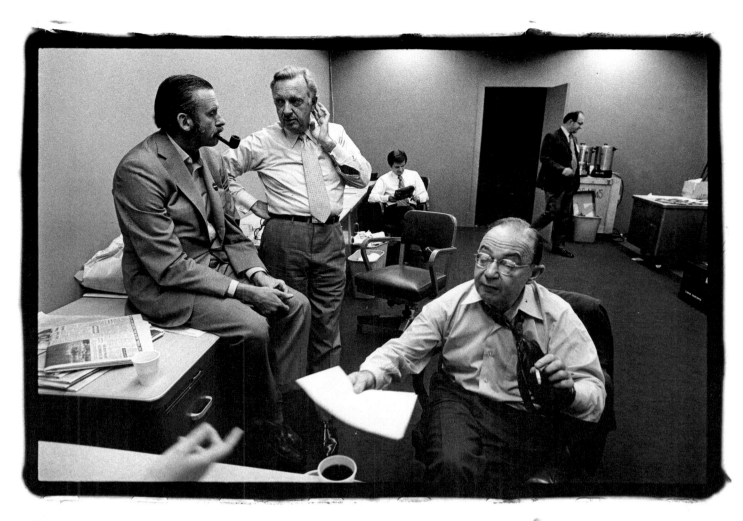

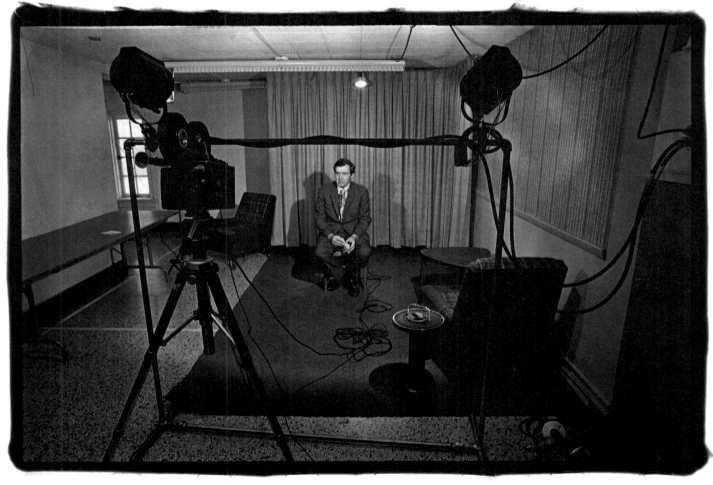

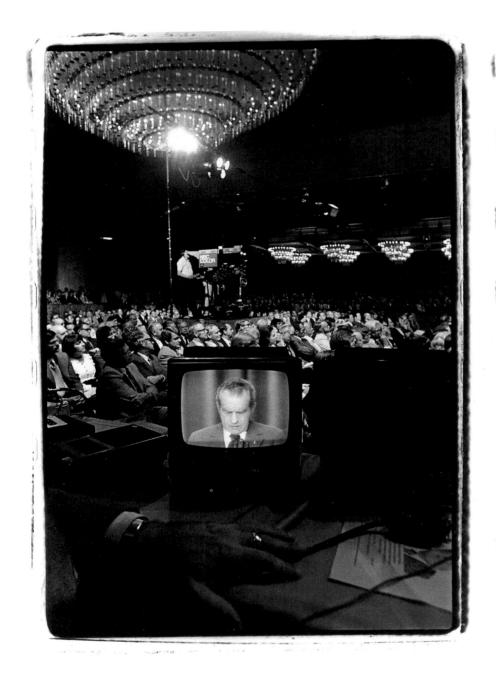 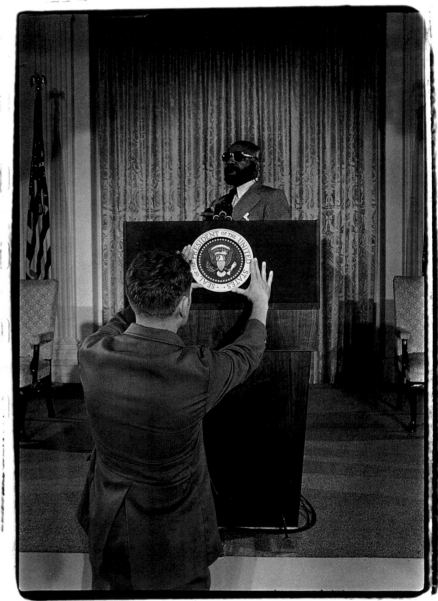

Richard Nixon's resignation, *Los Angeles and Washington, D.C., 1974*

Dan Rather in Lafayette Park, 1974

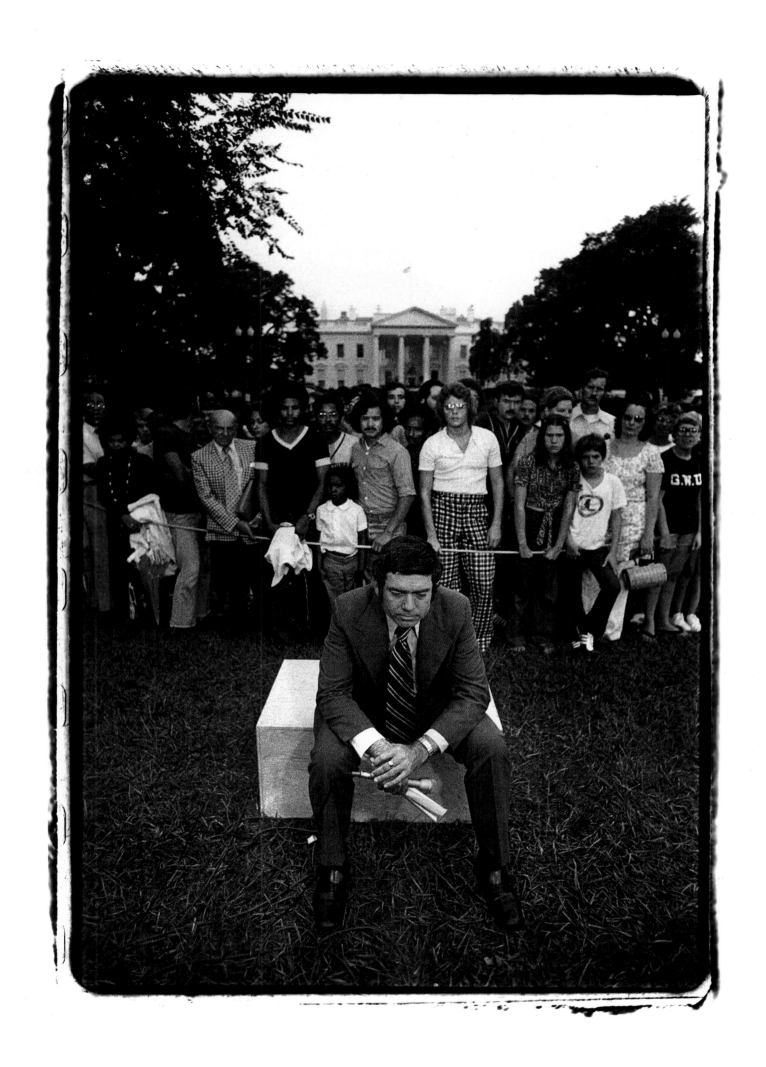

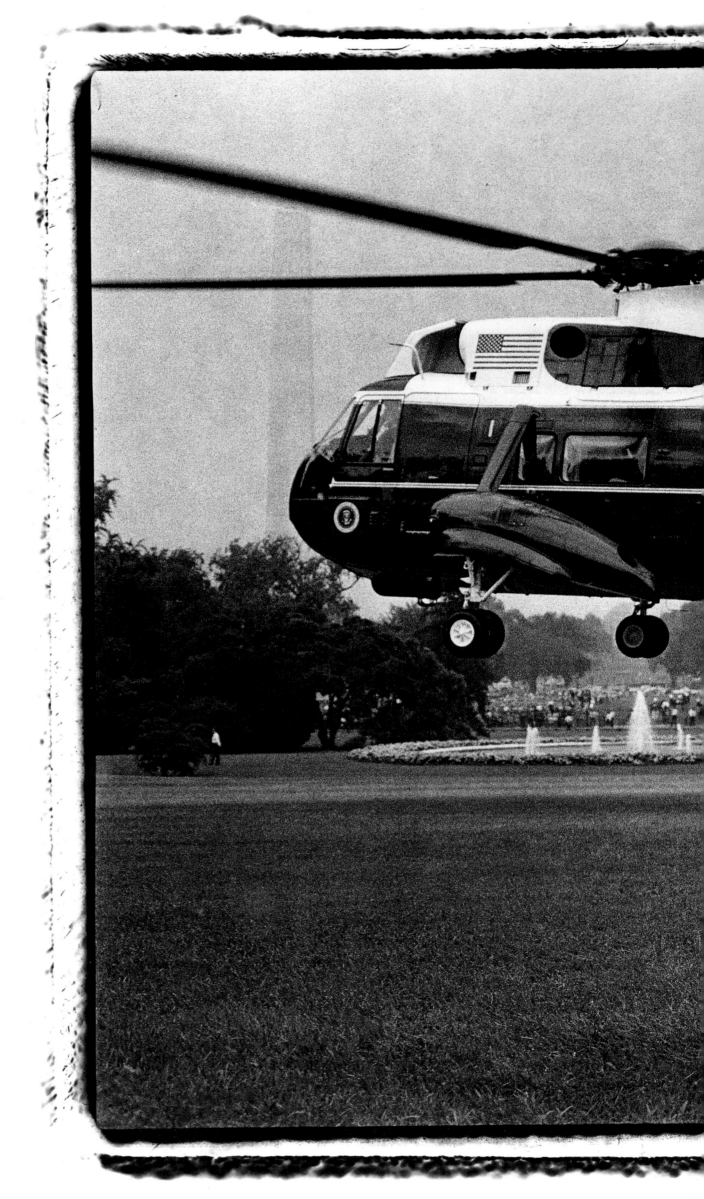

Nixon leaving the White House,
Washington, D.C., 1974

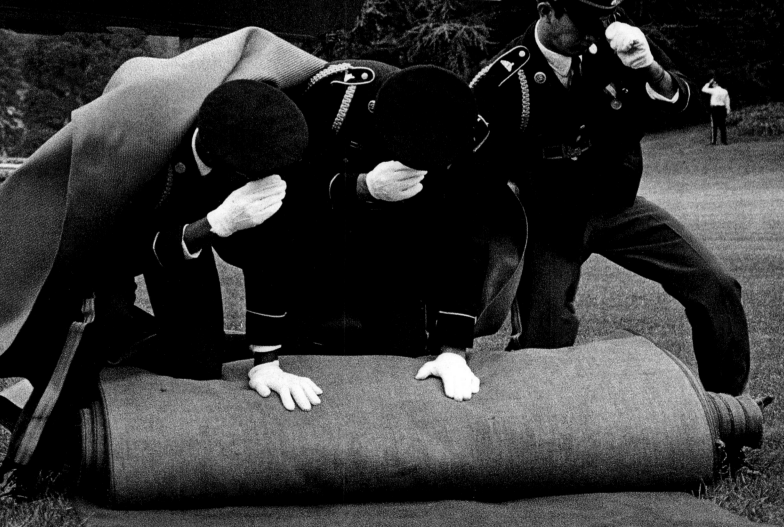

The Rolling Stones, *Buffalo, New York, and Memphis, Tennessee, 1975*

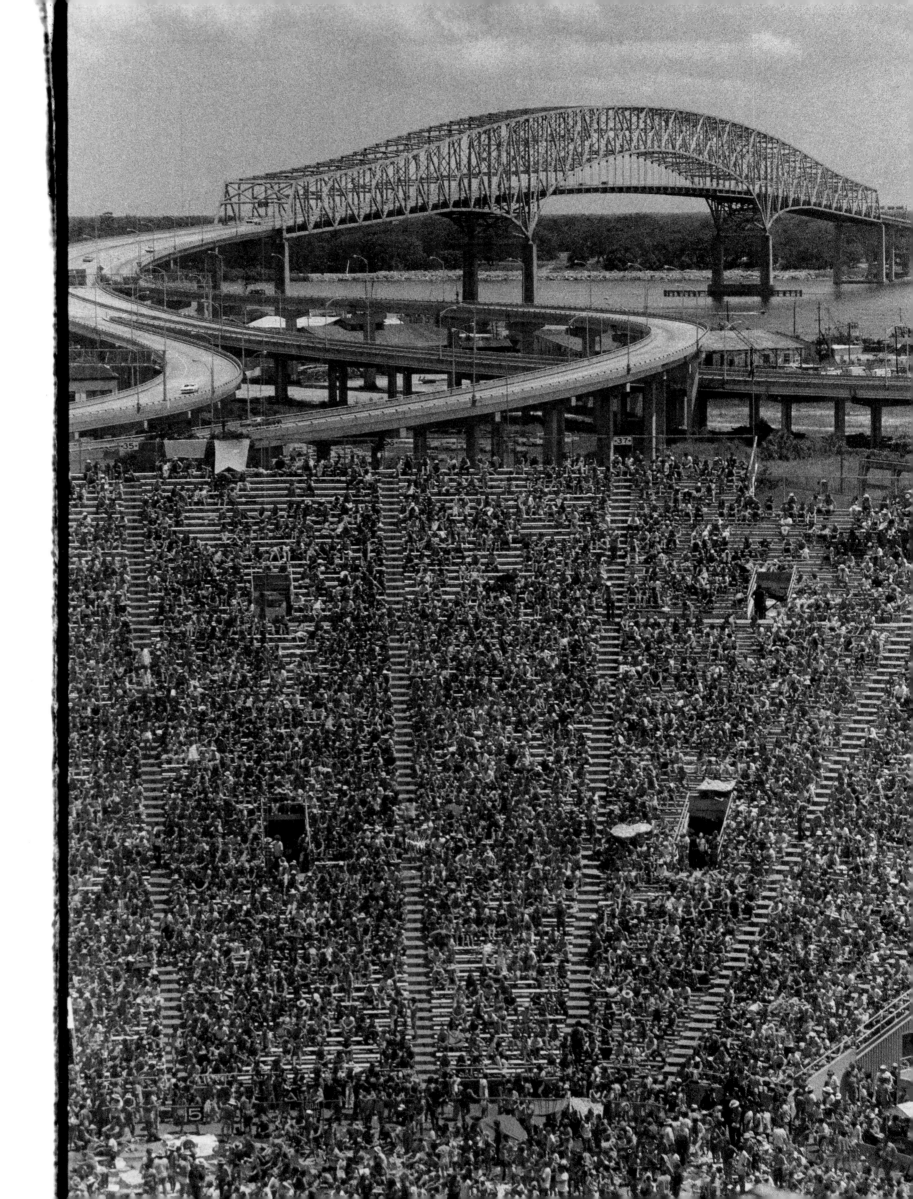

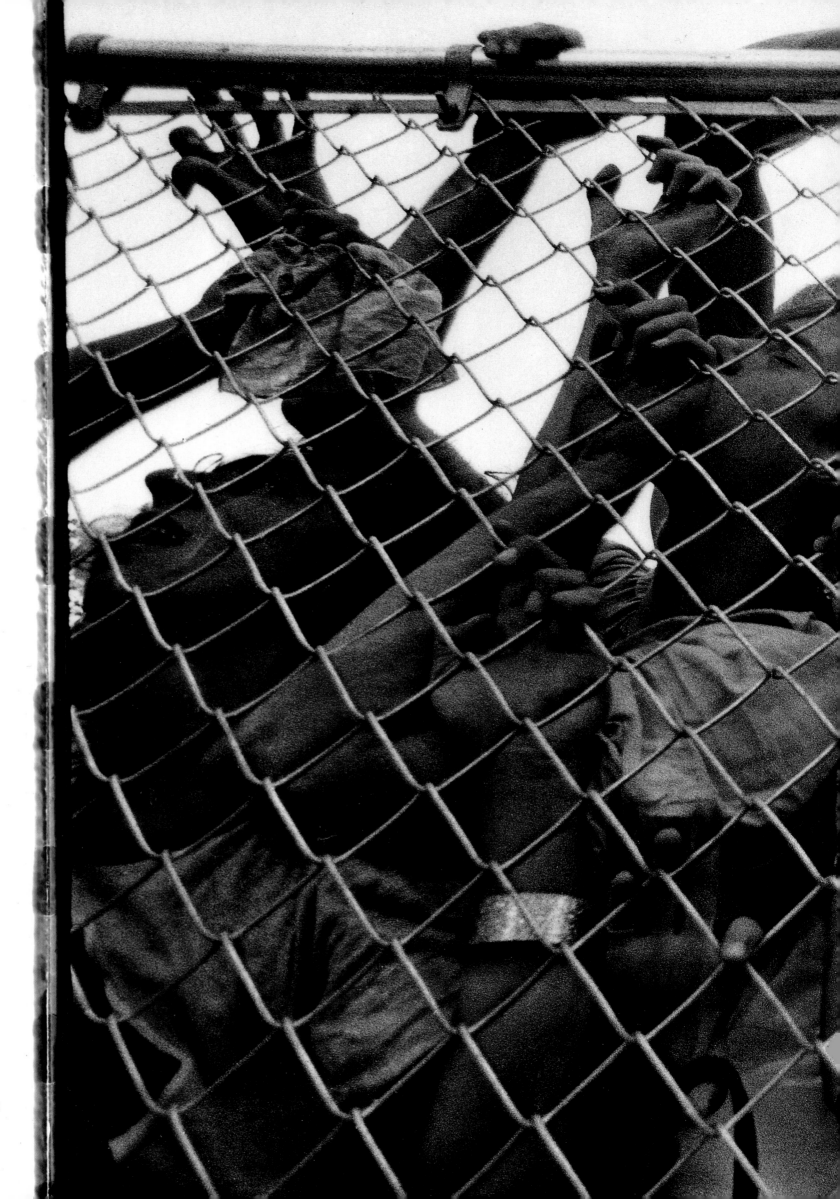

Cleveland, Ohio, 1975

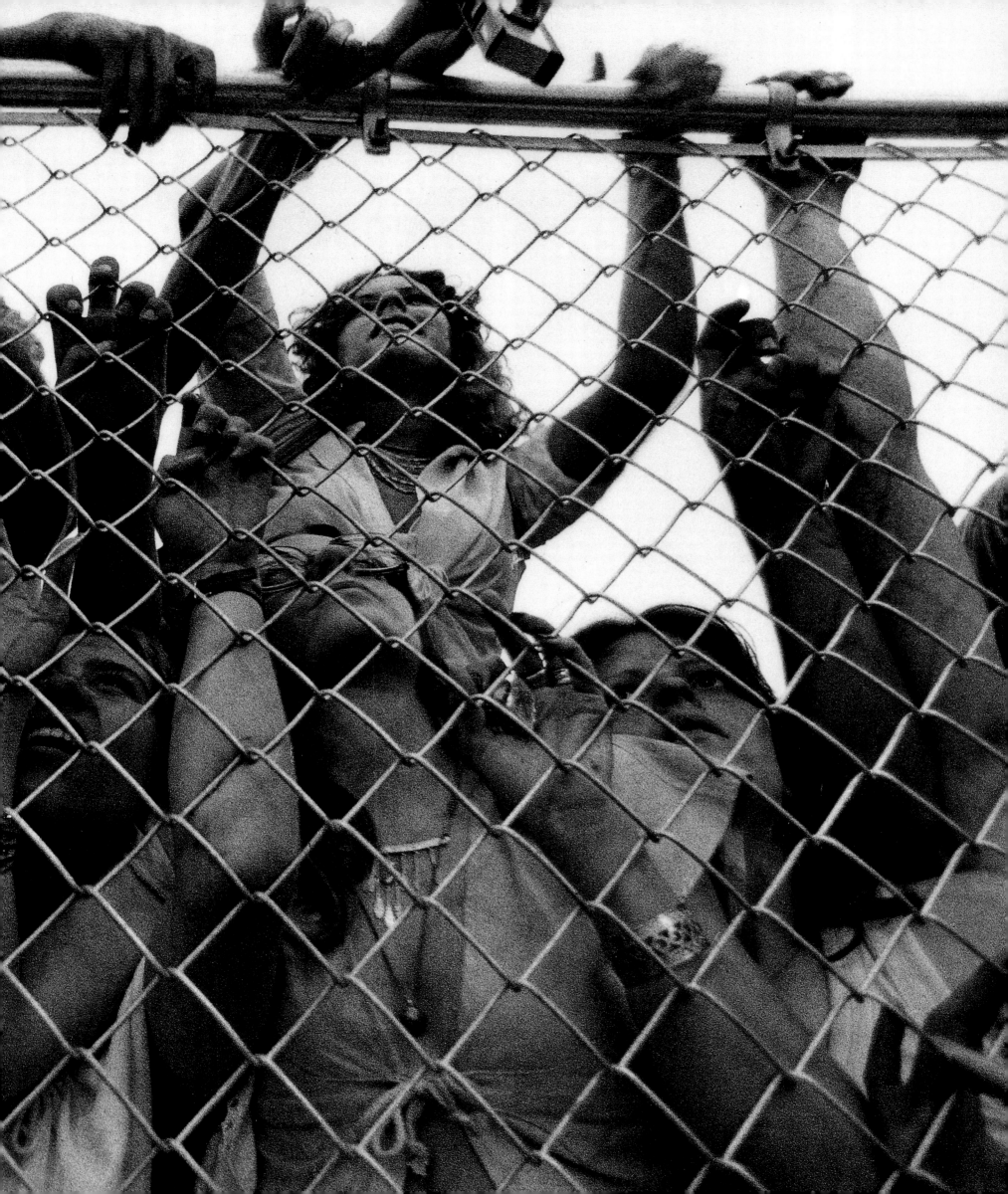

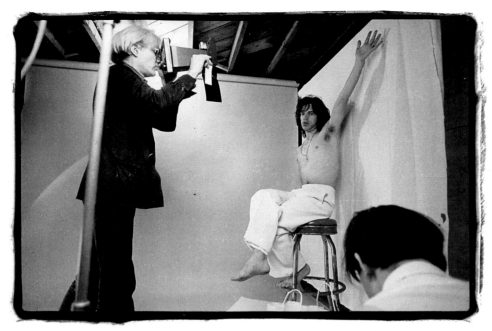

Andy Warhol and Mick Jagger, *Montauk, Long Island, 1975*

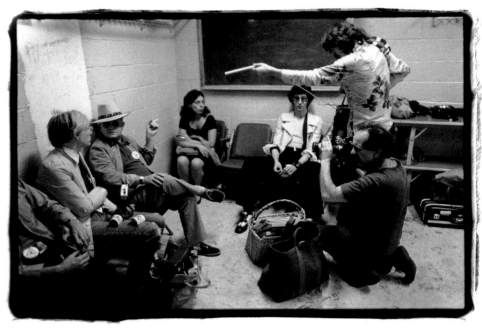

Andy Warhol, Truman Capote, and Robert Frank, *New Orleans, 1972*

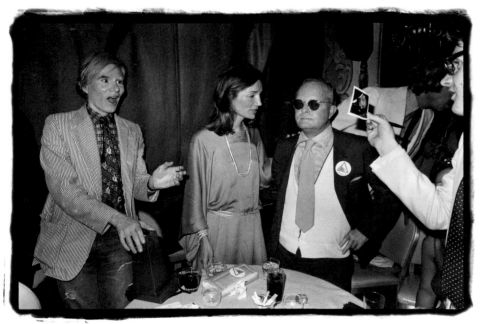

Andy Warhol, Lee Radziwill, and Truman Capote, *New York City, 1972*

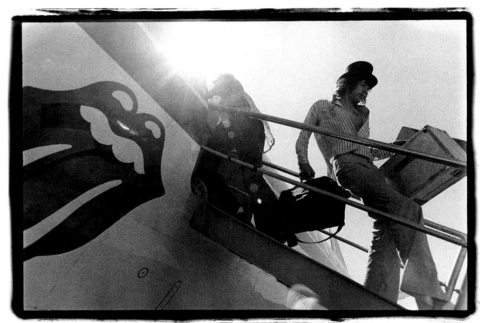

Mick Jagger, *Kansas, 1972*

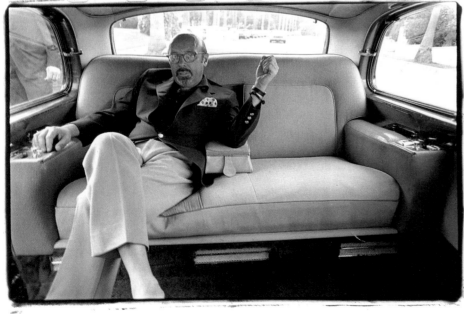

Ahmet Ertegun, *Beverly Hills, 1971*

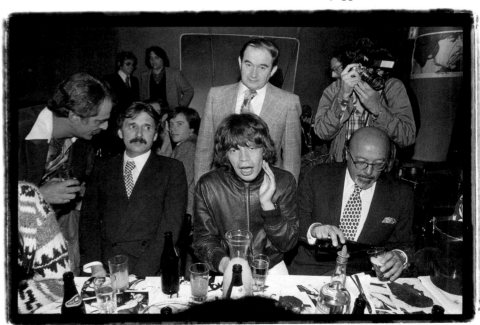

Earl McGrath, Mick Jagger, and Ahmet Ertegun, *New York City, 1975*

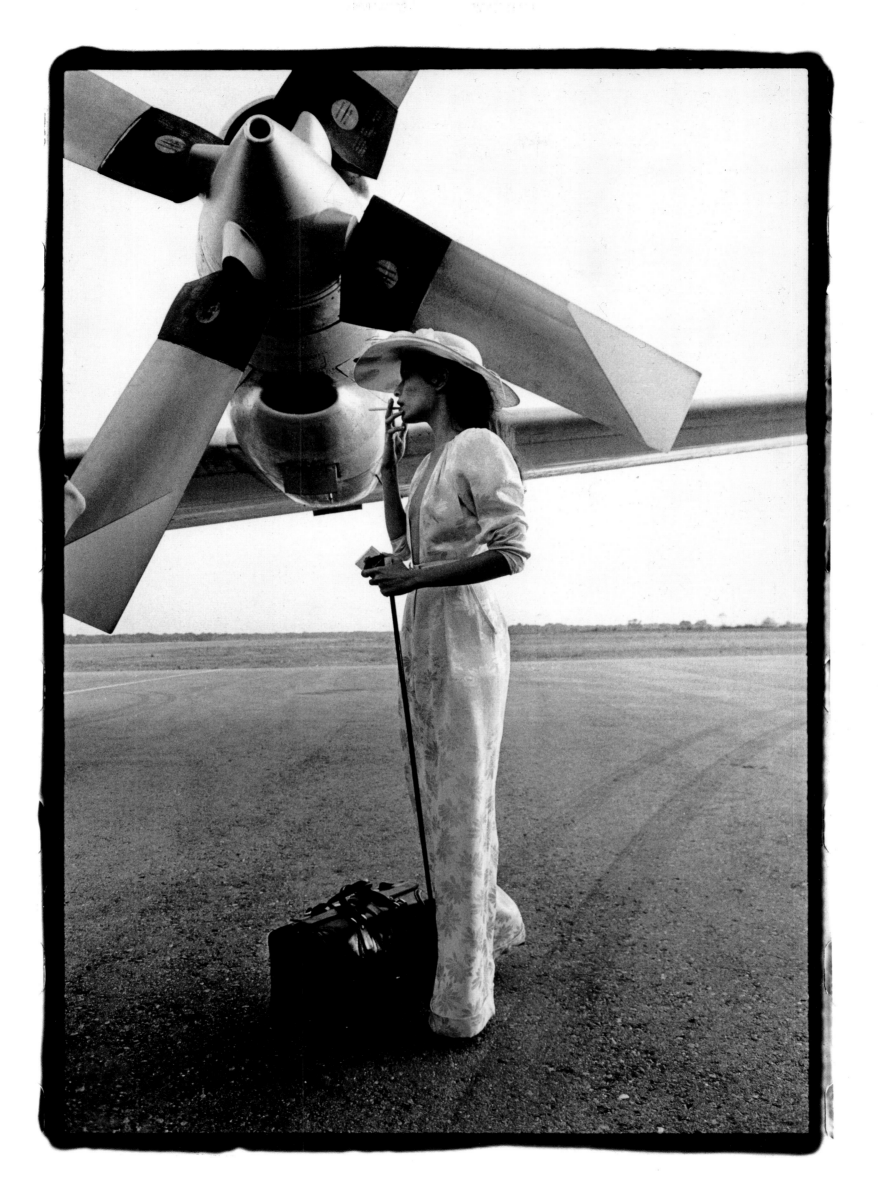

Keith Richards, *Toronto, 1977*

Preceding page:

Bianca Jagger, *Kansas, 1972*

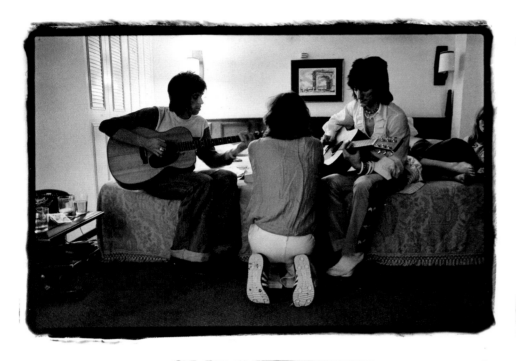

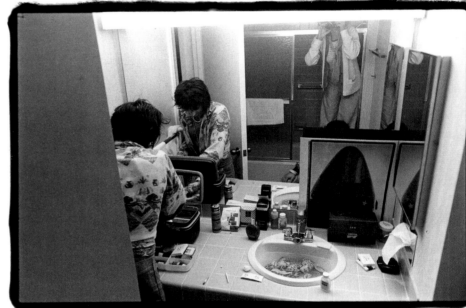

The Rolling Stones on the road, 1975

82

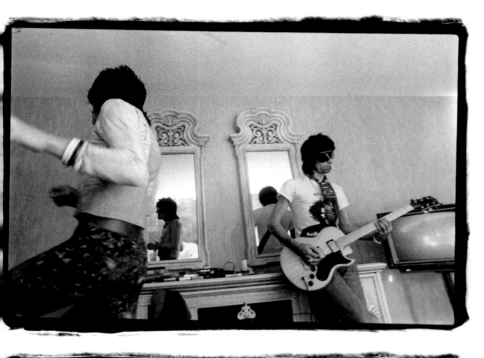 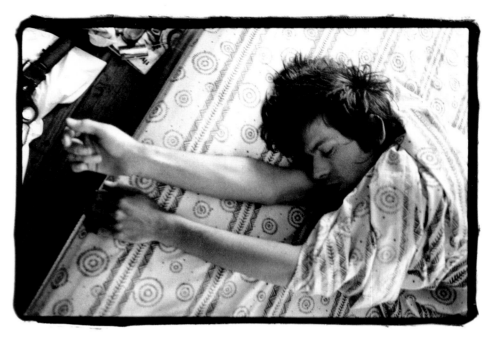

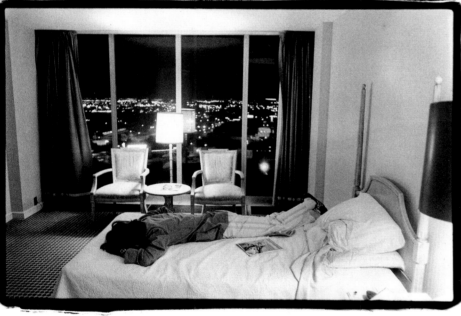 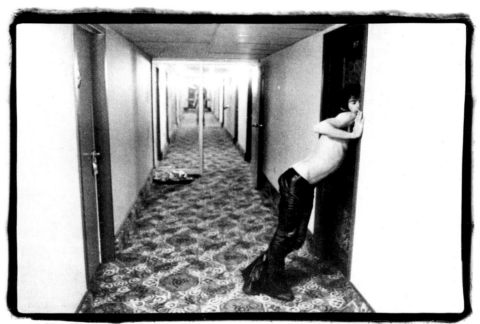

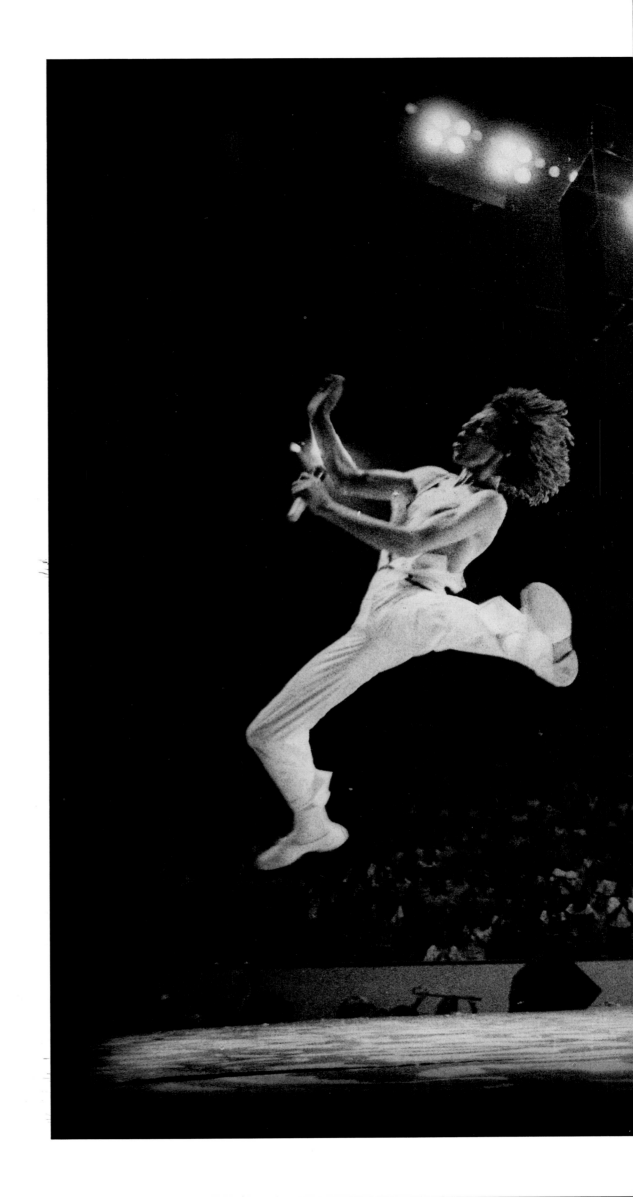

The Rolling Stones, *Philadelphia, 1975*

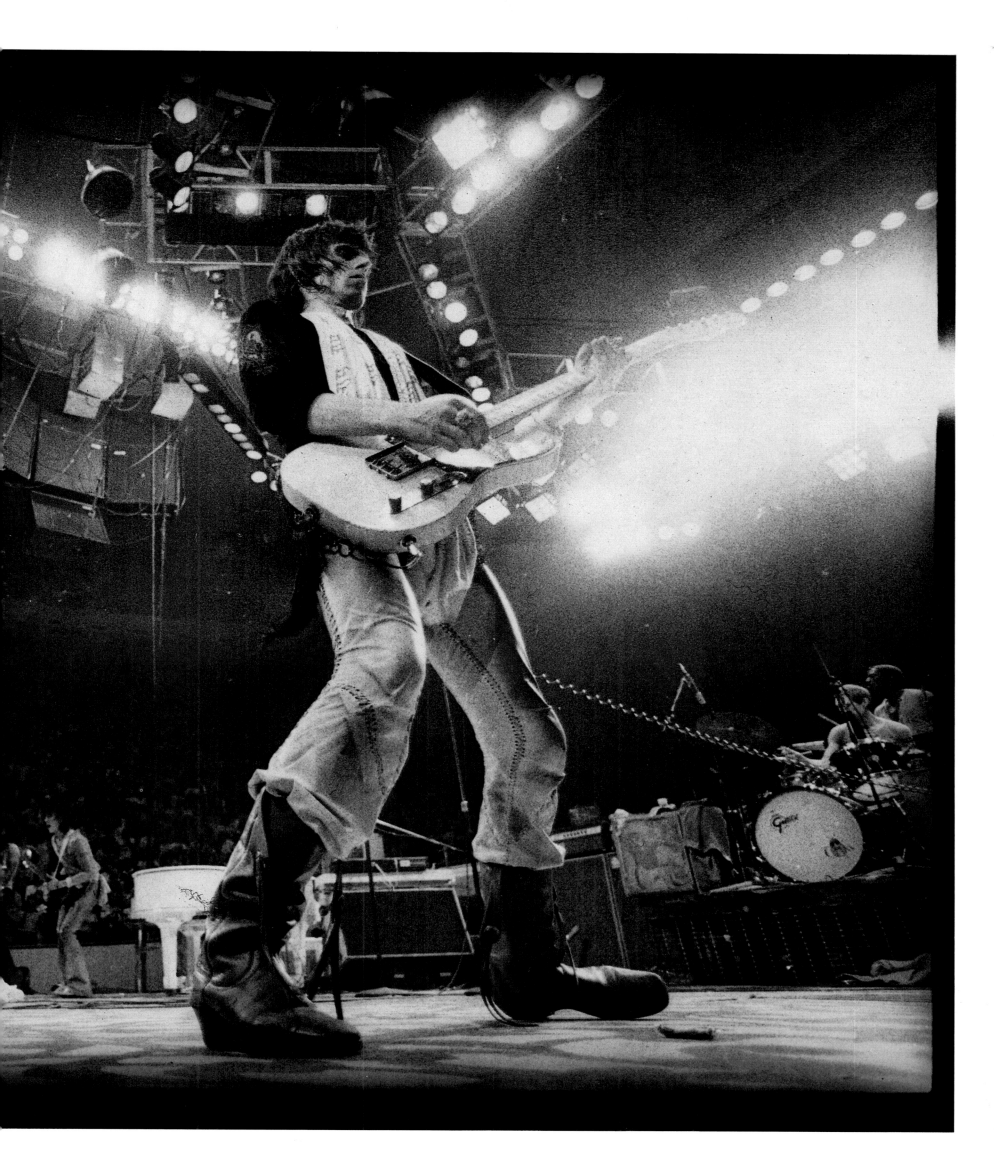

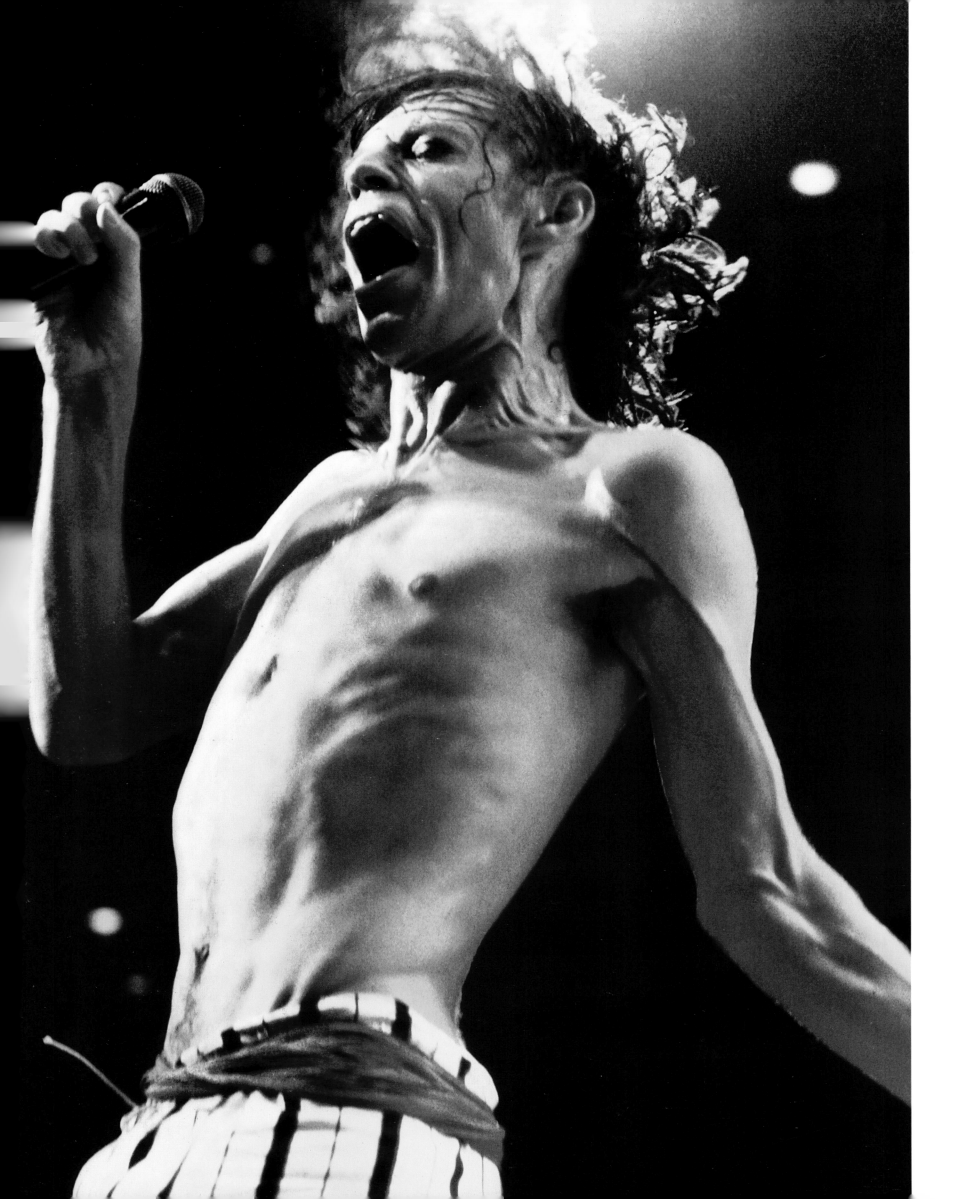

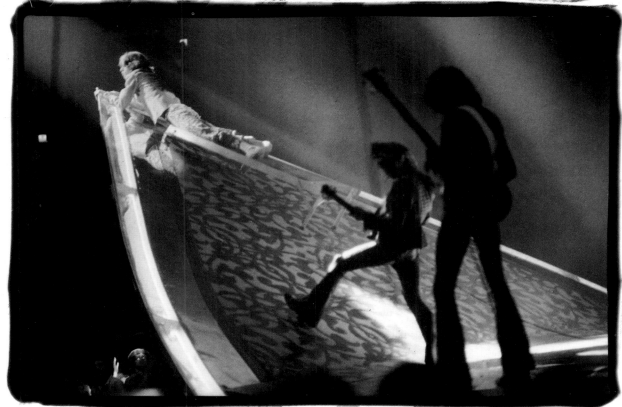

Mick Jagger, *Chicago, 1975*

Mick Jagger, Keith Richards, and Bill Wyman, *New York, 1975*

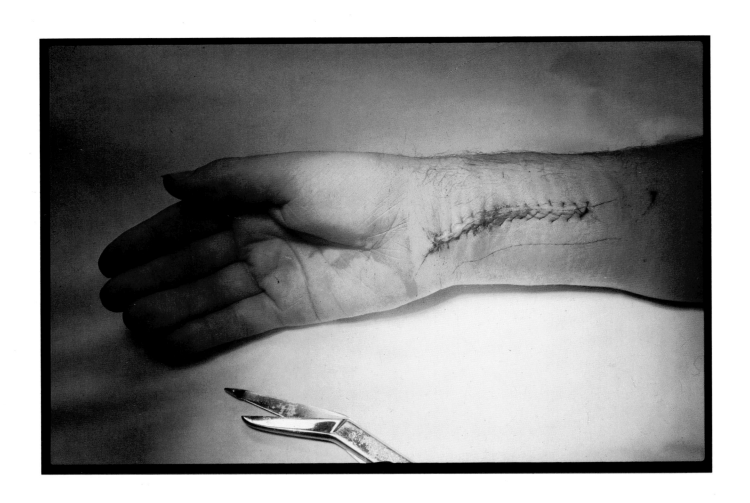

Mick Jagger, *Southampton, Long Island, and Buffalo, New York, 1975*

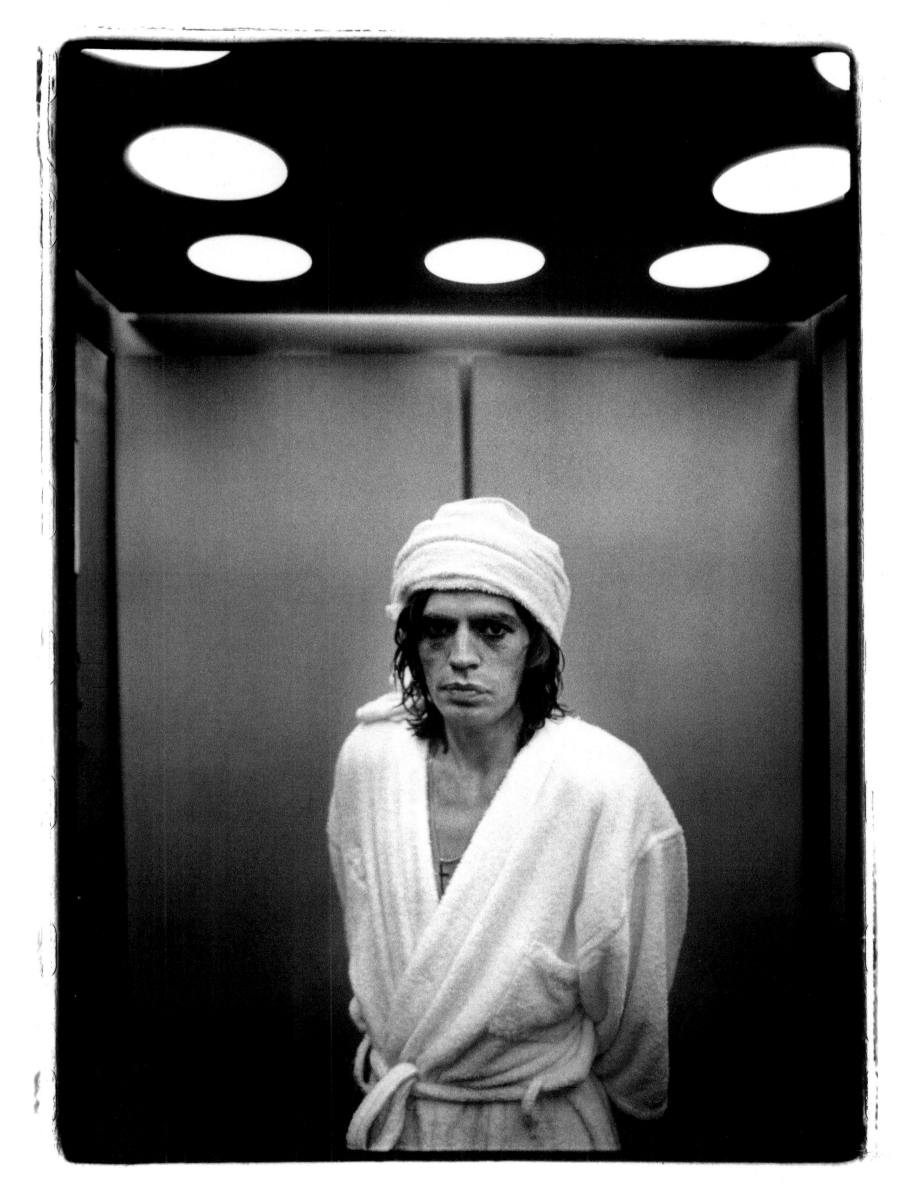

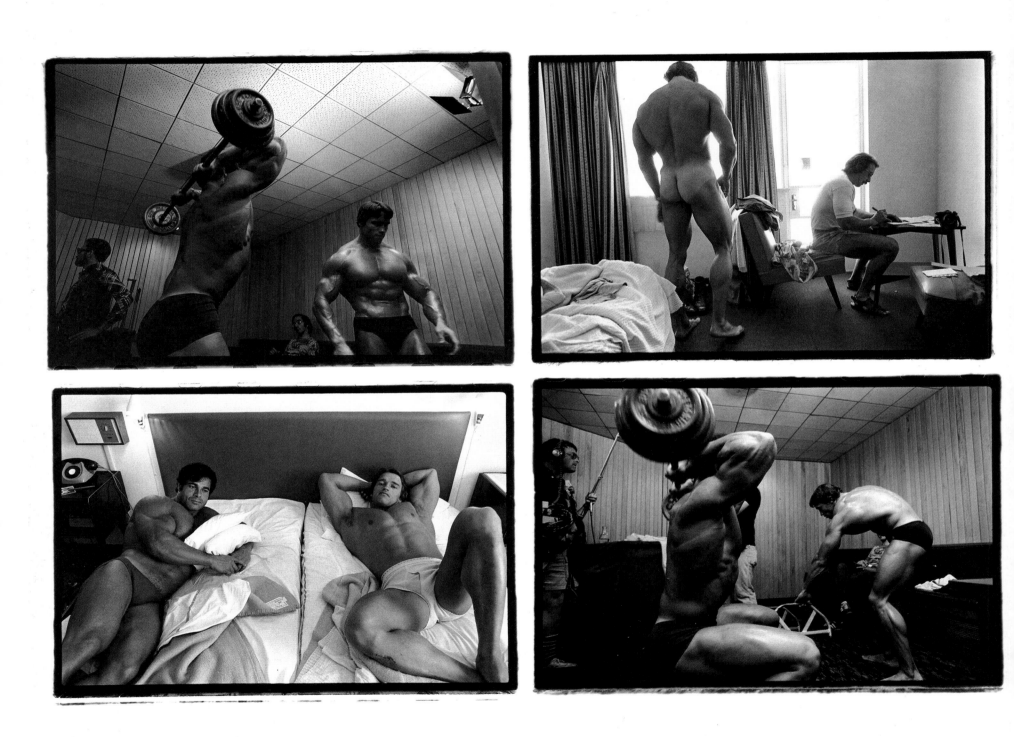

Arnold Schwarzenegger (with Franco Columbu, bottom left), *Johannesburg and Capetown, South Africa, 1976*

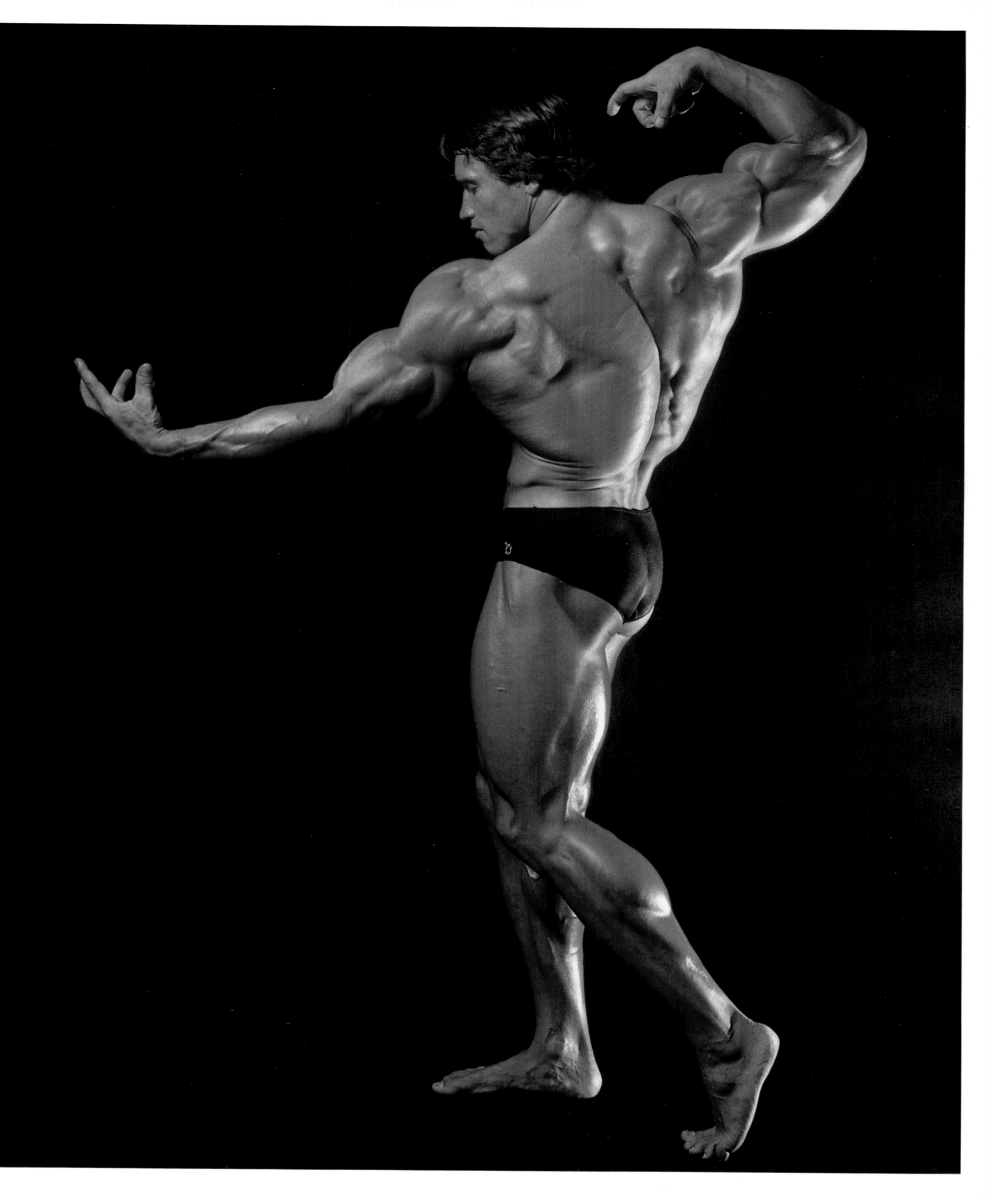

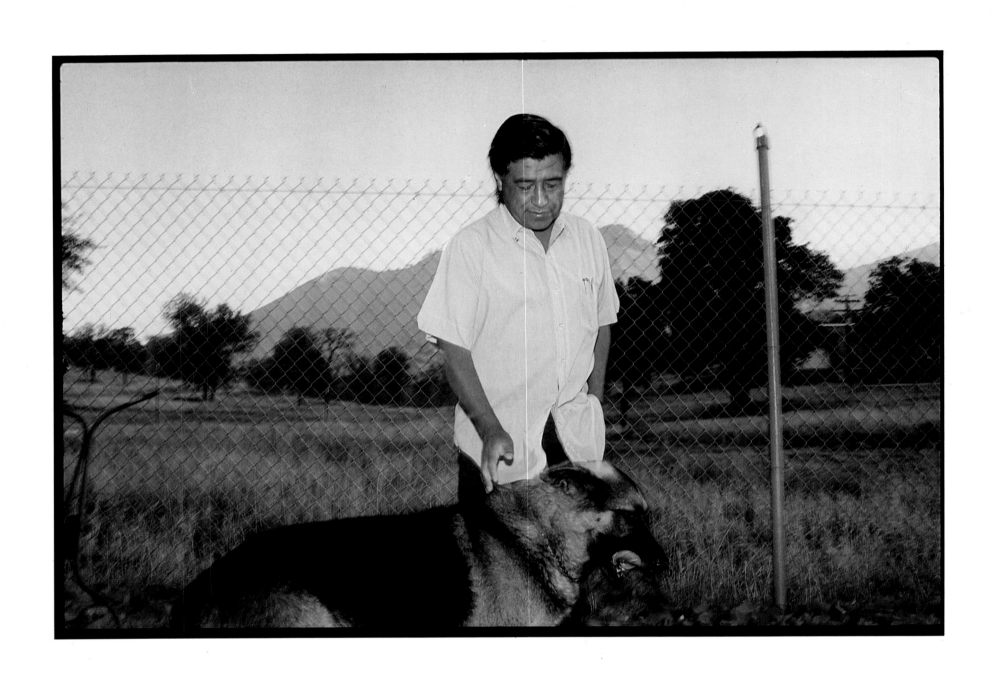

Cesar Chavez, *La Paz, California*, 1976

Linda Ronstadt, *Malibu, California, 1976*

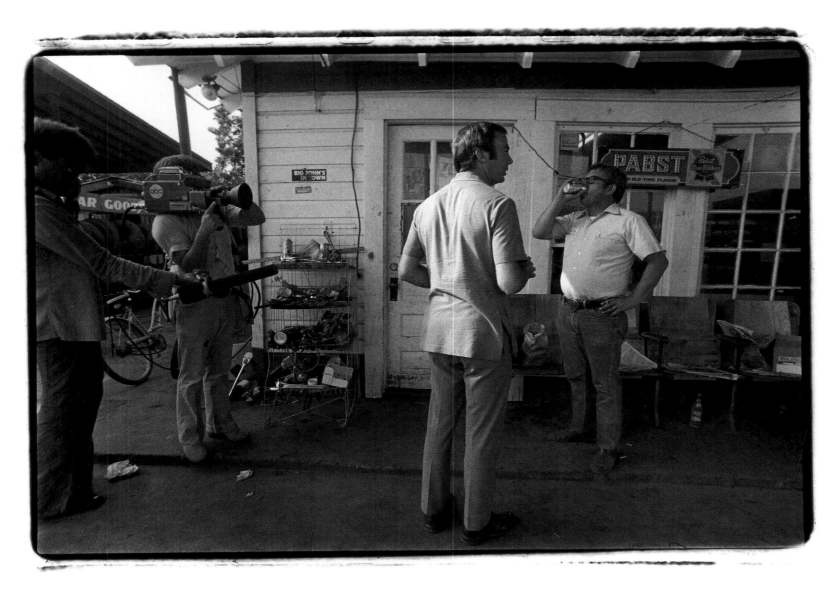

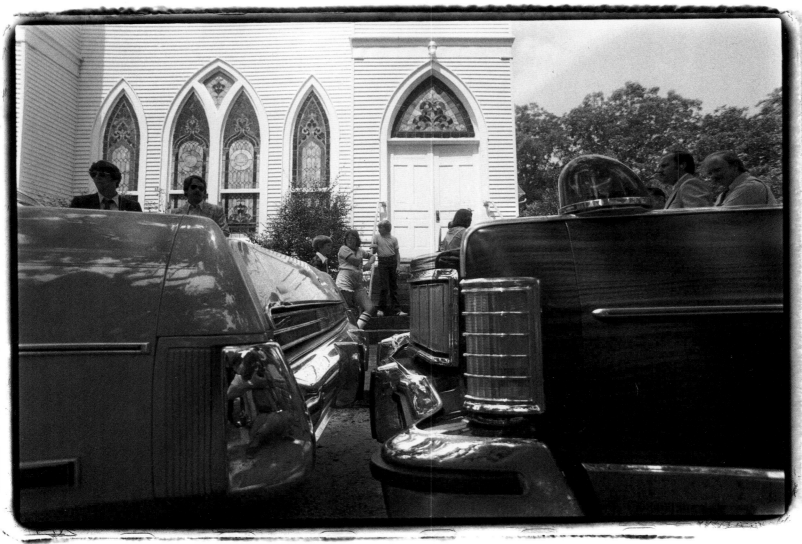

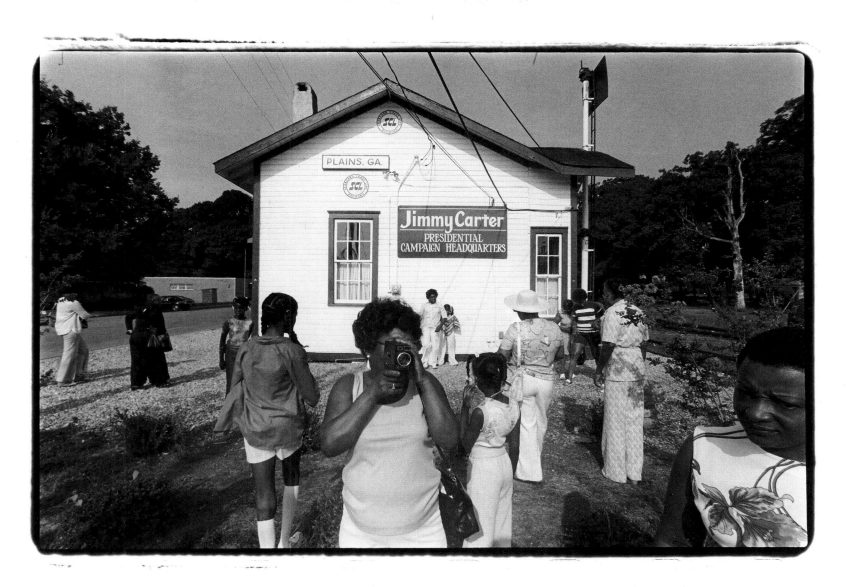

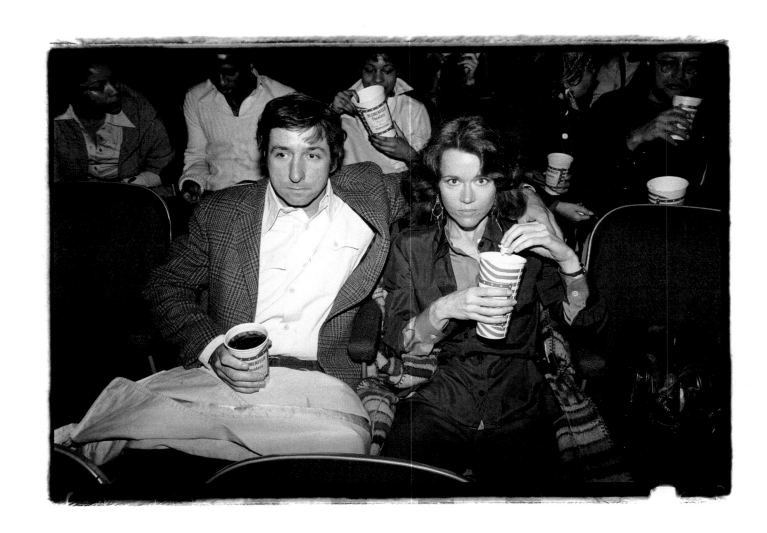

Tom Hayden and Jane Fonda, *San Francisco, 1978*

Brian Wilson, *Malibu, California, 1976*

Preceding pages:

Jimmy Carter's presidential campaign, *Plains, Georgia, 1976.*
Sam Donaldson and Billy Carter (upper left and lower right)

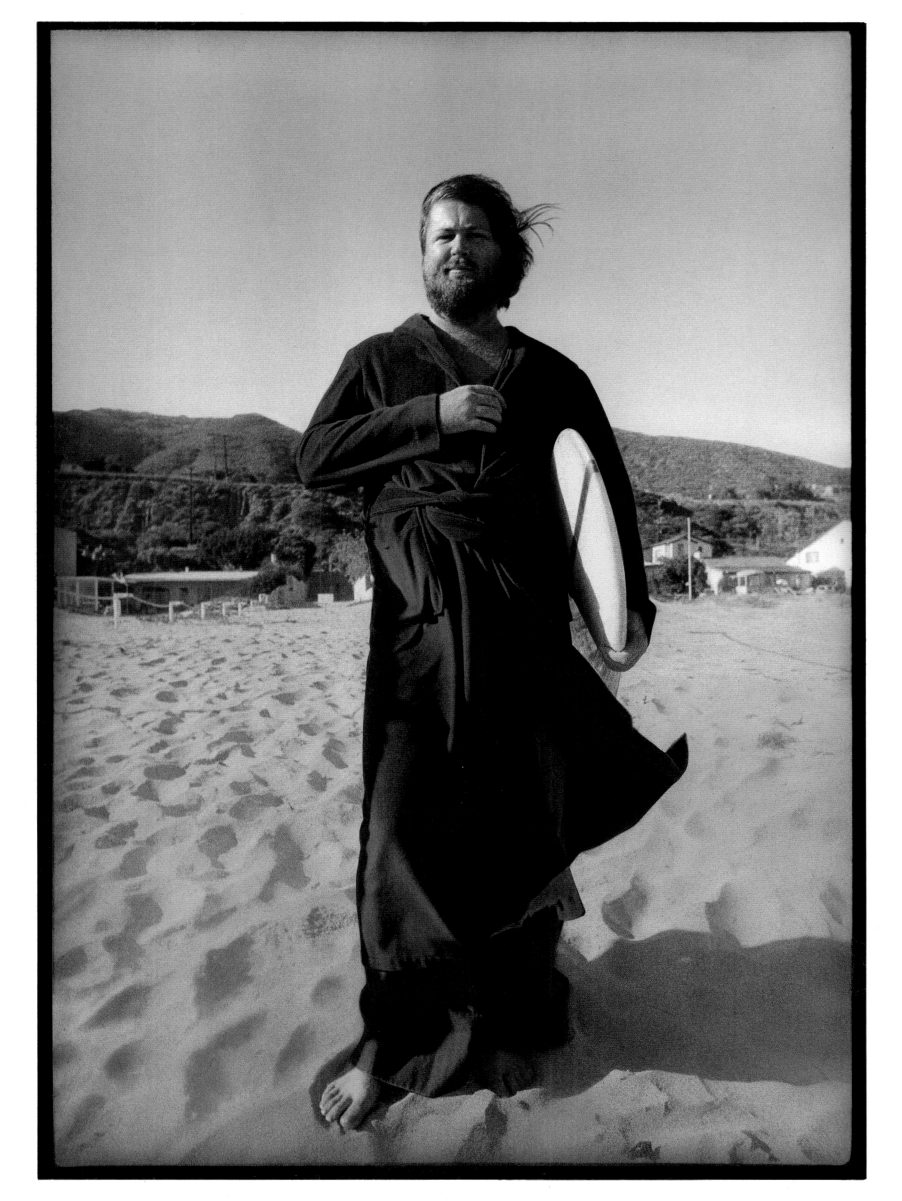

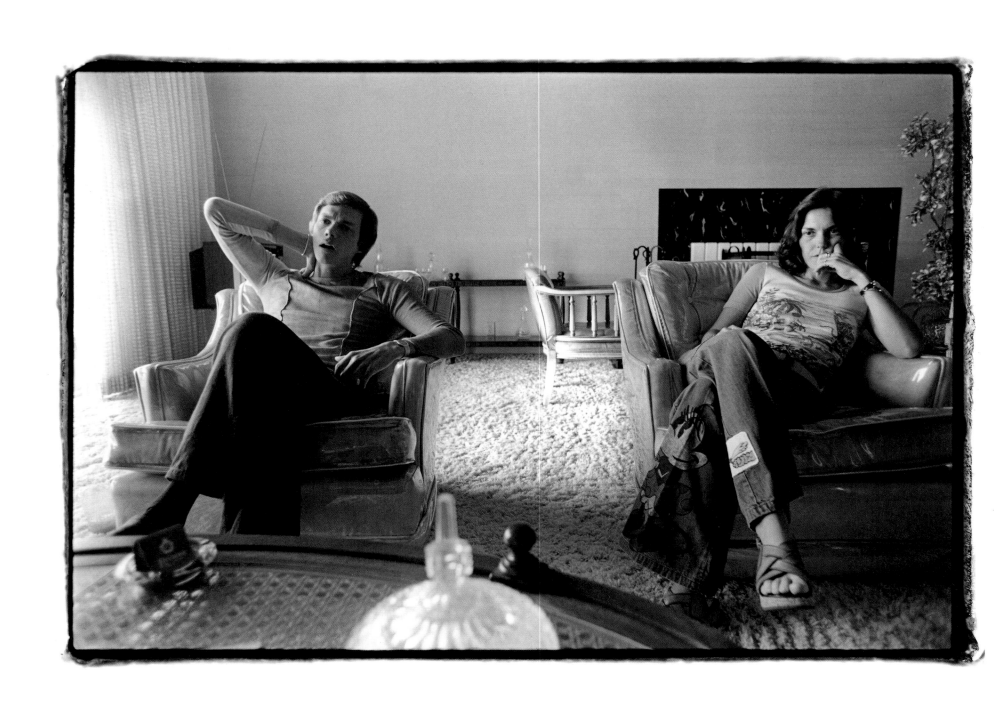

Richard and Karen Carpenter, *Los Angeles, California, 1974*

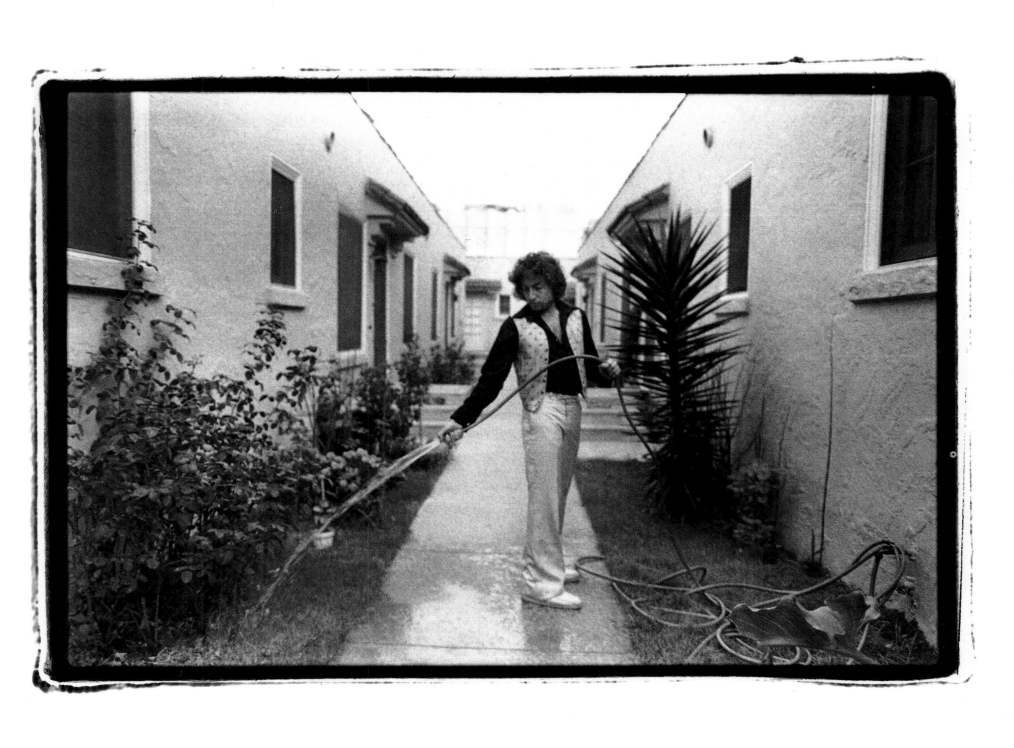

Bob Dylan, *Hollywood, 1978*

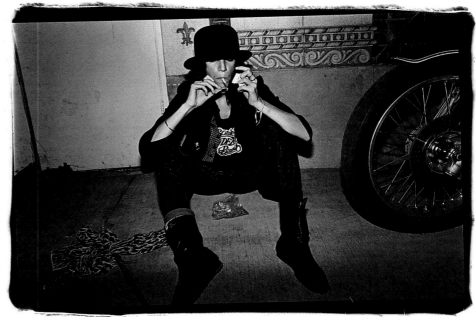
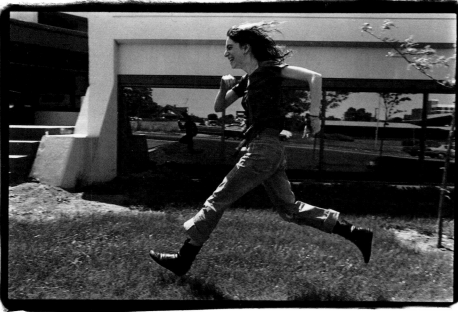
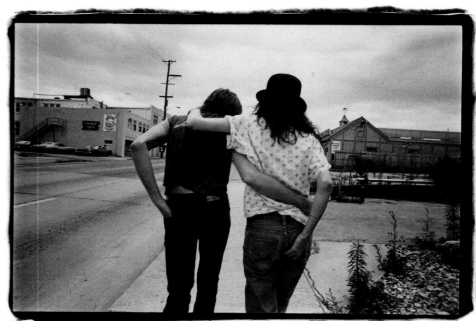

Patti Smith on tour, *St. Louis, Dallas, and New Orleans, 1978*

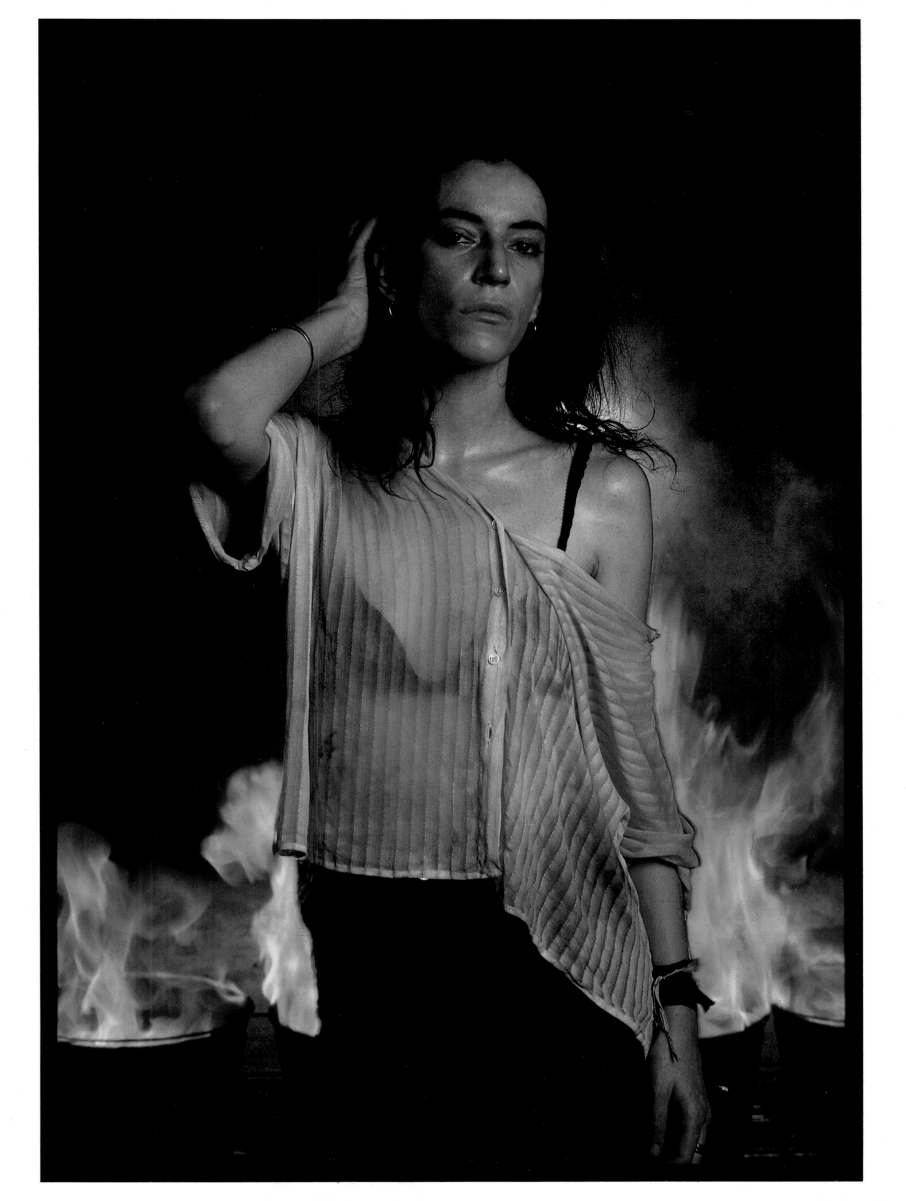

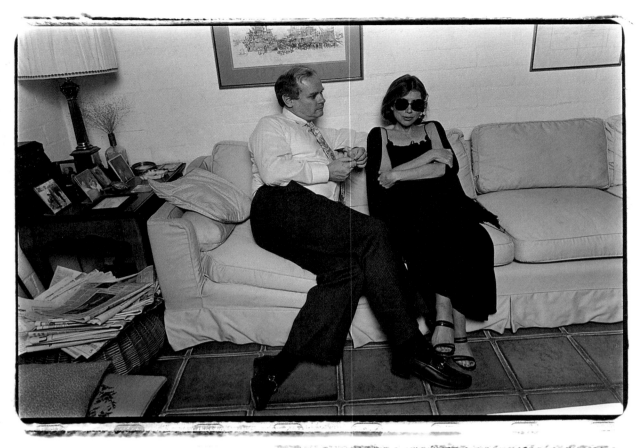

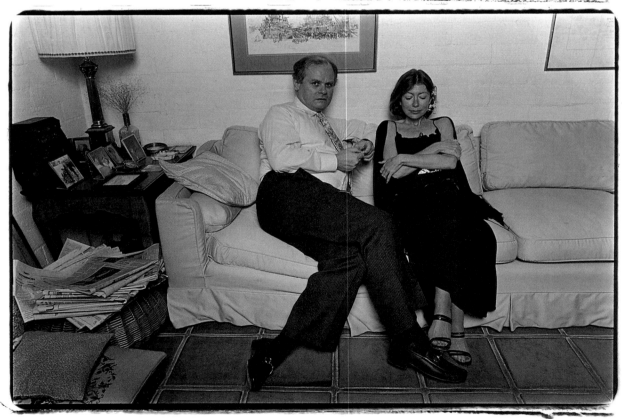

John Gregory Dunne and Joan Didion, *Malibu, California, 1978*

Sally Rand, *New York City, 1978*

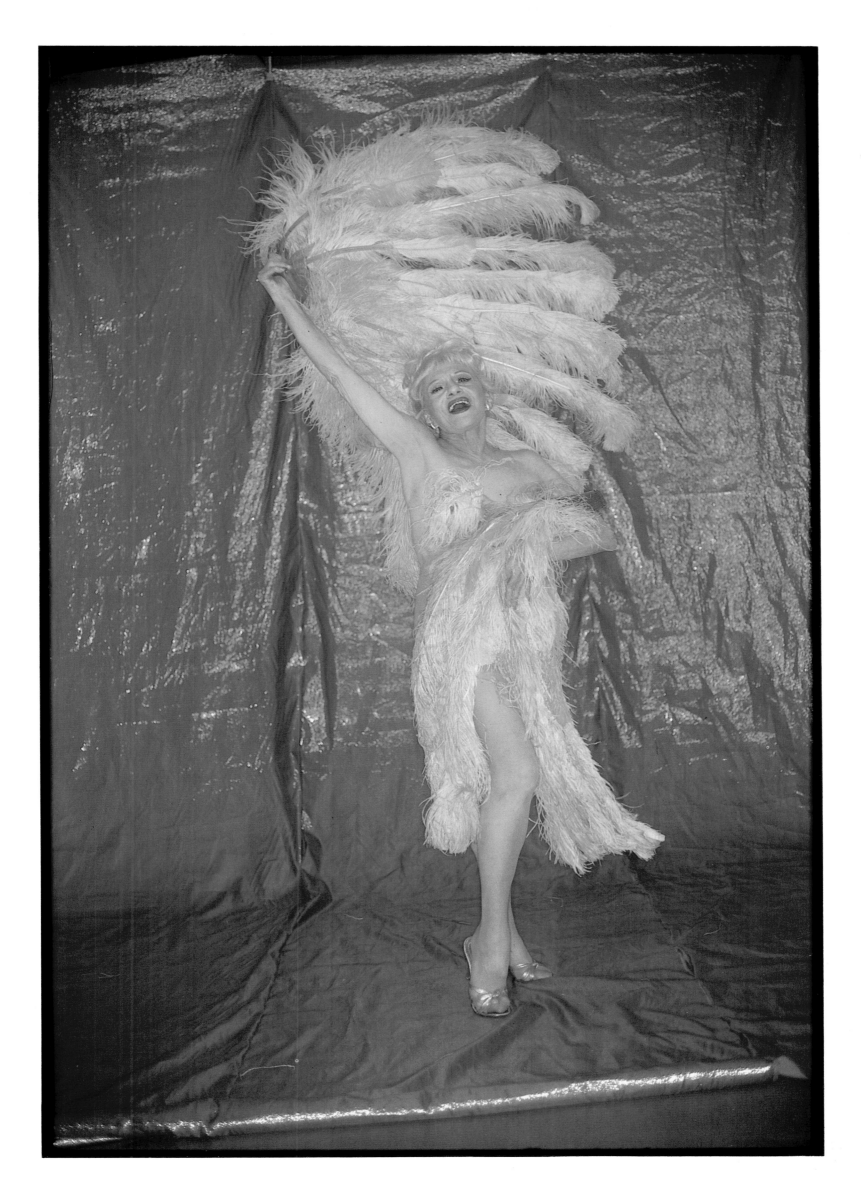

Richard Avedon, *Palo Alto, California, 1976*

Muhammad Ali, *Chicago, 1978*

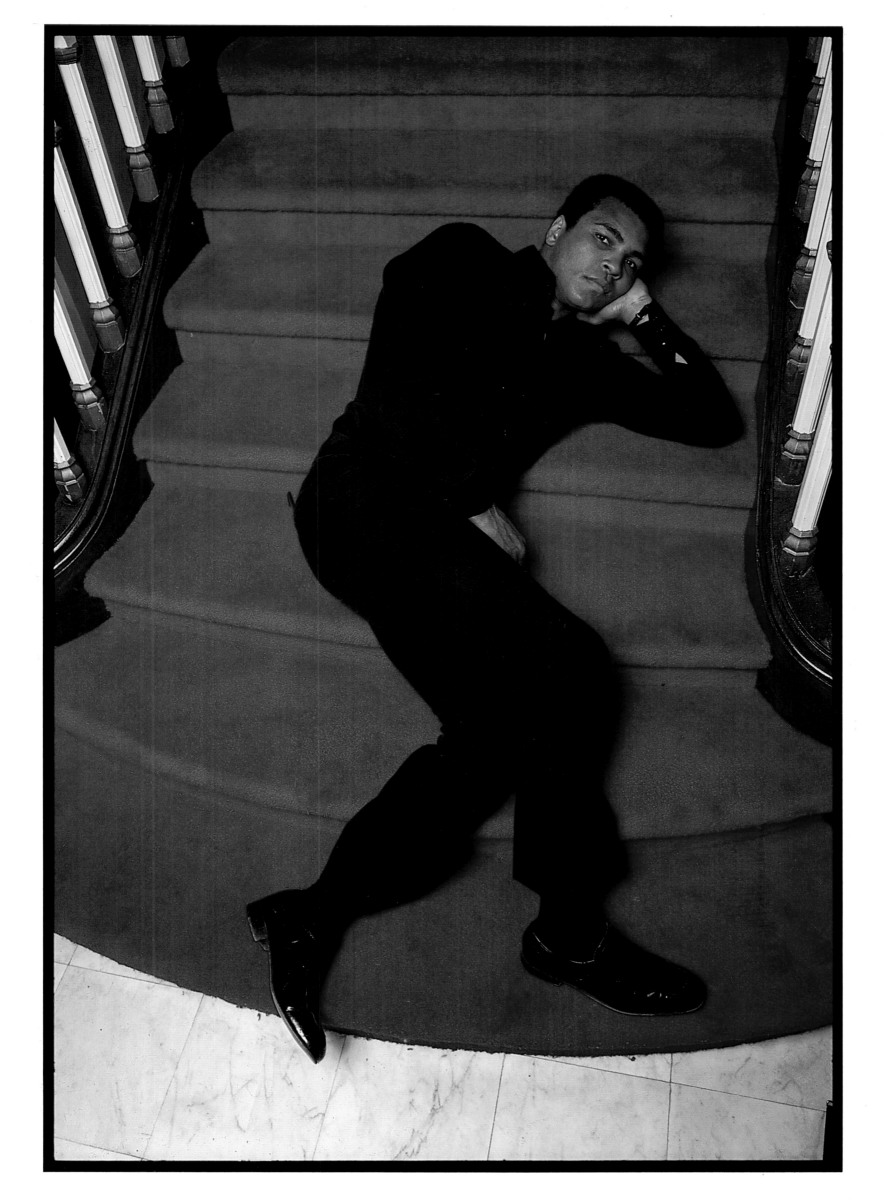

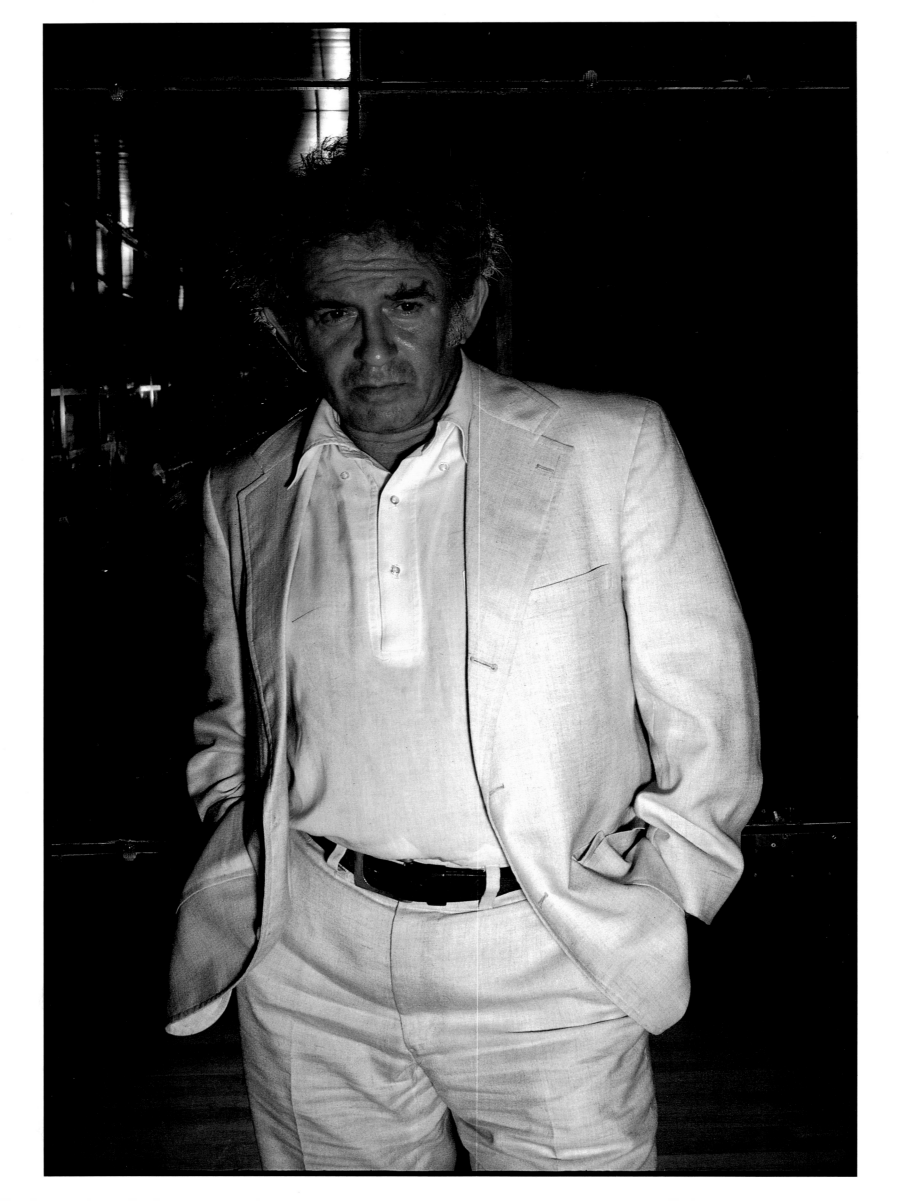

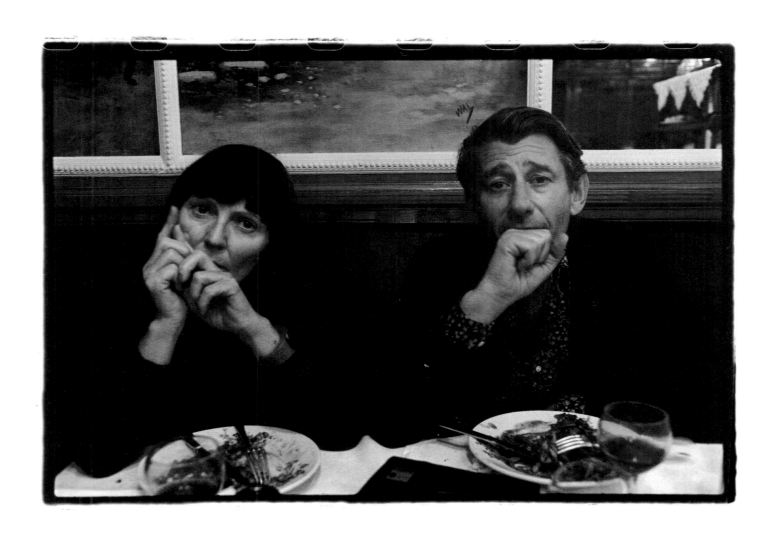

Norman Mailer, *Bar Harbor, Maine, 1974*

Alice Springs and Helmut Newton, *Paris, 1976*

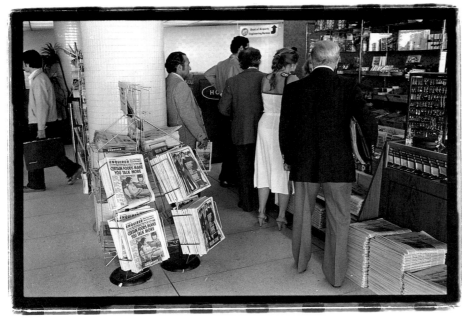
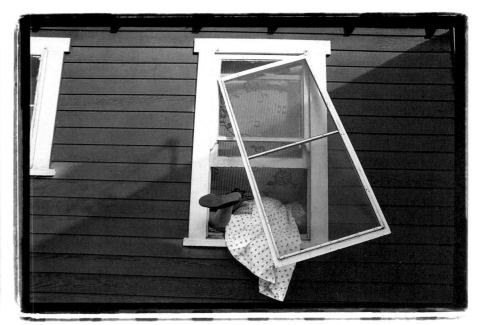
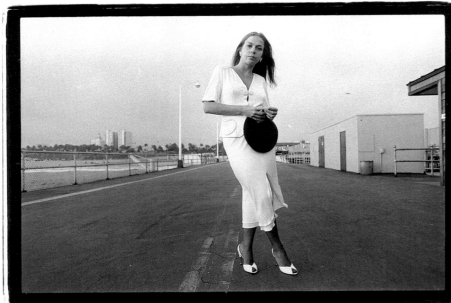
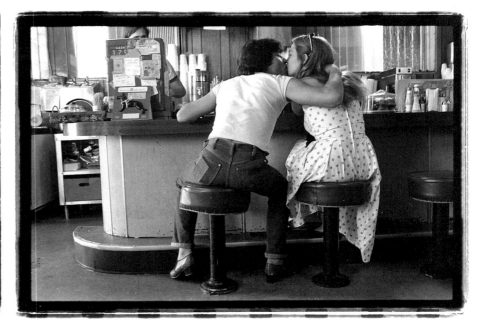
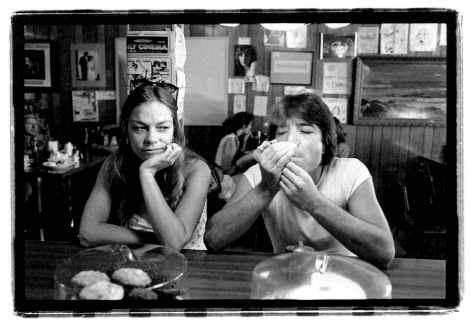
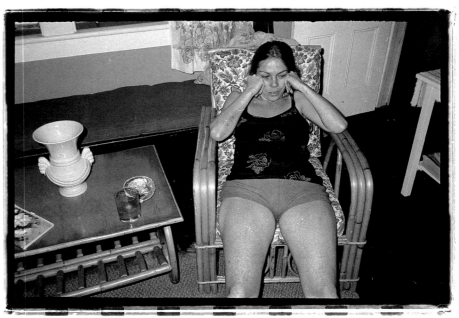

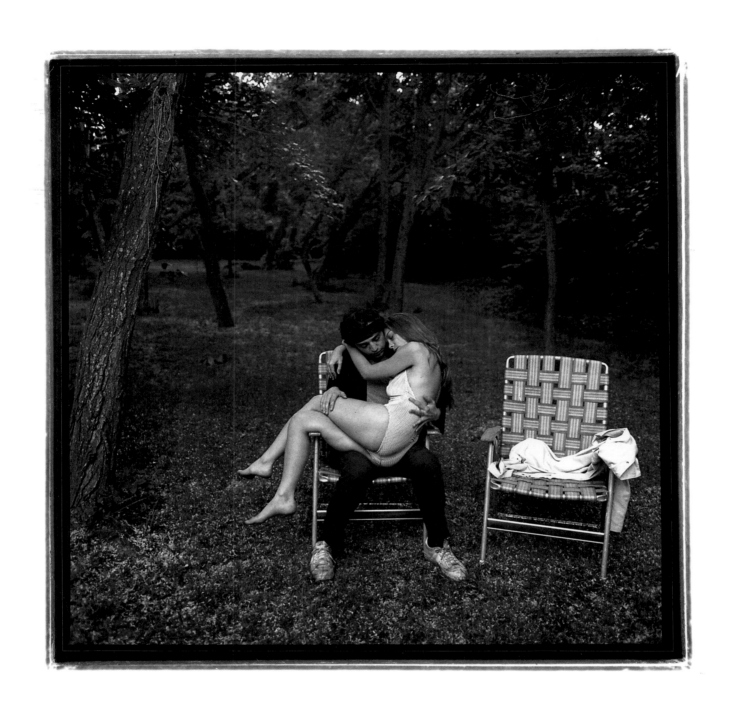

Rickie Lee Jones, *Los Angeles, California, 1979, and Mattituck, New York, 1981*

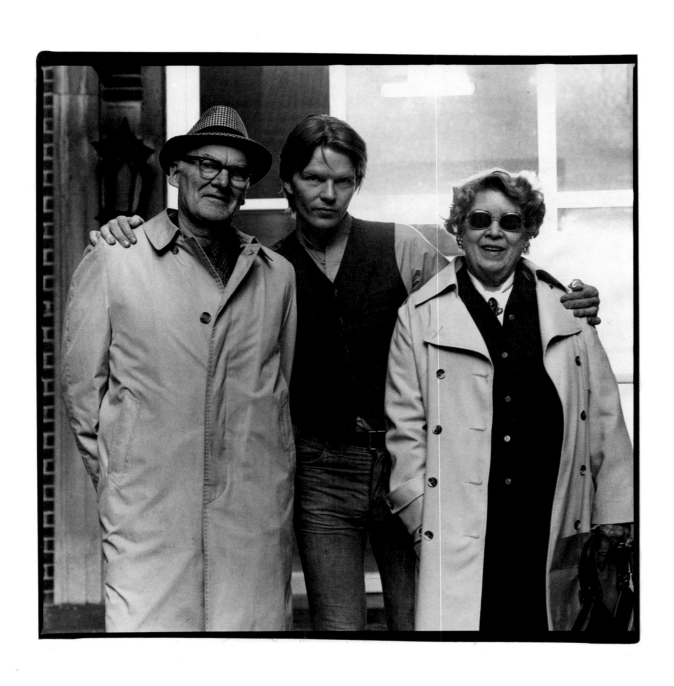

Jim Carroll and his parents, *New York City, 1980*

Laurie Anderson, *New York City, 1982*

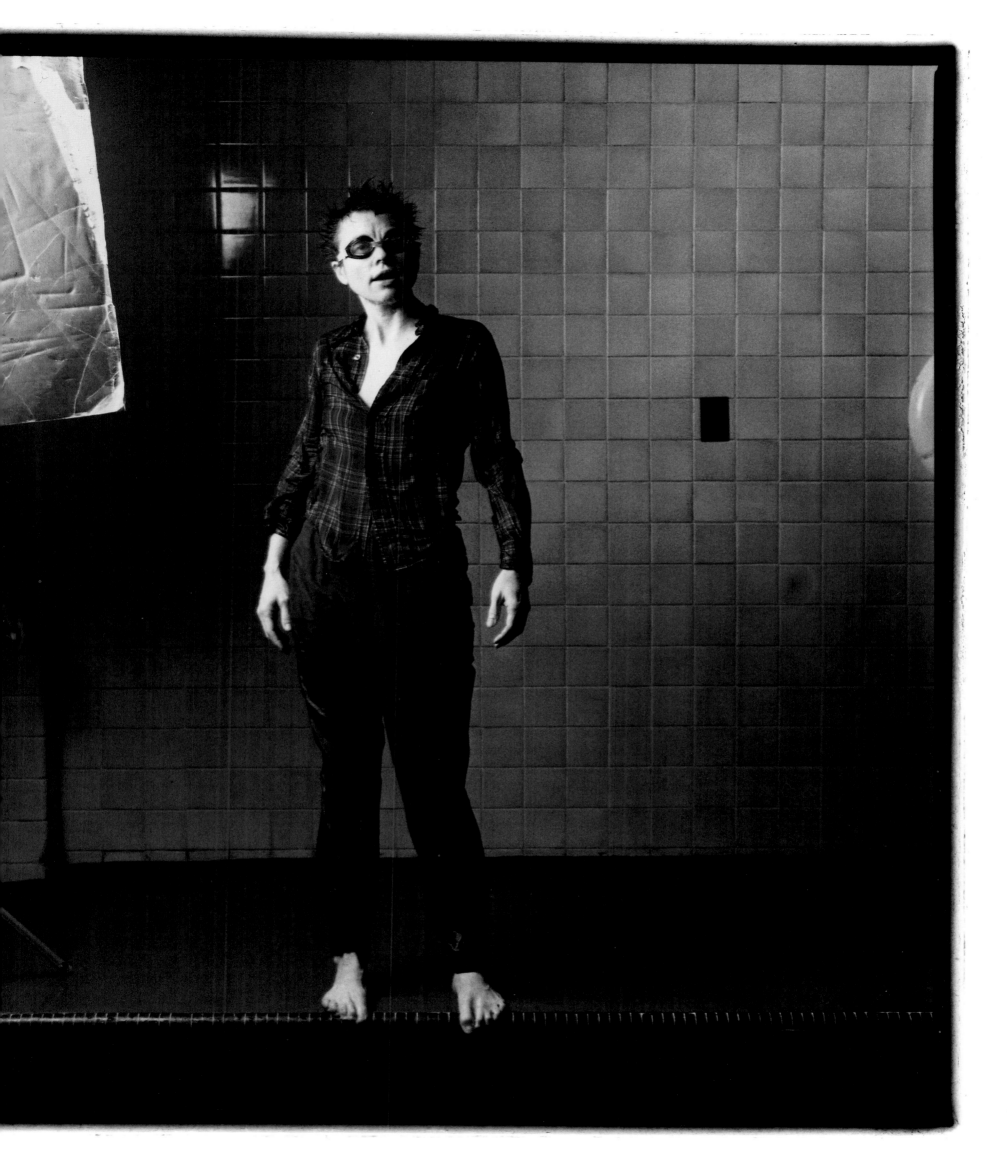

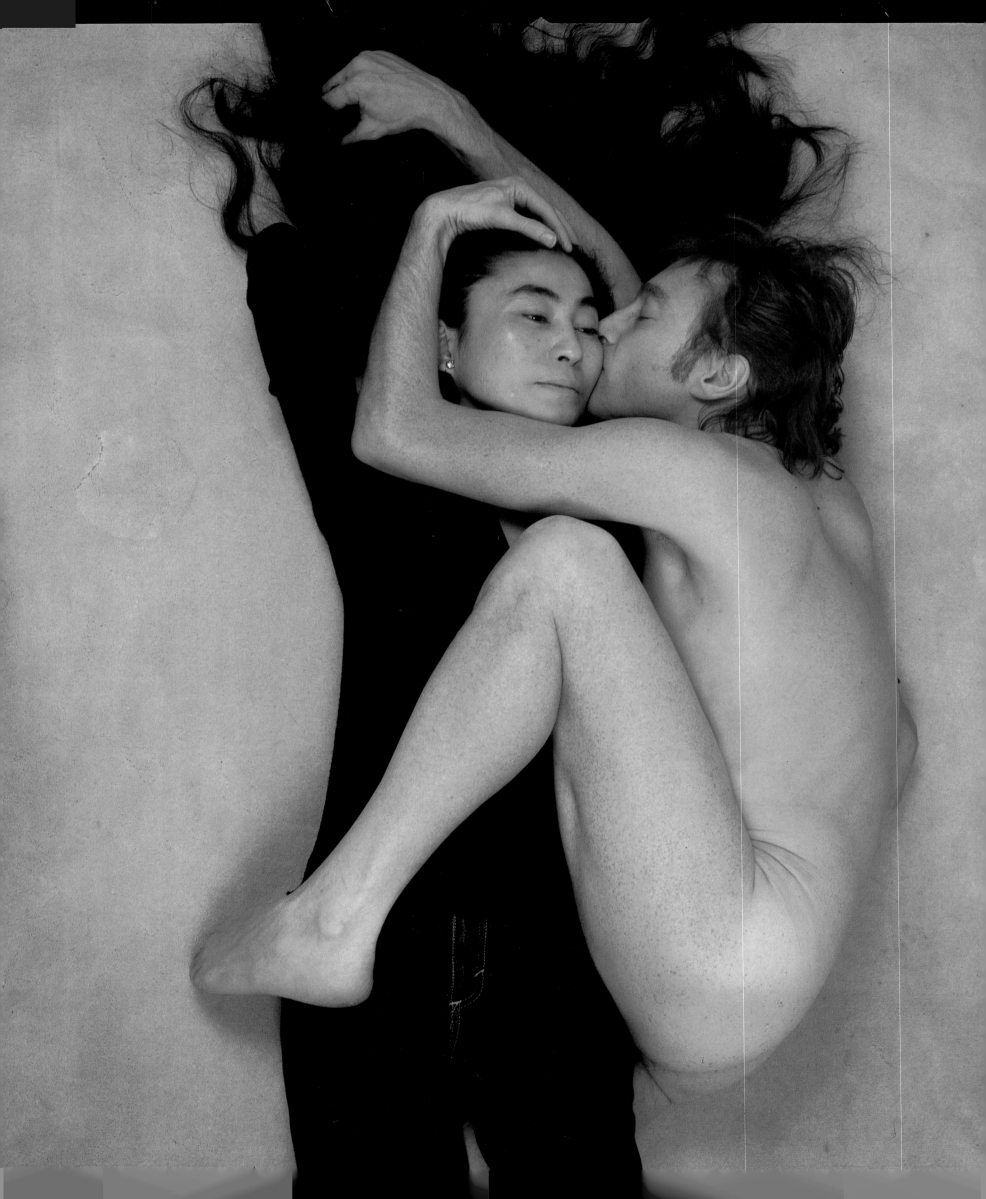

John Lennon and Yoko Ono, *New York City, December 8, 1980*

Yoko Ono,
Strawberry Field,
New York City, 1981

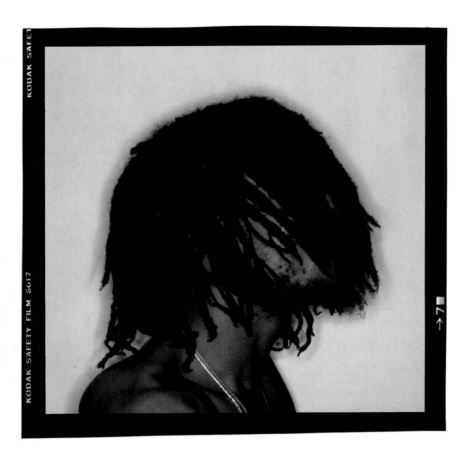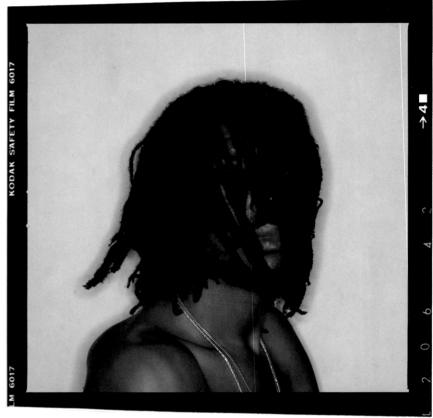

Peter Tosh, *New York City, 1982*

Christo, *New York City, 1981*

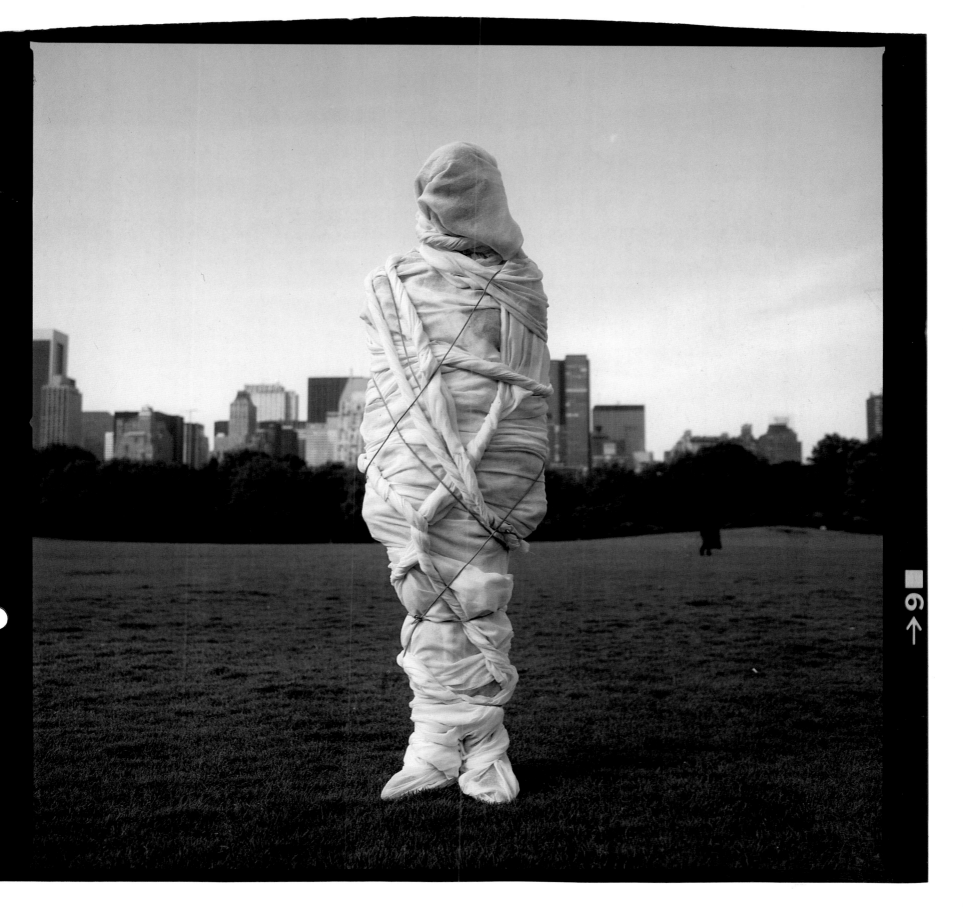

119

Lauren Hutton, *Oxford, Mississippi, 1981*

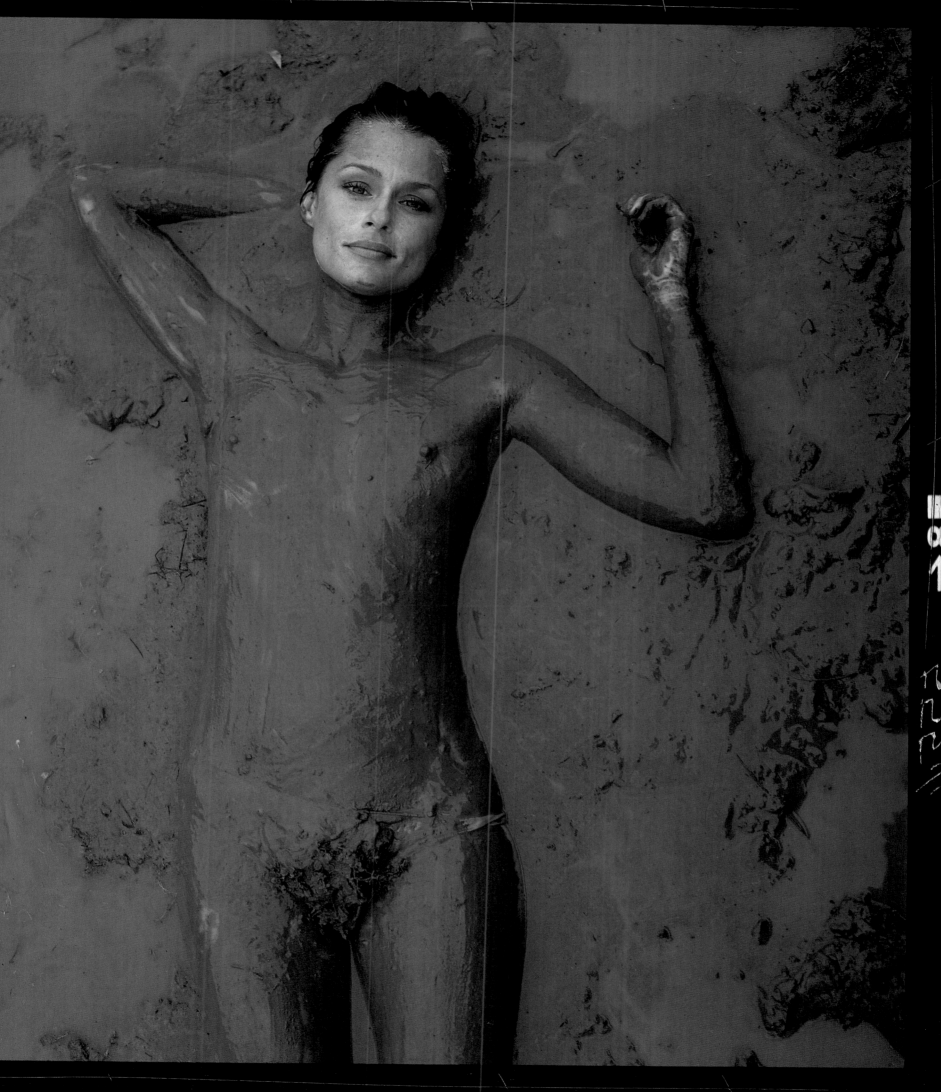

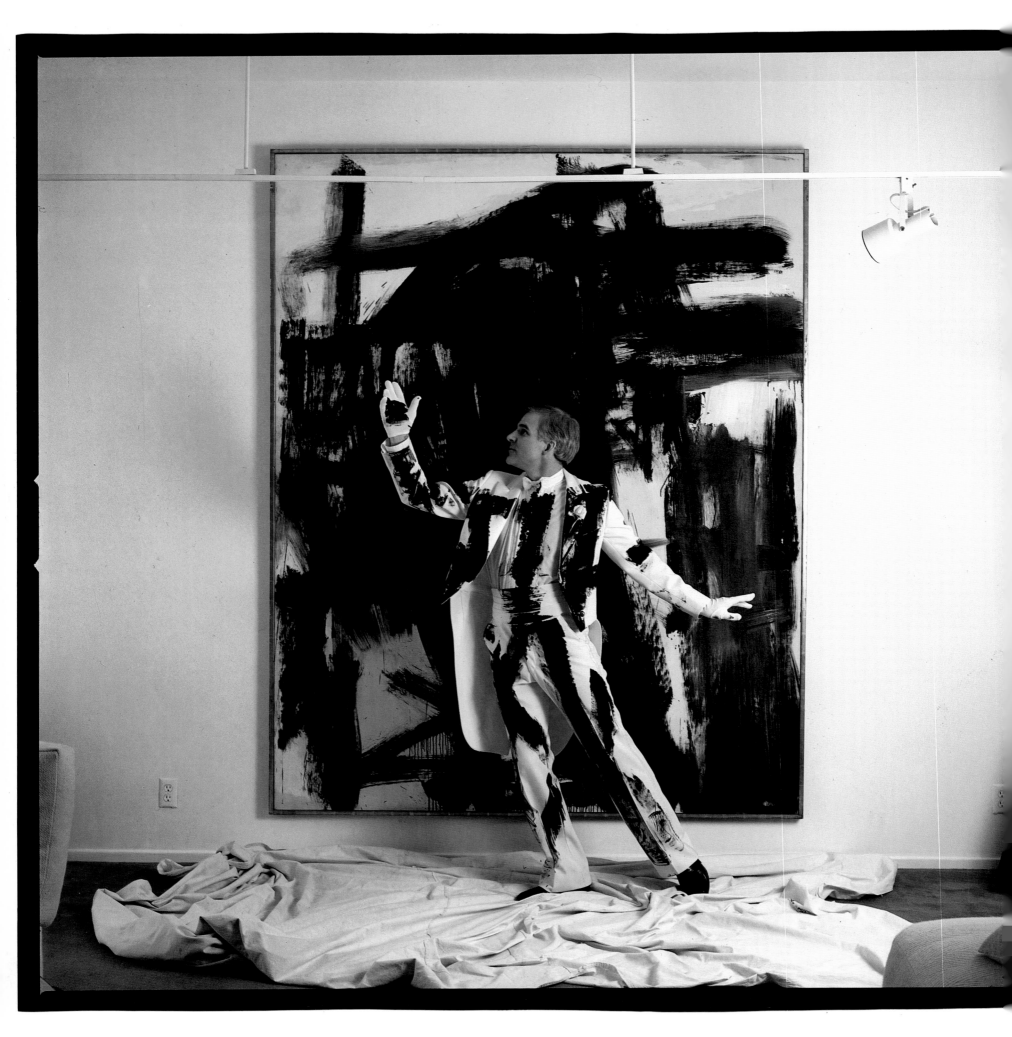

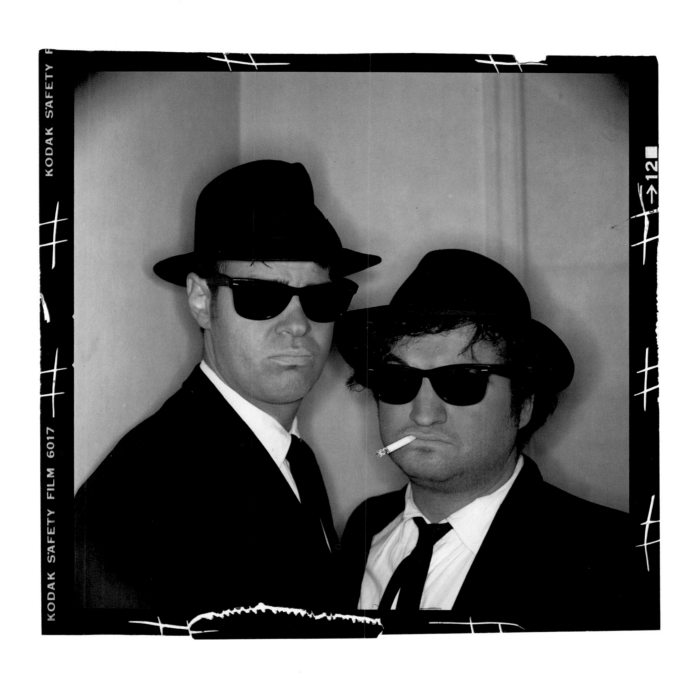

Steve Martin, *Beverly Hills, 1981*

John Belushi and Dan Aykroyd, *Hollywood, 1979*

123

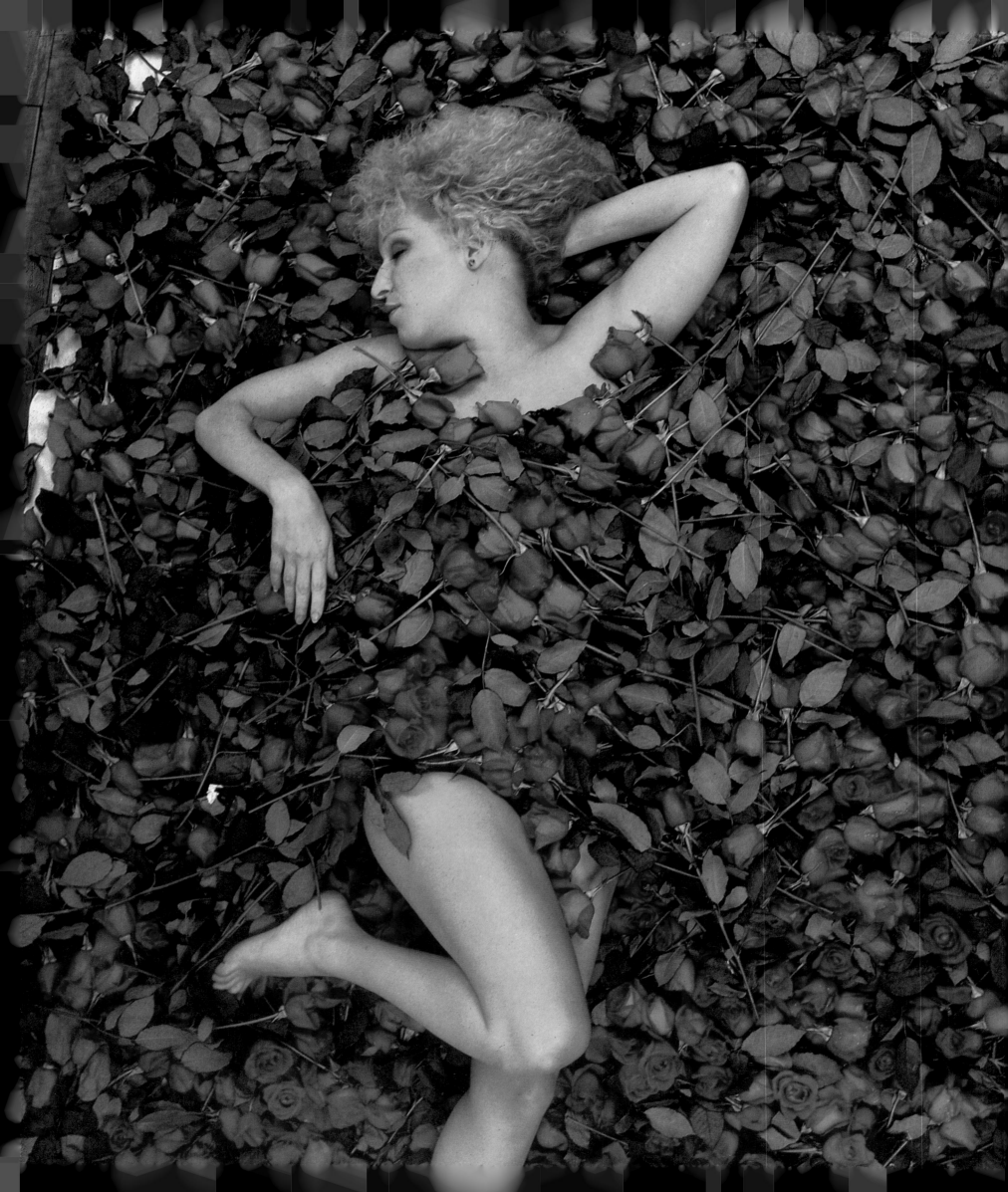

Bette Midler, *New York City, 1979*

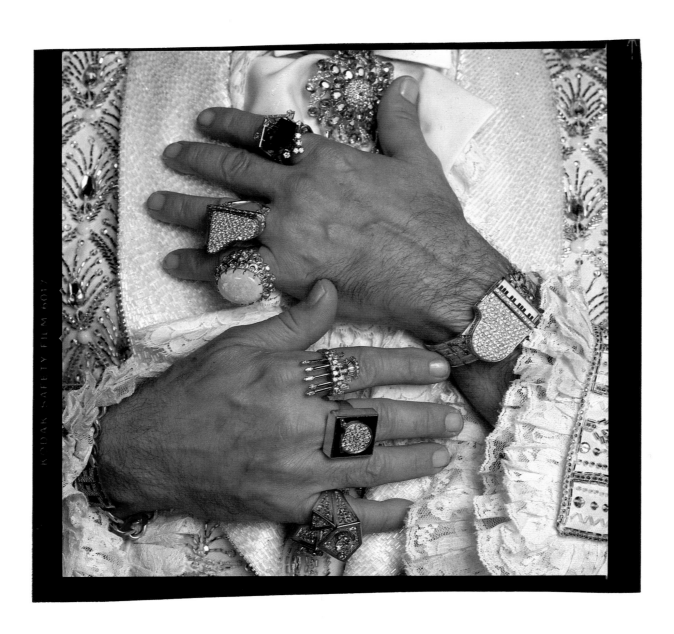

Liberace and Scott Thorson, *Las Vegas, 1981*

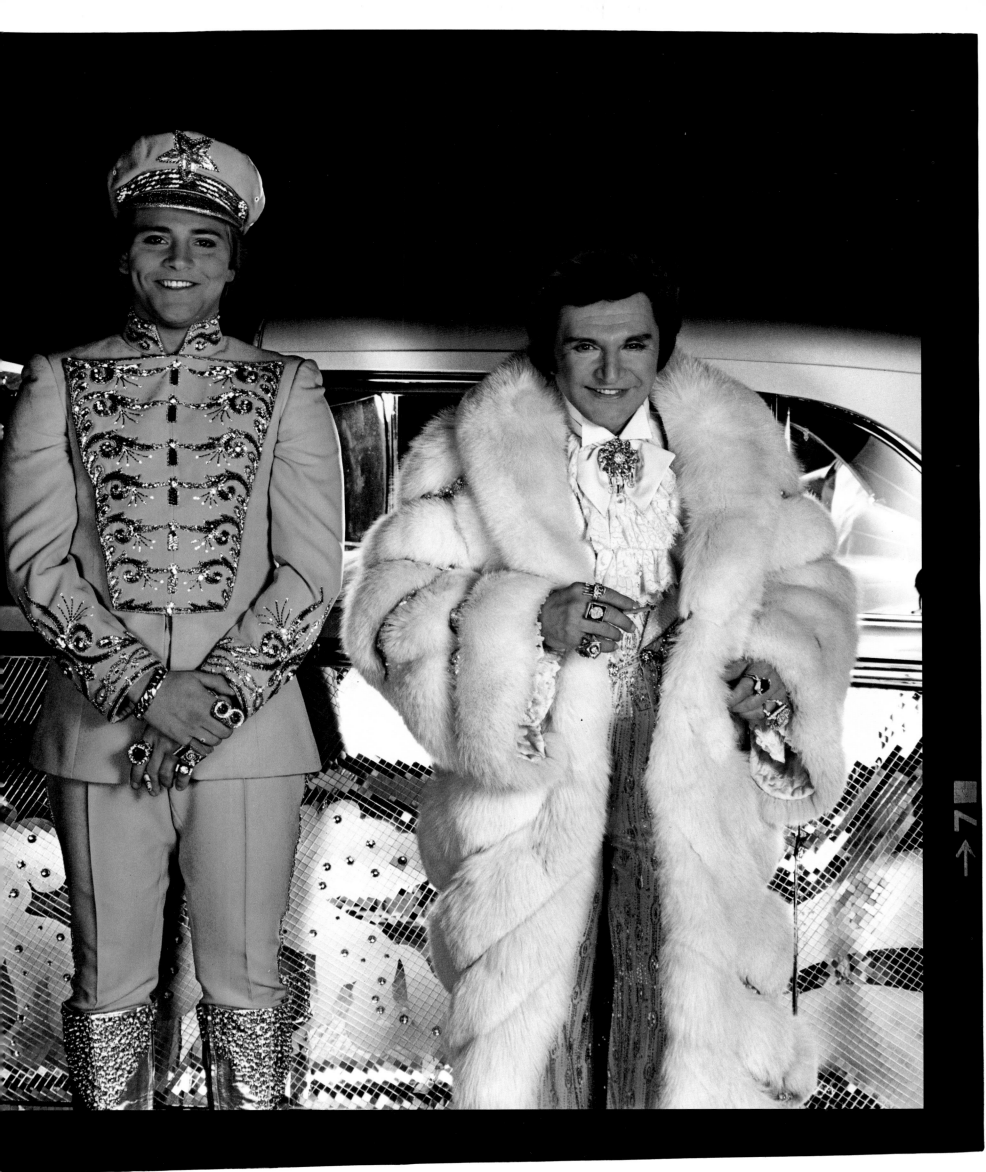

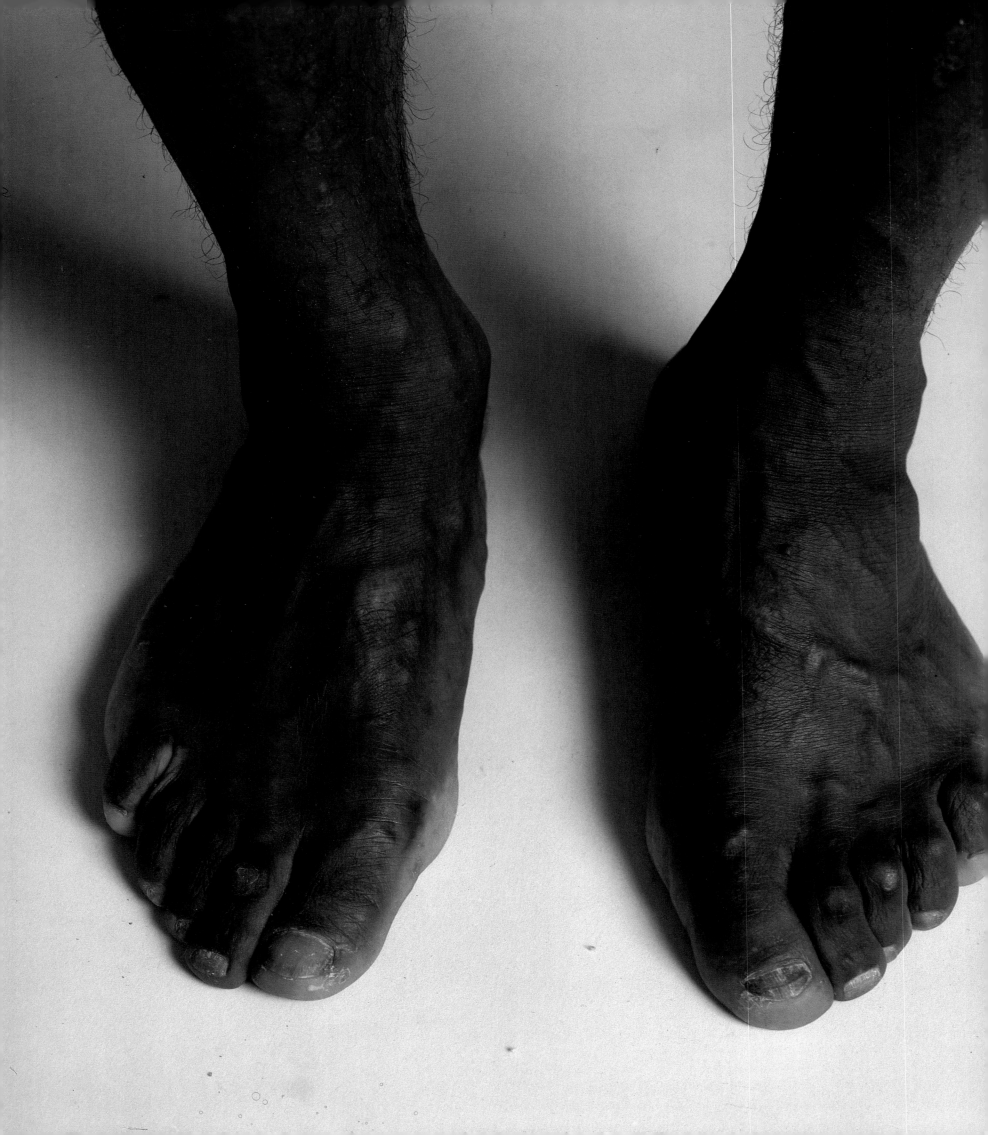

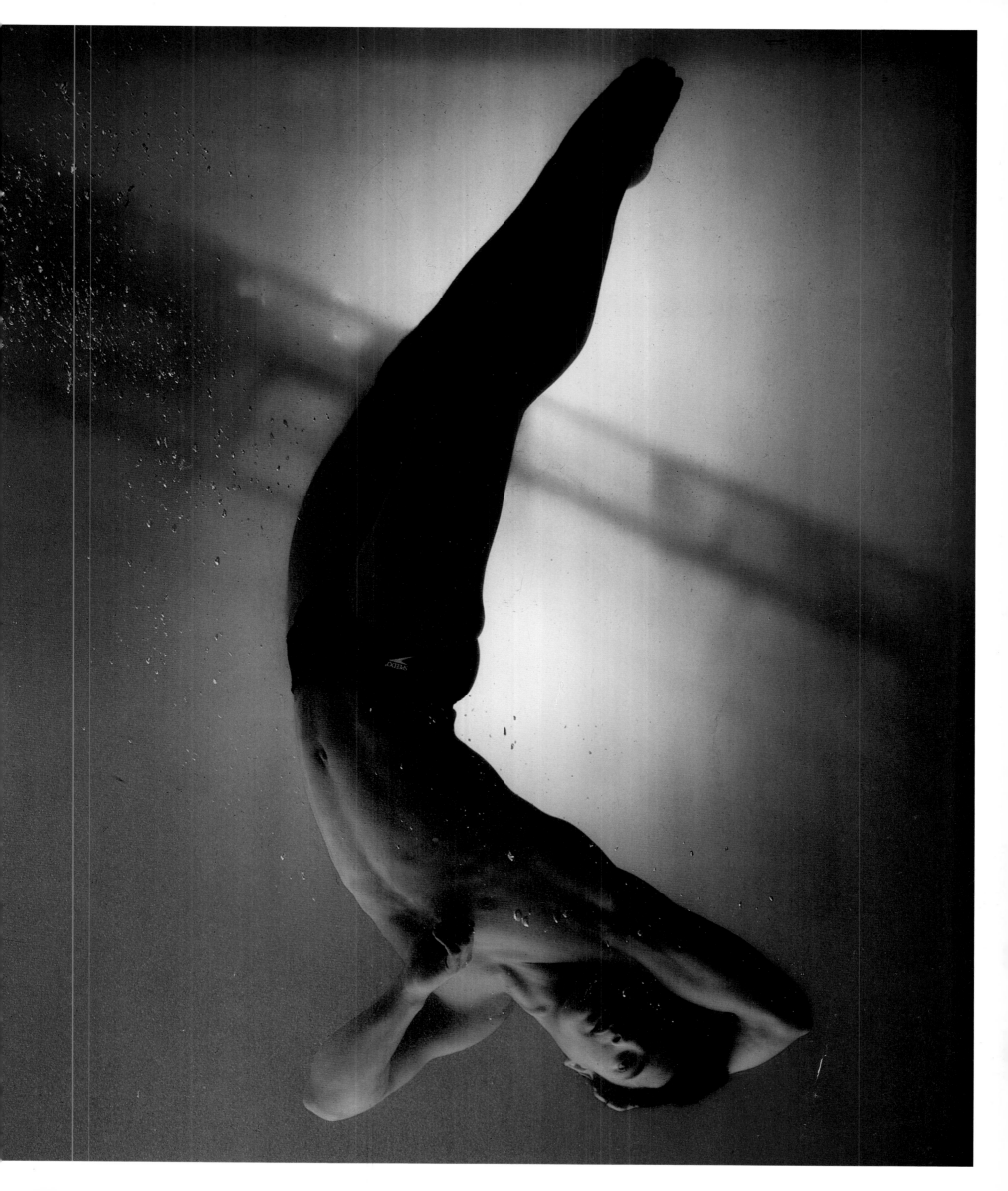

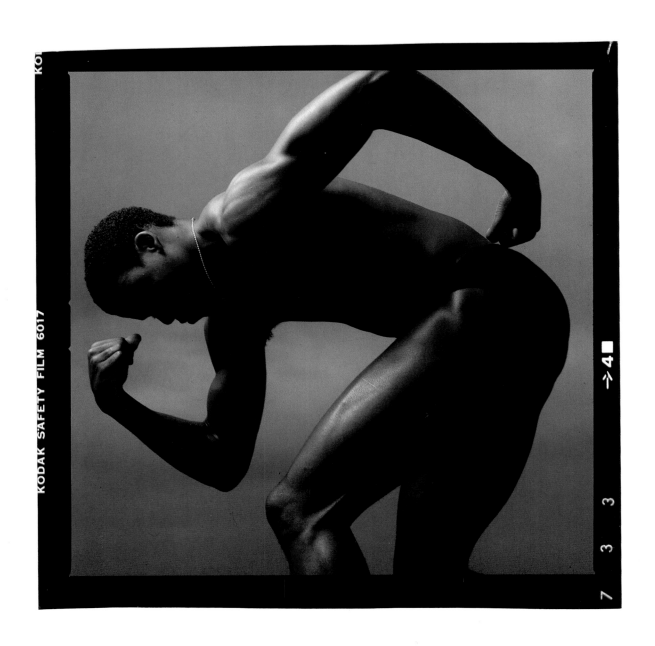

Carl Lewis, *Houston, Texas, 1983*

Evelyn Ashford, *El Mirage Dry Lake, California, 1988*

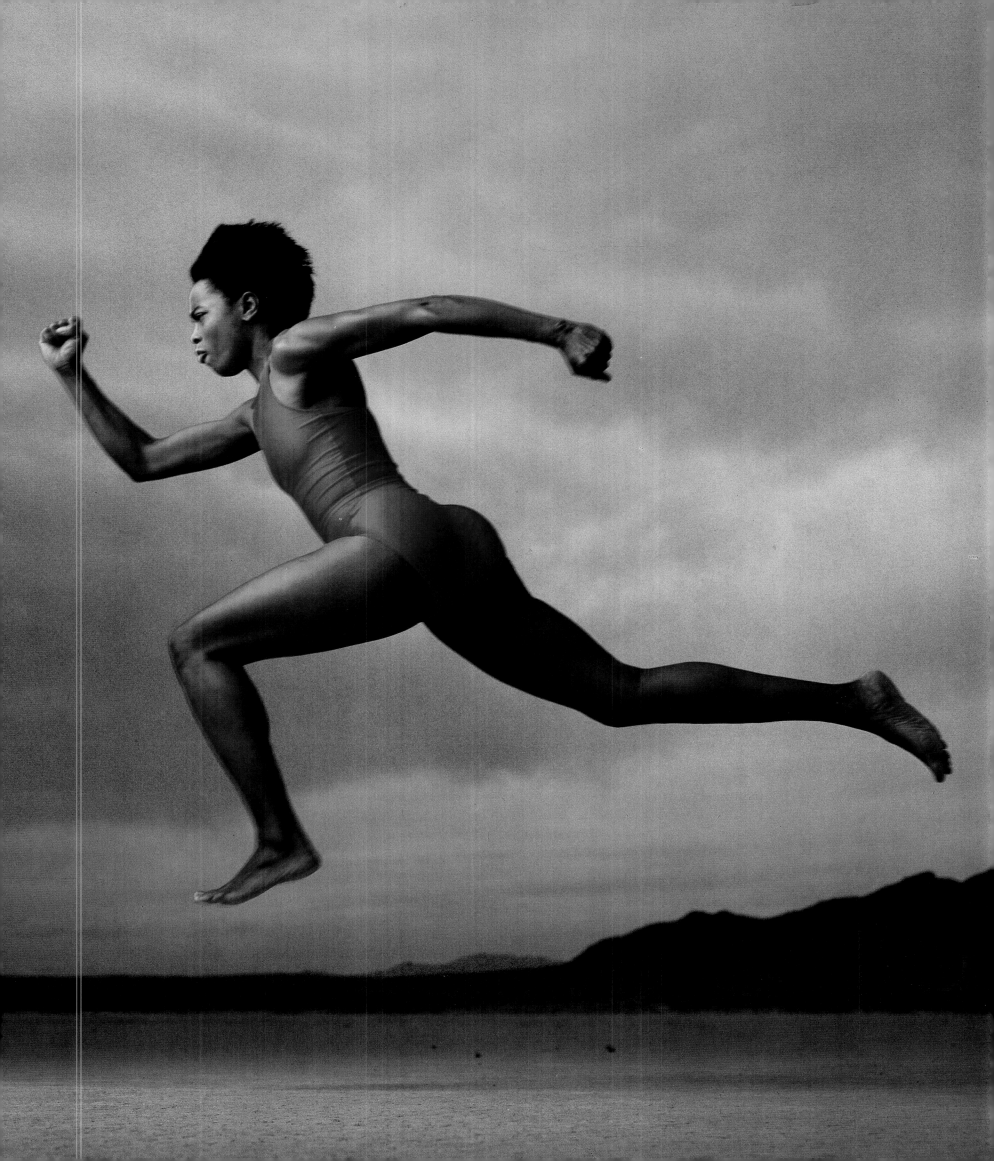

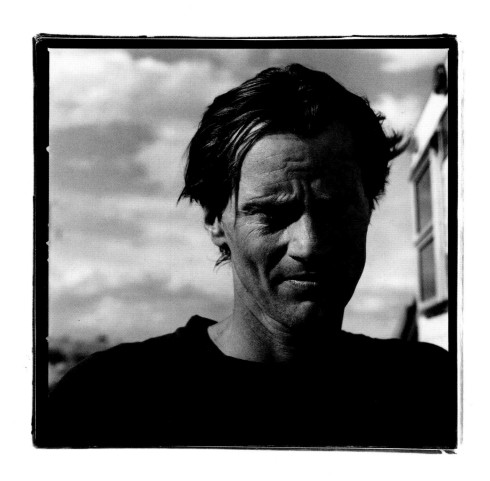

Sam Shepard, *Santa Fe, New Mexico, 1984*

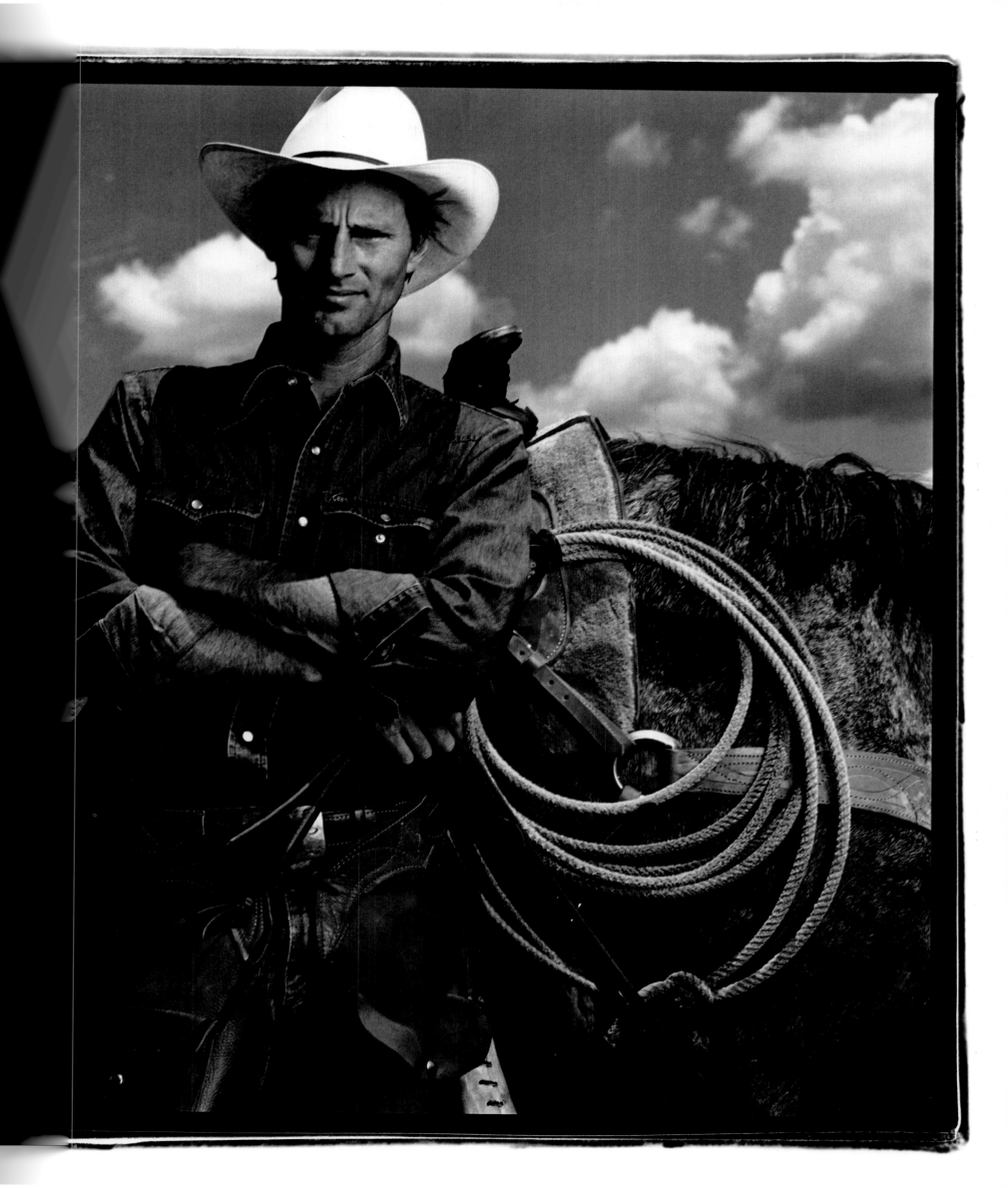

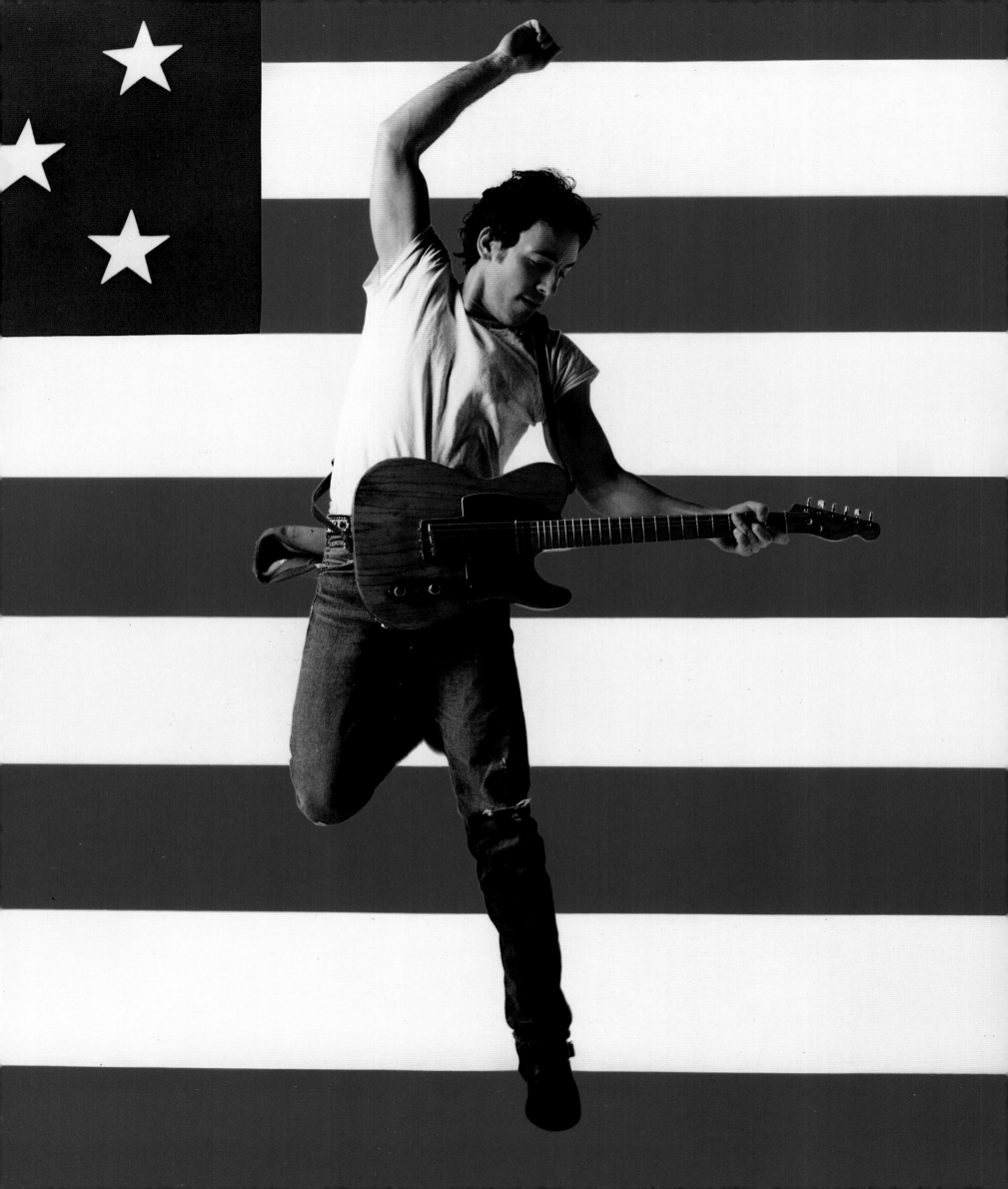

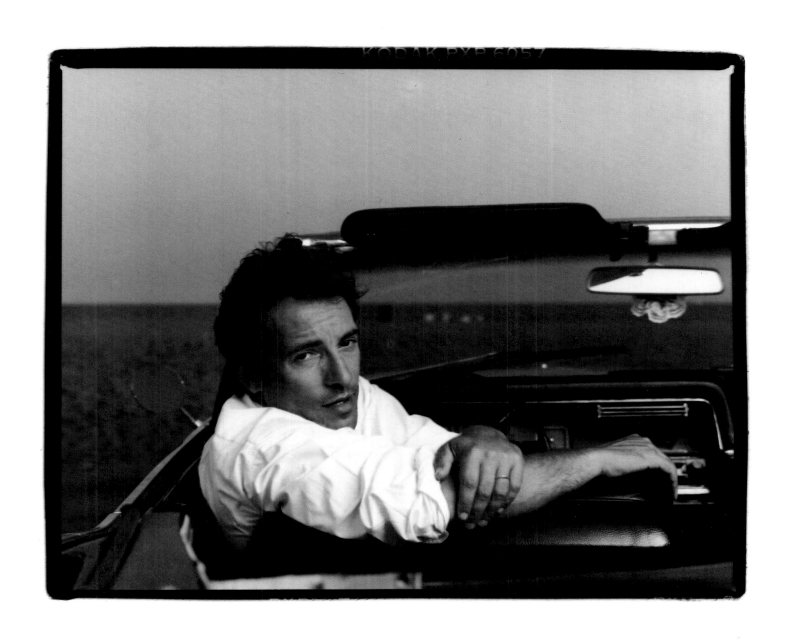

Bruce Springsteen, *New York City, 1984, and Asbury Park, New Jersey, 1987*

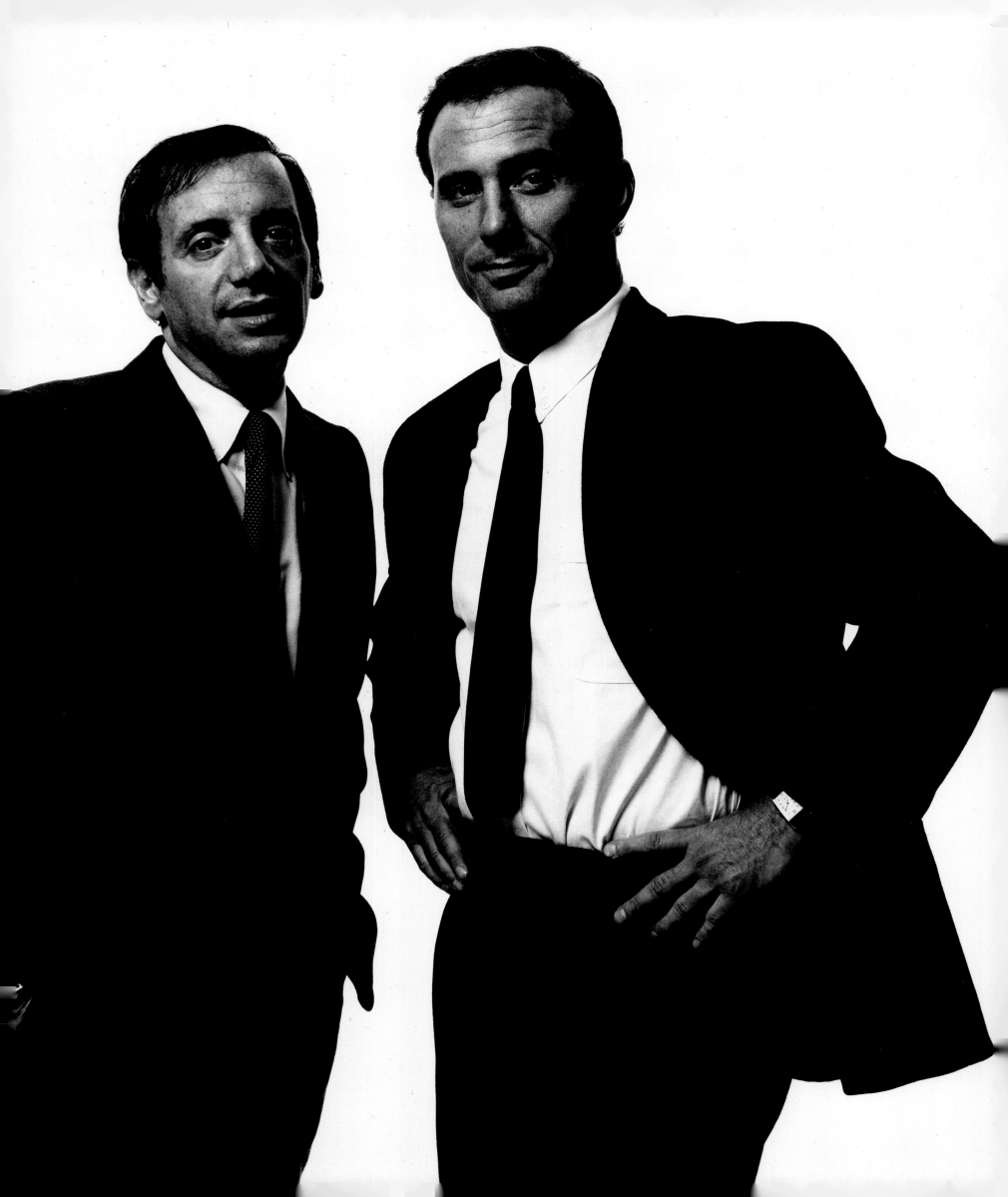

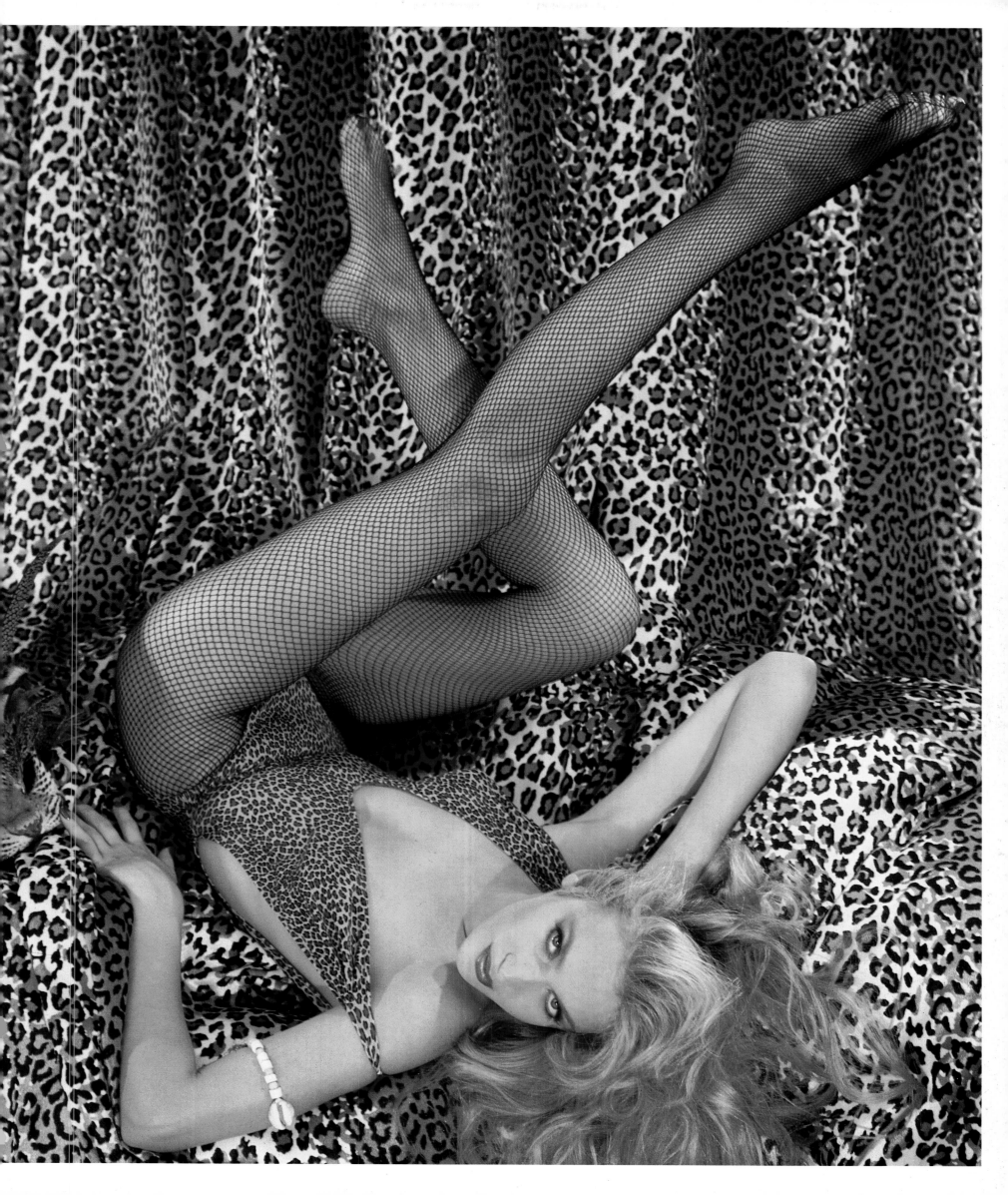

Whoopi Goldberg, *Berkeley, California, 1984*

Preceding pages:

Steve Rubell and Ian Schrager, *New York City, 1986*

Jerry Hall, *New York City, 1985*

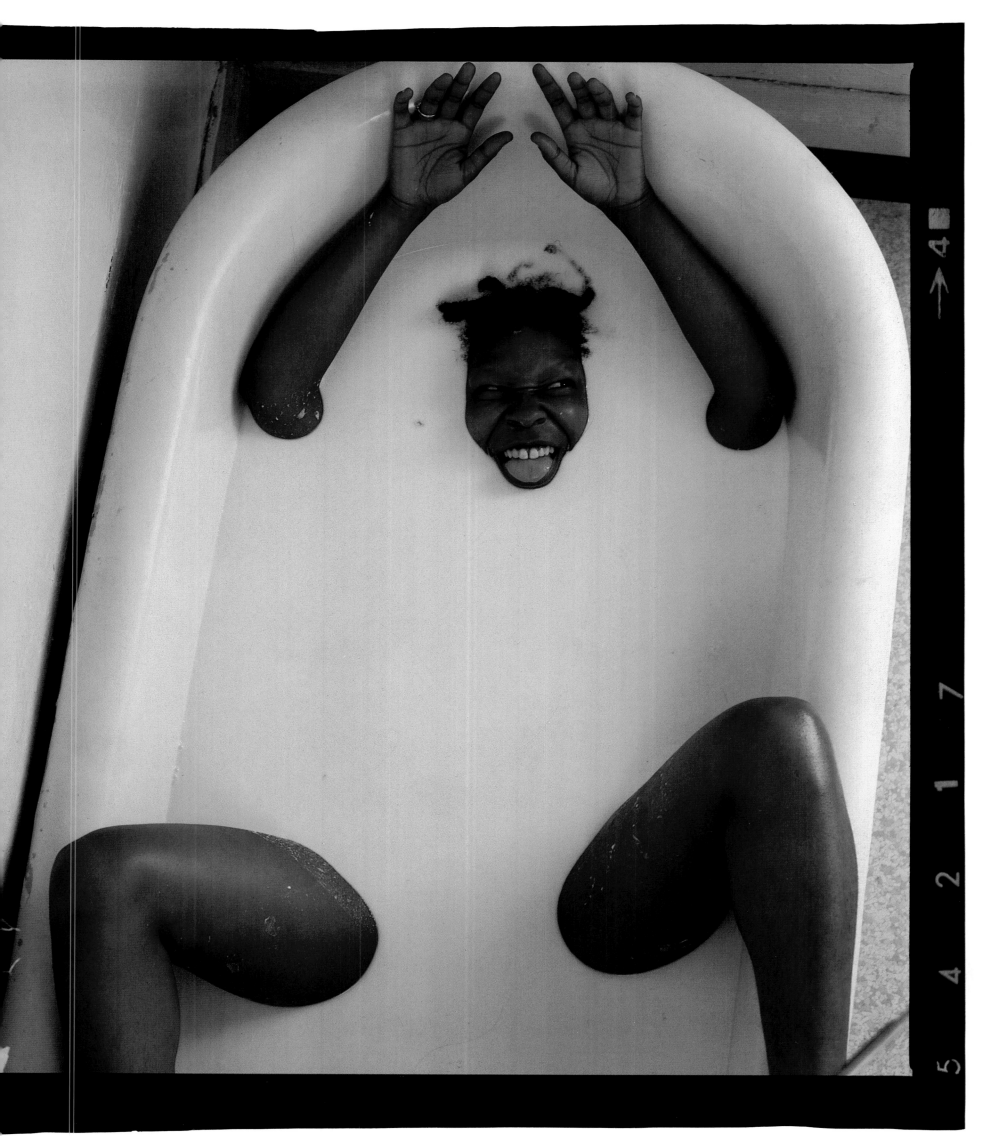

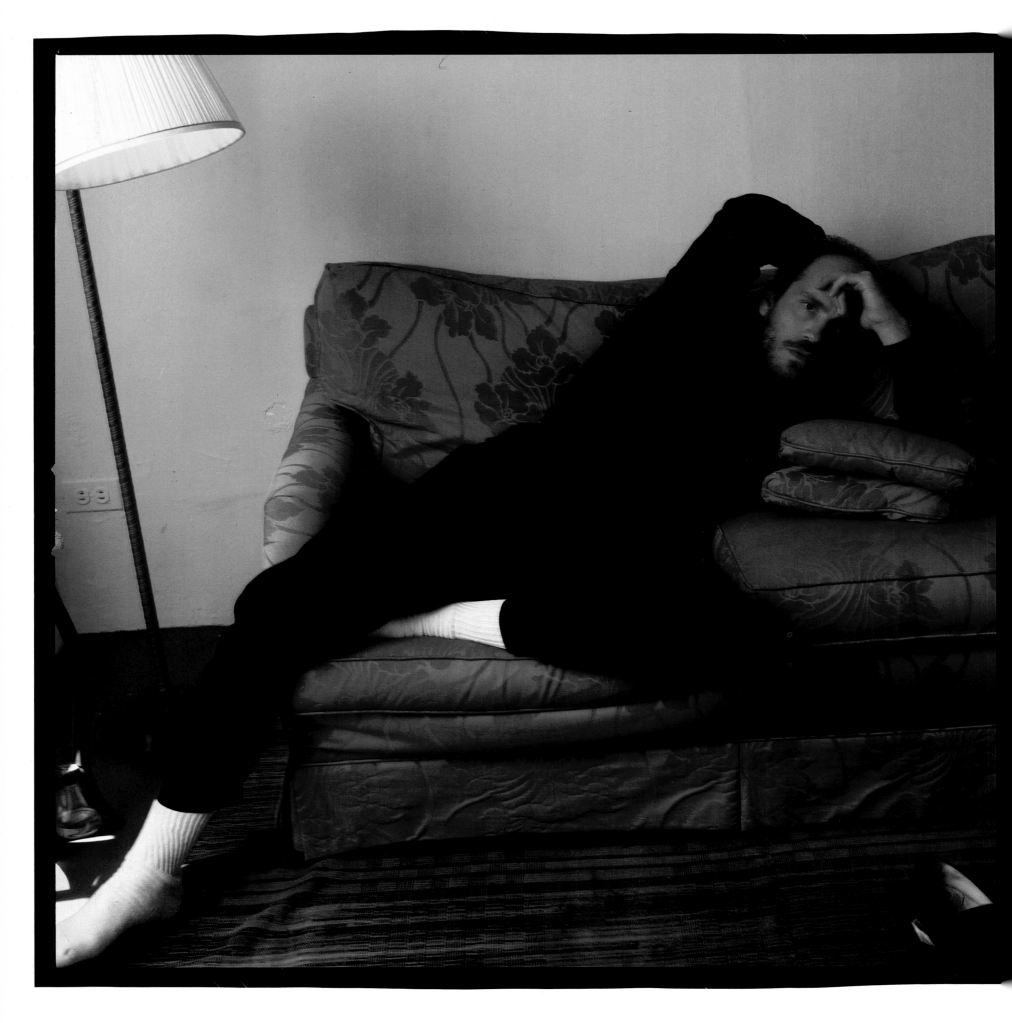

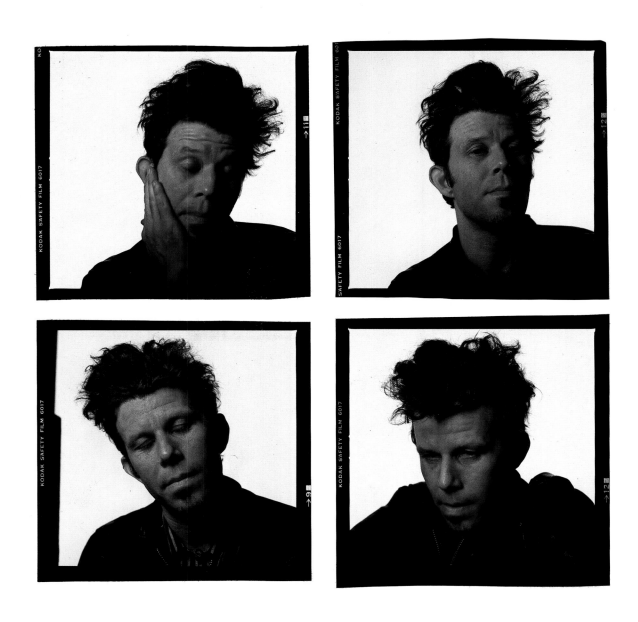

John Malkovich, *New York City, 1984*

Tom Waits, *New York City, 1985*

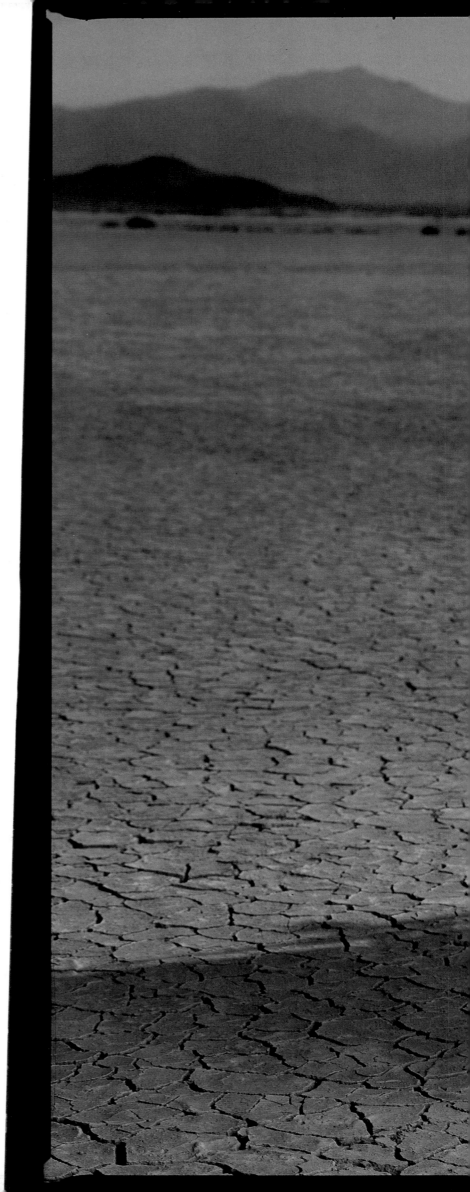

Sting, *Lucerne Valley, California, 1985*

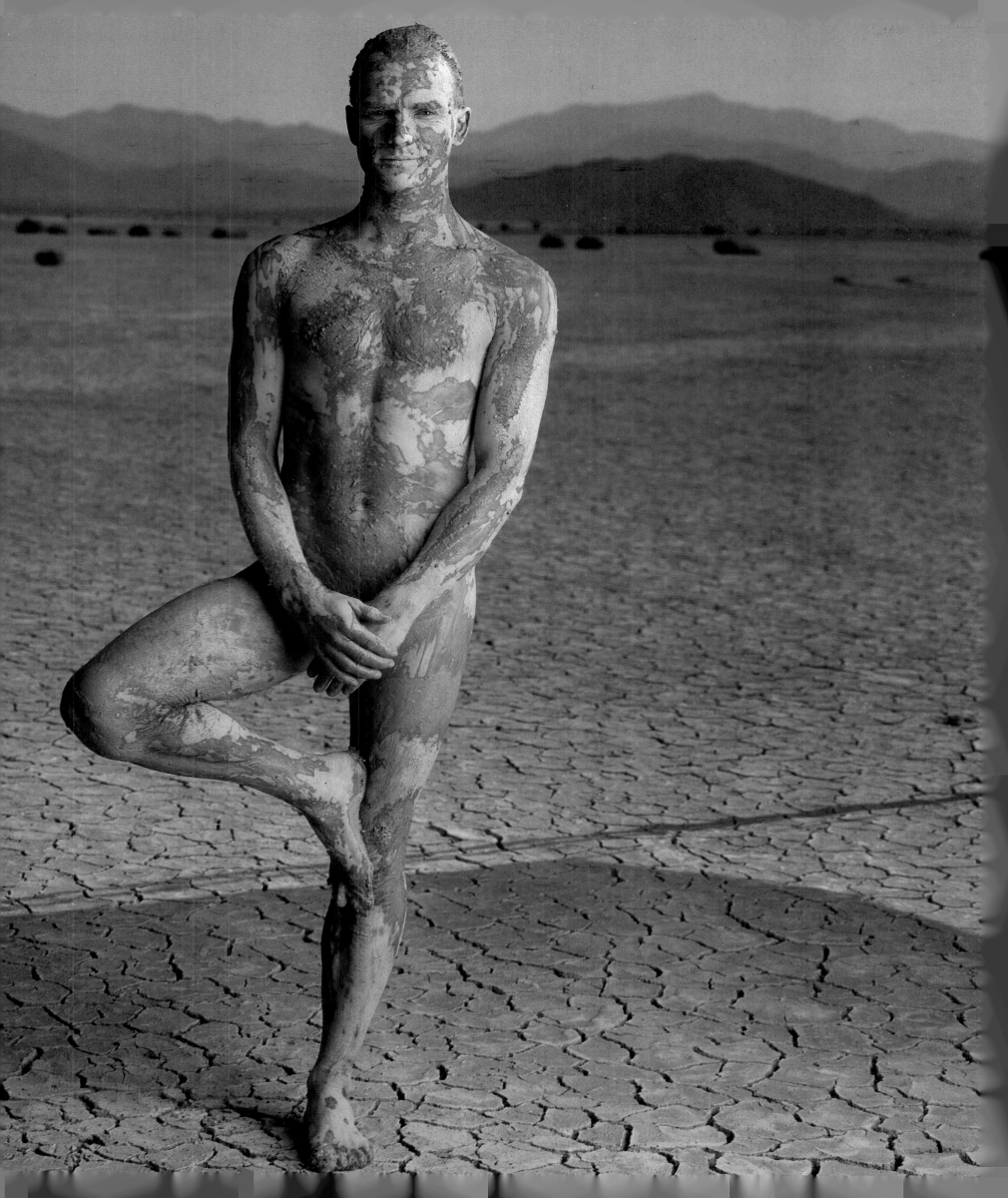

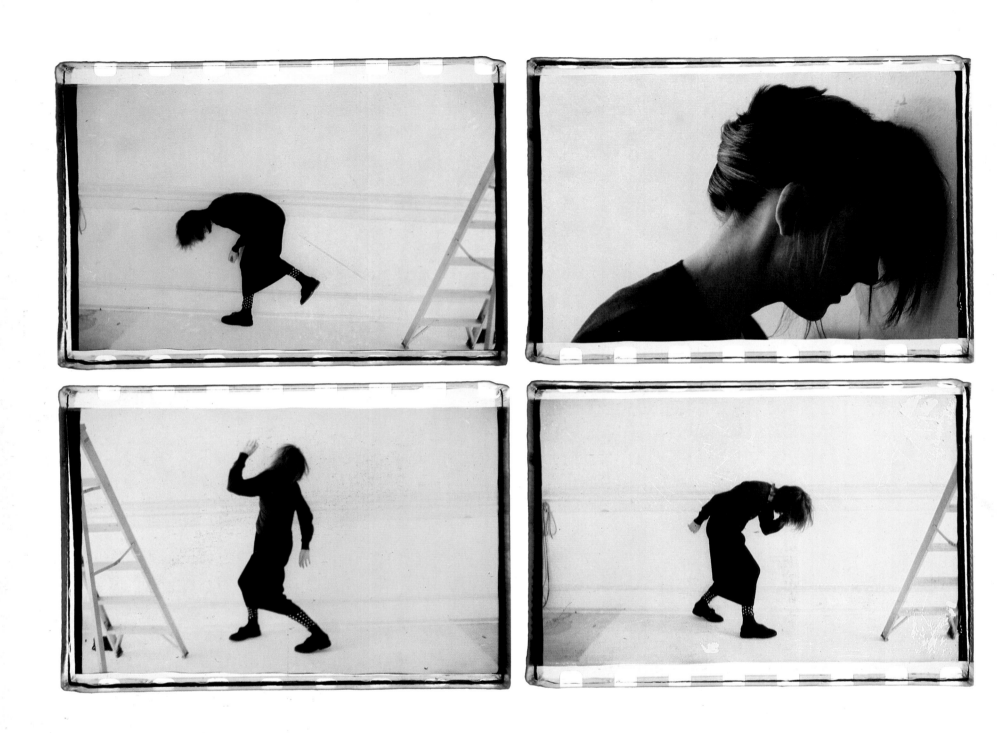

Diane Keaton, *Los Angeles, 1986*

Isabella Rossellini and David Lynch, *New York City, 1986*

152

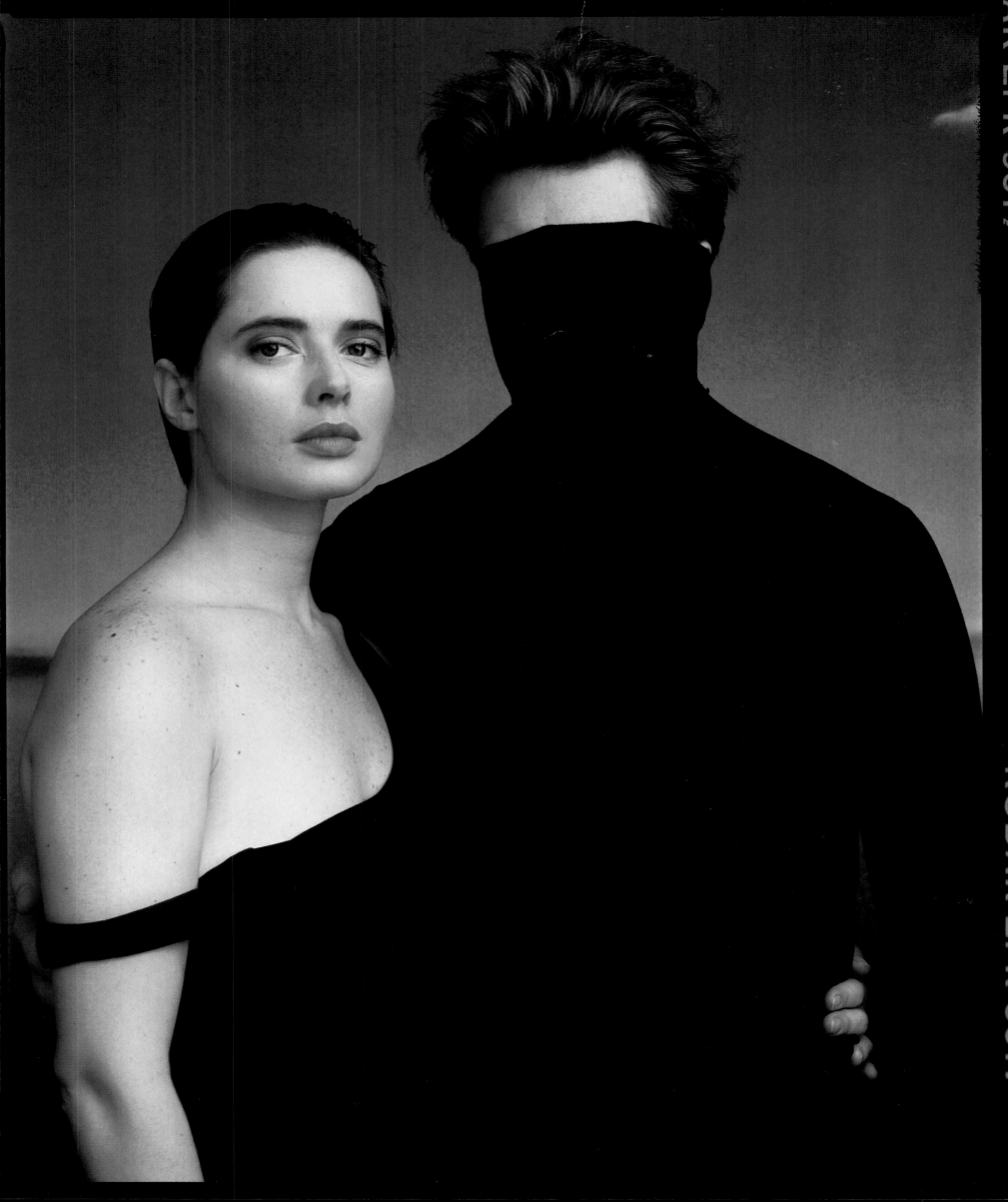

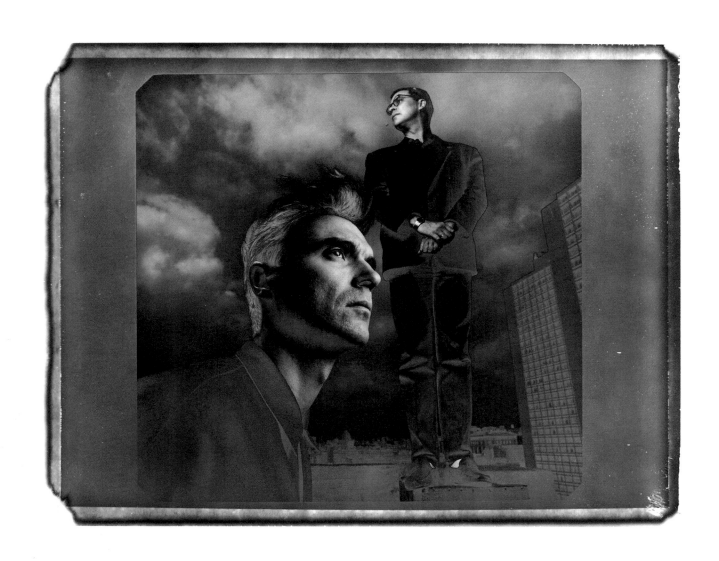

David Byrne and Robert Wilson, *New York City, 1988*

David Byrne, *Los Angeles, 1986*

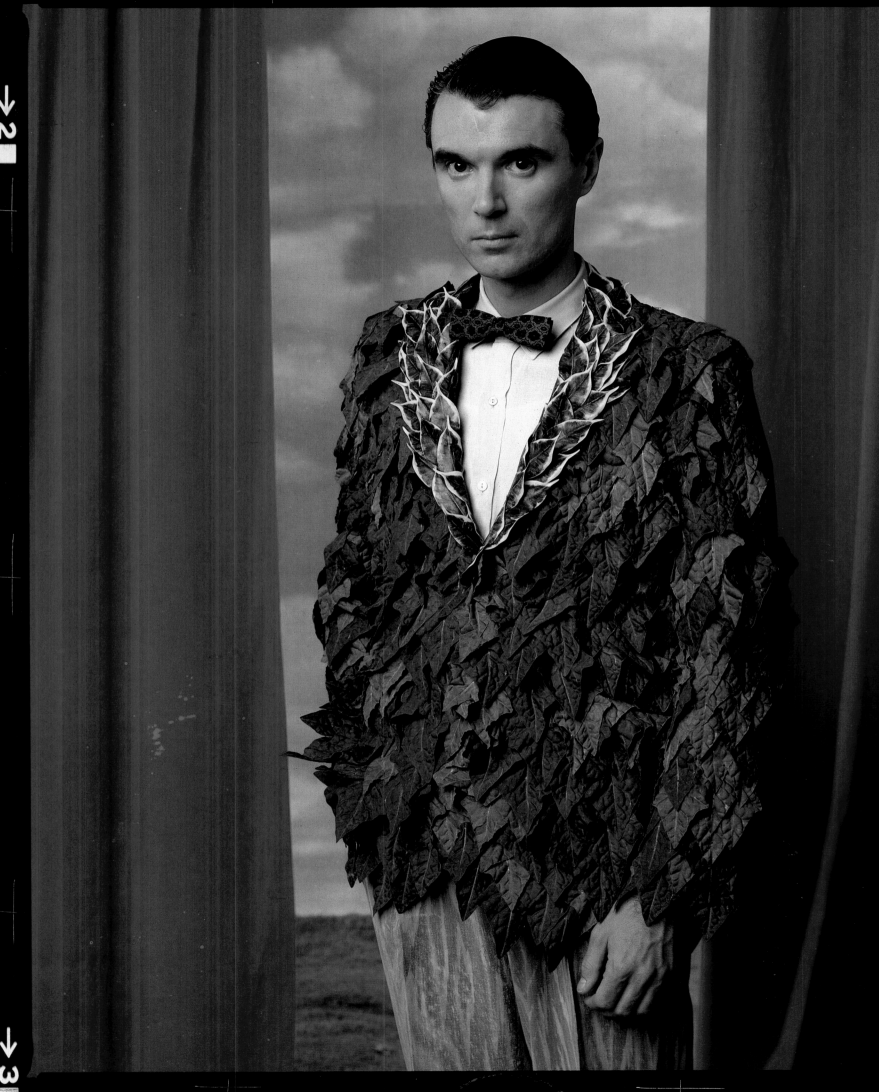

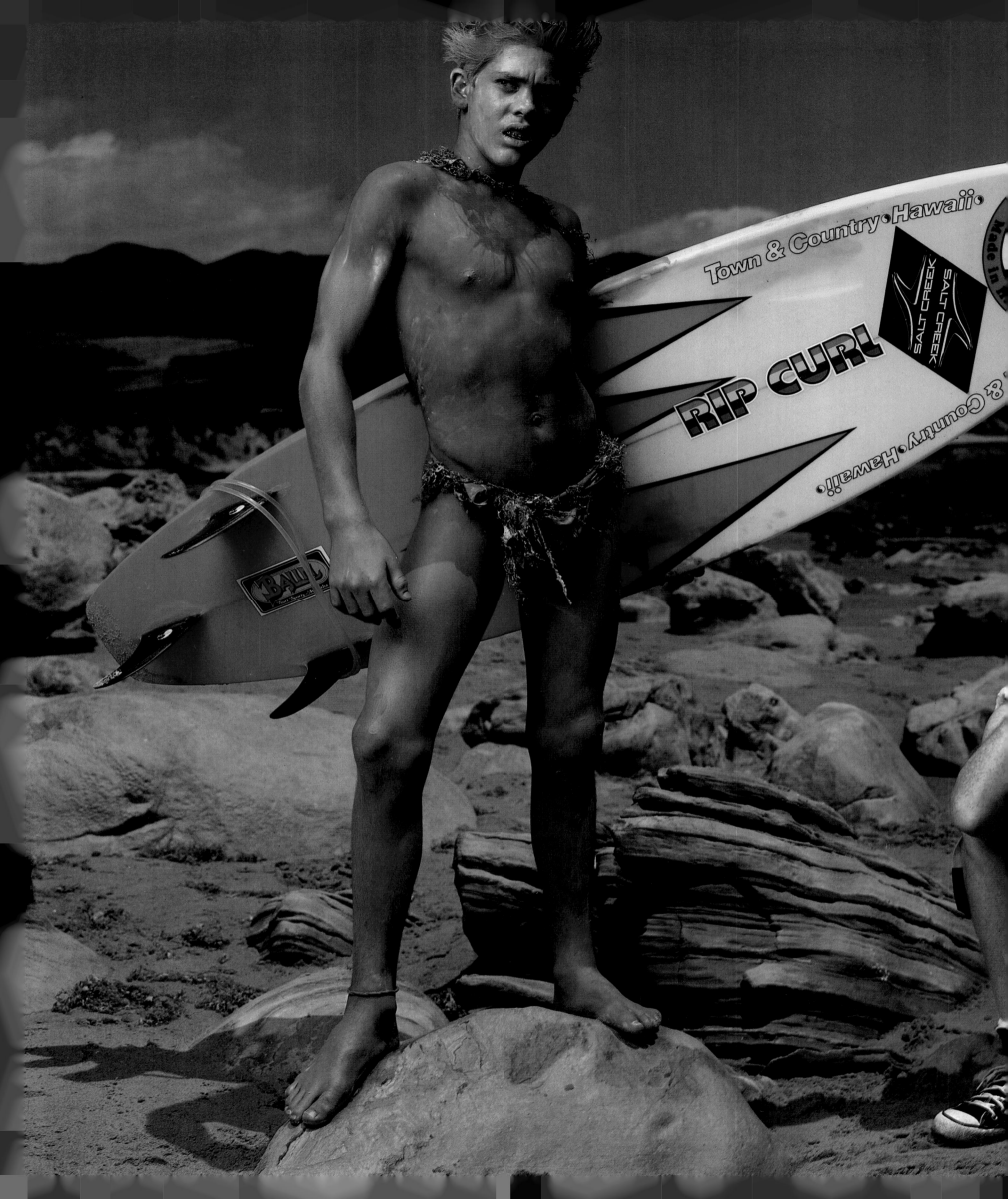

Malcolm McLaren and blue boy, *Point Dume, California, 1985*

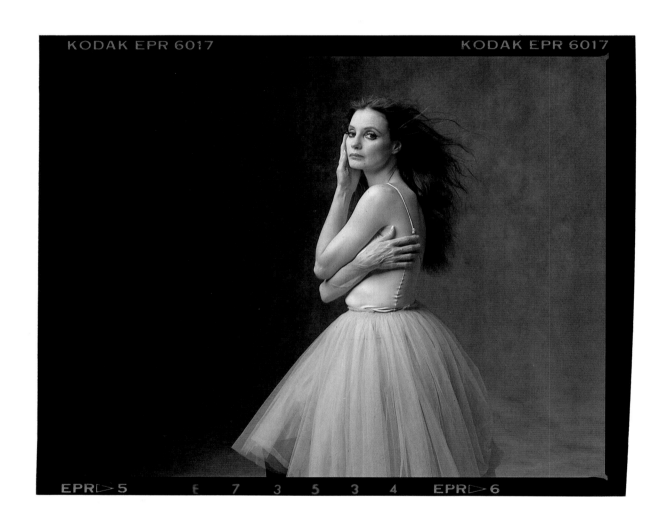

Suzanne Farrell, *New York City, 1986*

Klaus Maria Brandauer, *Altaussee, Austria, 1986*

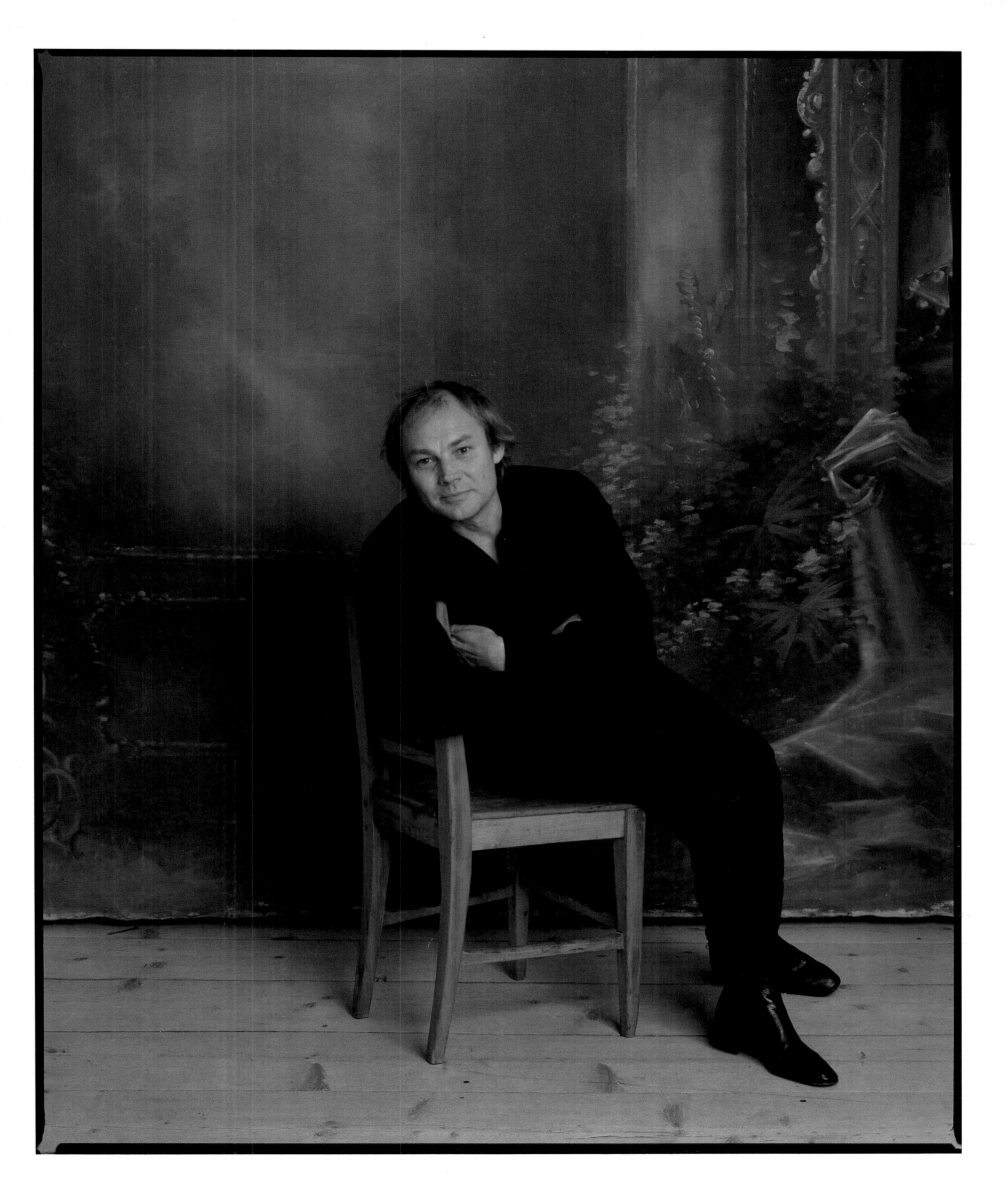

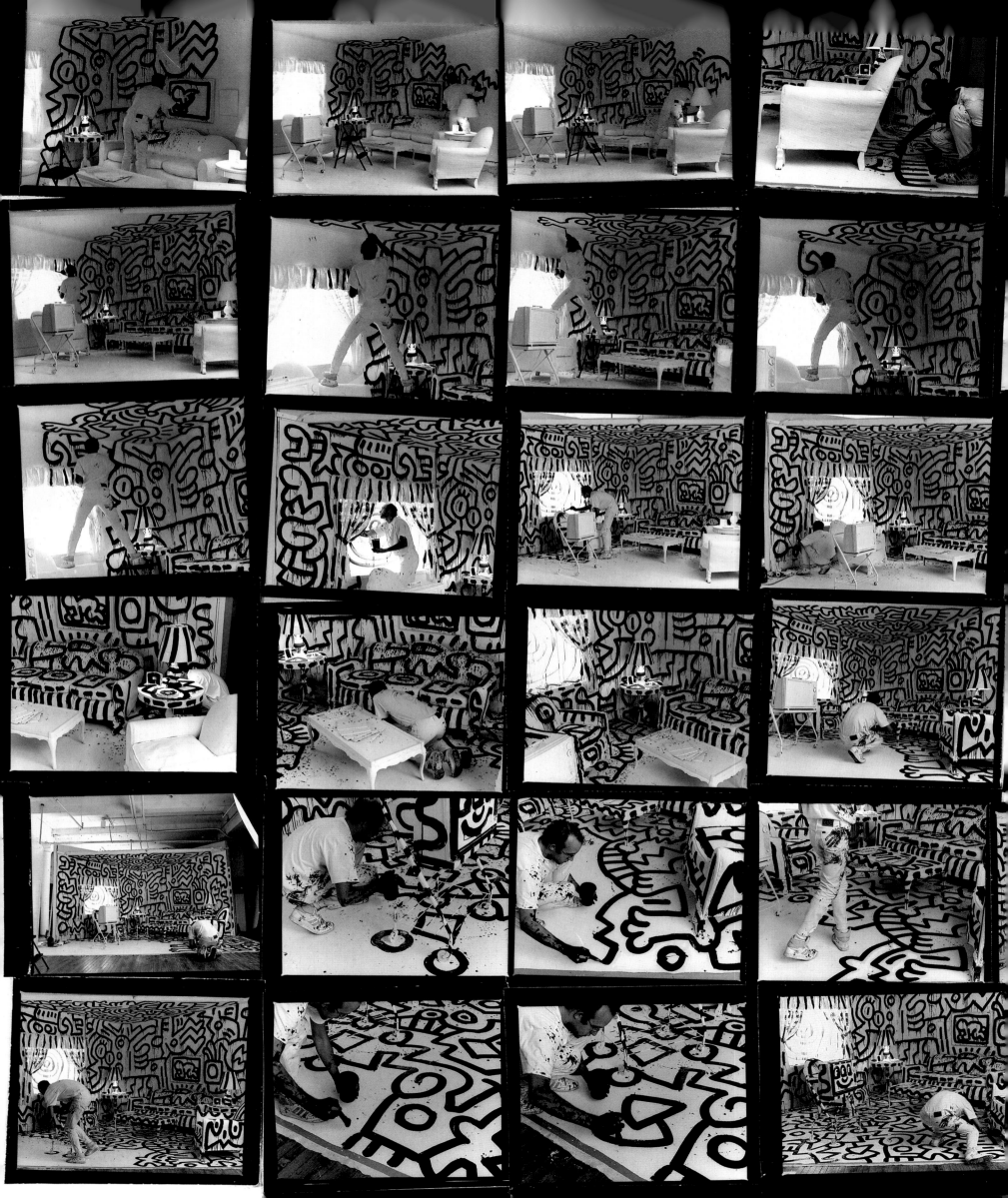

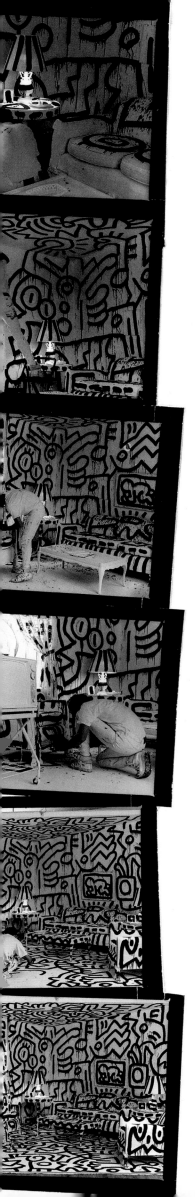

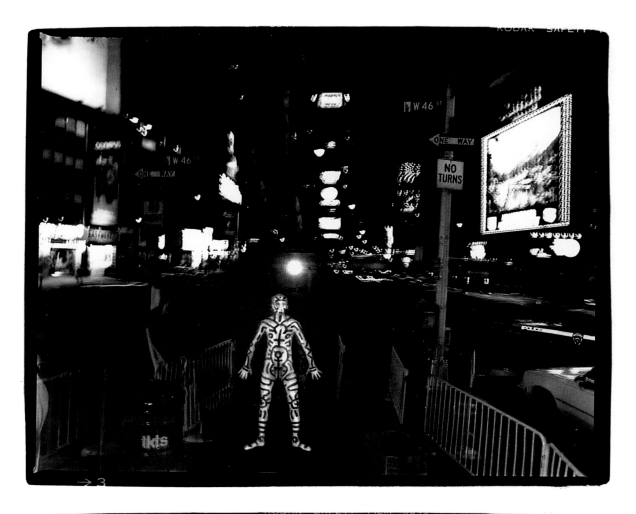

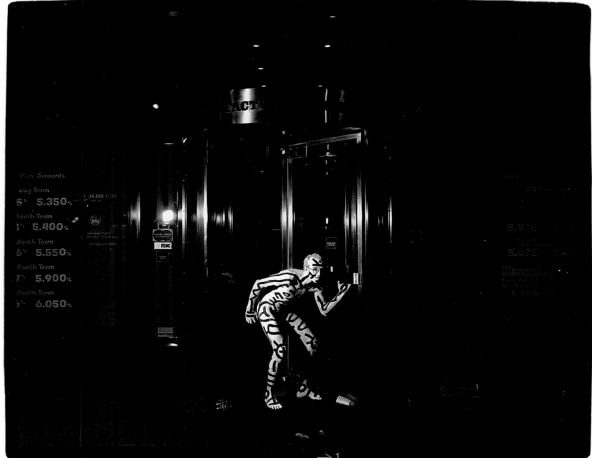

Keith Haring, *New York City, 1986*

161

Keith Haring, *New York City, 1986*

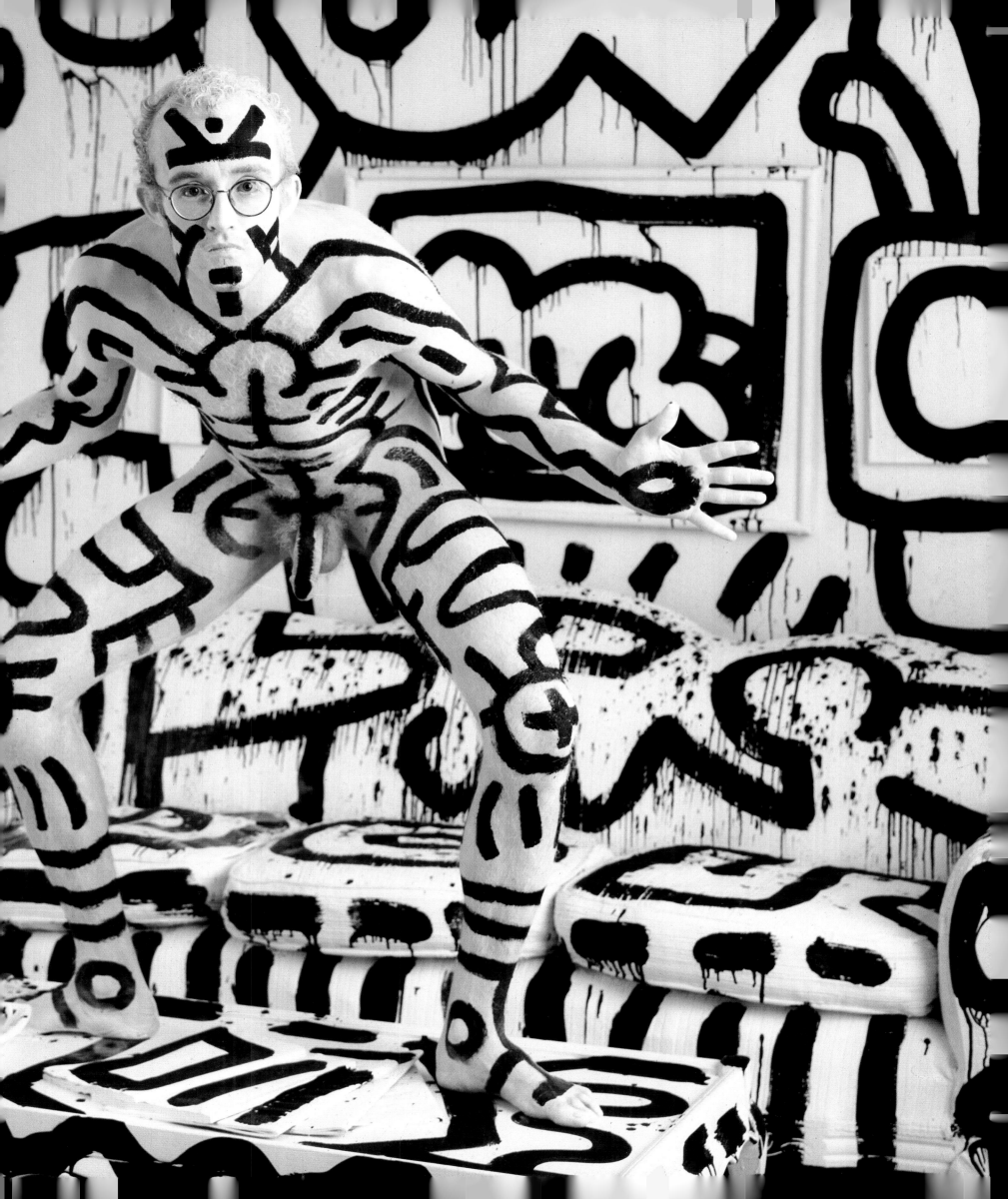

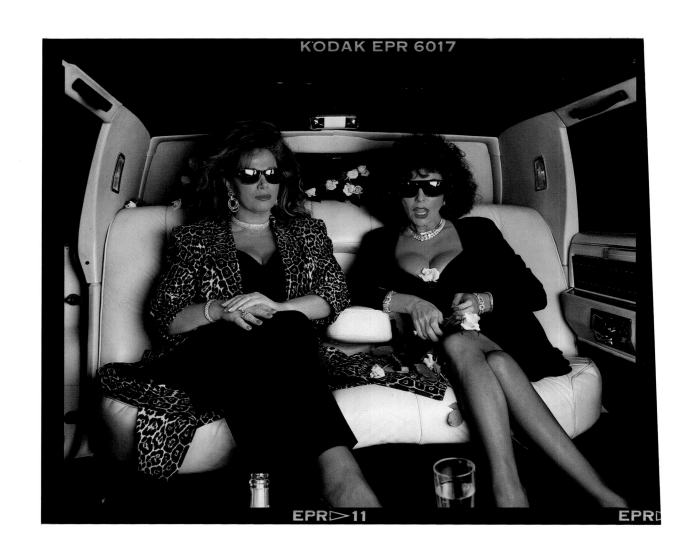

Jackie and Joan Collins, *Los Angeles, 1987*

Dennis Hopper, *Lucerne Dry Lake, California, 1986*

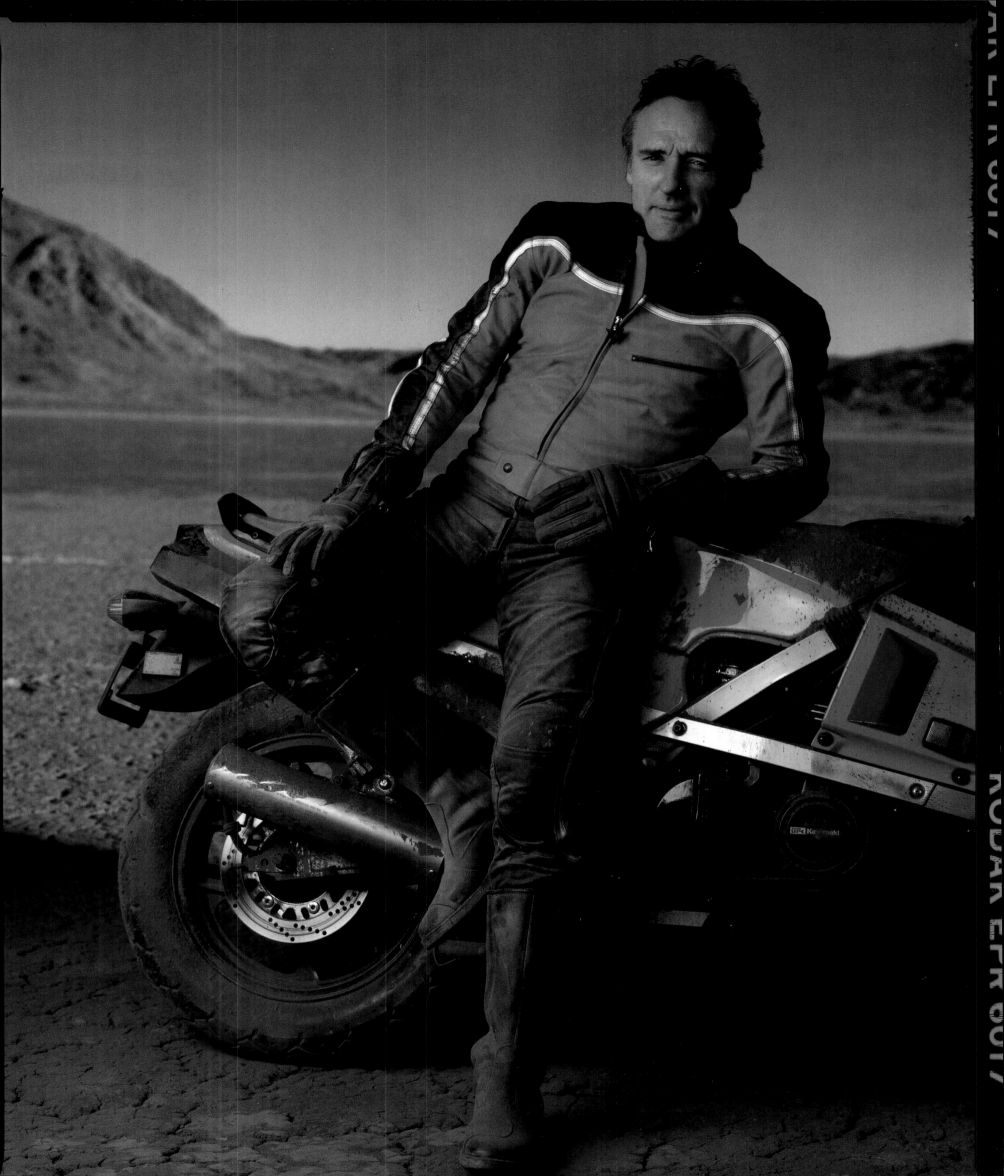

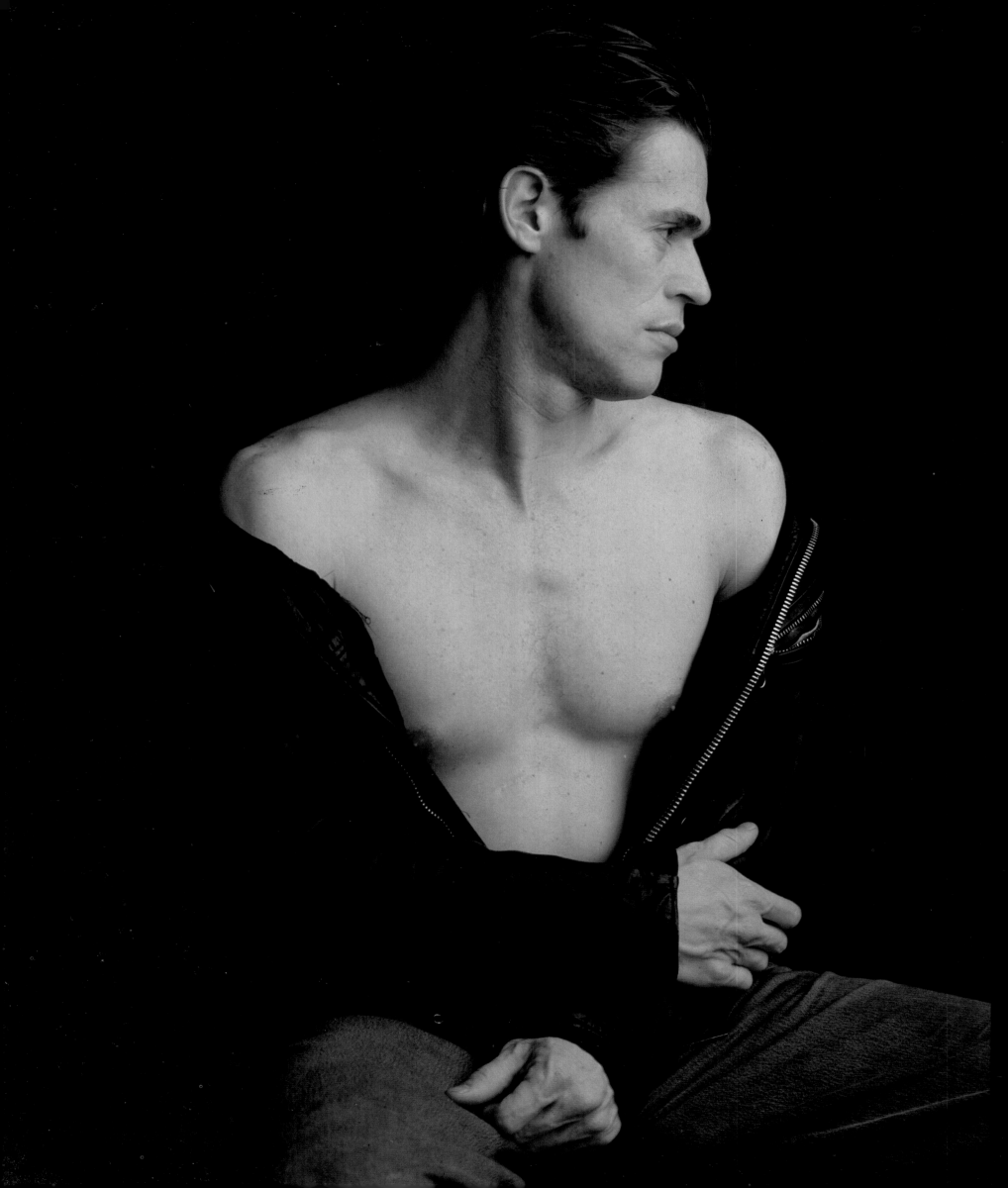

Willem Dafoe, *New York City, 1987*

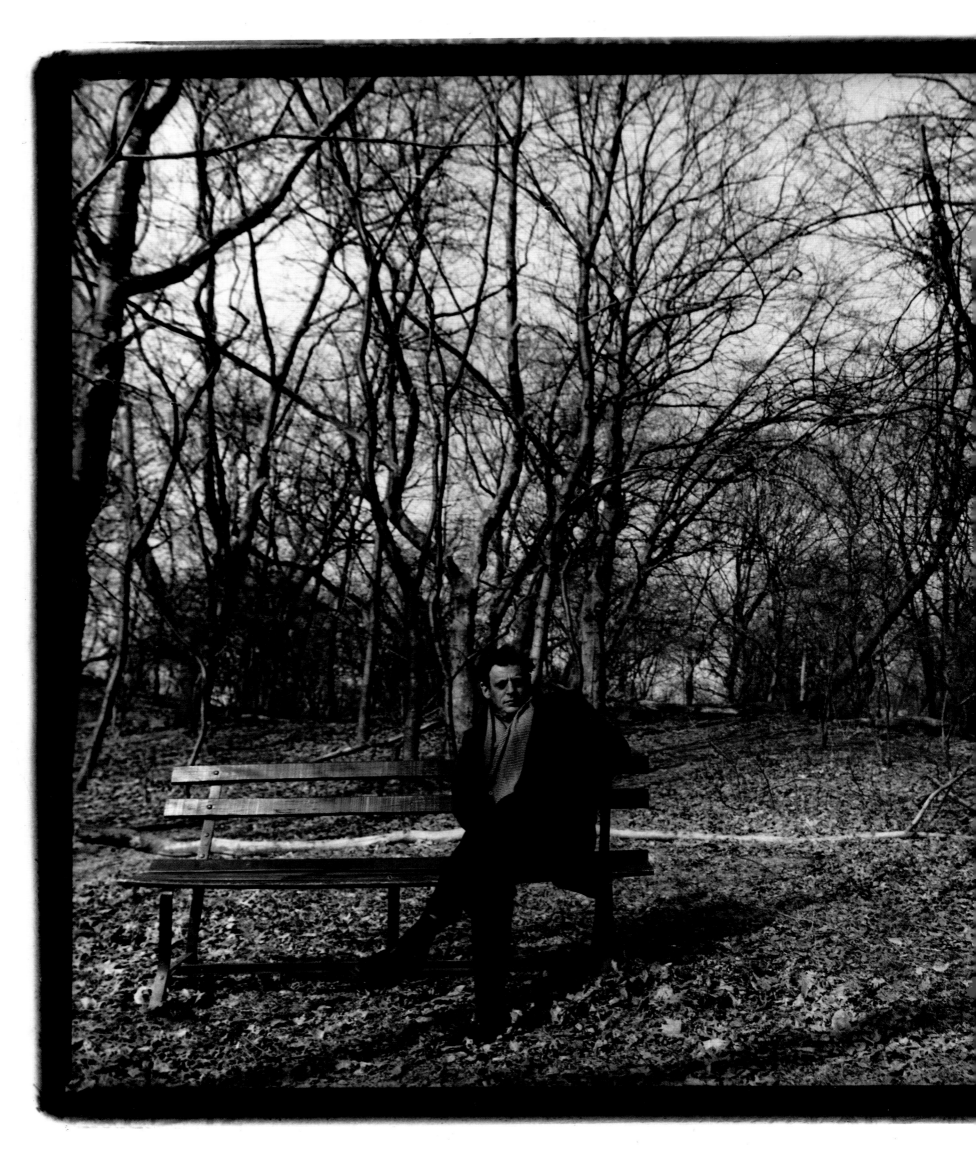

Philip Glass, *New York City, 1987*

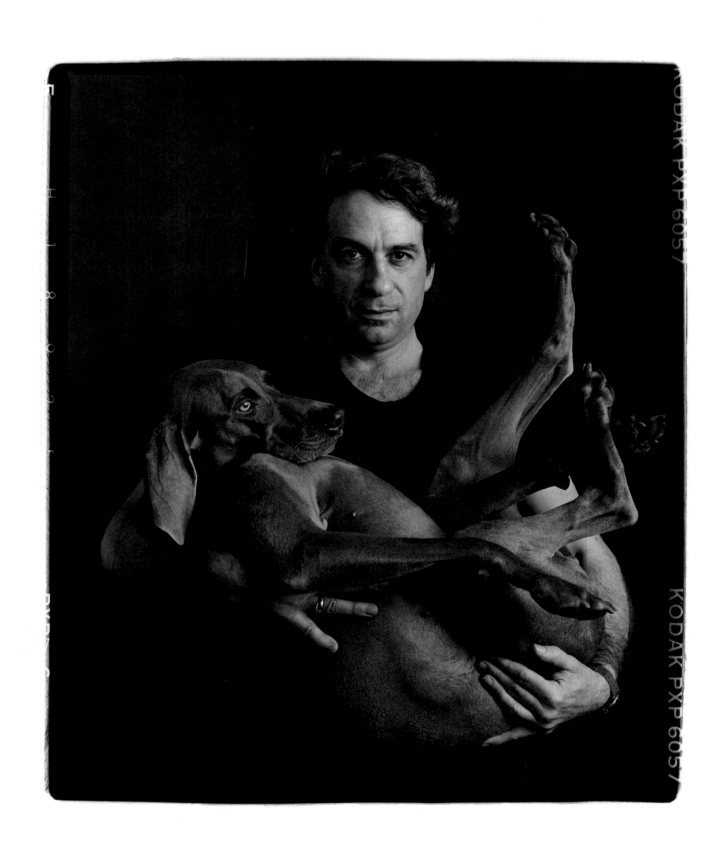

William Wegman and Fay Ray, *New York City, 1988*

Philippe Petit, *New York City, 1989*

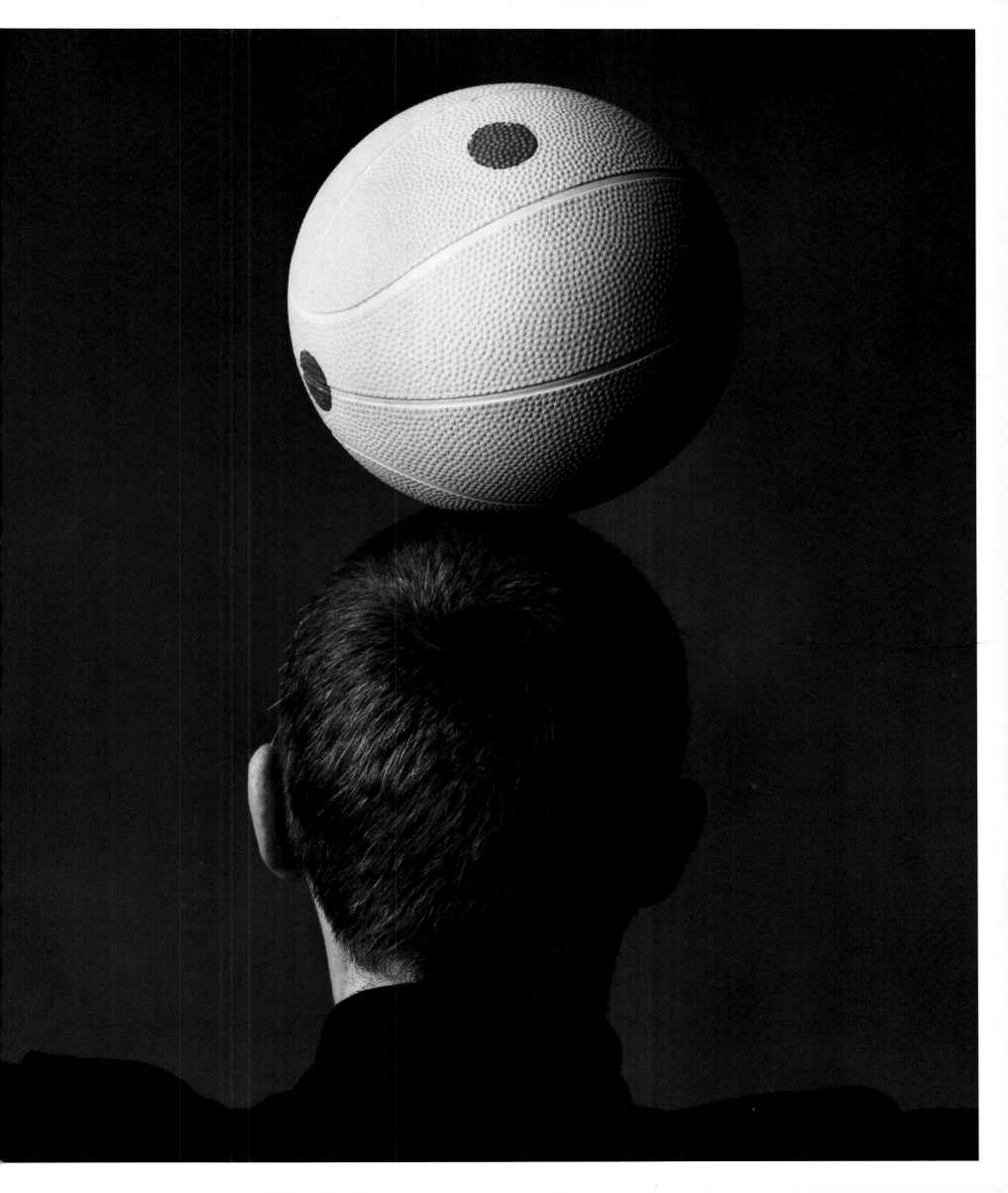

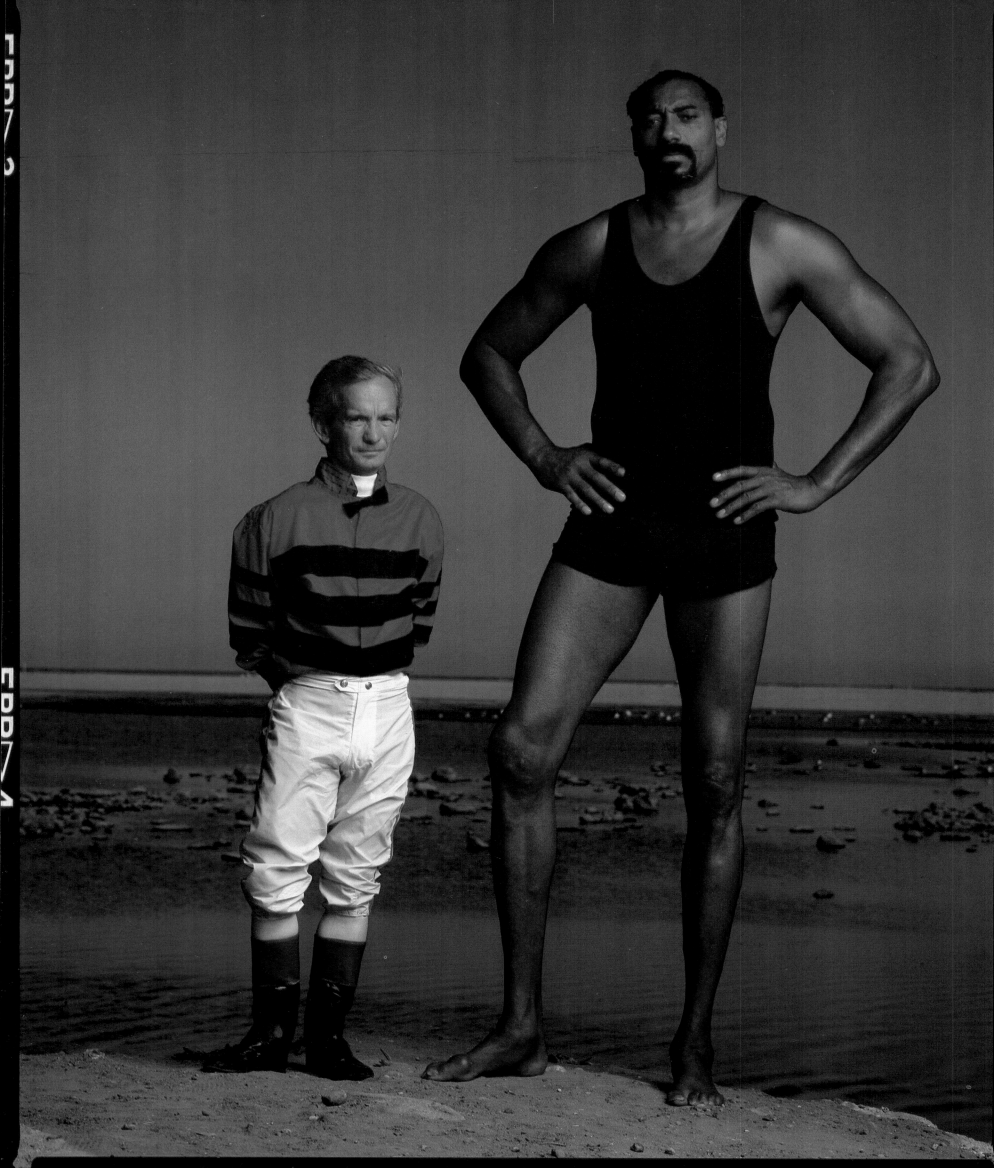

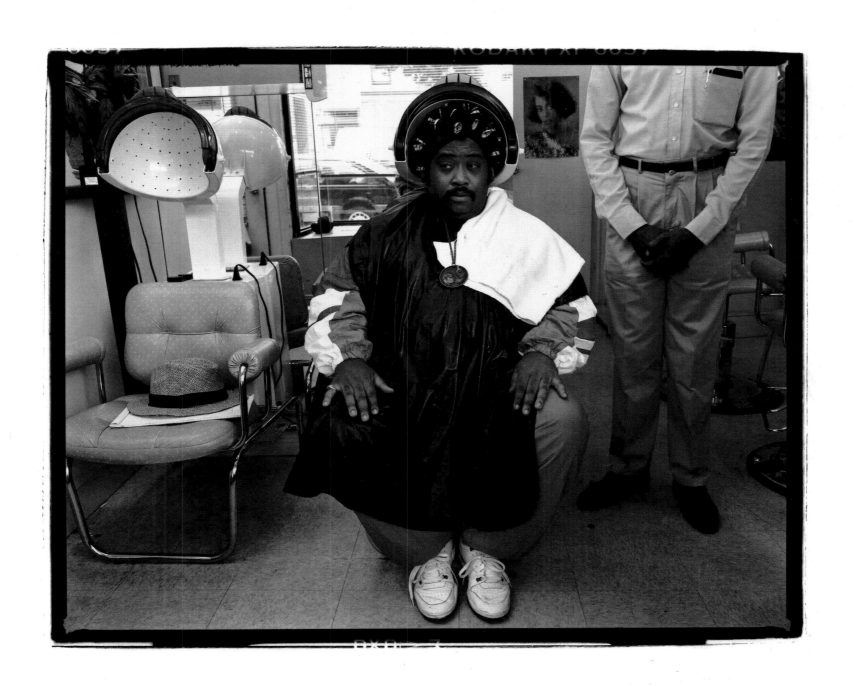

Willie Shoemaker and Wilt Chamberlain, *Malibu, California, 1987*

The Reverend Al Sharpton, Primadonna beauty salon, *Brooklyn, New York, 1988*

Marla Maples, *New York City, 1990*

174

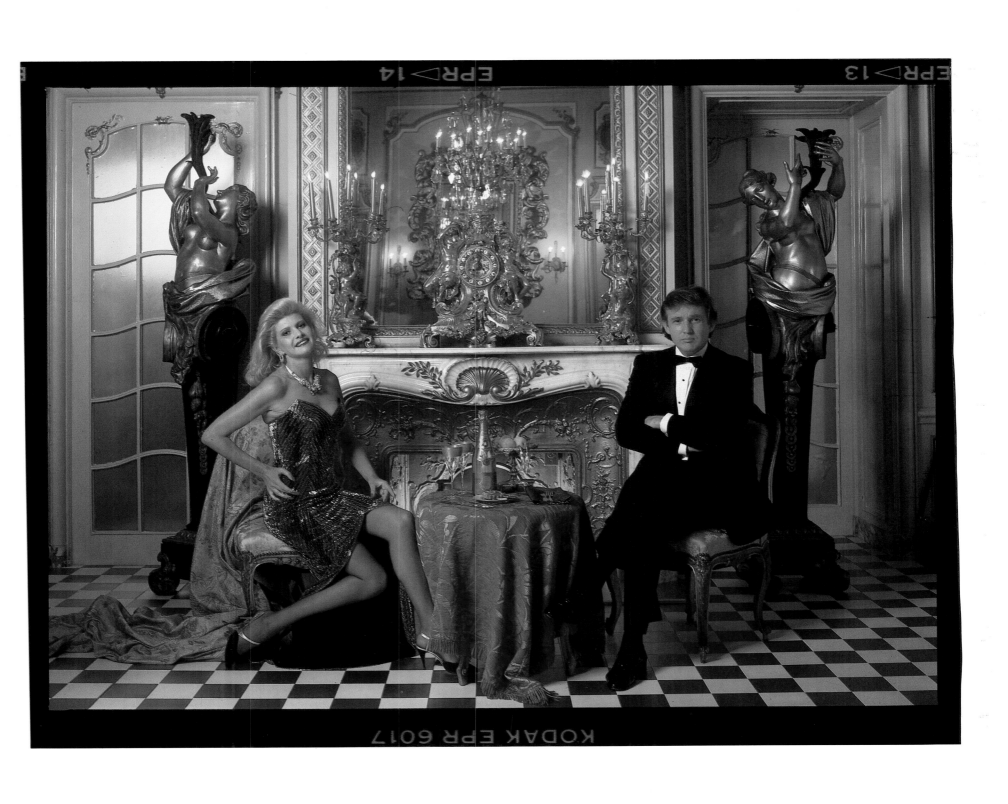

Ivana and Donald Trump, *Plaza Hotel, New York City, 1988*

Arnold Schwarzenegger, *Malibu, California, 1988*

Following pages:

Sammy Davis, Jr., *Las Vegas, 1989*

Ella Fitzgerald, *Beverly Hills, 1988*

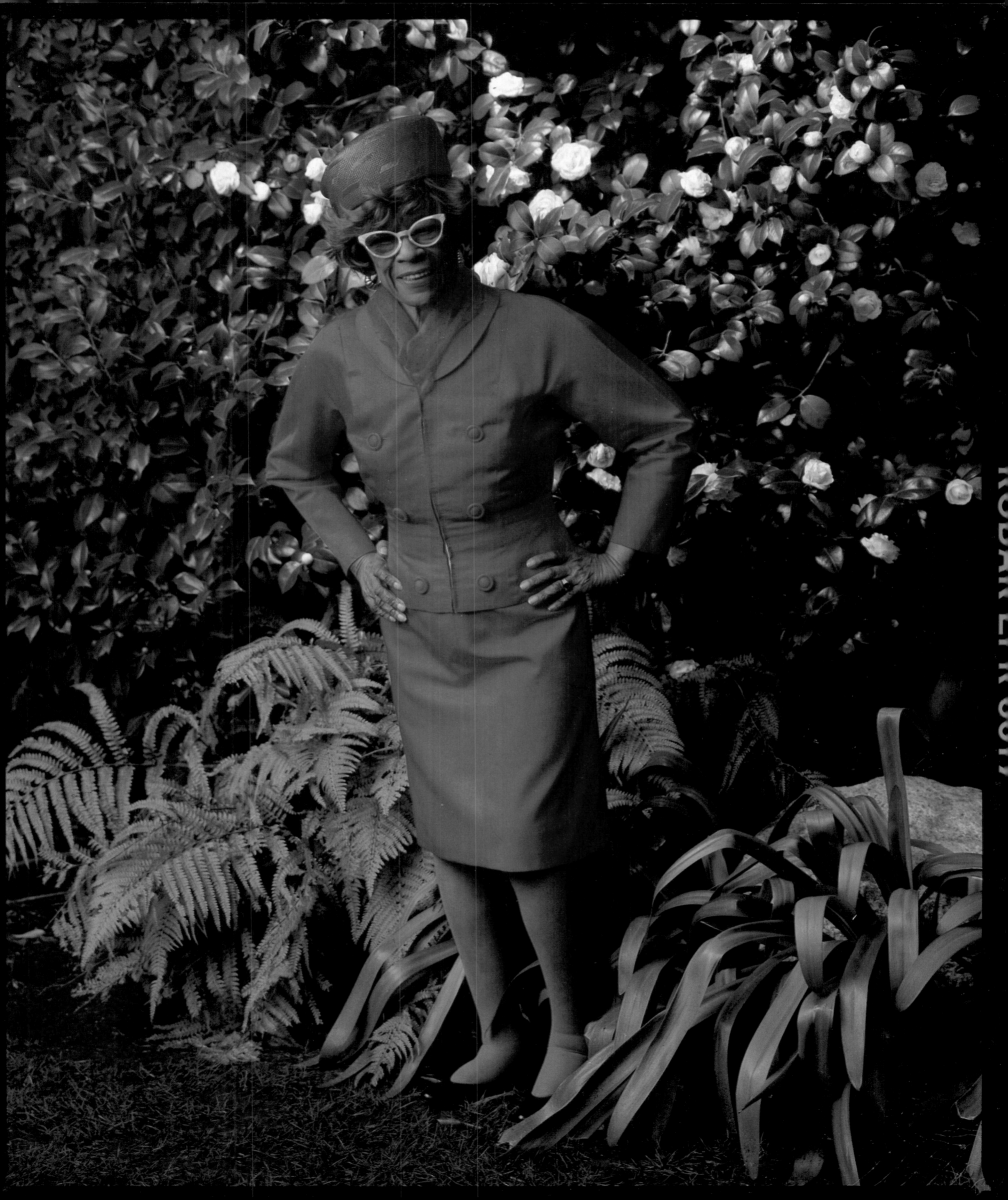

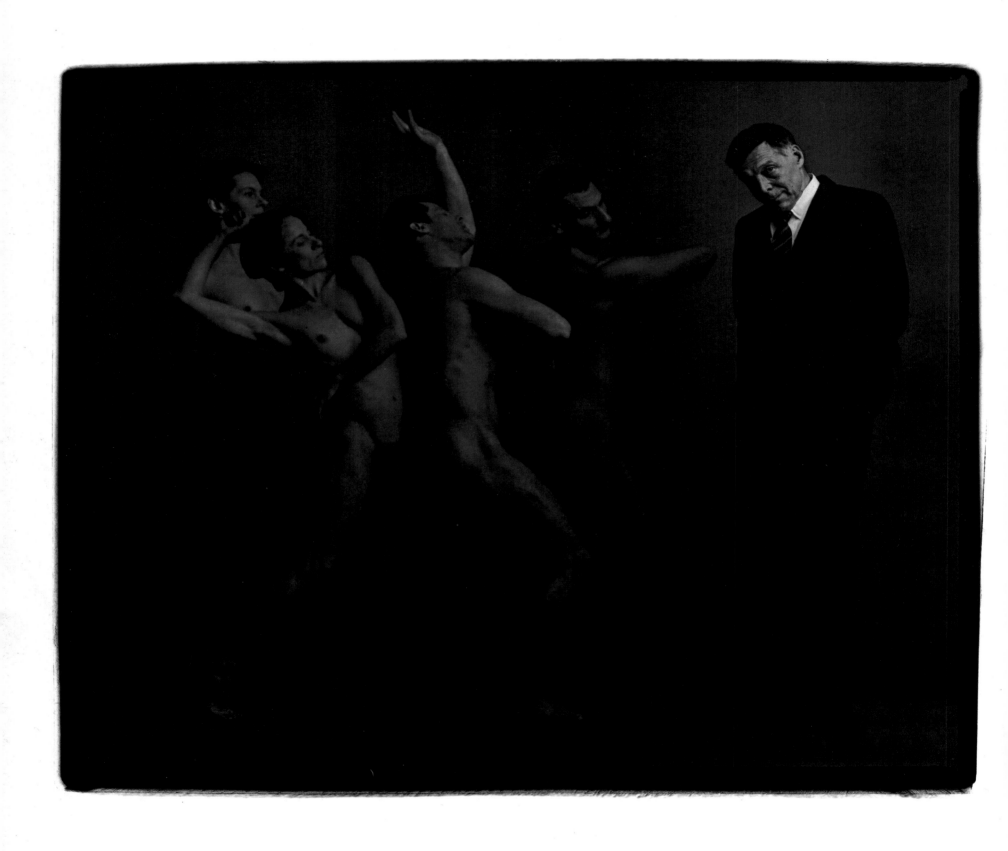

Paul Taylor with Kathy McCann, Kate Johnson, Christopher Gillis, and Elie Chaib, *New York City, 1990*

Kirby Puckett, *Orlando, Florida, 1988*

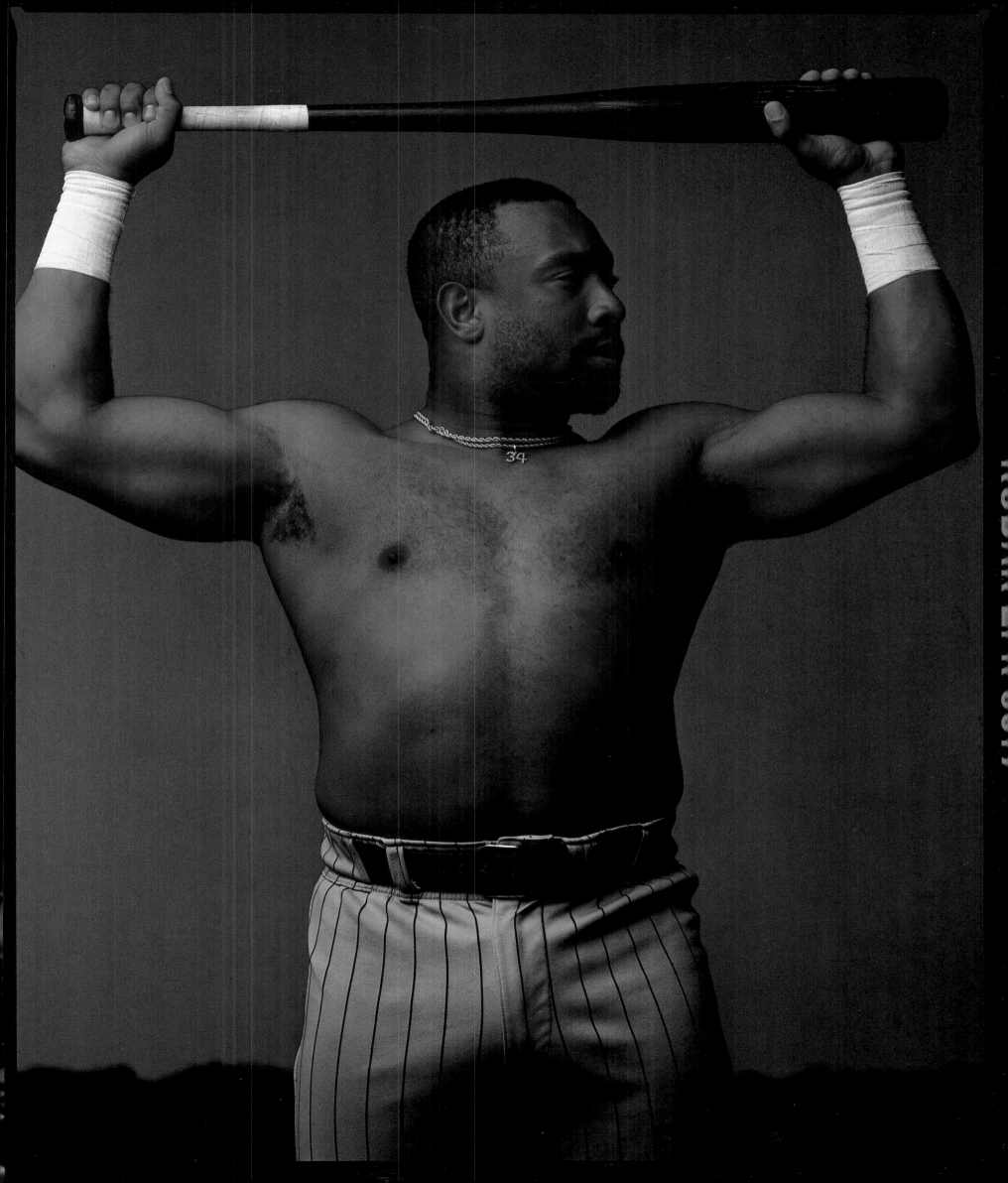

Christopher Walken, *New York City, 1988*

Following pages:

Jessye Norman, *New York City, 1988*

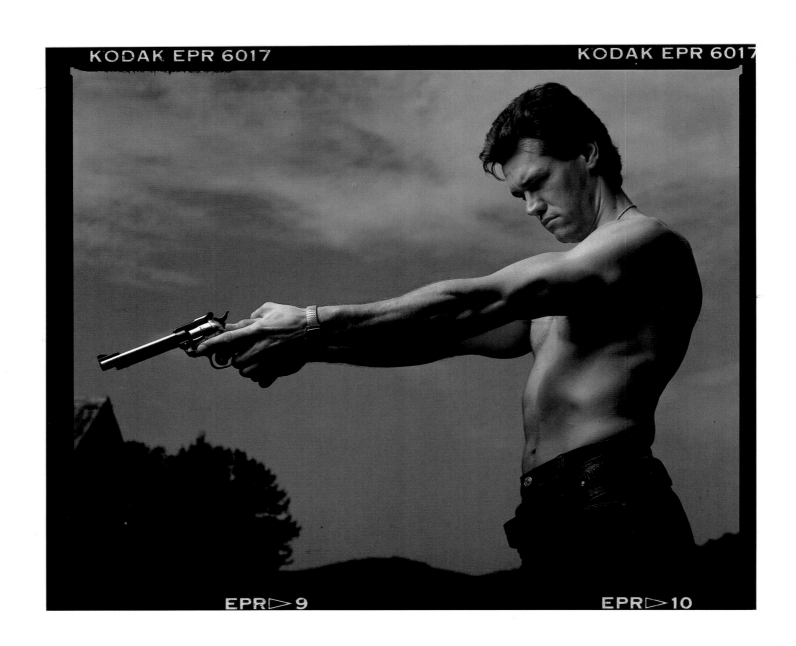

Randy Travis, *Nashville, Tennessee, 1987*

Jodie Foster, *Malibu, California, 1988*

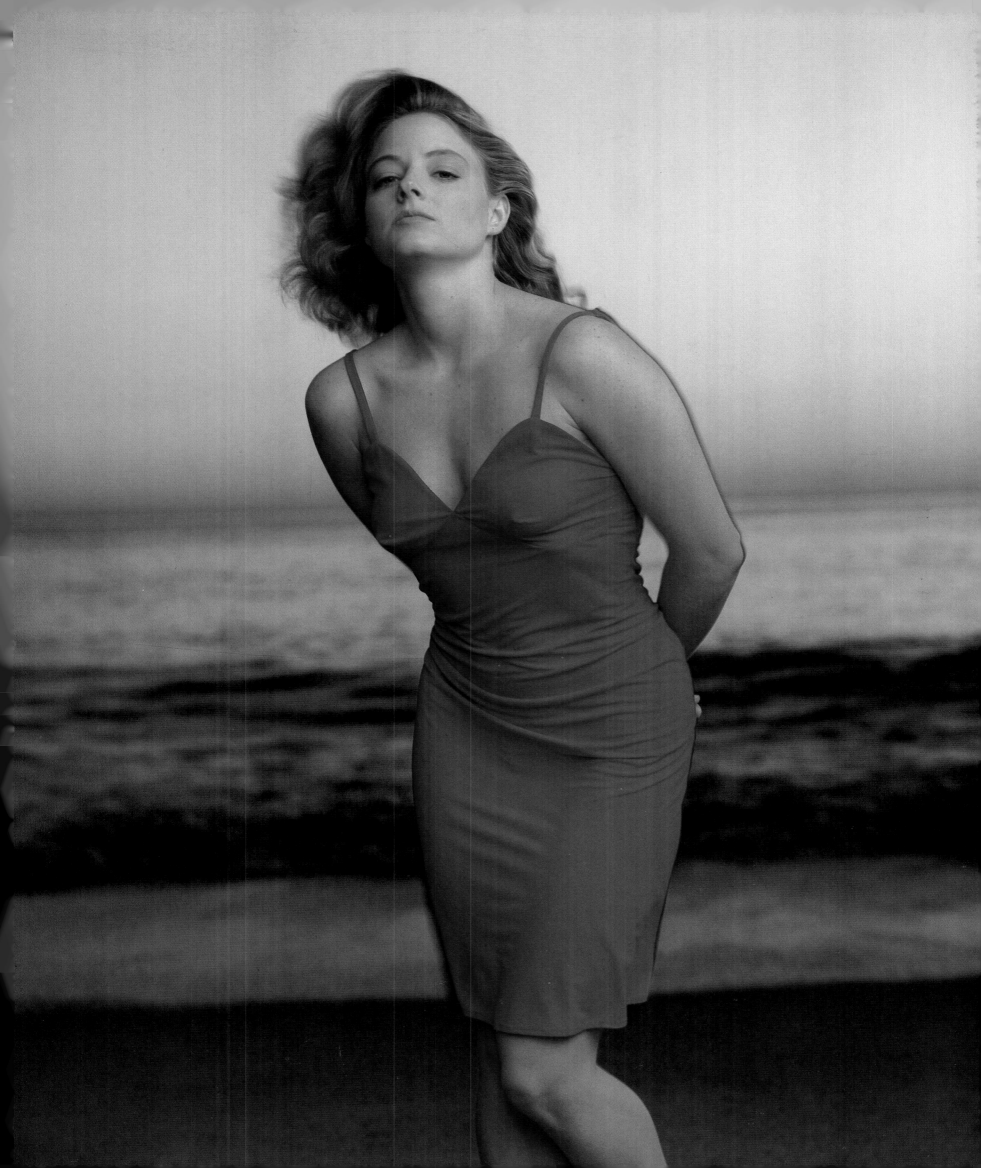

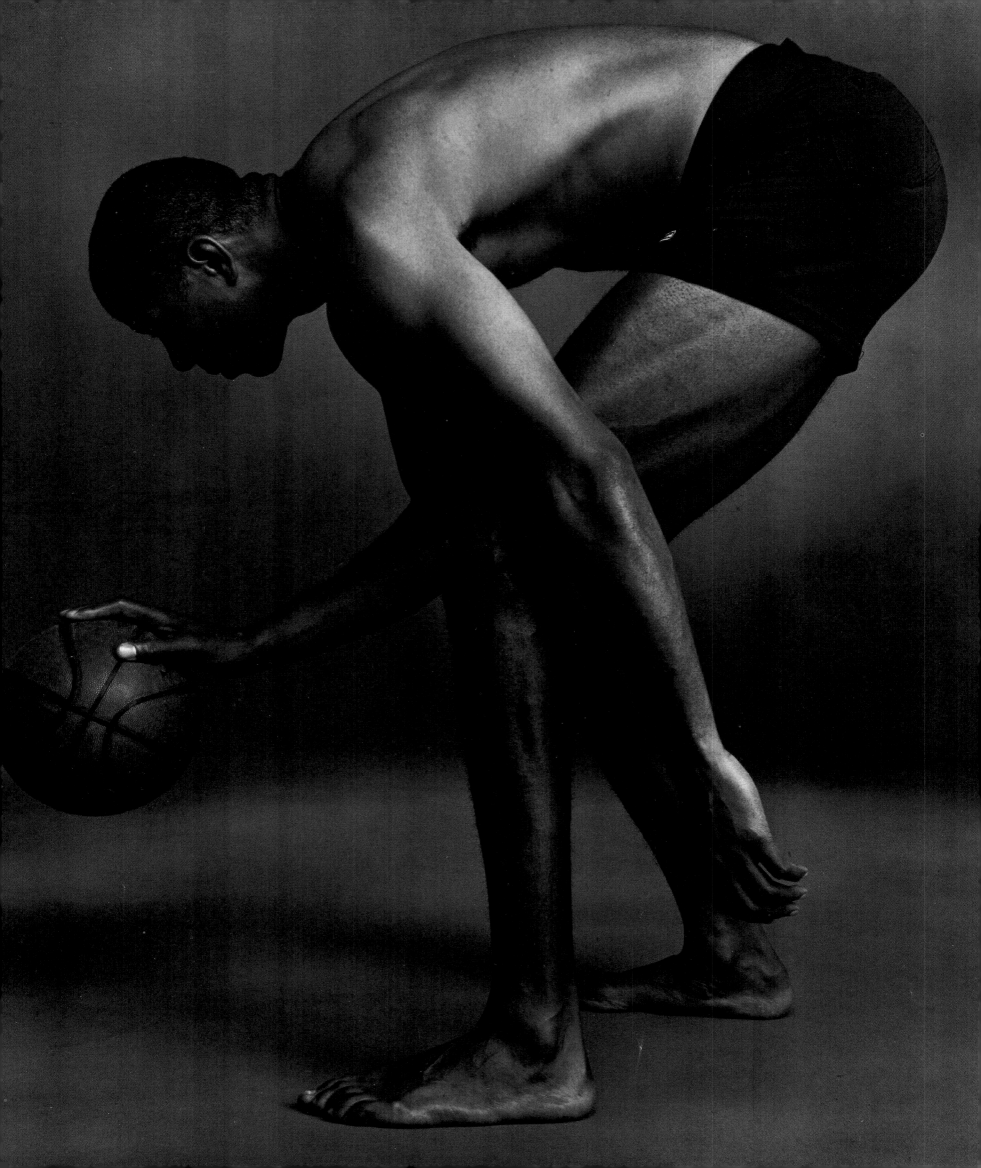

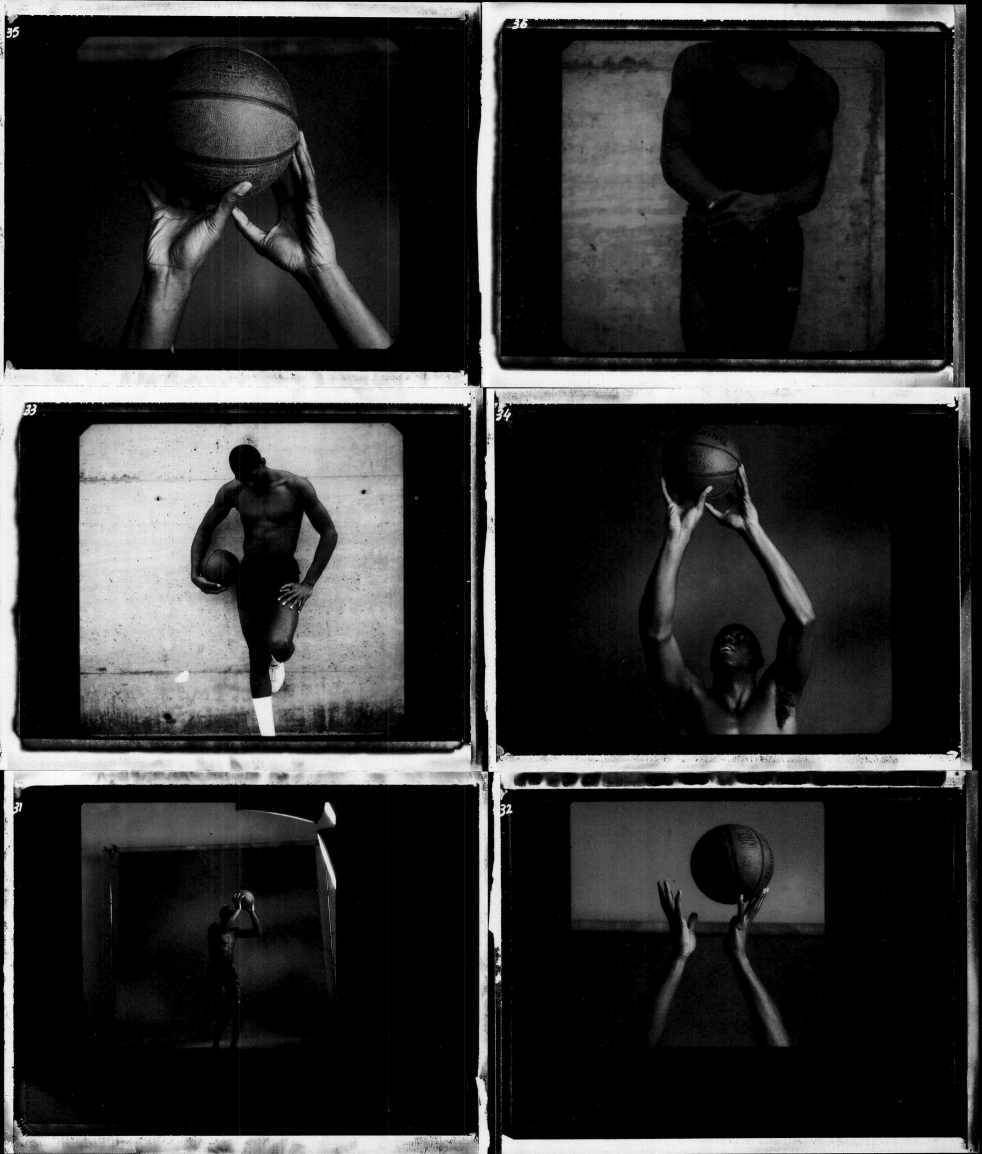

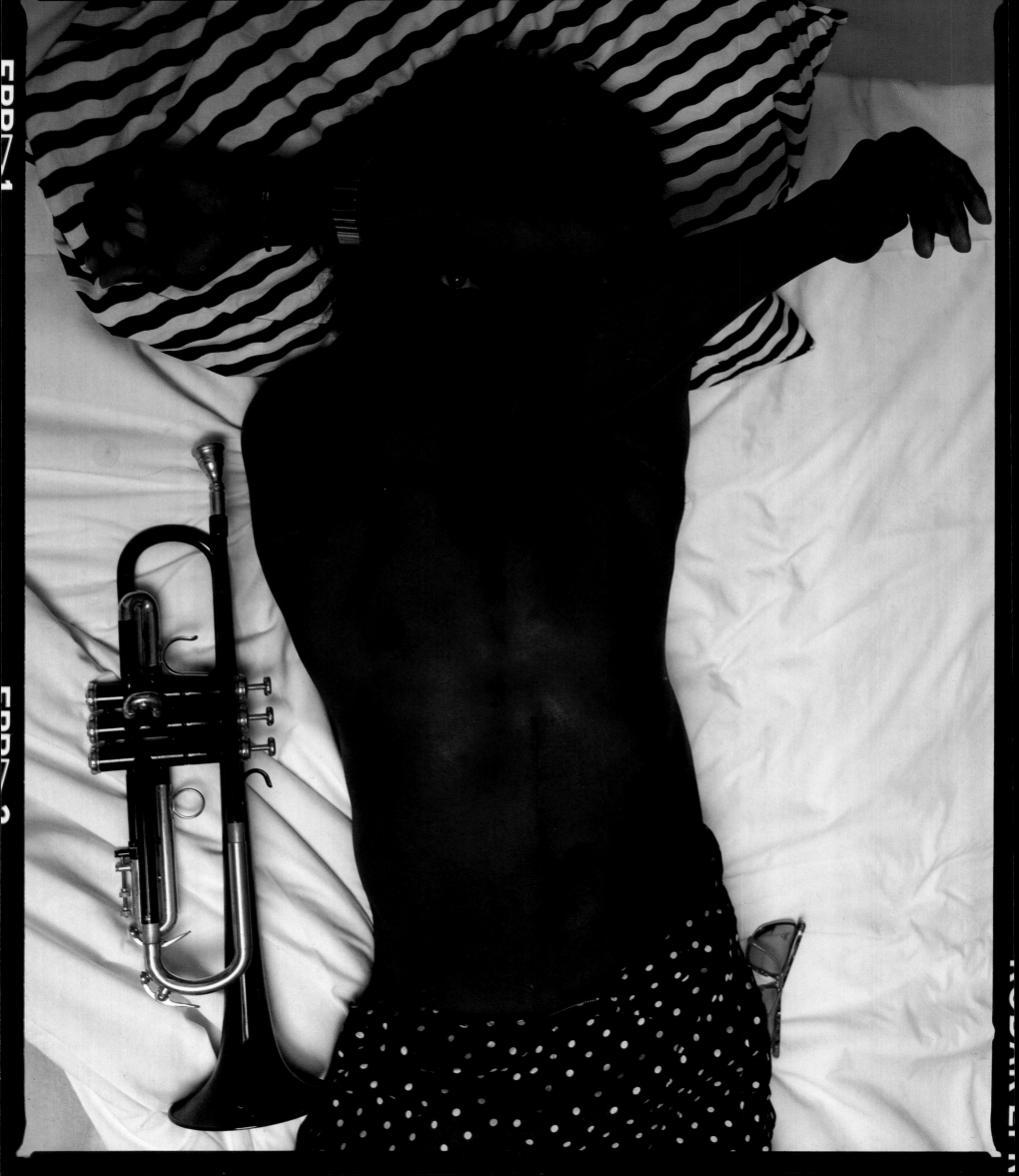

Miles Davis, *New York City, 1989*

Preceding pages:

Magic Johnson, *Los Angeles, 1989*

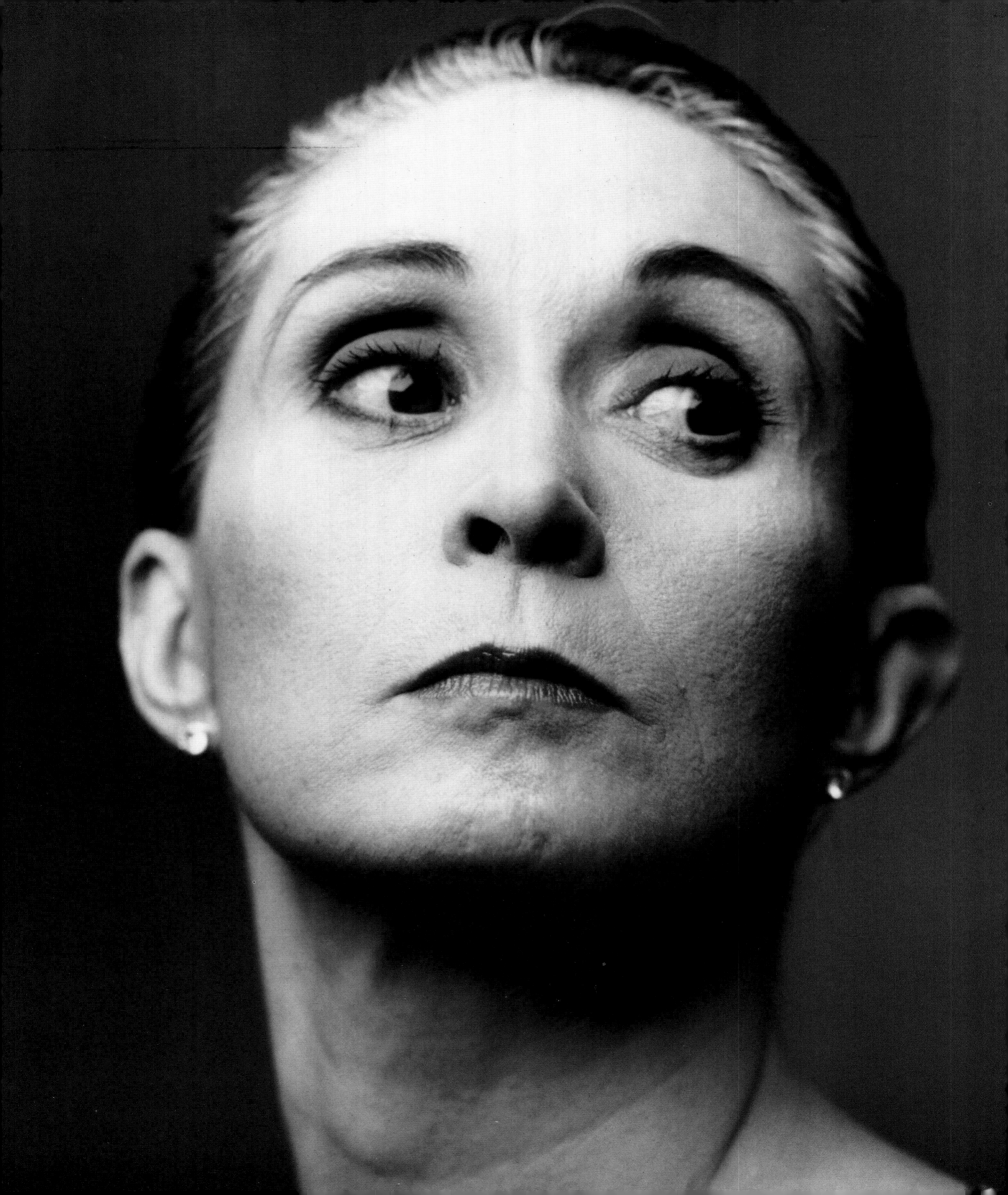

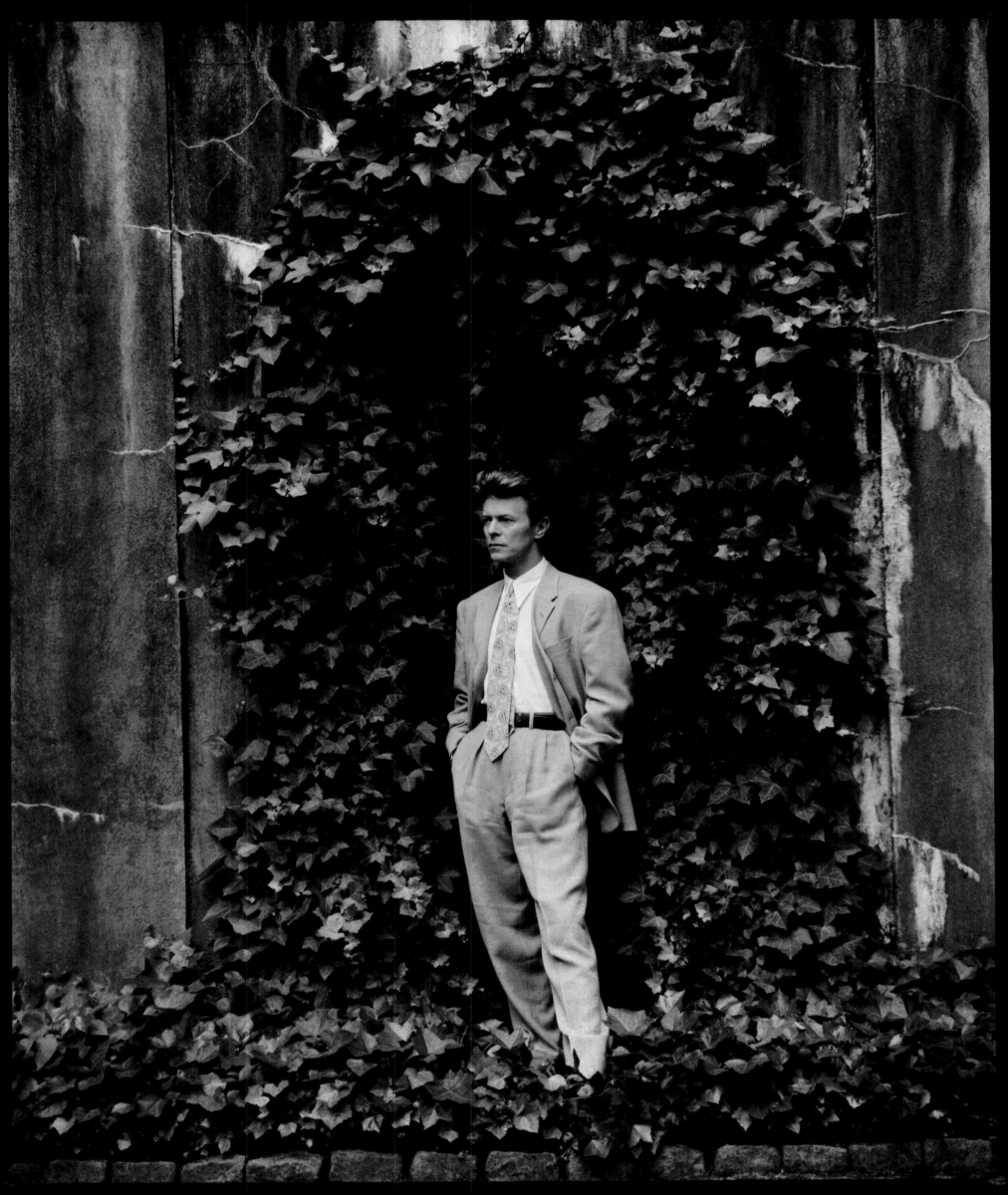

Robert Wilson, *New York City, 1989*

Preceding pages:

Twyla Tharp, *New York City, 1989*

David Bowie, *Atlanta, Georgia, 1990*

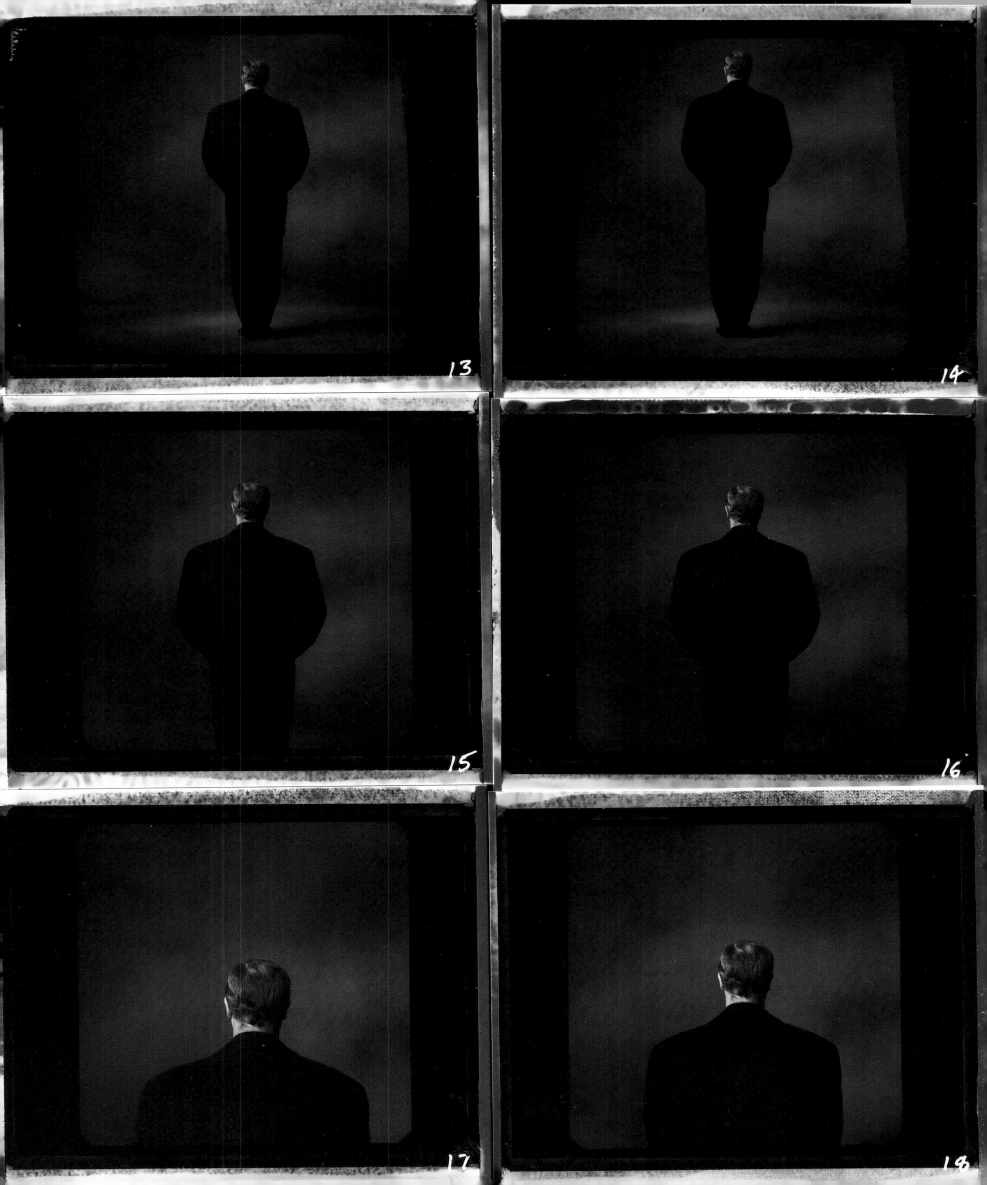

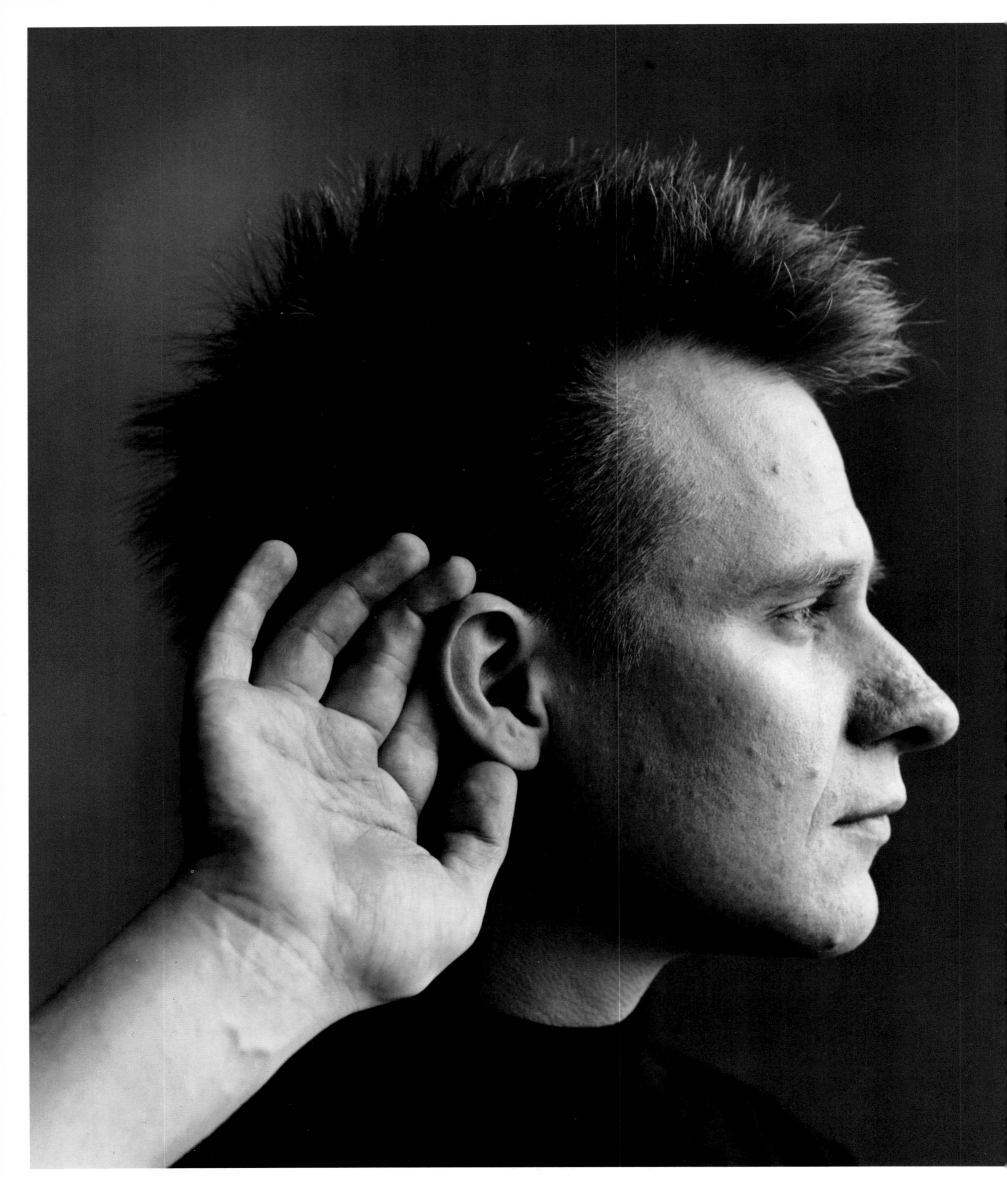

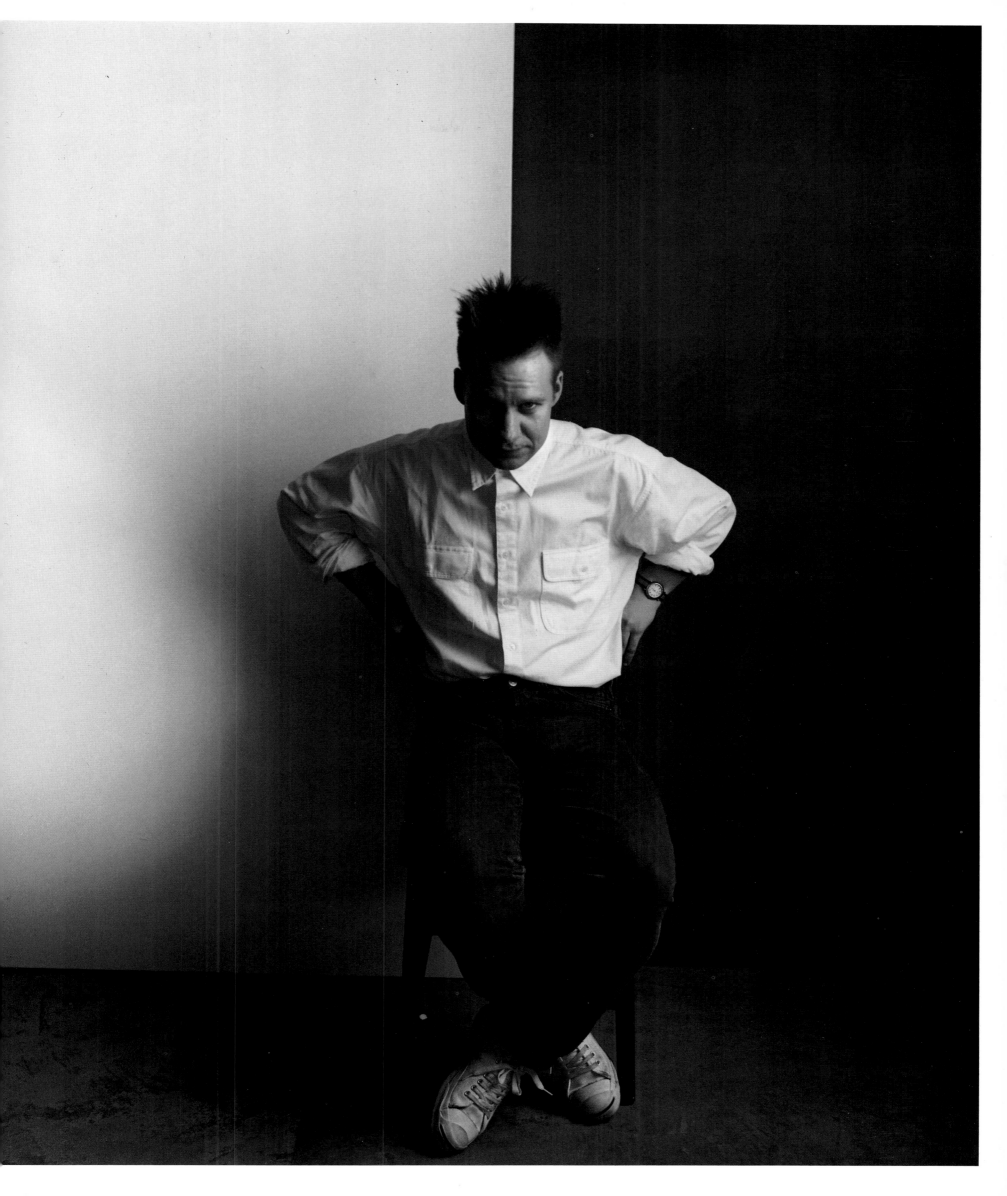

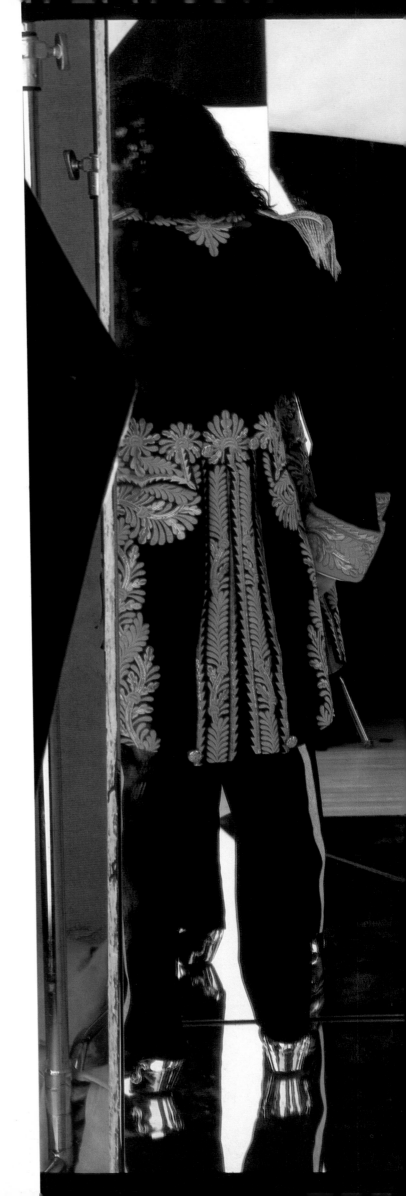

Michael Jackson, *Los Angeles, 1989*

Preceding pages:

Peter Sellars, *New York City, 1989*

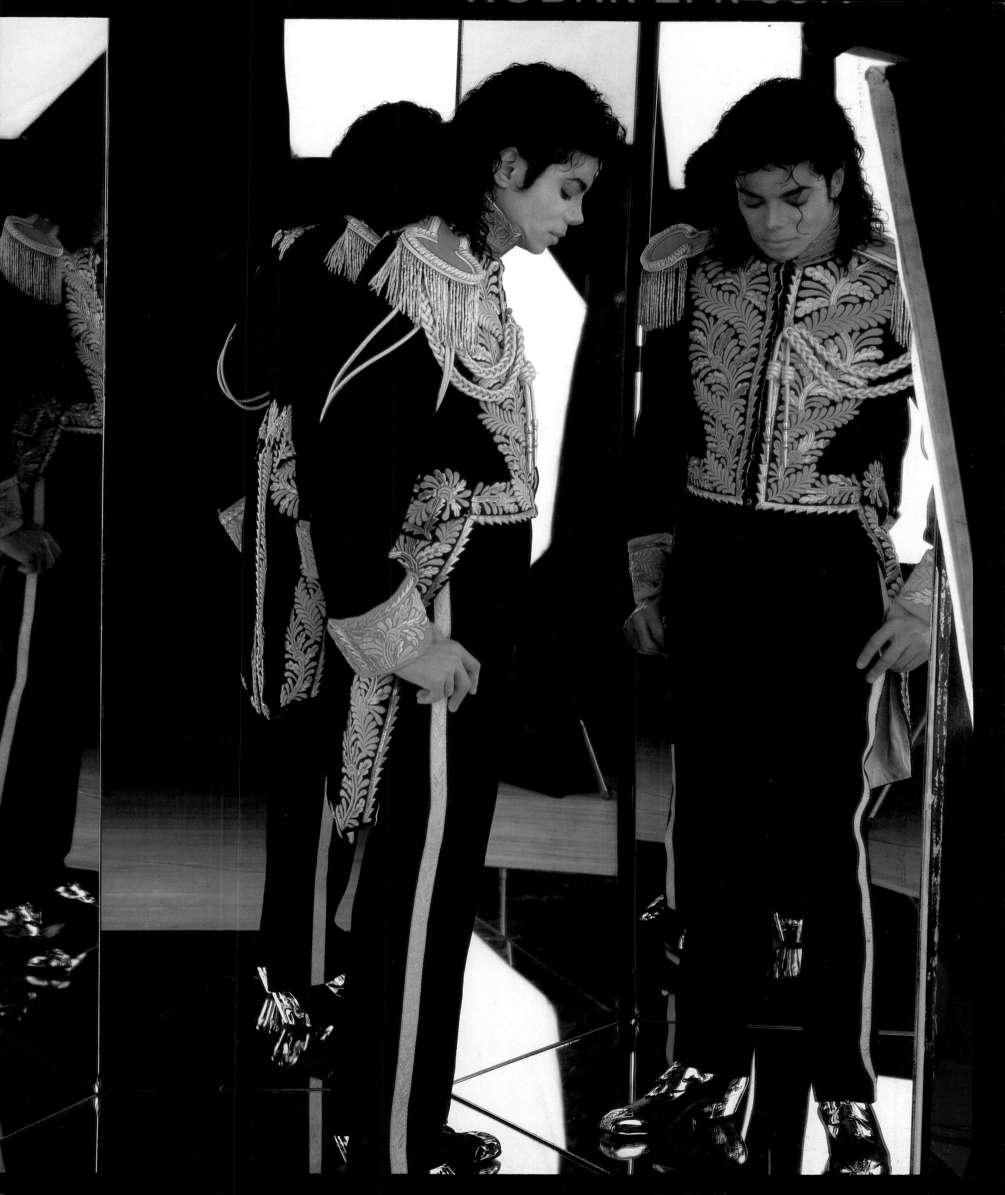

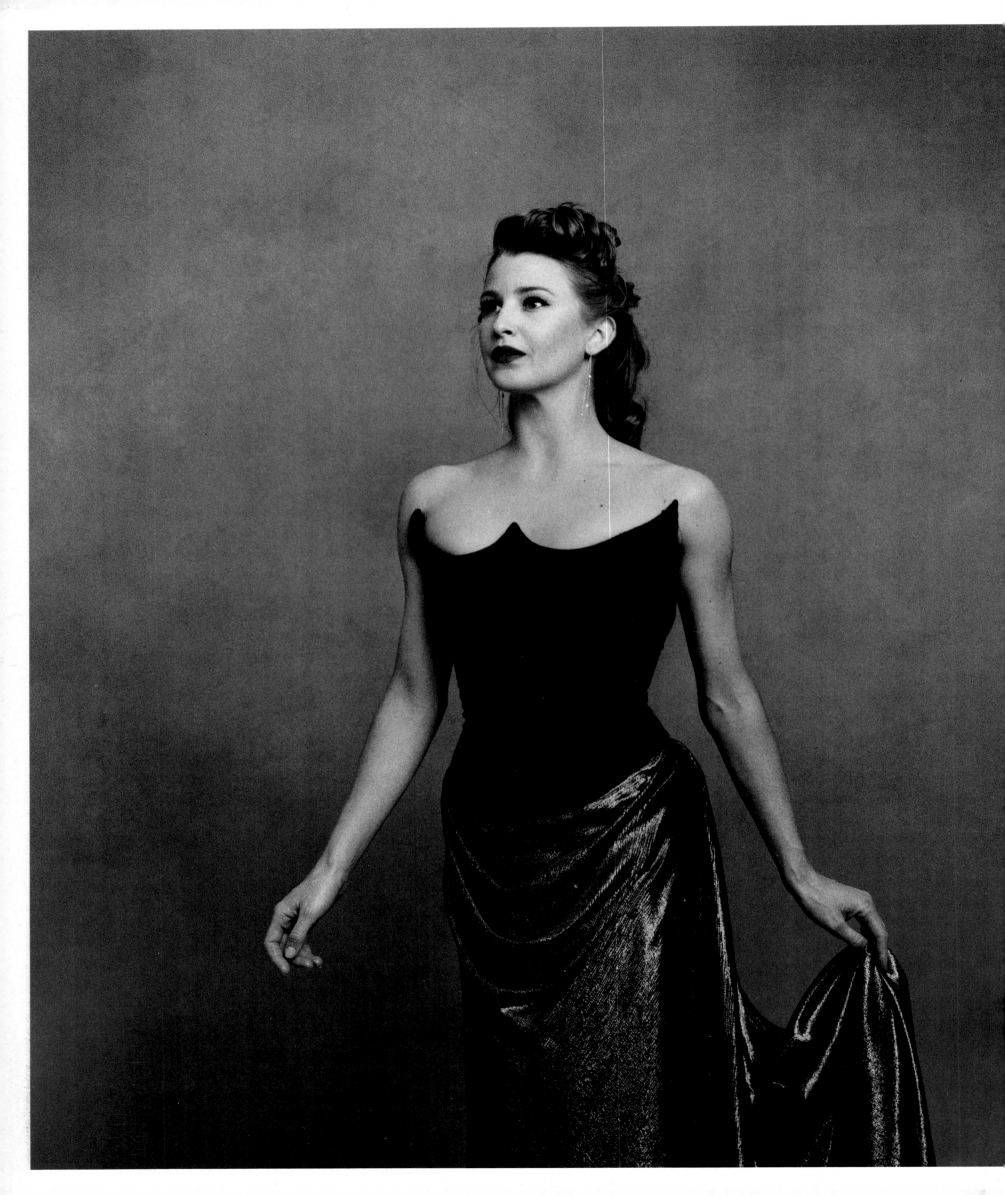

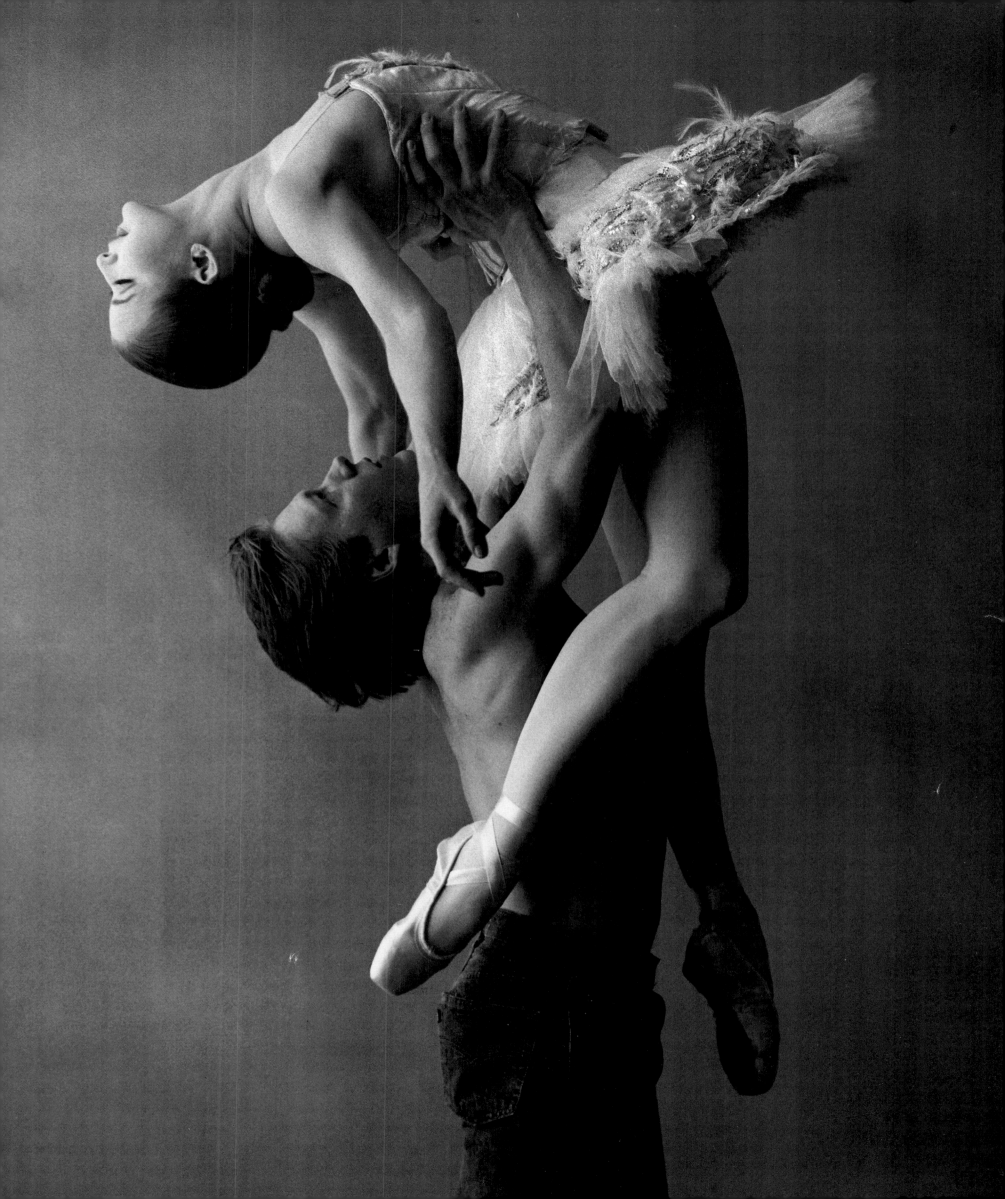

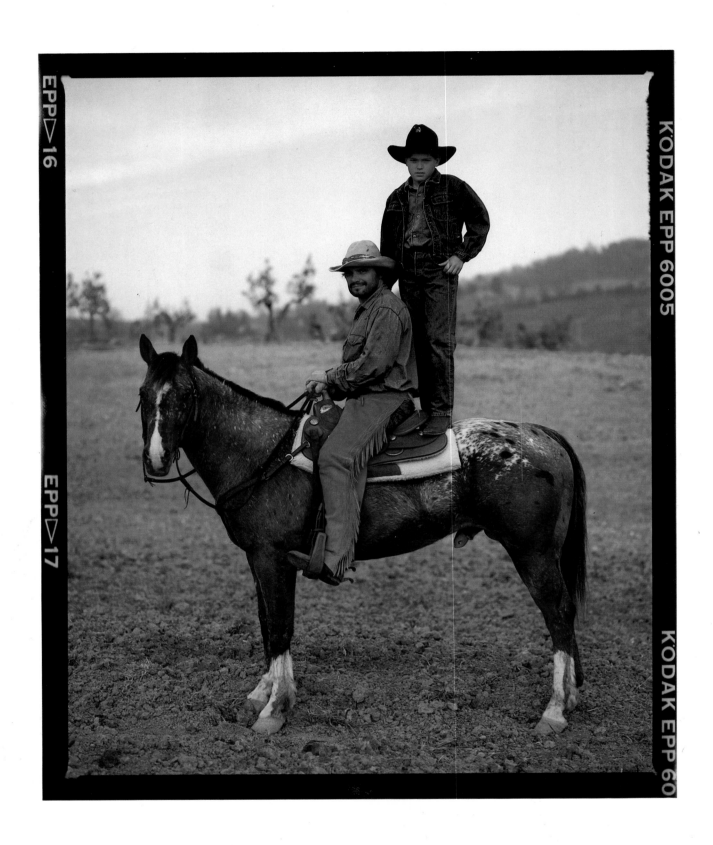

Oliviero Toscani and his son Rocco, *Cecina, Italy, 1990*

Beth Henley, *Jackson, Mississippi, 1987*

Preceding pages:

Darci Kistler and Robert La Fosse, *New York City, 1990*

202

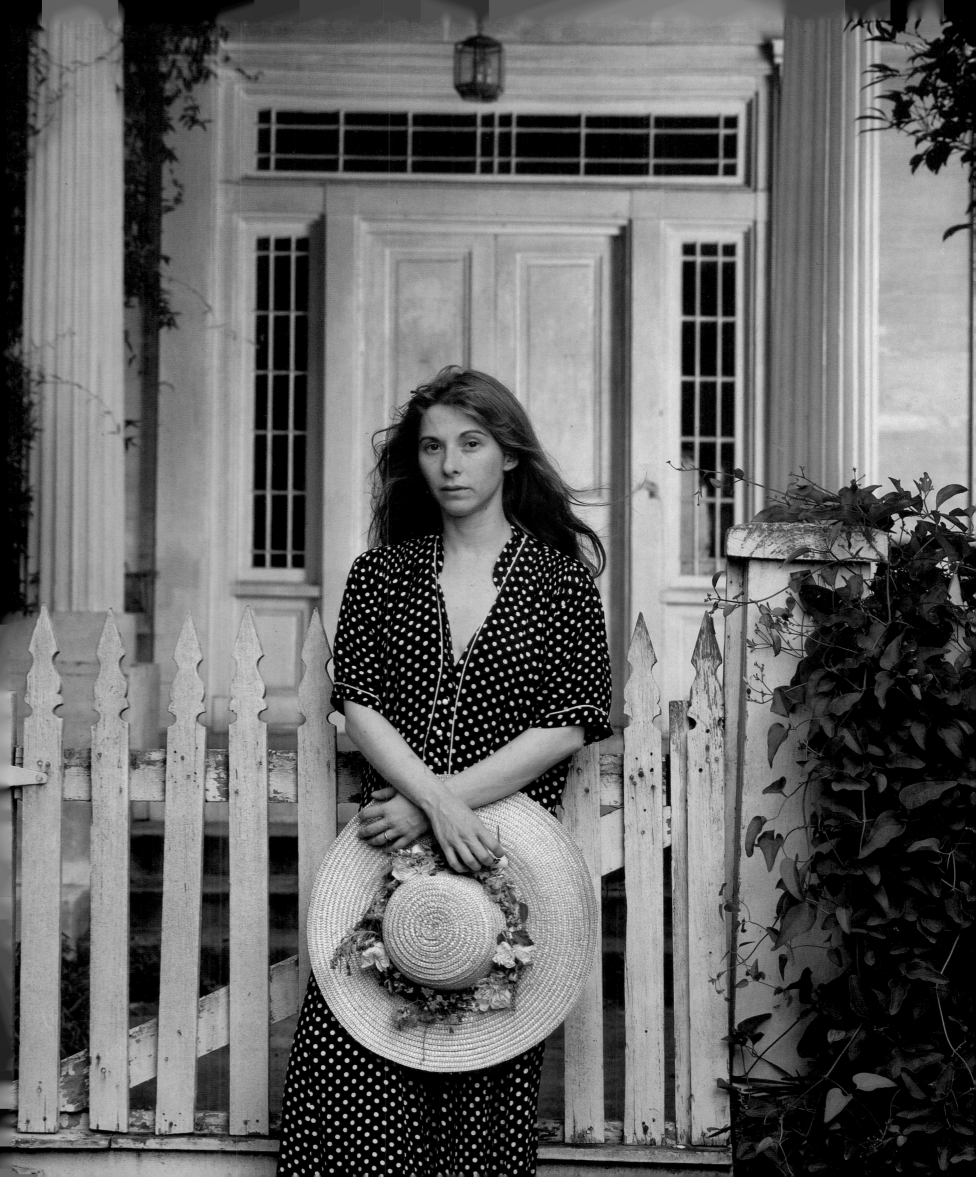

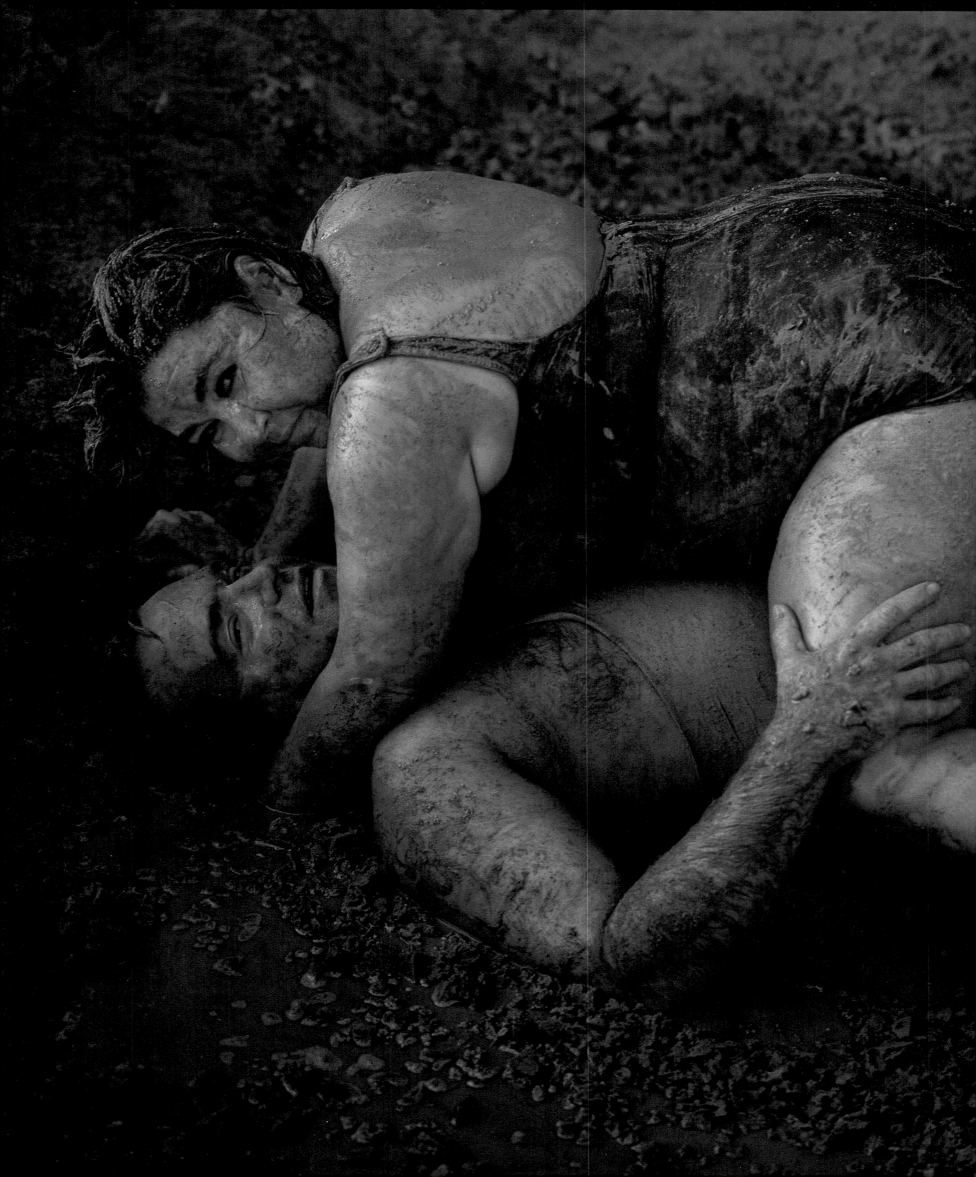

Roseanne Barr and Tom Arnold, *Malibu, California, 1990*

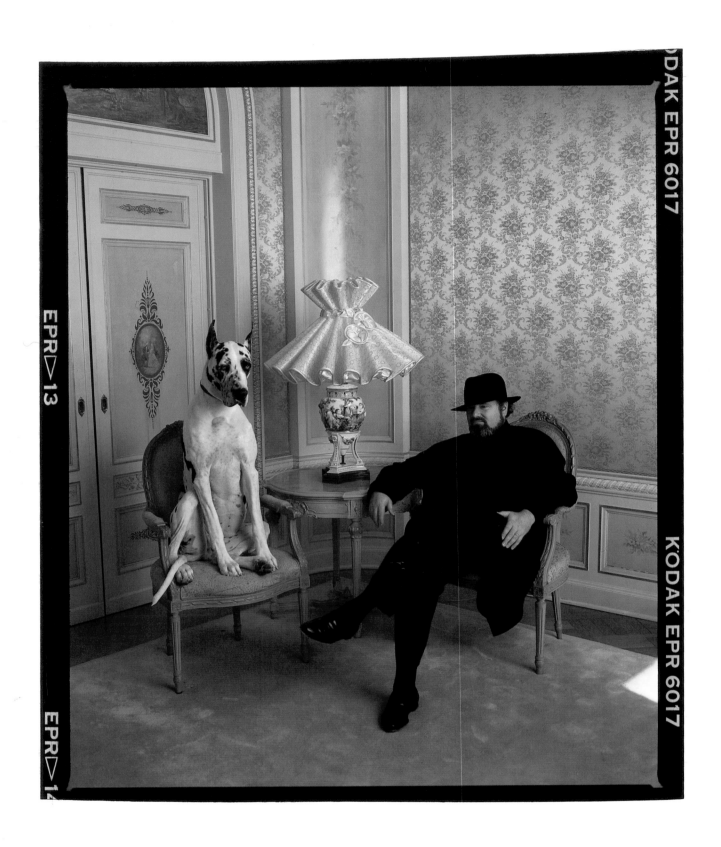

Rob Reiner, *Los Angeles, 1989*

John Cleese, *London, 1990*

Following pages:

Christian Lacroix, *Arles, France, 1990*

Andrée Putman, *New York City, 1989*

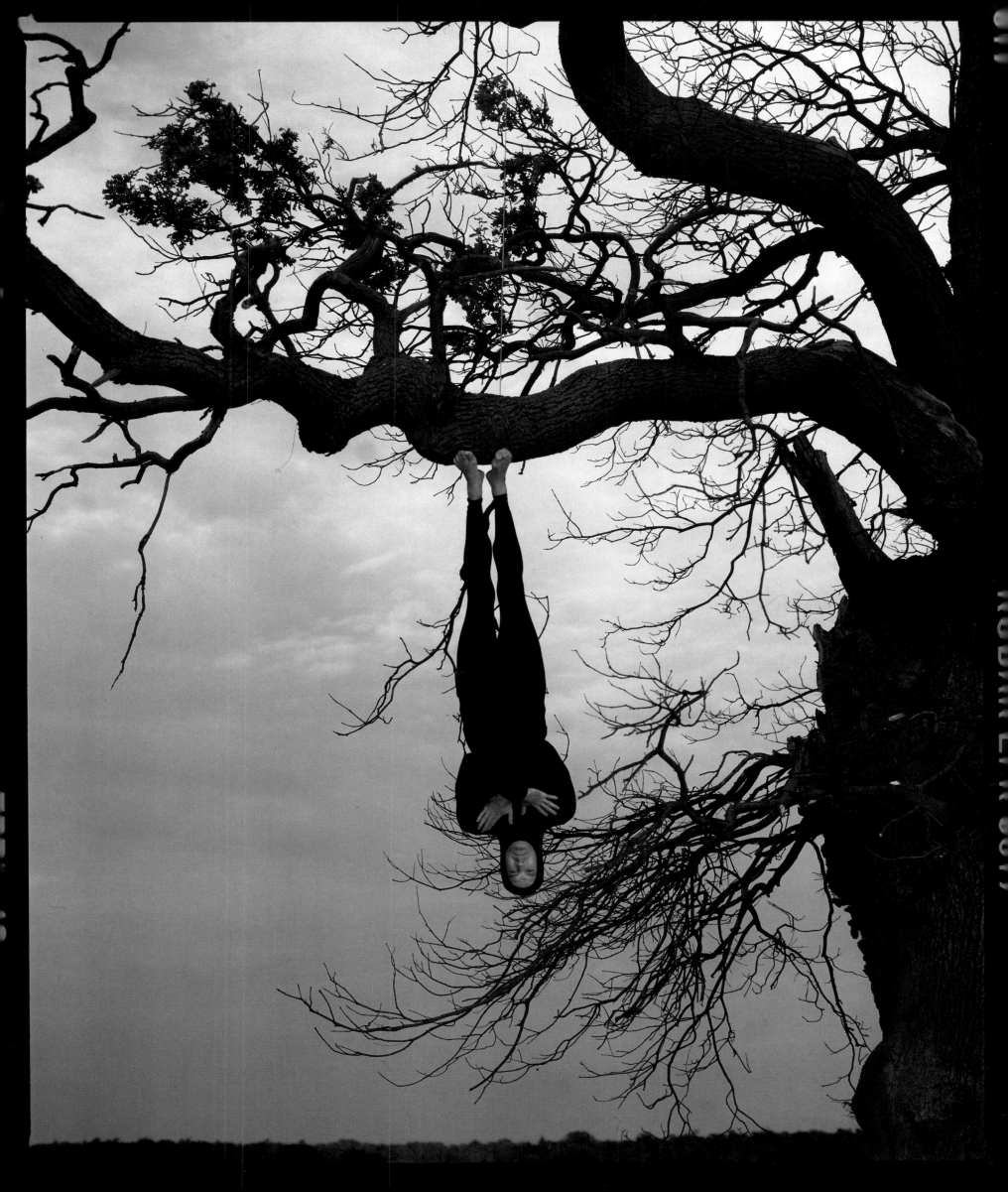

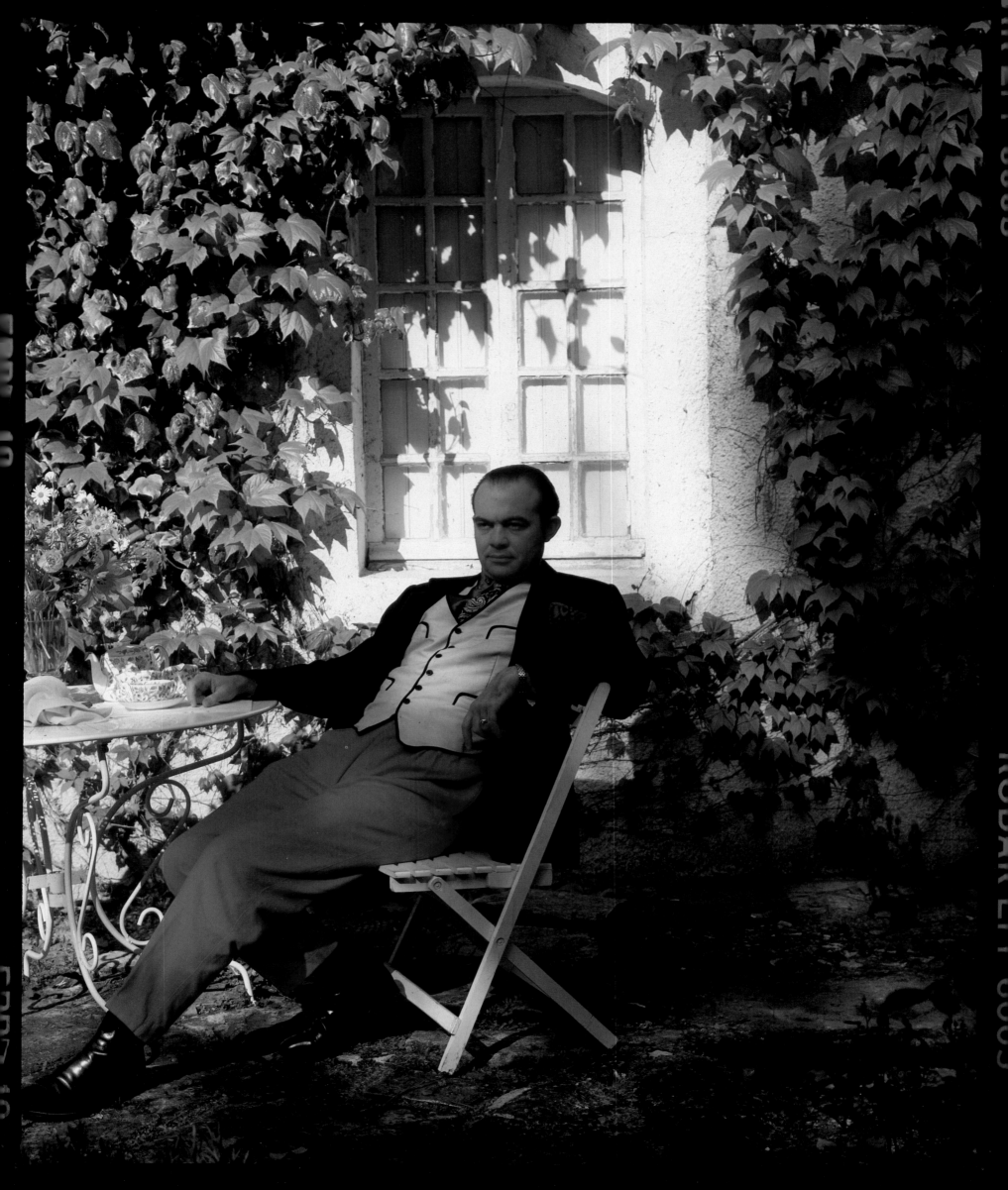

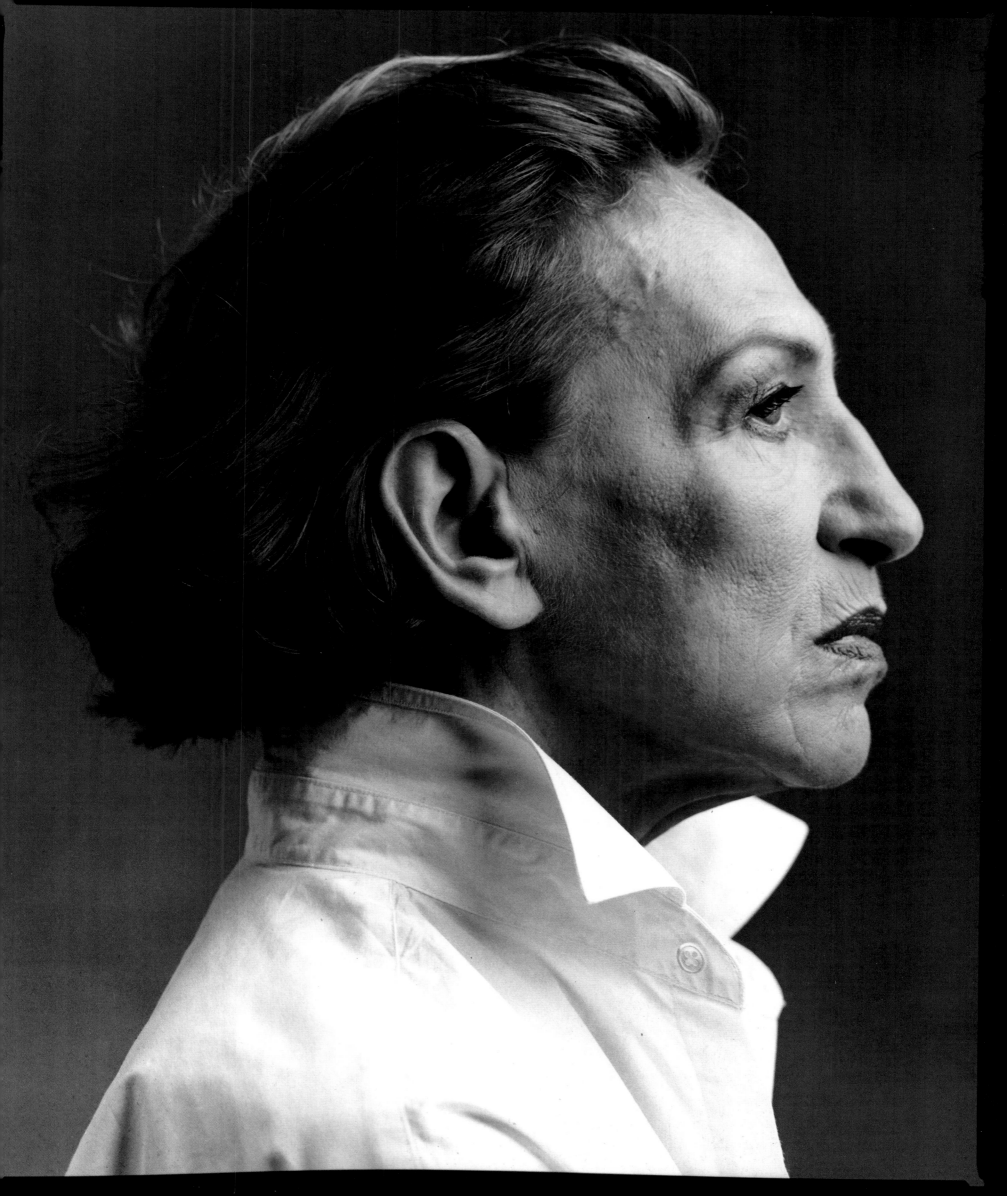

Peter Matthiessen, *Sagaponack, New York, 1990*

Following pages:

Barbara Kruger, *New York City, 1990*

Jeff Koons, *Munich, 1990*

The Dalai Lama, *Washington, New Jersey, 1990*

Václav Havel, *Prague, 1990*

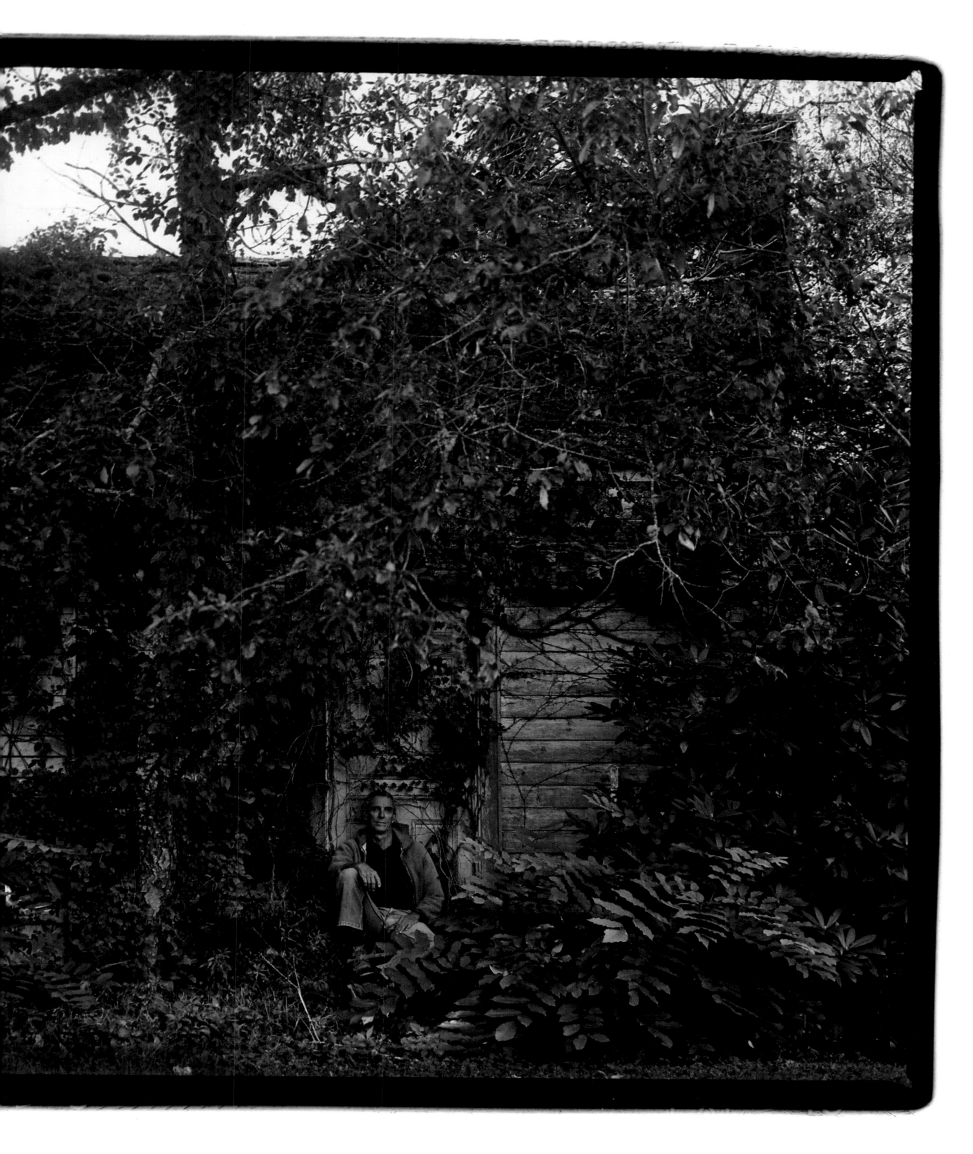

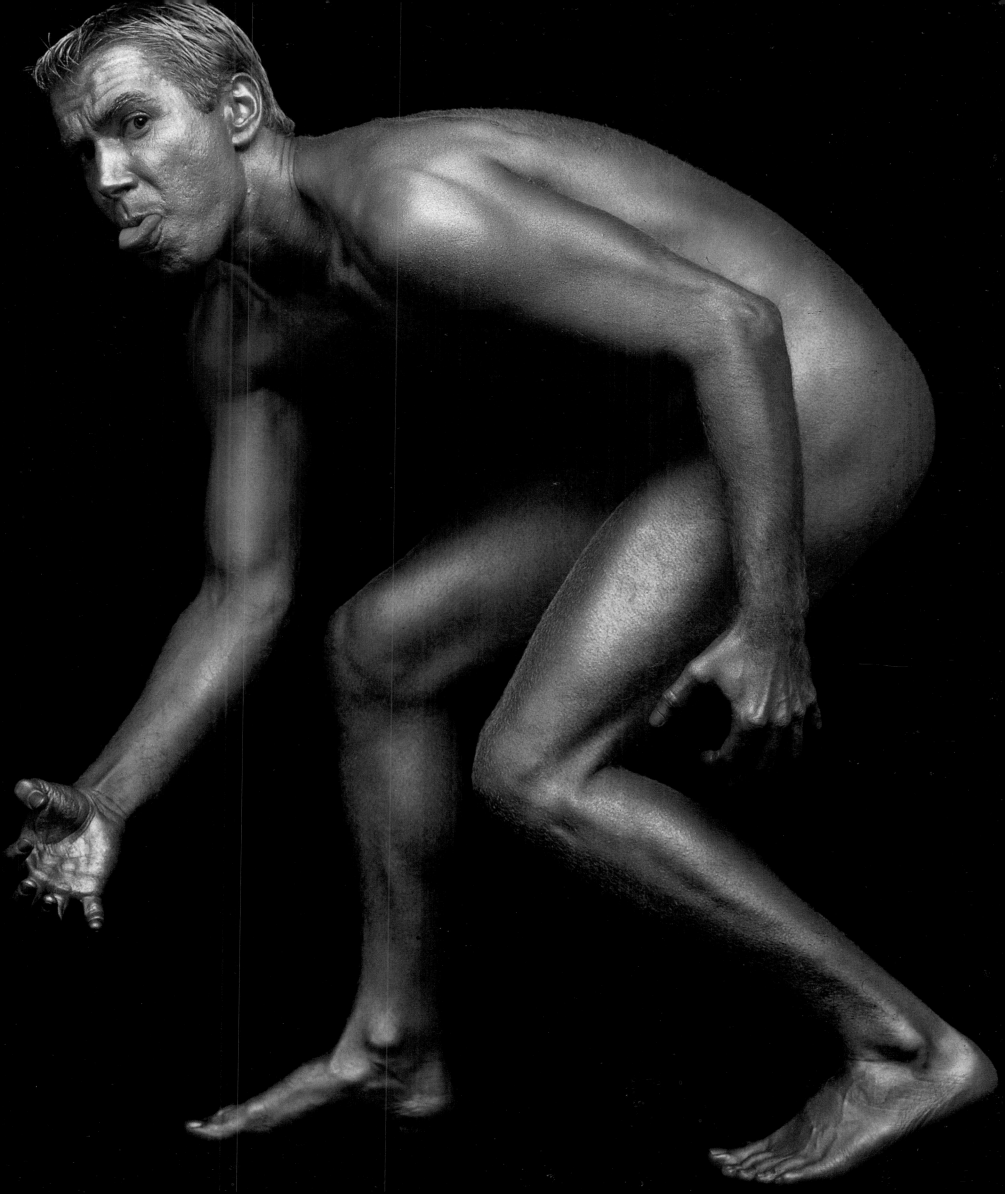

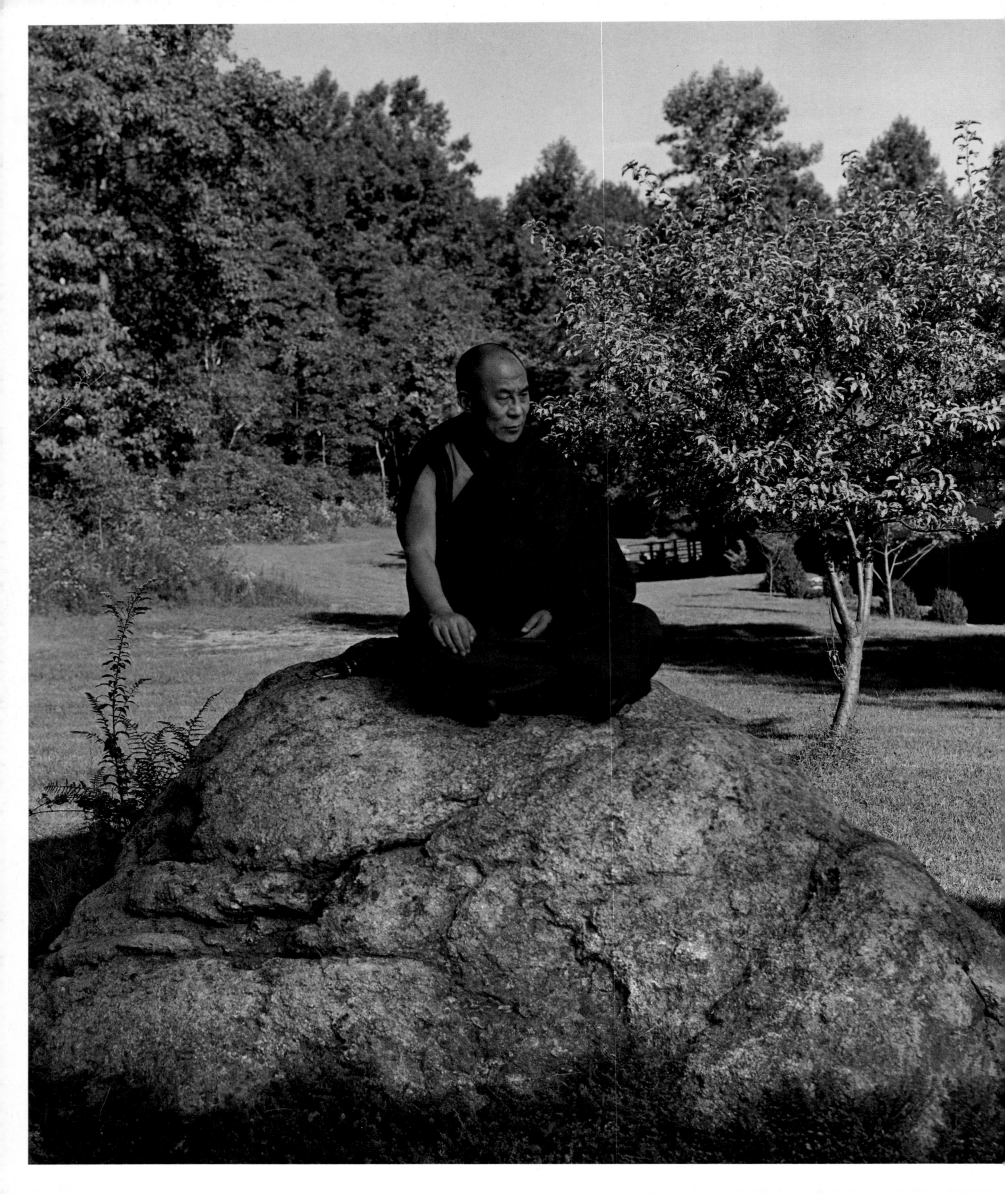

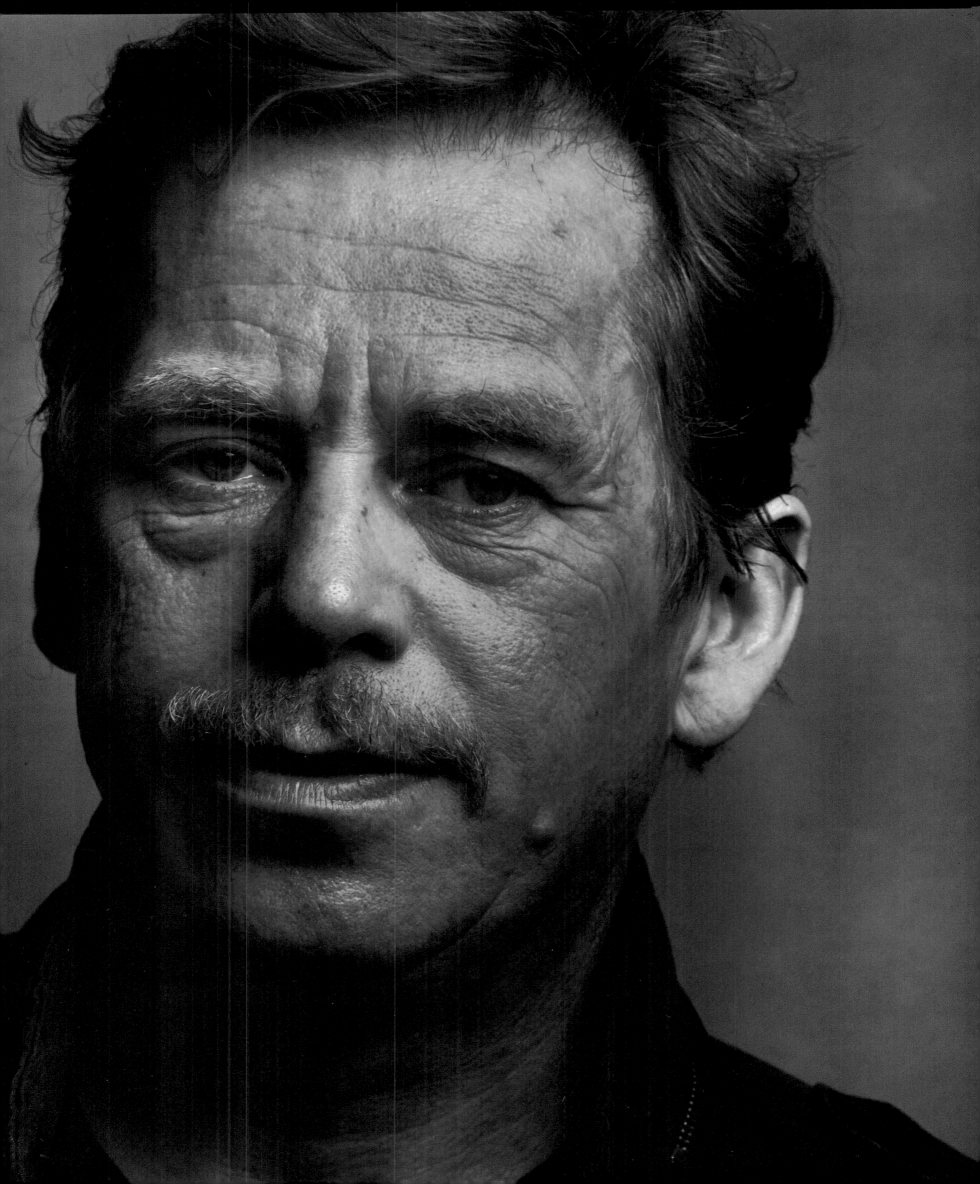

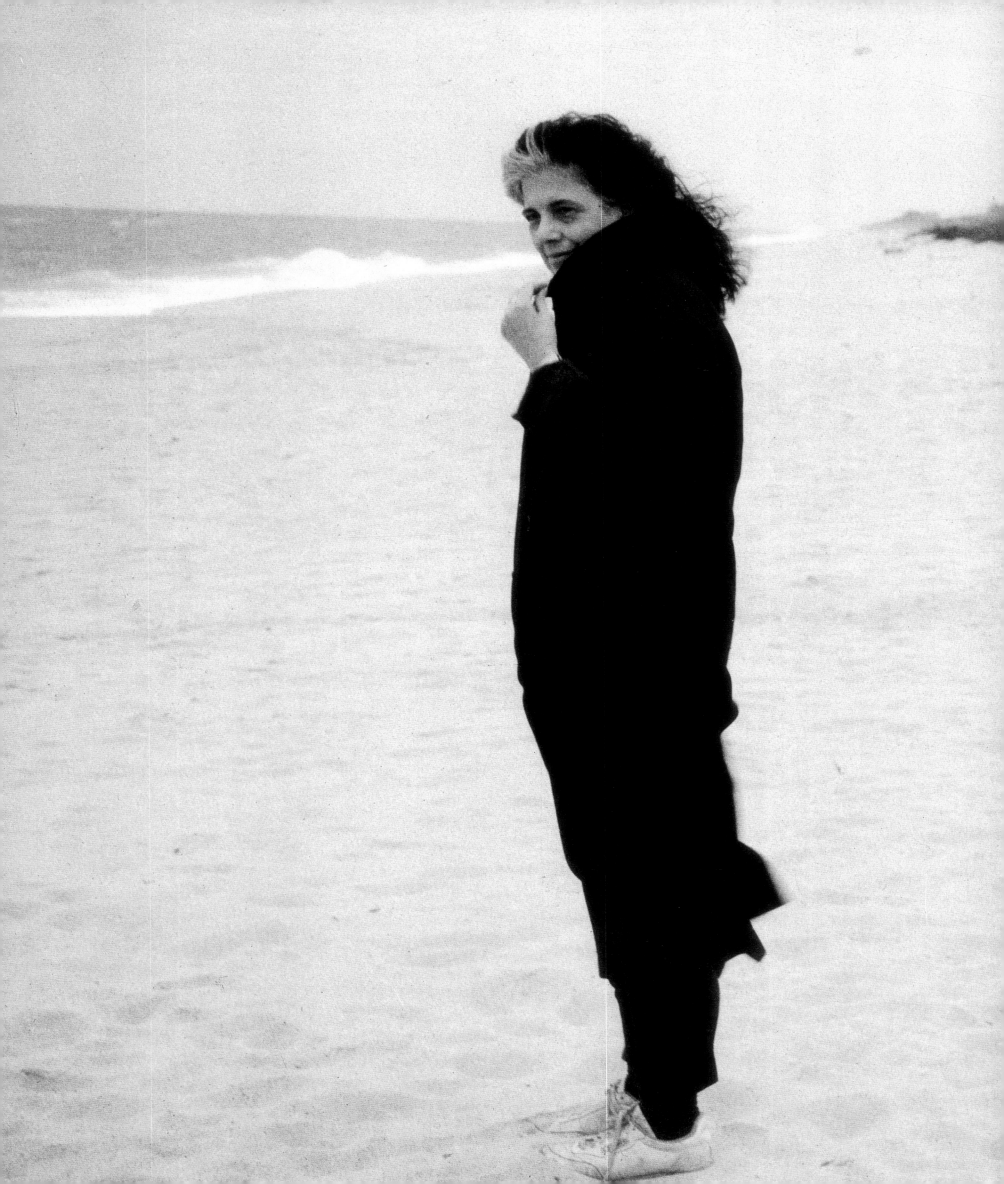

Susan Sontag,
Long Island, New York, 1990

Following pages:

Mikhail Baryshnikov,
New York City, 1989,
and Florida, 1990

217

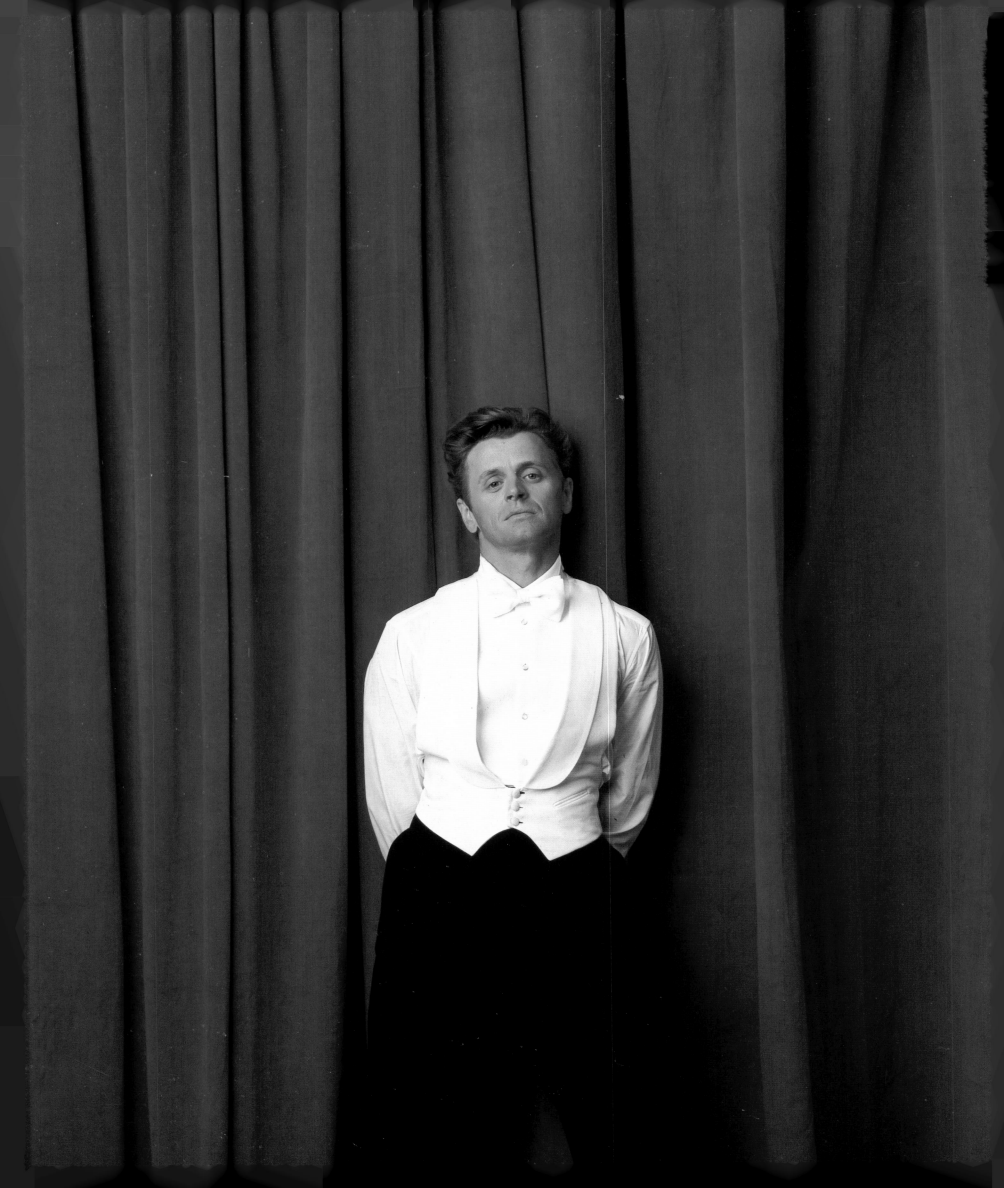

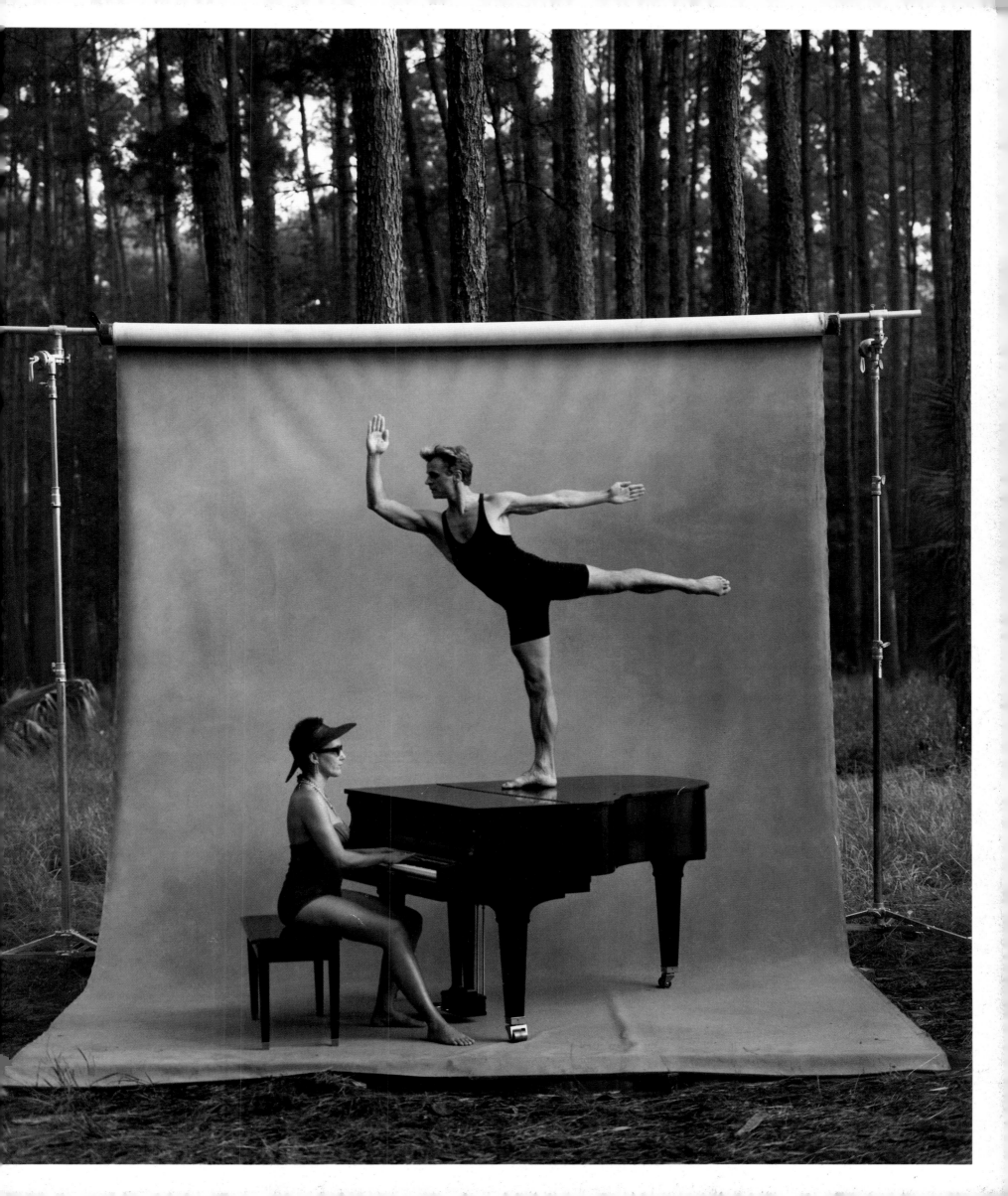

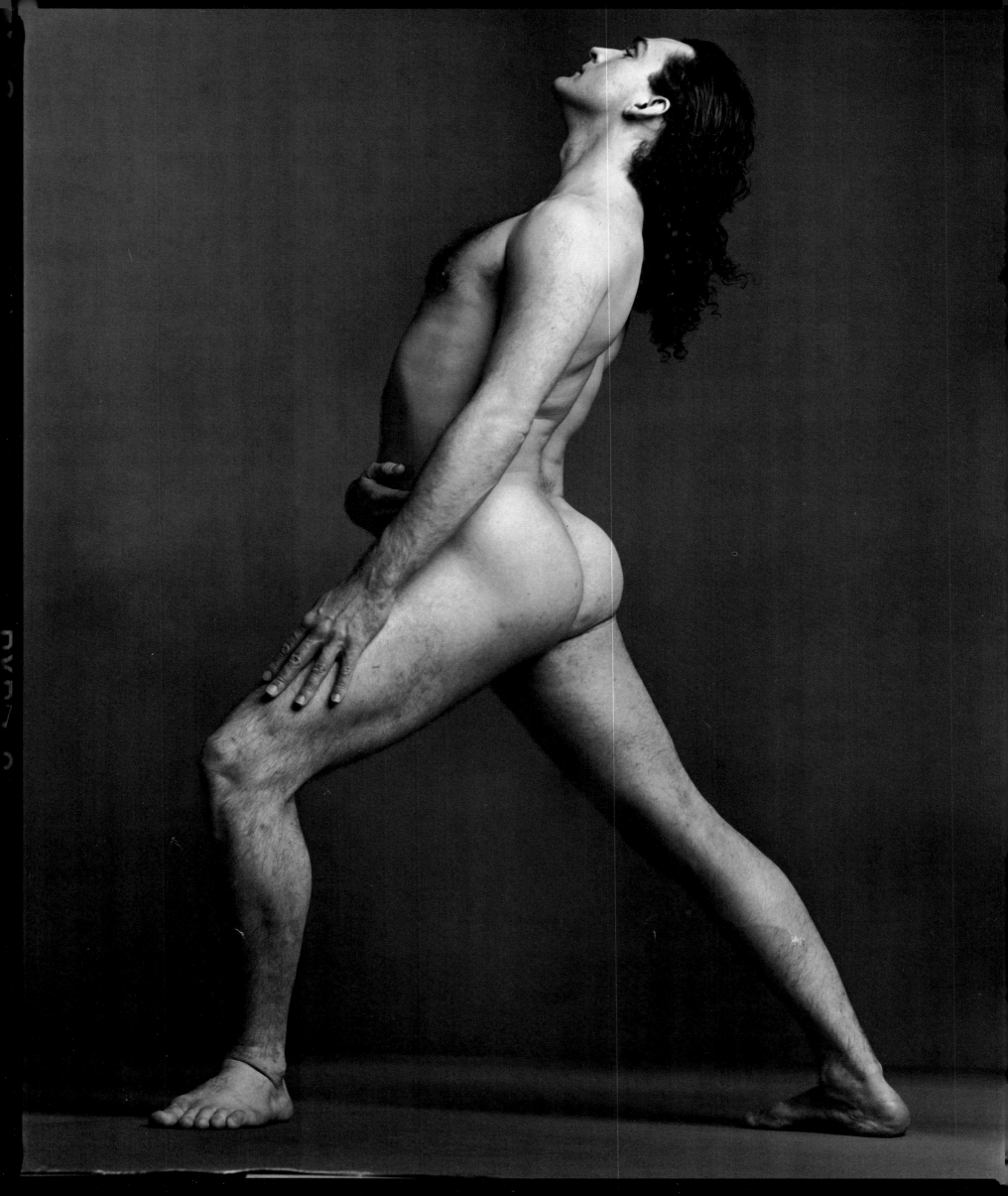

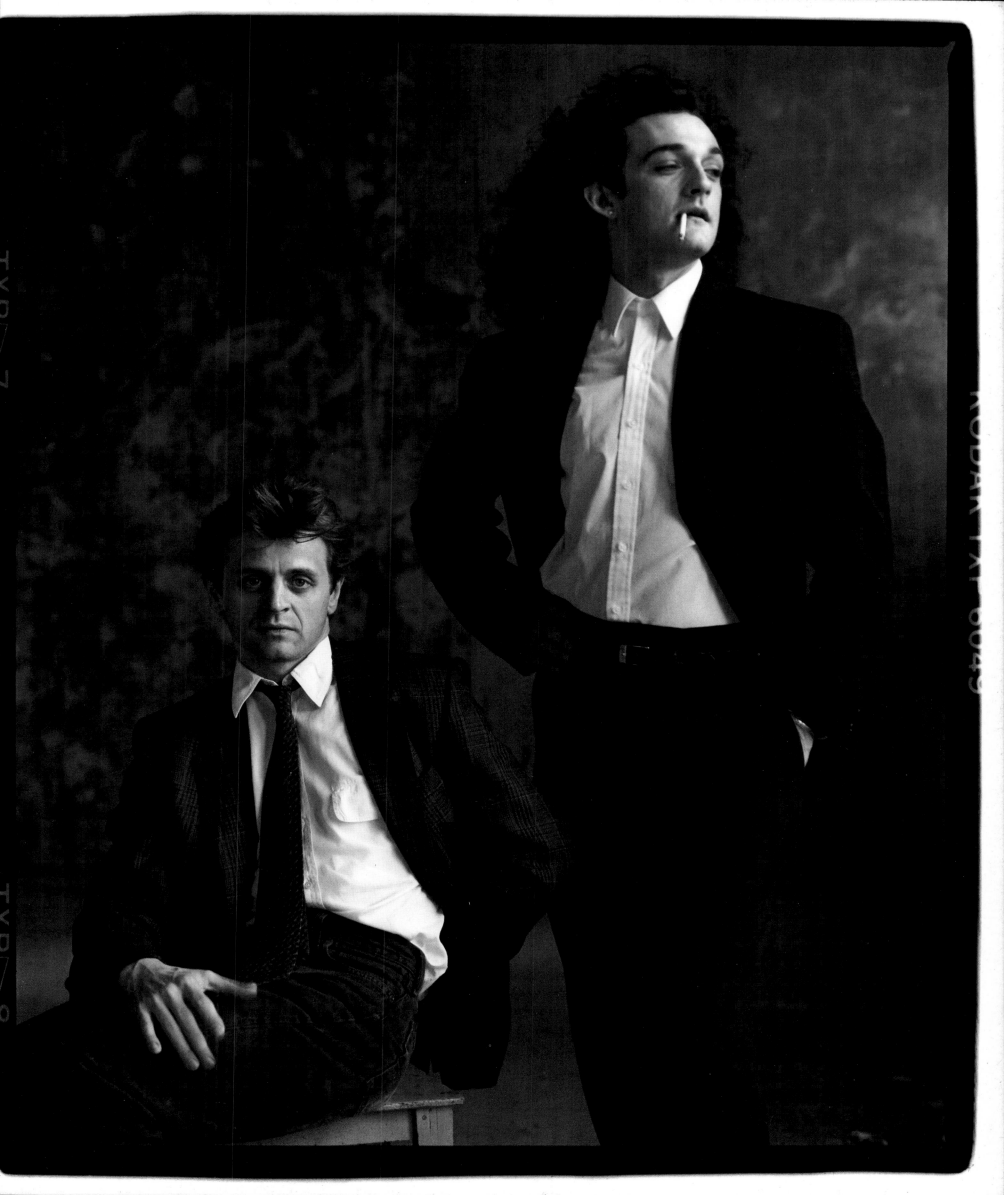

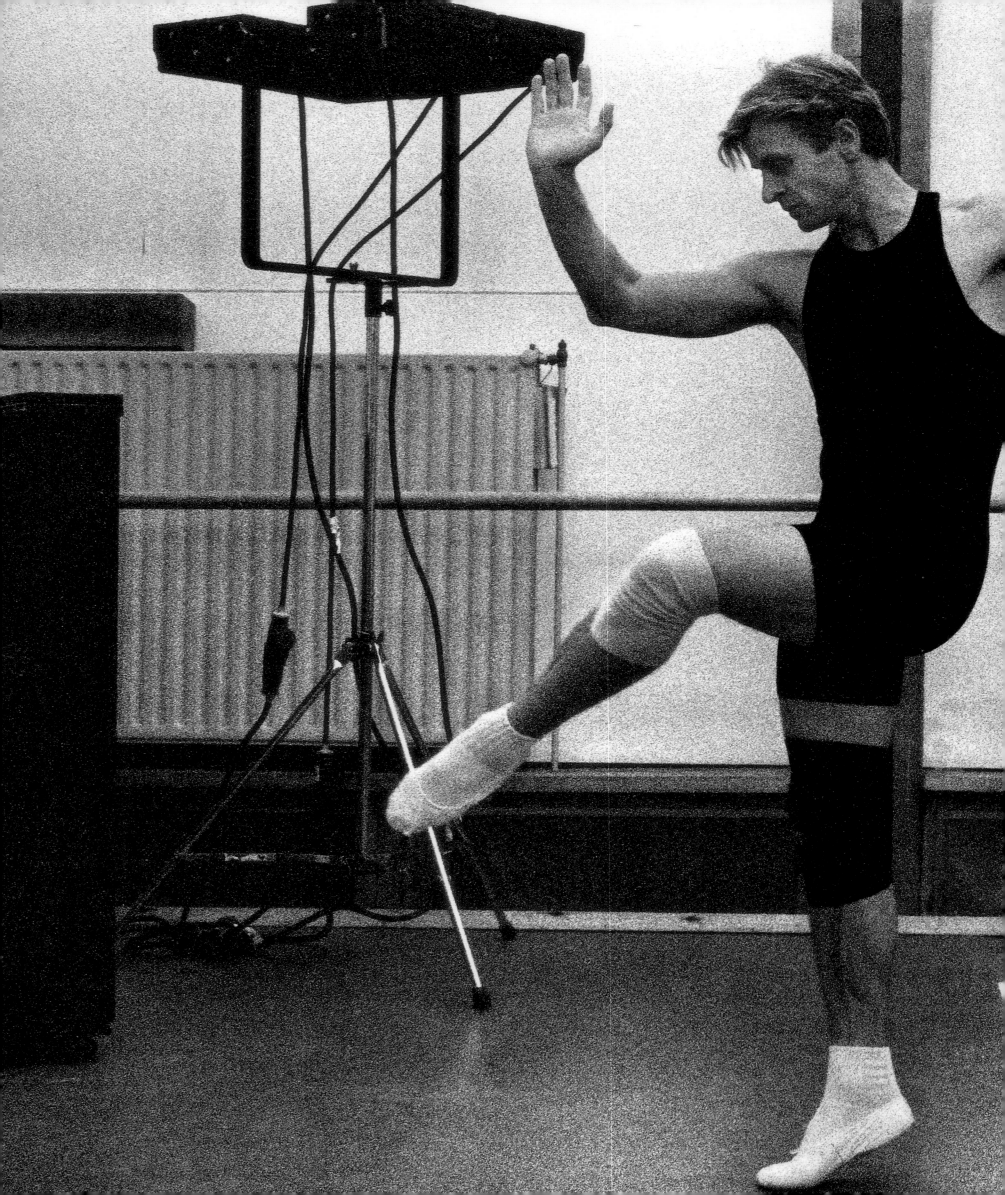

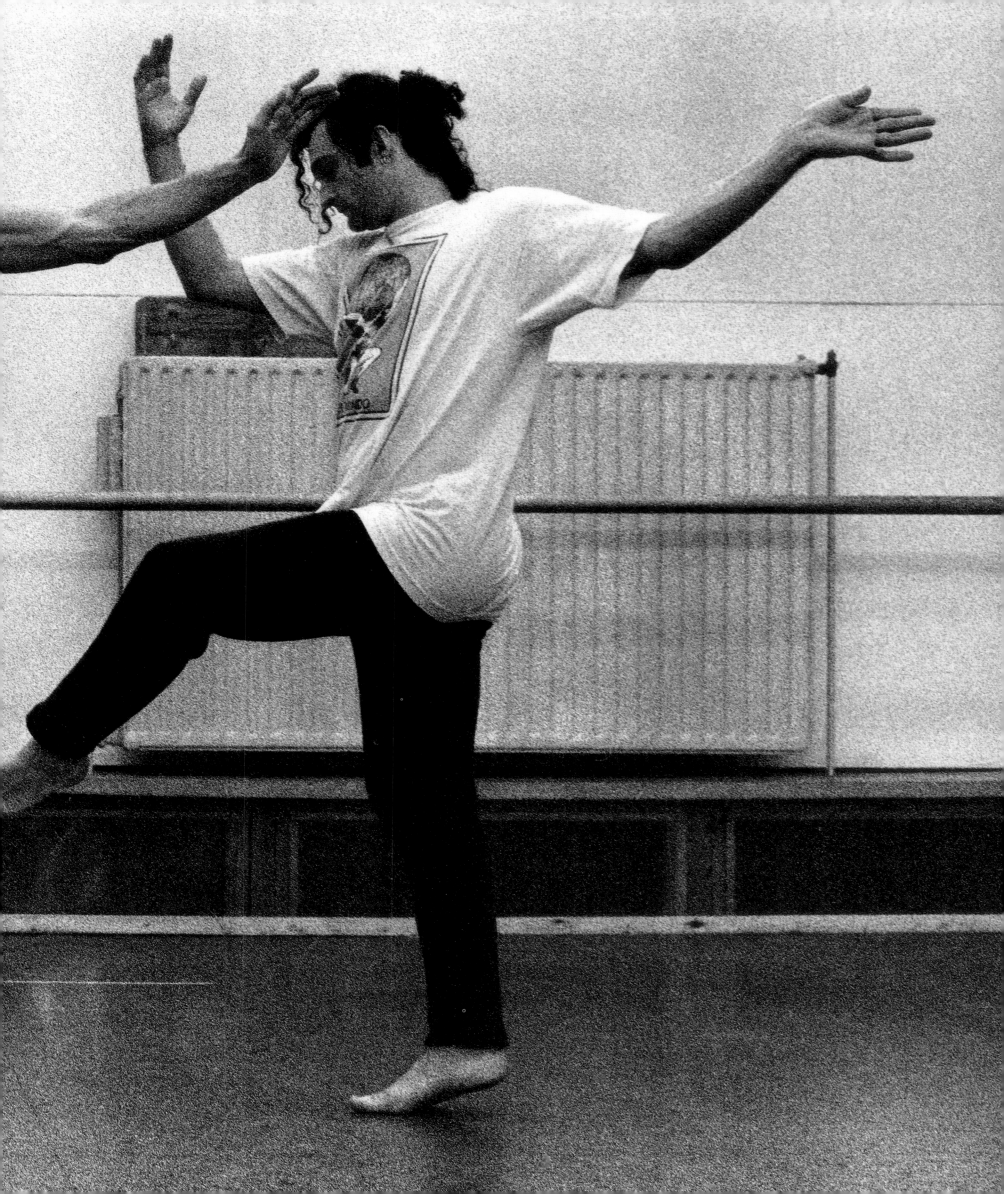

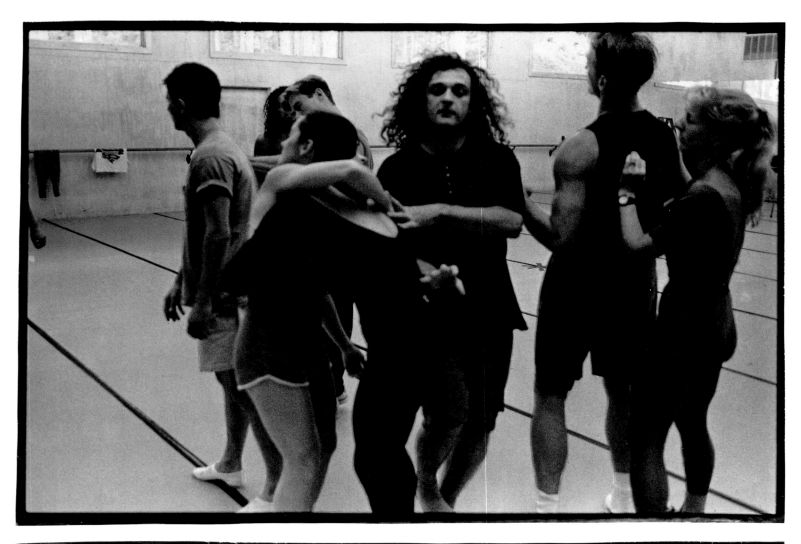
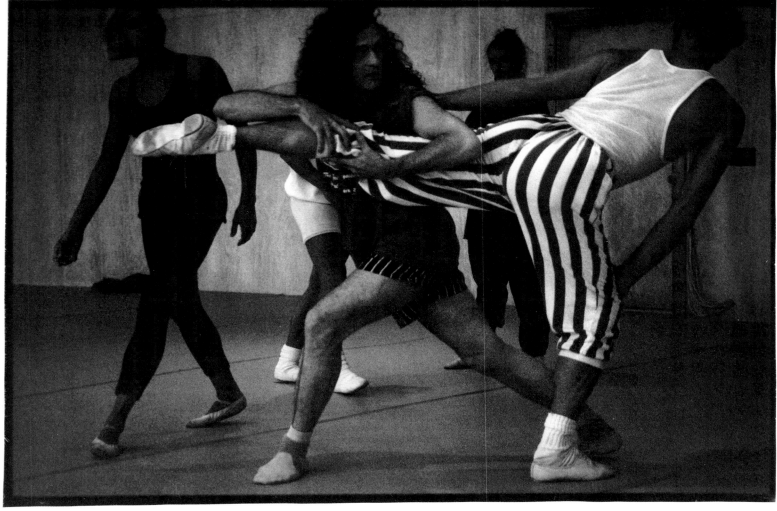

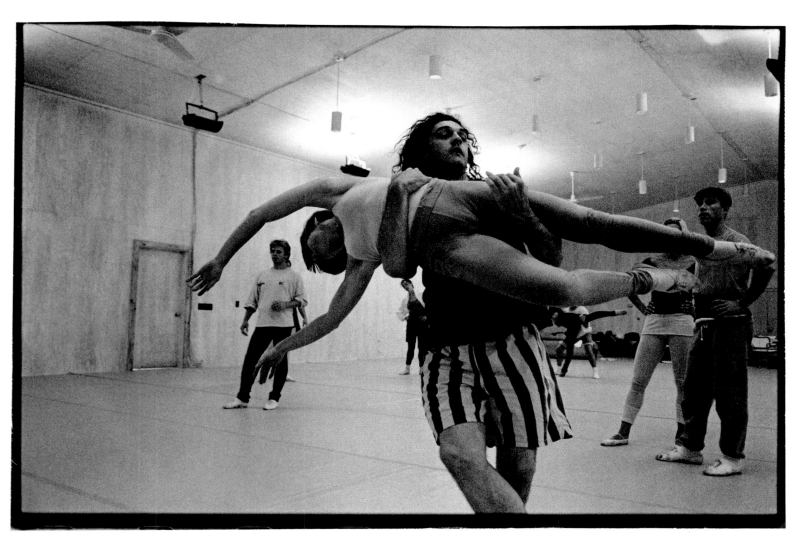

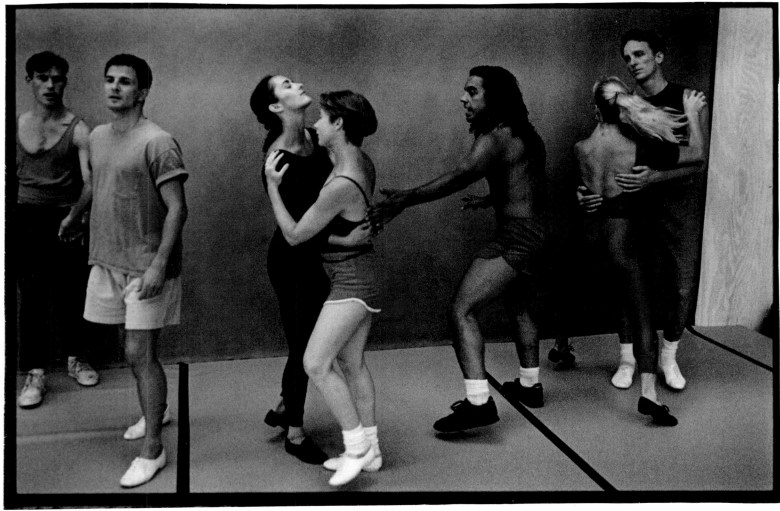

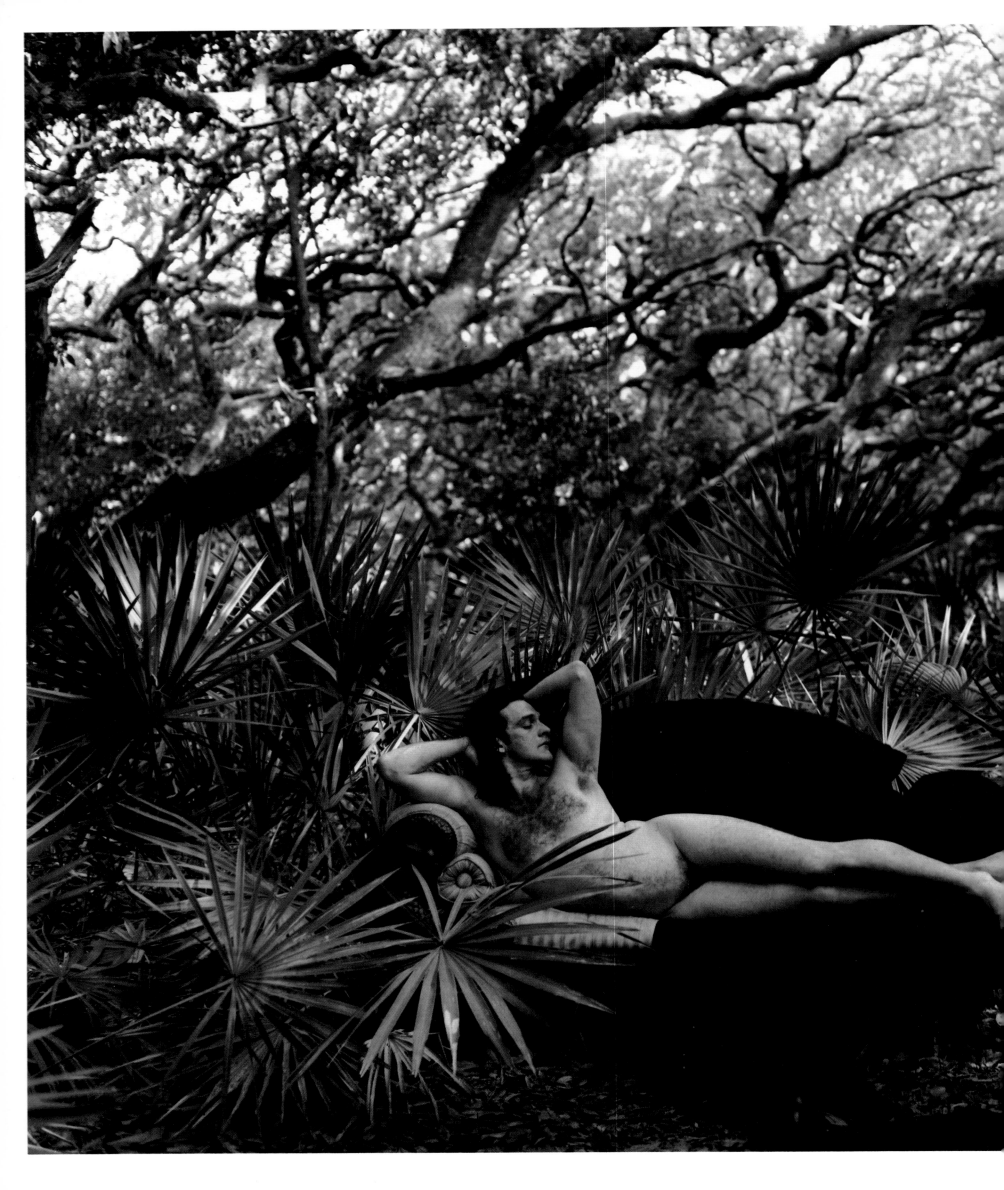

Mark Morris, *Cumberland Island, Florida, 1990*

Preceding pages:

Mark Morris, *New York City, 1989*

Mikhail Baryshnikov and Mark Morris, *New York City, 1988*

Baryshnikov and Morris, *Brussels, Belgium, 1990*

The White Oak Dance Project, *Florida, 1990*

Following page:

Dancers, *Florida, 1990*

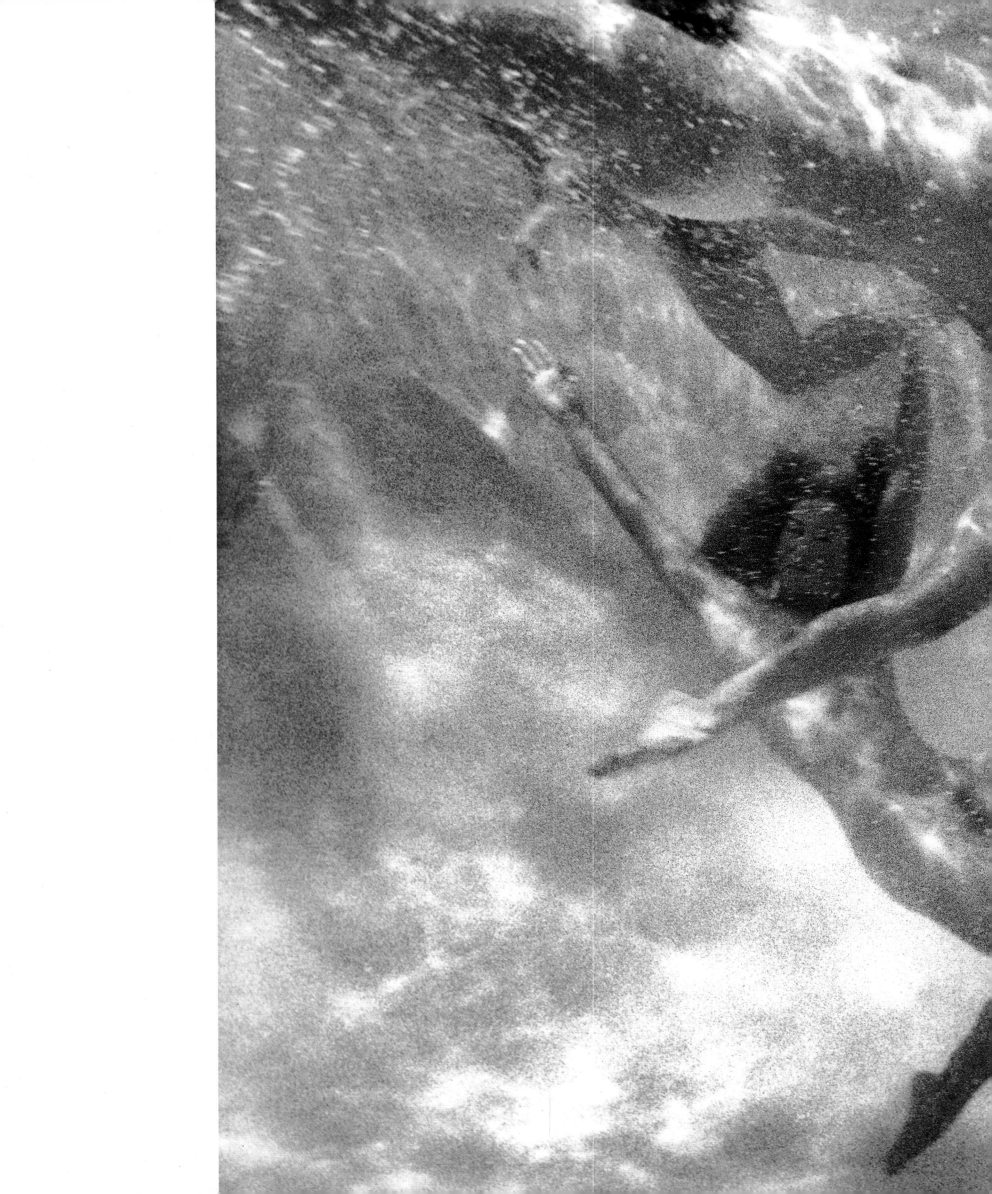

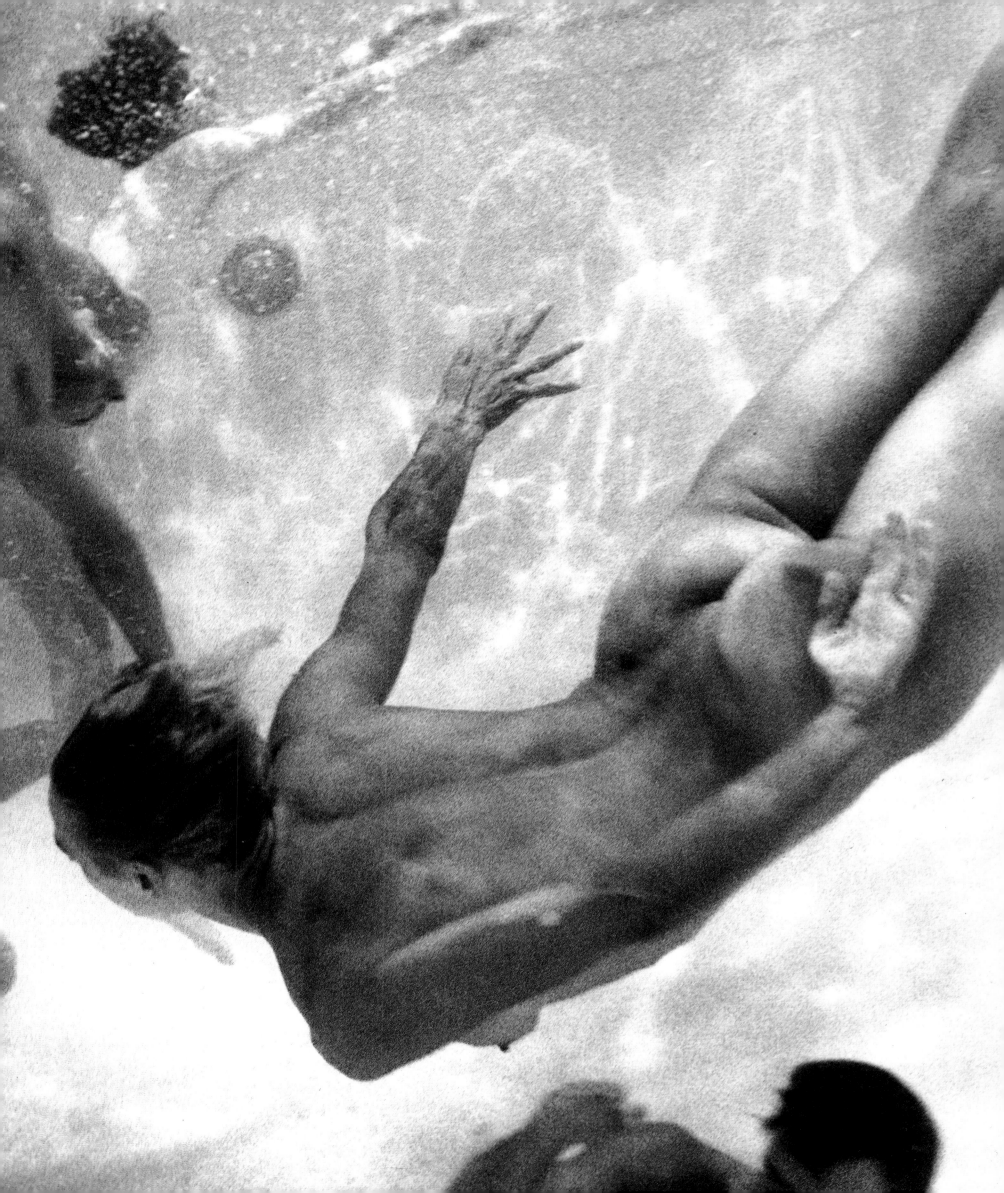

LIST OF PHOTOGRAPHS

* This photograph was not published, although a similar photograph from the same session was used.

GRATEFUL ACKNOWLEDGMENTS TO

Jann and Jane Wenner

Bea Feitler

Jim Moffat

Tina Brown

David Felton Earl McGrath Eve Babitz

Lloyd Ziff Robert Pledge Ruth Ansel

Robert Kingsbury Tony Lane

Michael Salisbury Roger Black Mary Shanahan

Karen Mullarkey Beth Filler Laurie Kratochvil

Eileen Kasofsky Susan Beeson

Parry Merkley Lori Goldstein

Jane Sarkin Marina Schiano

Sharon DeLano

Chuck Boone George Lange Andrew Eccles

Casey Butts Dave Rose Kevin Guiler

Carol Leflufy Jim Johnson Jeffrey Smith

Kasia Górska Lee Ng Helen Crowther

Chong Lee Rowena Otremba

Jim Megargee